THE WORLD OF BIEDERMEIER

A PREFACE

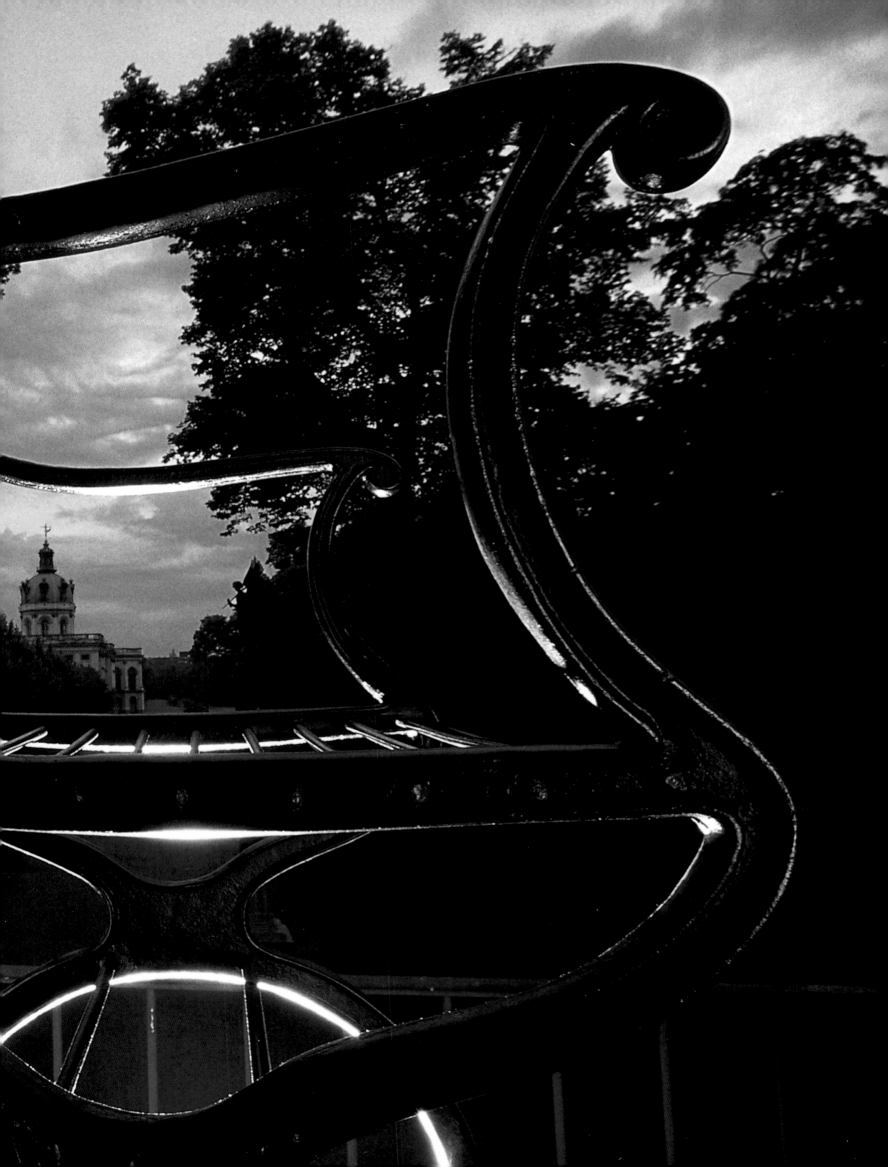

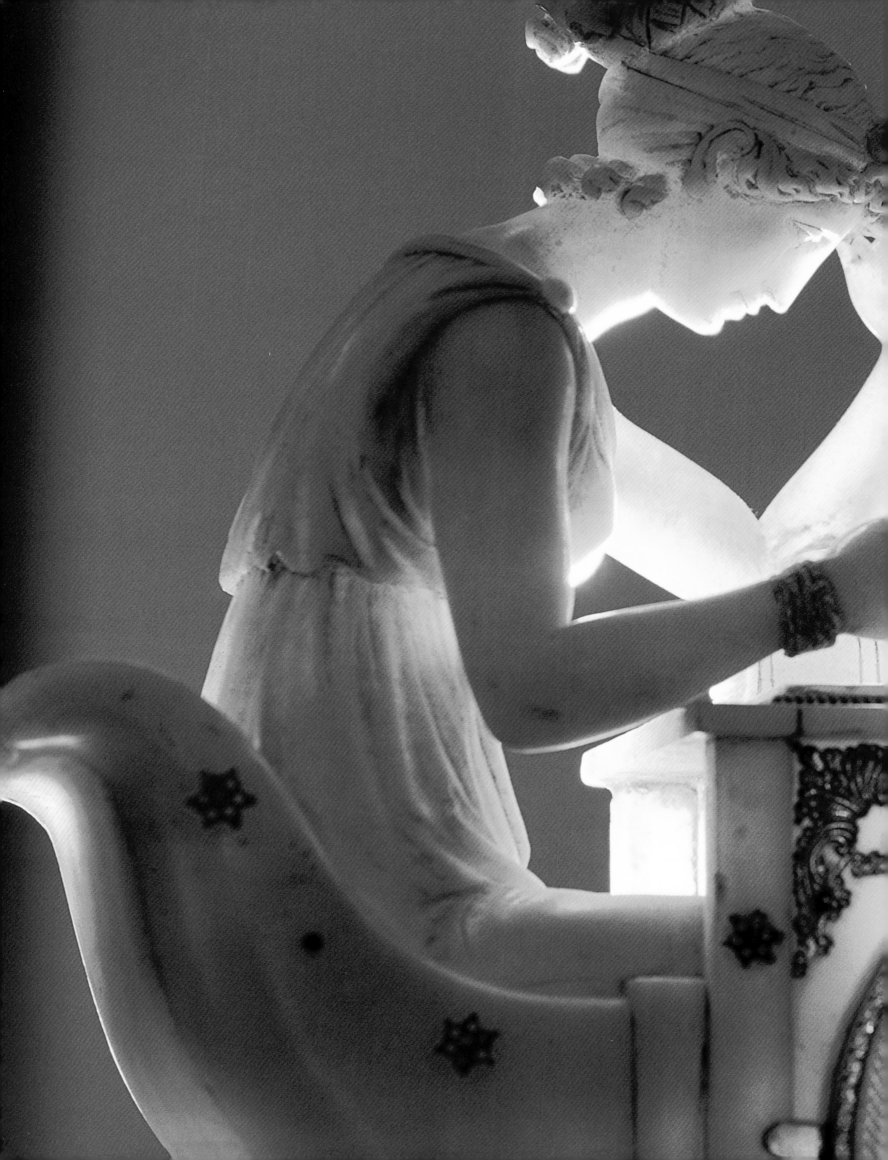

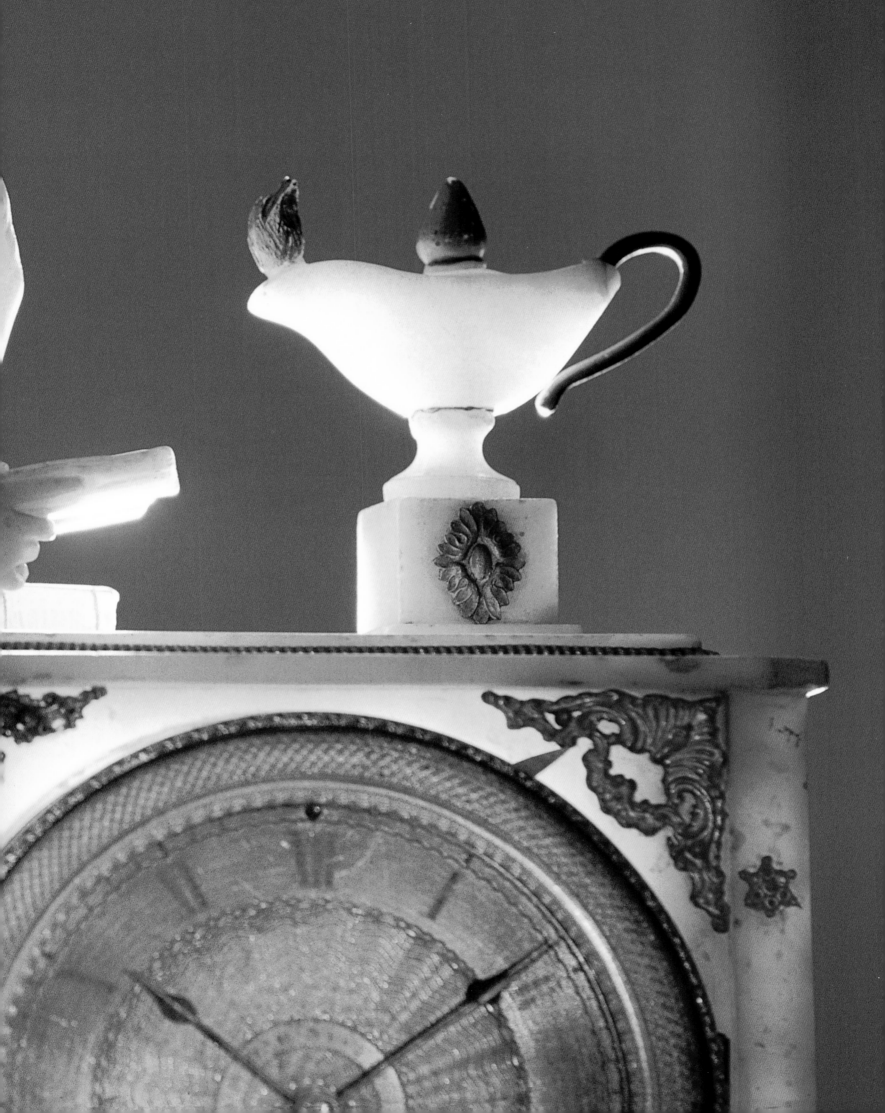

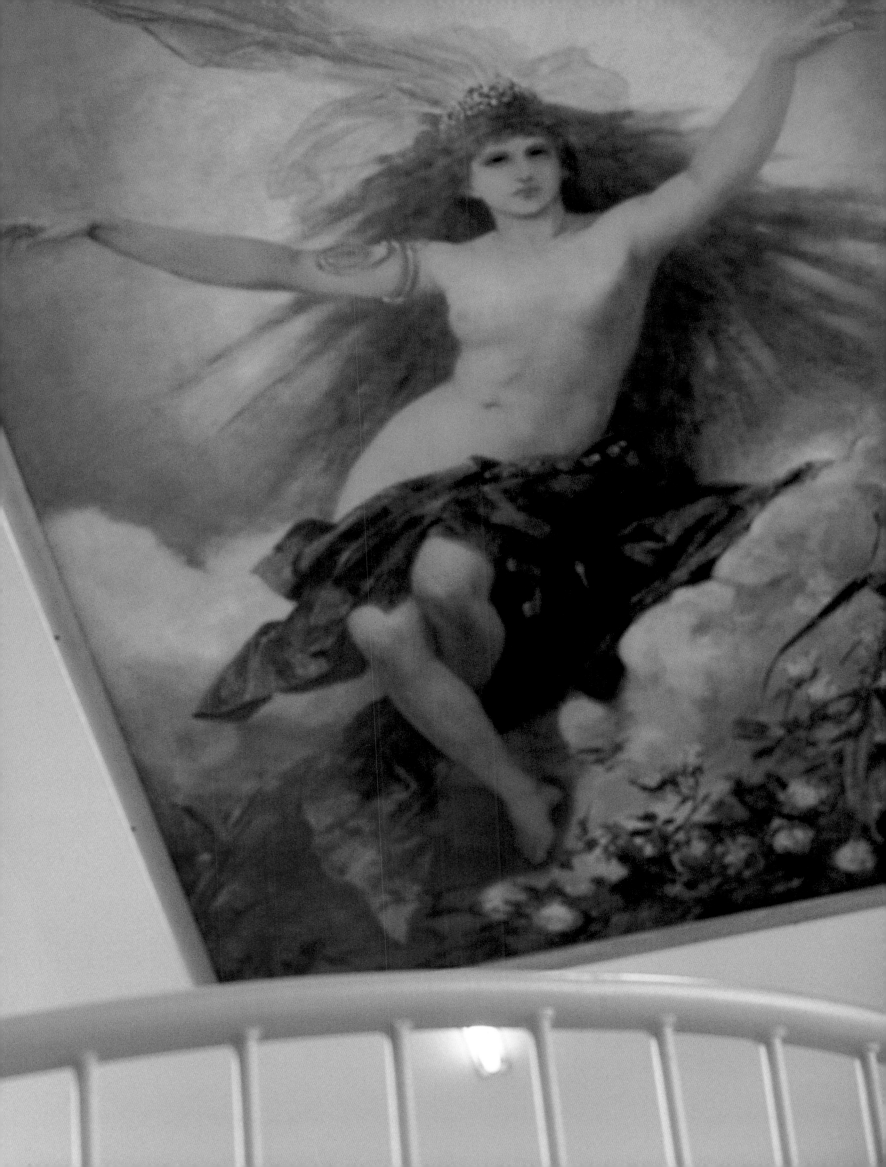

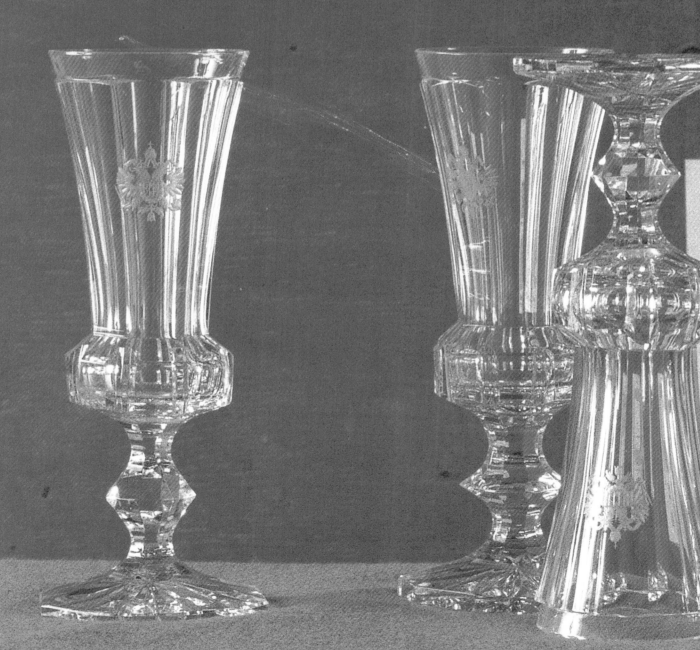

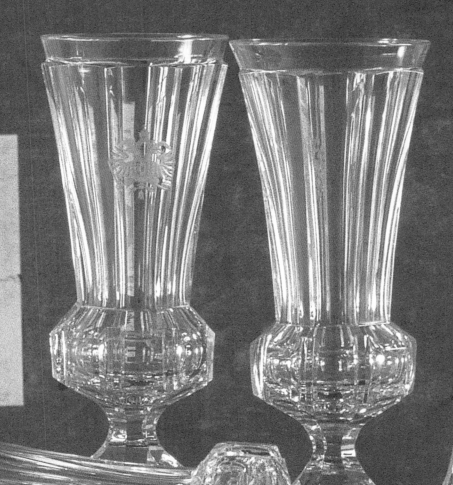

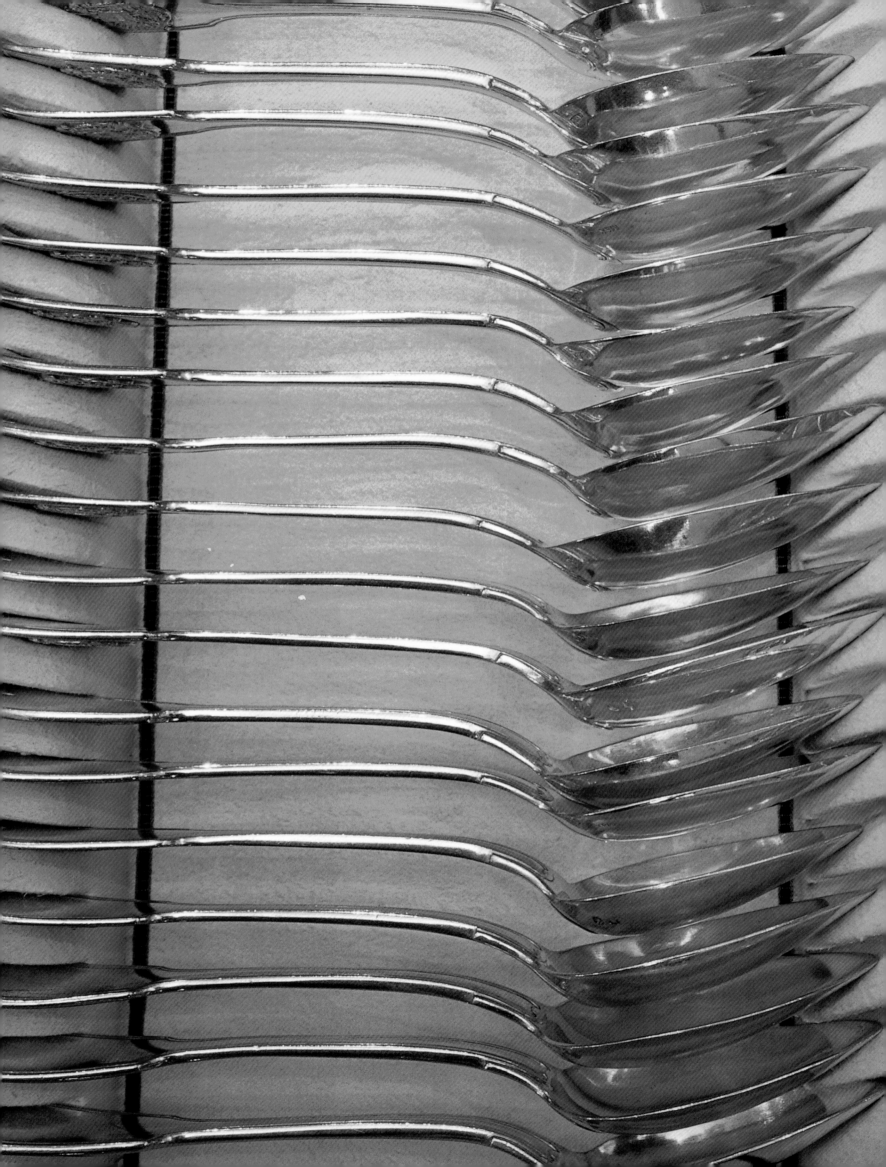

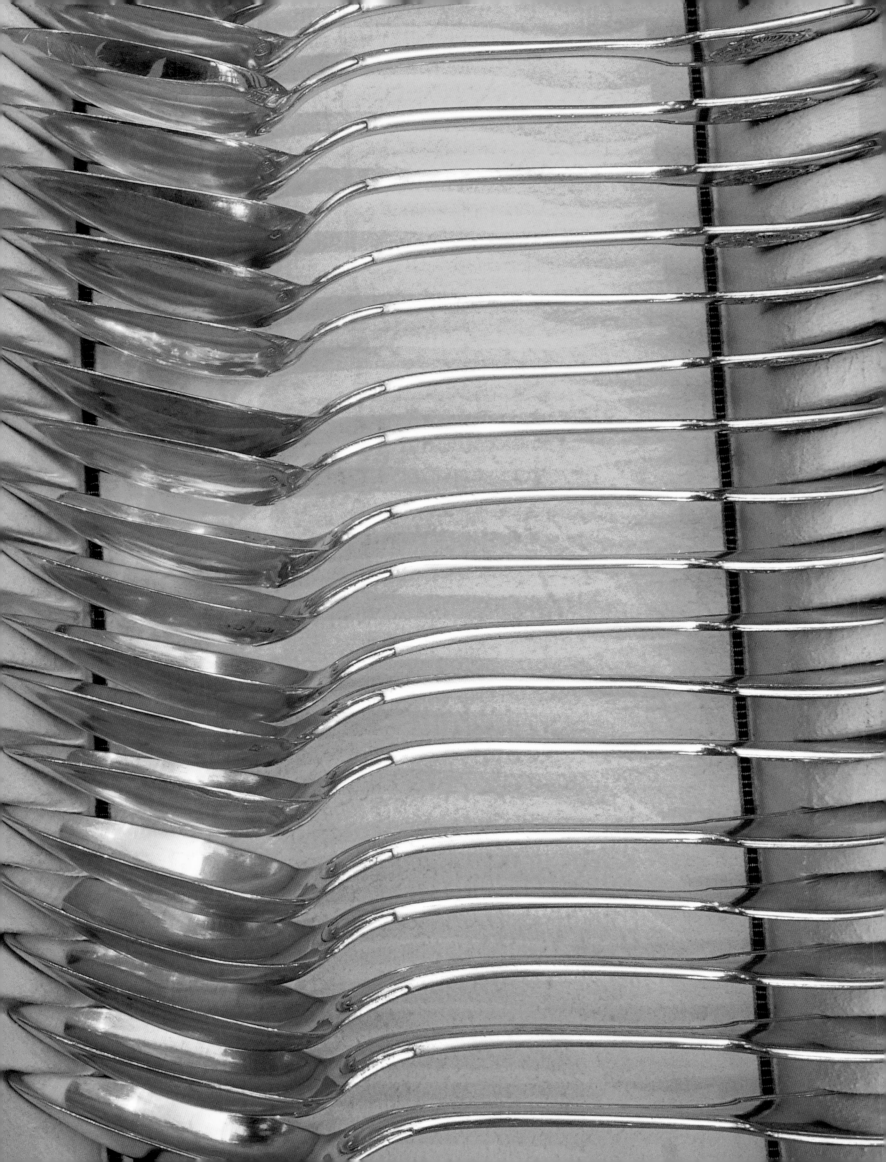

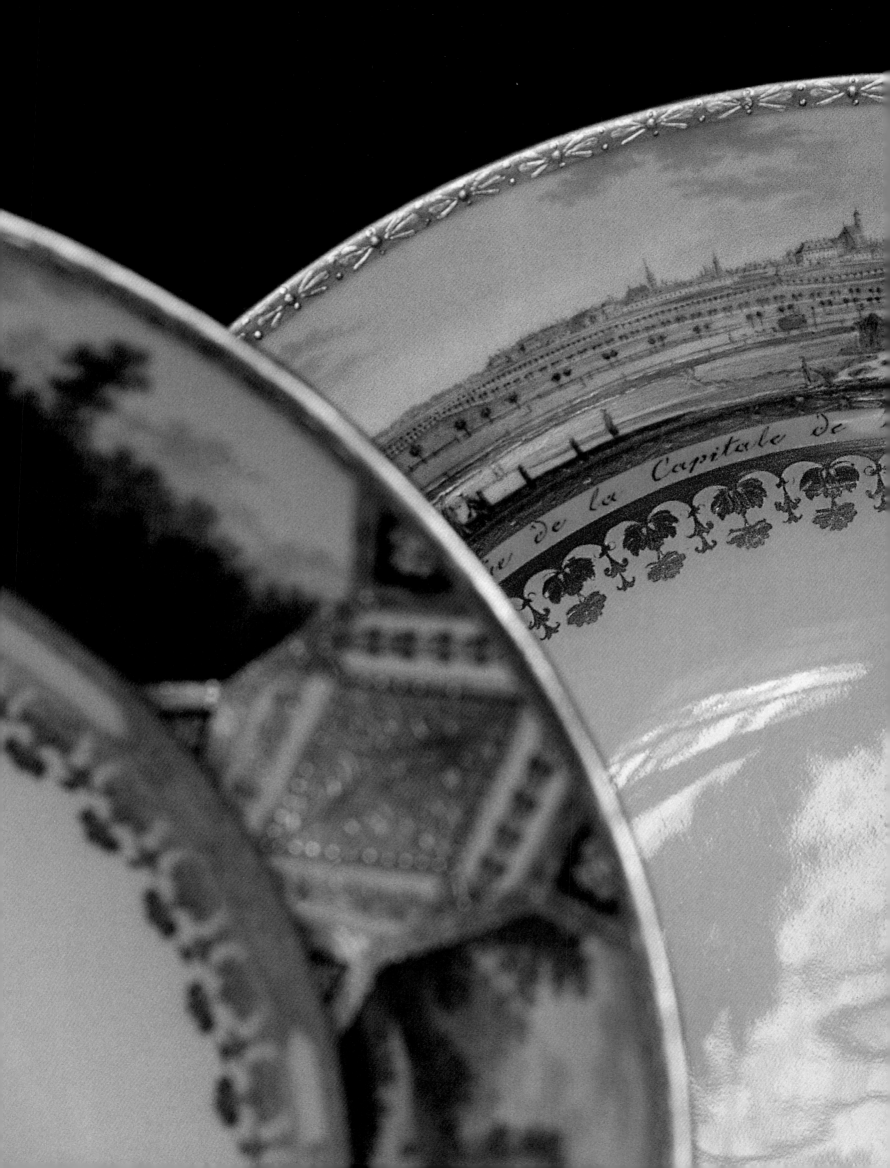

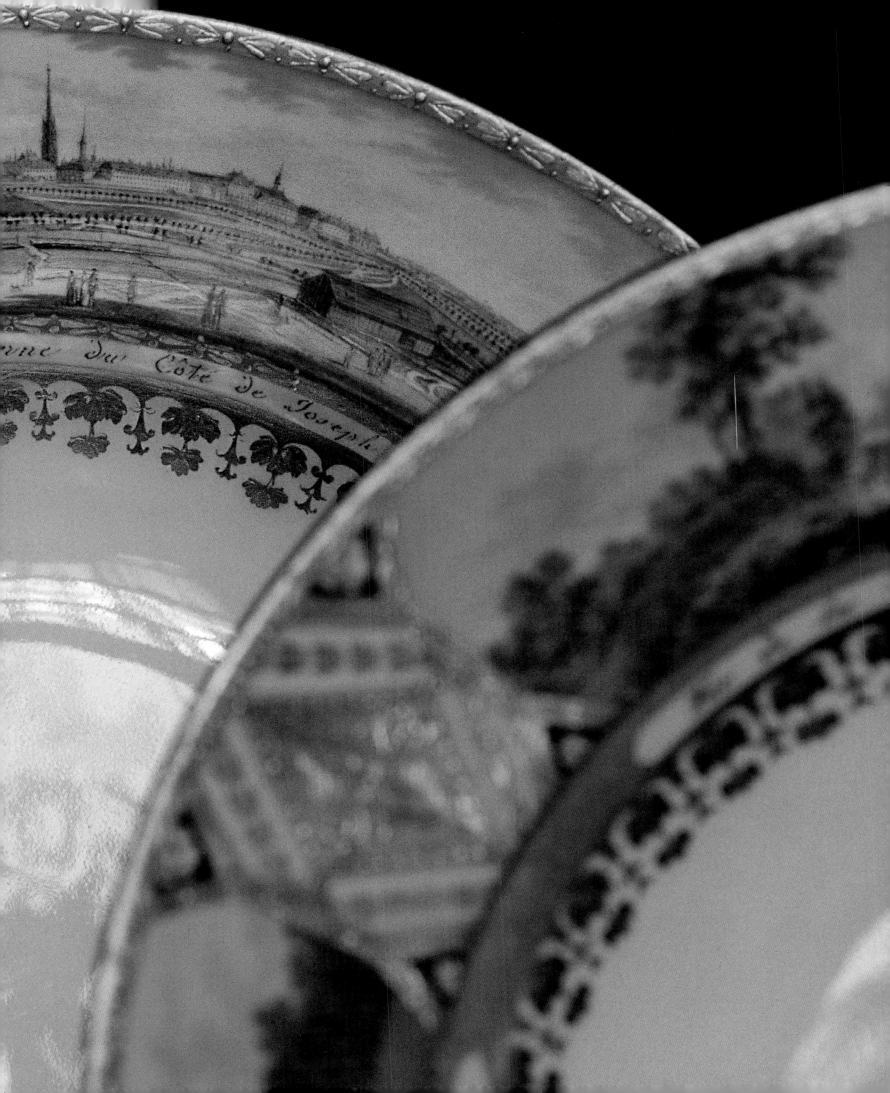

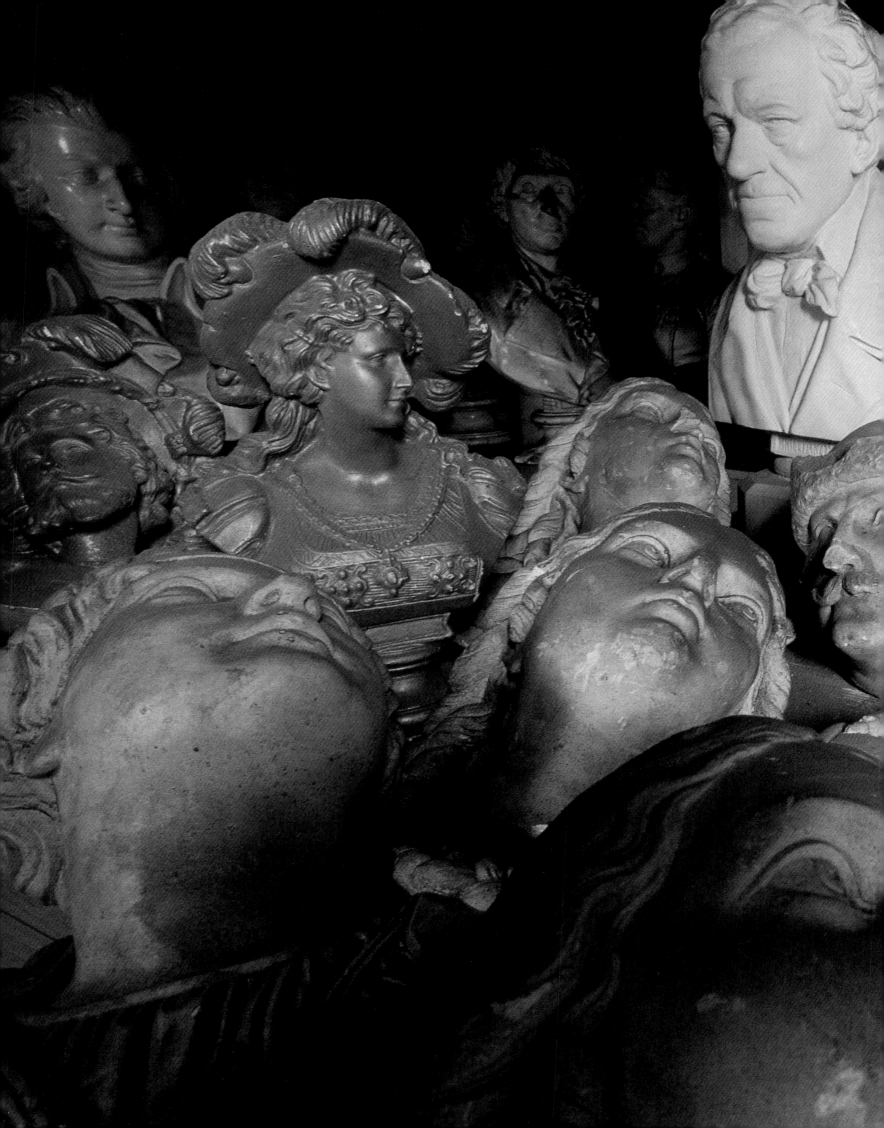

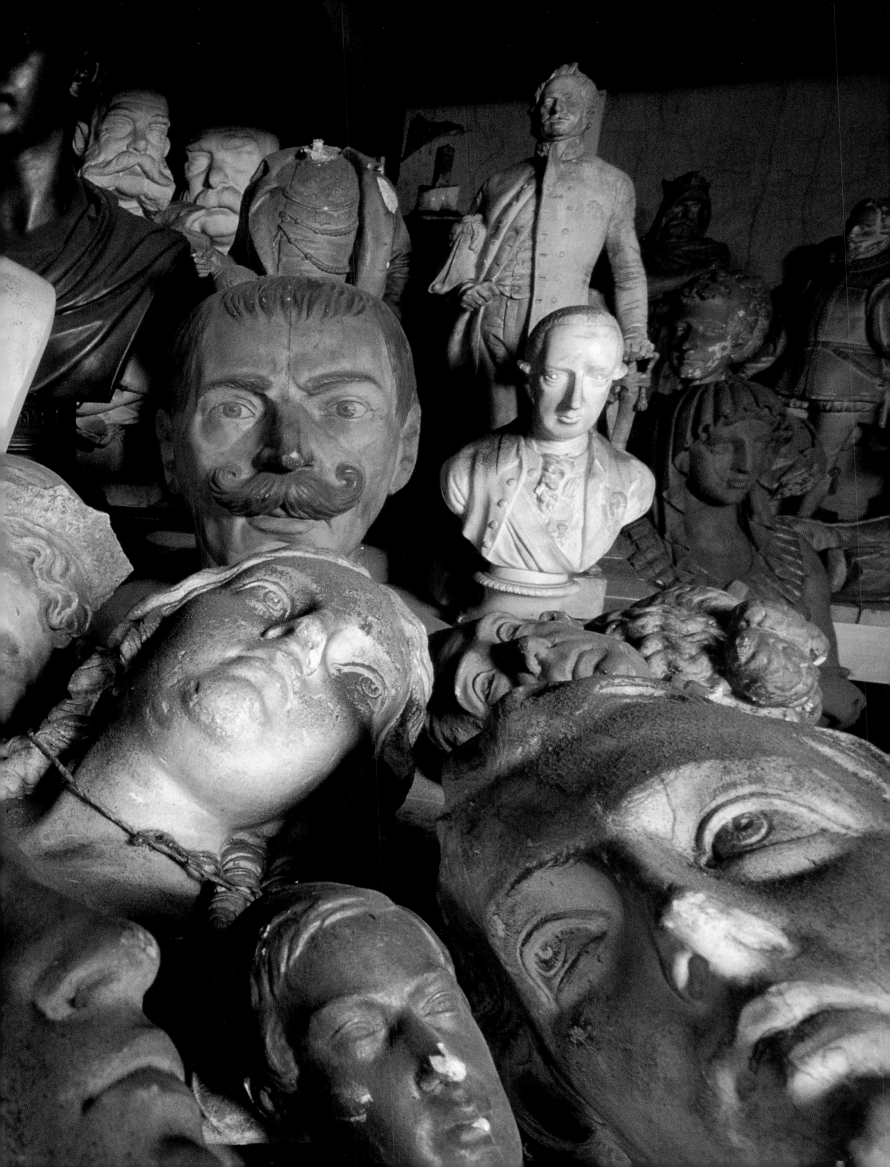

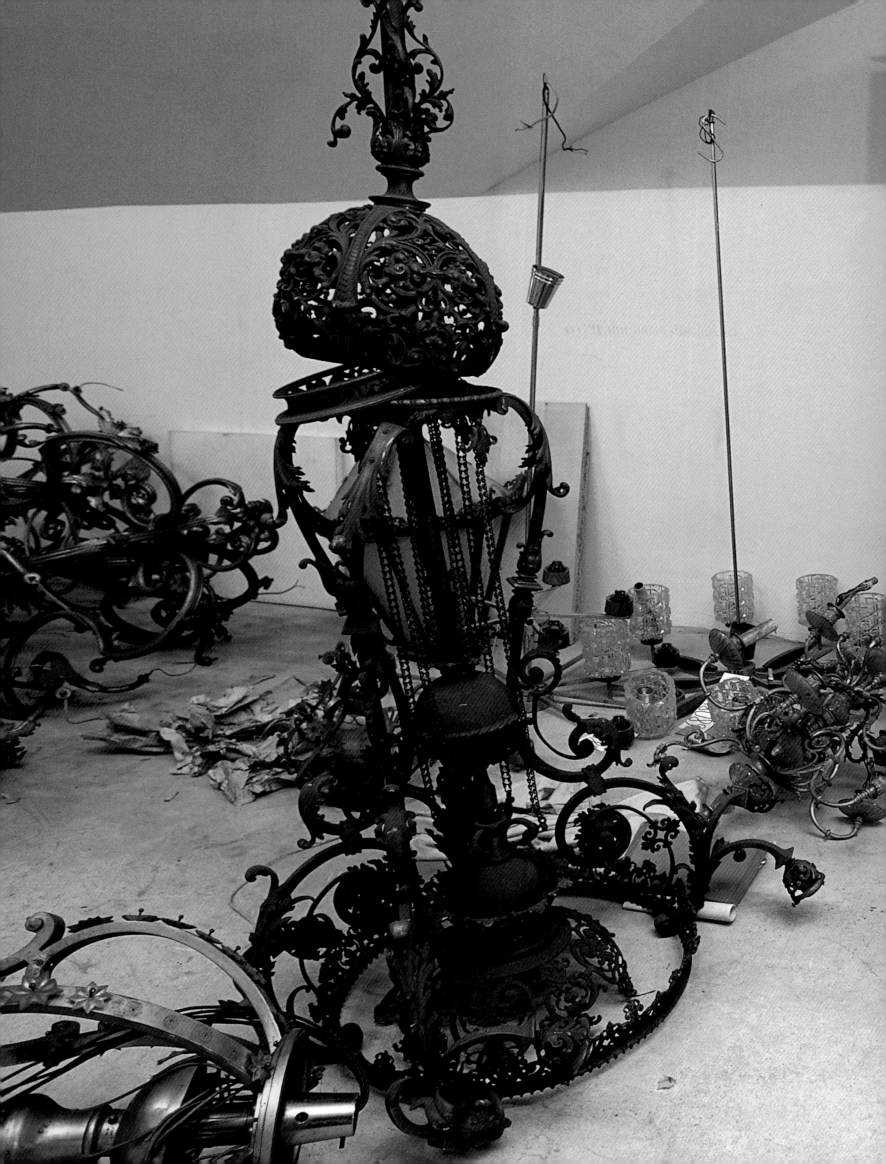

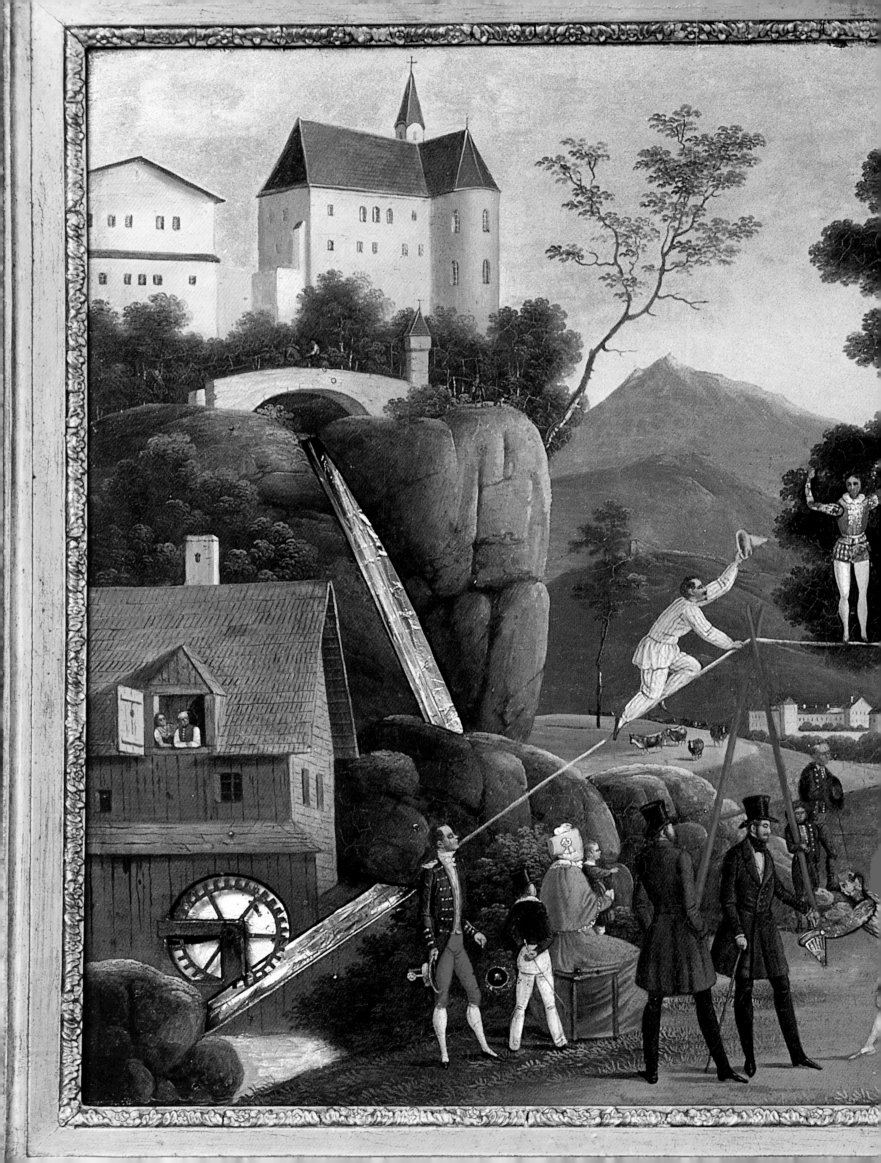

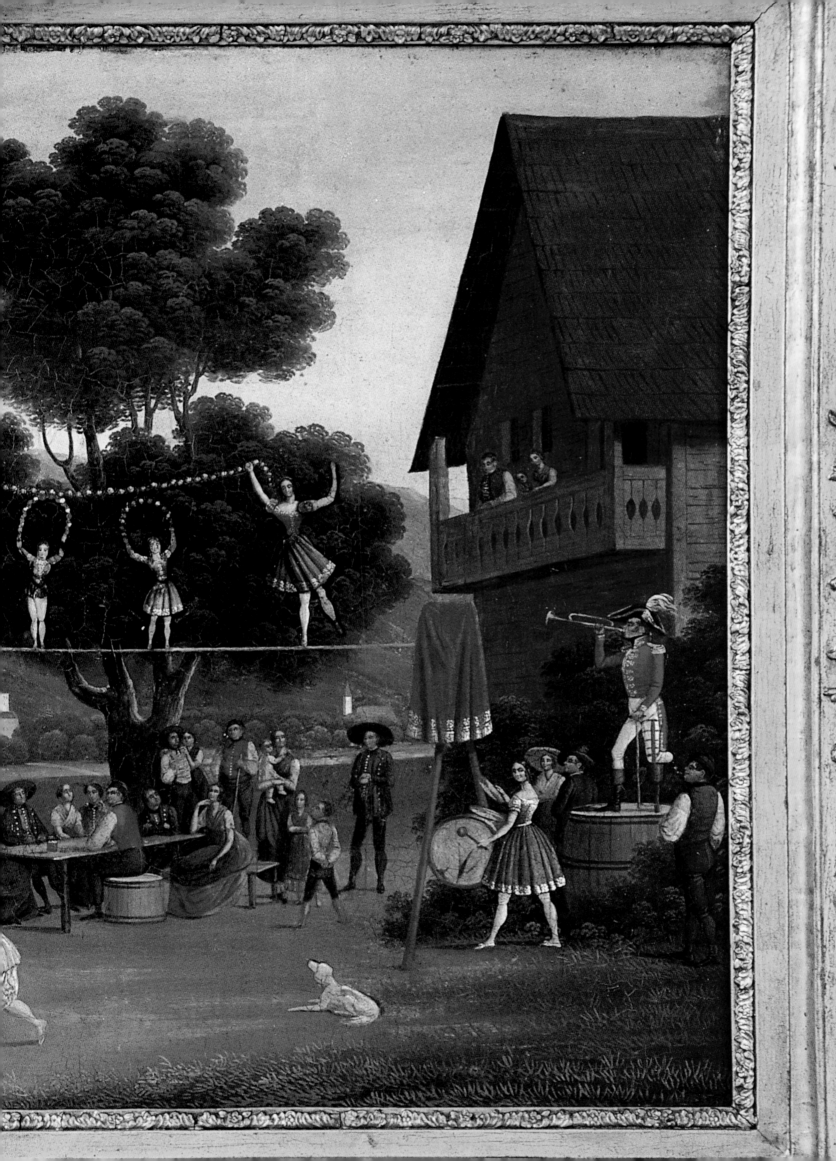

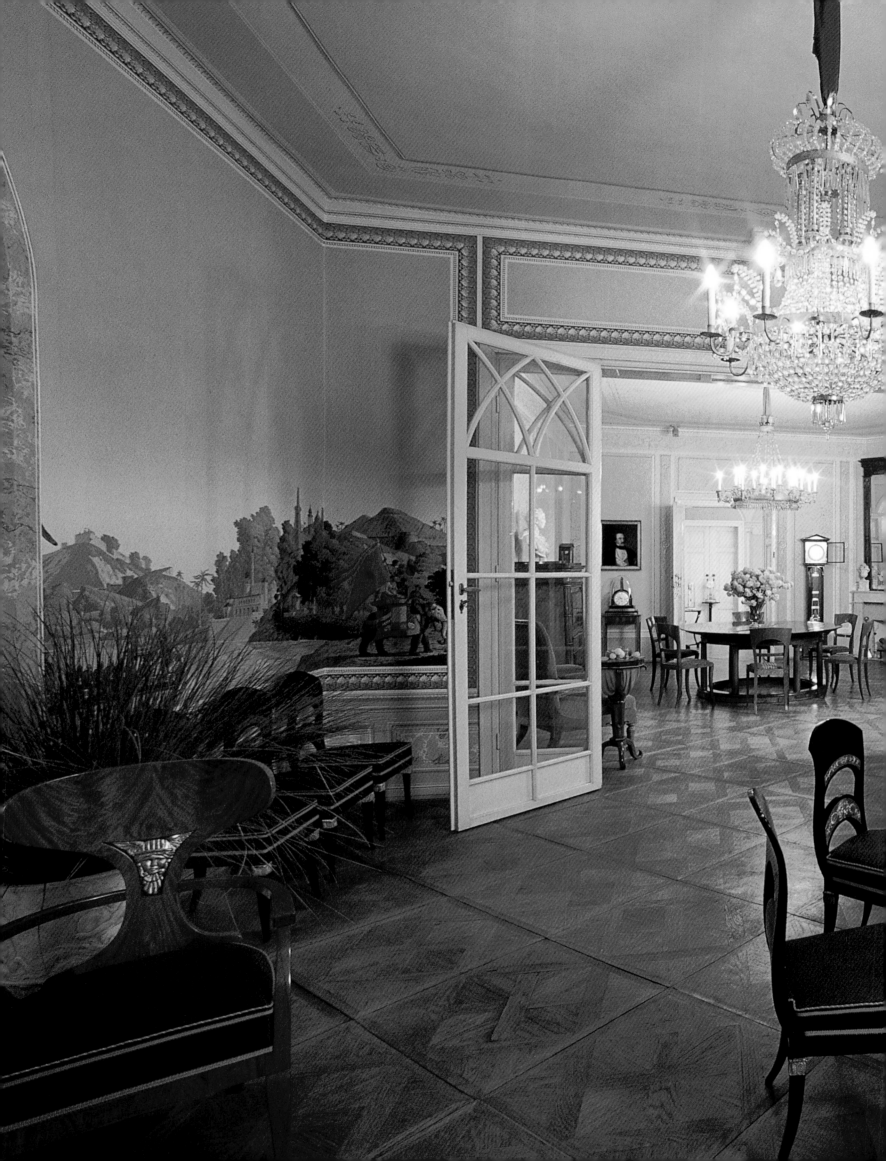

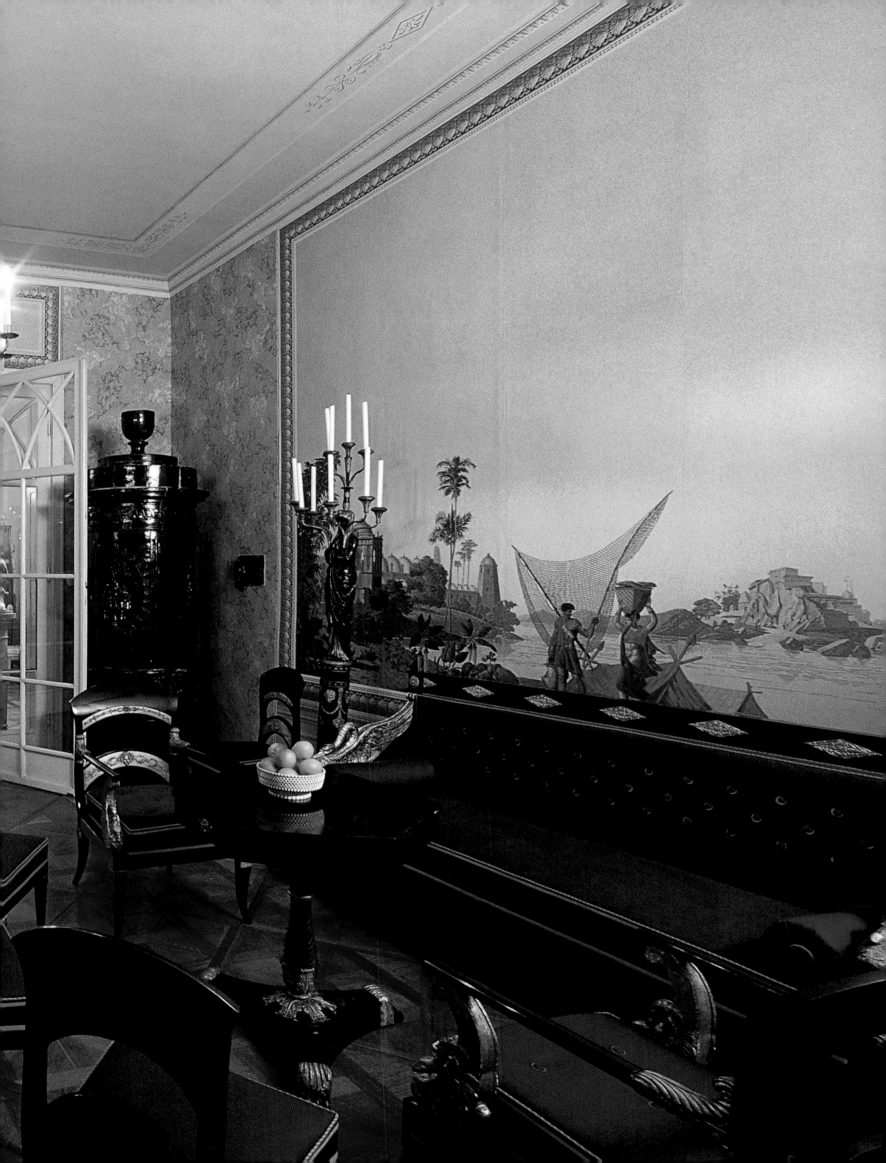

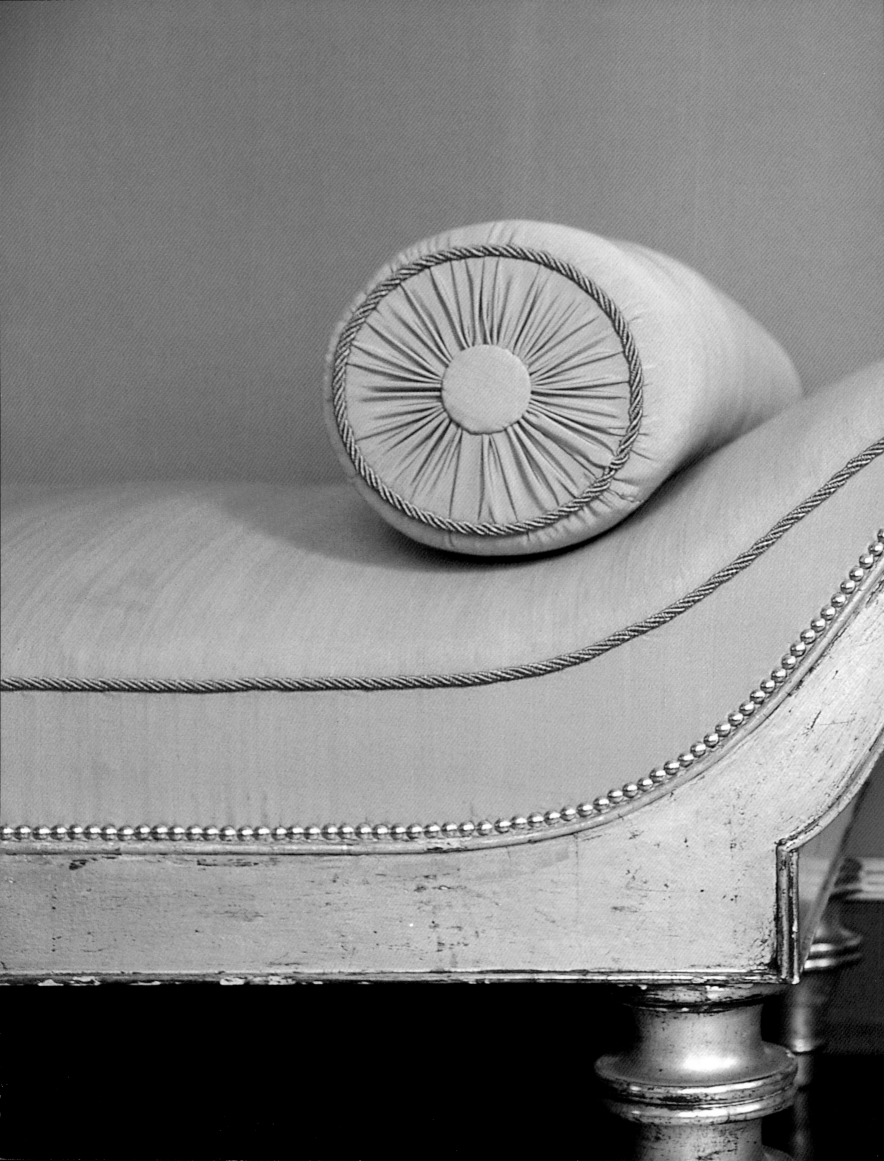

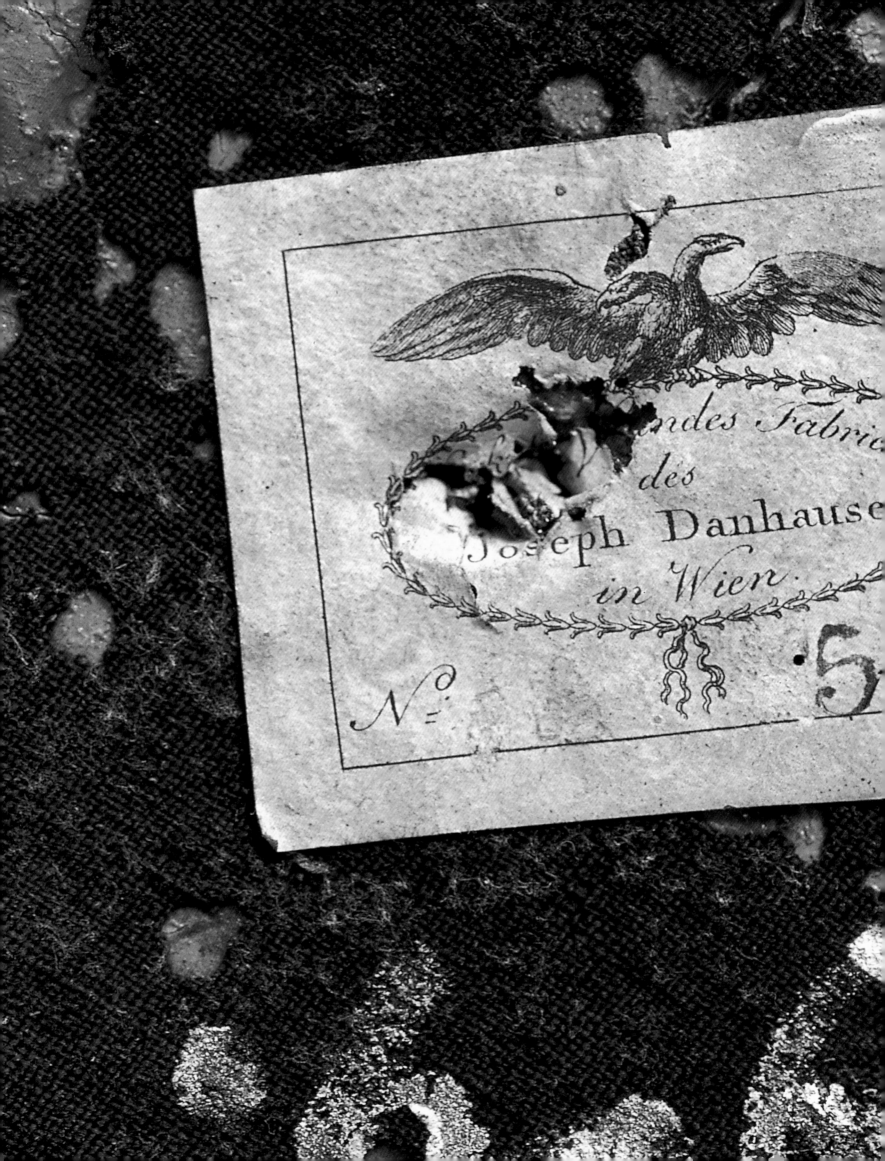

[COVER] DETAIL OF AN EBONIZED FRUITWOOD SIDECHAIR, VIENNA CIRCA 1820. PRIVATE COLLECTION, NEW YORK CITY. [BACKCOVER] FIGURAL ALABASTER MANTEL CLOCK PROBABLY BY CASPAR KAUFMANN, VIENNA 1824. GEYMÜLLER-SCHLÖSSL. [2] CAST IRON ARMCHAIR DESIGNED BY KARL FRIEDRICH SCHINKEL, BERLIN EARLY 19TH CENTURY. SCHINKEL PAVILION, CASTLE CHARLOTTENBURG. [4] PORCELAIN CHOCOLATE CUP MANUFACTURED BY KÖNIGLICHE PREUSSISCHE PORZELLANMANUFAKTUR (KPM), BERLIN CIRCA 1815. PRIVATE COLLECTION, NEW YORK CITY. [6] ALABASTER MANTEL CLOCK PROBABLY BY CASPAR KAUFMANN, VIENNA CIRCA 1824. GEYMÜLLER-SCHLÖSSL. [8] WALNUT SIDECHAIR, VIENNA CIRCA 1820. HOFMOBILIENDEPOT MUSEUM. [10] WALNUT CUSPIDOR, VIENNA CIRCA 1825. OIL ON CANVAS BY HANS MAKART, VIENNA 1825. HOFMOBILIENDEPOT MUSEUM. [12] CUT GLASS BY JOSEPH ROHRWECK, VIENNA CIRCA 1828. SILBERKAMMER. [14] SILVER SOUPSPOONS MANUFACTURED BY MAYERHOFER & KLINKOSCH (M&K), VIENNA 1845. SILBERKAMMER. [16] PORCELAIN MANUFACTURED BY VIENNA PORCELAIN FACTORY, VIENNA 1804. SILBERKAMMER. [18] ASSEMBLY OF BUSTS. HOFMOBILIENDEPOT ATTIC, VIENNA. [20] VIEW OF A WORKROOM. HOFMOBILIENDEPOT ATTIC, VIENNA. [22] DETAIL OF WALNUT BURL SIDECHAIRS, AUSTRIA CIRCA 1828. PRIVATE COLLECTION, HOUSTON, TEXAS. [24] DISPLAY OF 18TH, 19TH, 20TH CENTURY CHAIRS. HOFMOBILIENDEPOT MUSEUM, VIENNA. [26] PICTURE CLOCK, VIENNA CIRCA 1840-1850. GEYMÜLLER-SCHLÖSSL. [28] VIEW OF THE BLUE SALON DESIGNED BY JOSEPH ULRICH DANHAUSER. GEYMÜLLER-SCHLÖSSL, VIENNA. [30] CHAISE LONGUE DESIGNED BY KARL FRIEDRICH SCHINKEL, CASTLE CHARLOTTENHOF, CIRCA 1827. POTSDAM. [32] MANUFACTURER'S LABEL OF JOSEPH ULRICH DANHAUSER, VIENNA CIRCA 1825. SILBERKAMMER. [35] BIEDERMEIER HANDICRAFT, PRAGUE CIRCA 1840. GEYMÜLLER-SCHLÖSSL, VIENNA. [36] DETAIL OF A YOUNG LADY'S BEDROOM, VIENNA CIRCA 1810-1815. HOFMOBILIENDEPOT MUSEUM. [38] DETAIL OF A BRONZE SCULPTURE BY JOHANN GEORG DANNINGER, DEPICTING "APOLLO IN THE SUN CHARIOT," VIENNA CIRCA 1840. HOFMOBILIENDEPOT MUSEUM. [40] SOLID MAHOGANY CRADLE WITH BALDAQUIN, BRASS MOUNTS, AUSTRIA CIRCA 1820. PRIVATE COLLECTION, CONNECTICUT.

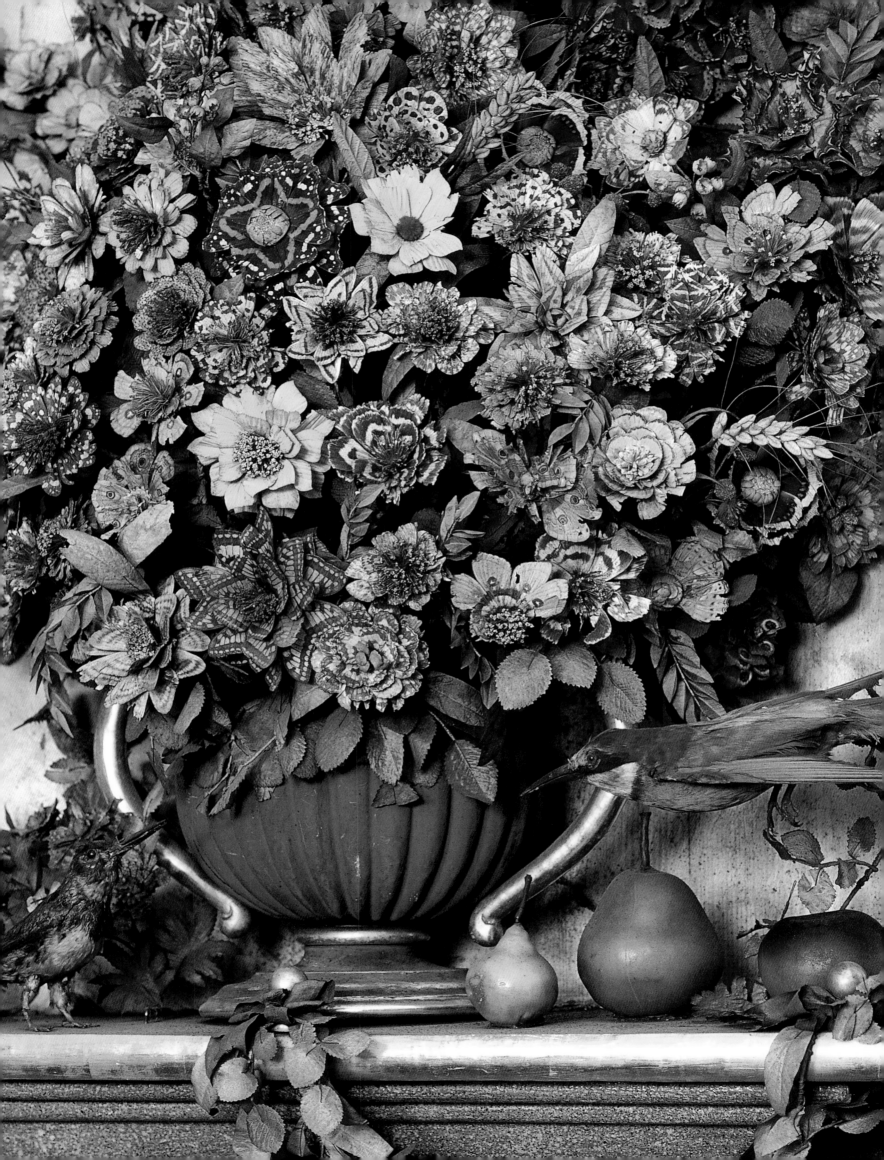

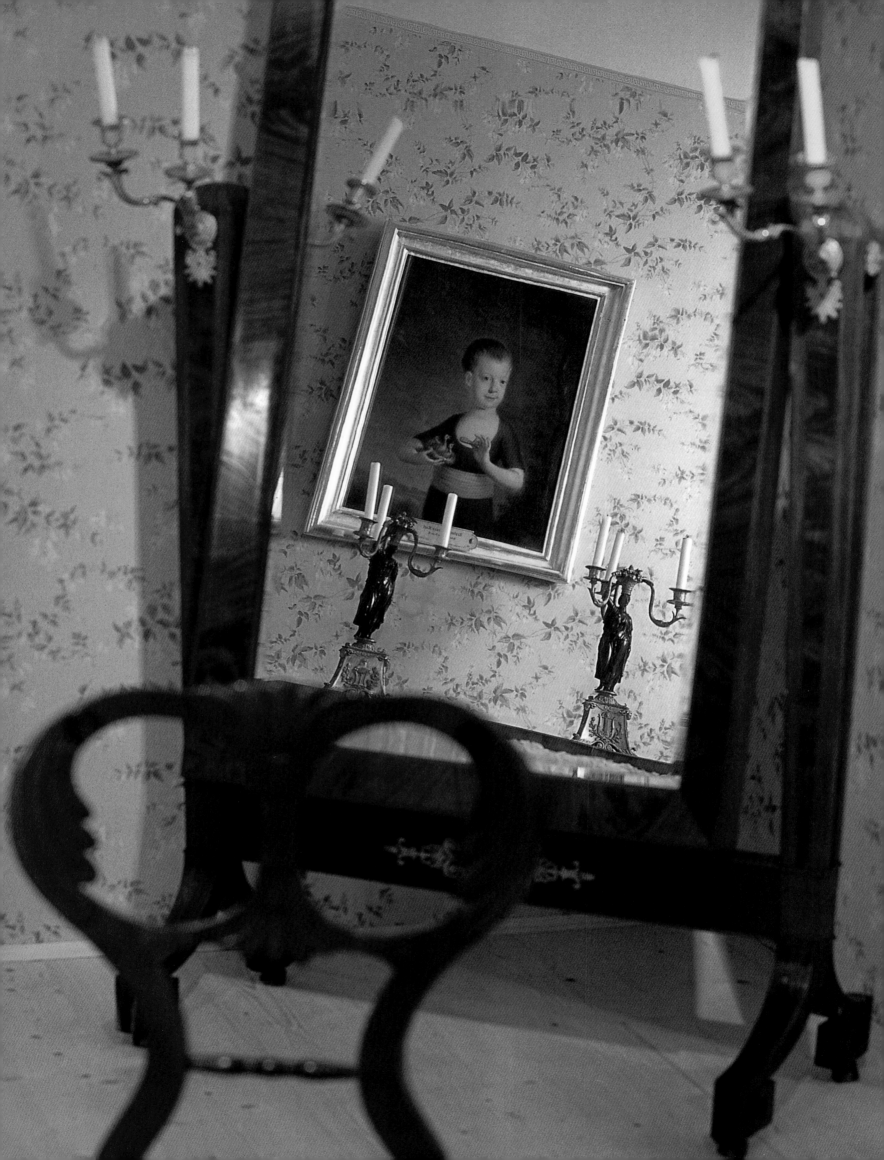

THE WORLD OF
BIEDERMEIER

LINDA CHASE KARL KEMP

PHOTOGRAPHY BY
LOIS LAMMERHUBER

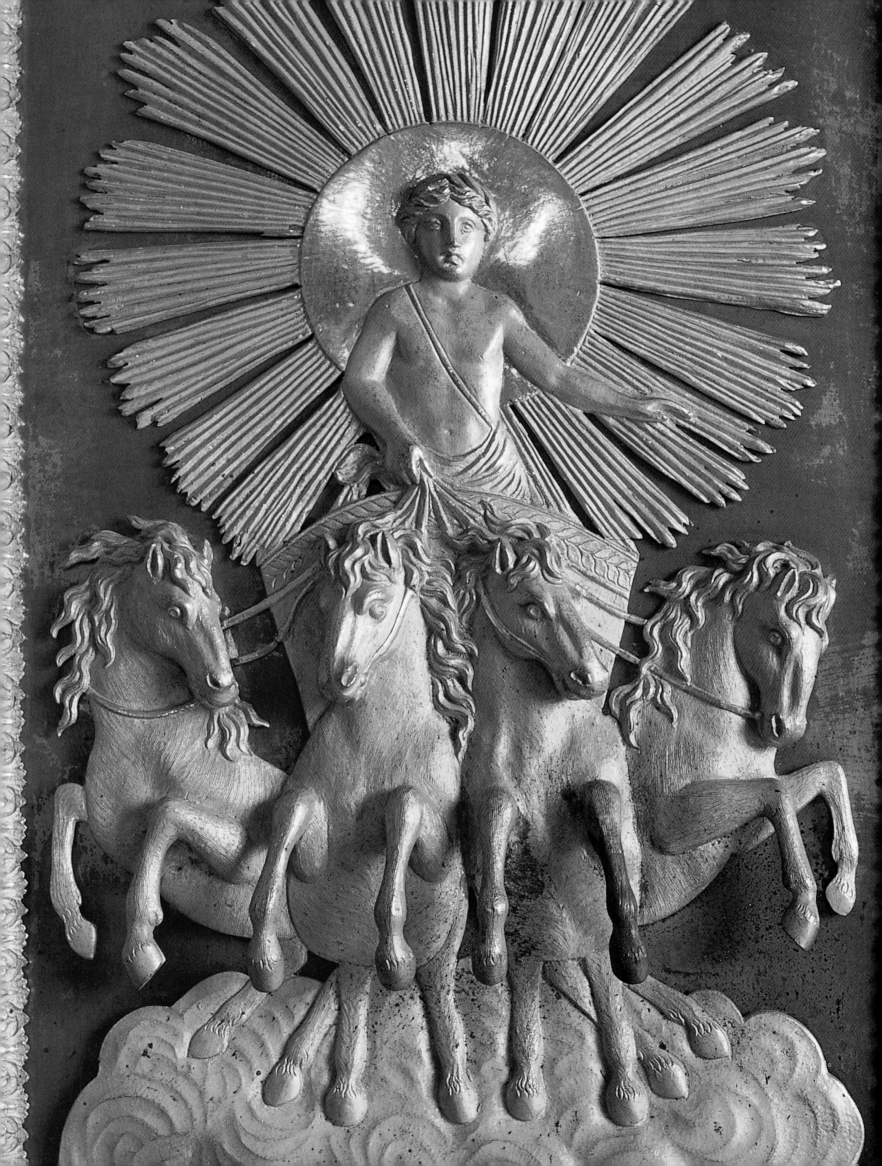

TABLE OF CONTENTS

FOREWORD I HAVE NO ILLUSIONS. THE CRITICAL RESEARCHER AND WRITER OF A BOOK HAS NO OTHER CHOICE BUT TO TRANSFORM THE SUBJECT OF HIS ATTENTION TO SUIT HIS OWN SIZE AND FIGURE. "LIFE IS LIKE A BOOK, AND ONE WHO DOES NOT TRAVEL IS NOT READING MUCH OF IT," SAID THE GERMAN WRITER JEAN PAUL. FOR ME, TRAVELING IS A COMFORTABLE YET IMPRACTICAL AND VERY EXPENSIVE WAY TO LEARN. AND IT IS THE DEATH OF PREJUDICE. THE ART OF TRAVELING IS ONE OF THE MOST DIFFICULT. I AM OFTEN SURPRISED TO HEAR OF JOURNALISTS WHO DROP WITH THEIR AIRPLANES FROM THE SKY, INVADING A COUNTRY TO MEET WITH KEY PEOPLE WHO HAVE SOMETHING IMPORTANT TO SAY, THROUGH KEY QUESTIONS, ONLY TO PRODUCE AN EXPECTED STORY. A STORY THAT COULD HAVE OFFERED MORE THAN A ROAD MAP OF WHERE THEY HAD BEEN. I KNOW THERE ARE MANY DIFFERENT PATHS TO THE TRUTH. AND WHAT I WRITE HERE WILL BE TRUE UNTIL SOMEONE ELSE MAKES THIS TRIP AND LOOKS AT THIS SAME SUBJECT WITH DIFFERENT EYES. AS A WRITER, WHETHER I LIKE IT OR NOT, I BECOME A CONNECTING LINK BETWEEN PEOPLE, PROFES- SIONS, CONTINENTS, POLITICAL AS WELL AS SOCIAL PARTIES, CLASSES OF SOCIETY, AND RACES. CULTURAL DIFFERENCES AND CONTRADICTIONS THAT MAKE UP A CONFUSED AND VAST WORLD COME TOGETHER IN MY EYES. MY INTENTION WITH THIS BOOK IS TO TRANSPORT THE READER TO THE PLACES WHERE IT ALL BEGAN AND TO REDISCOVER THE RICH PAST OF BIEDERMEIER—WITHOUT ANY PRECONCEIVED IDEAS. I HAVE COME TO REALIZE THAT THE TIME OF BIEDERMEIER HAD A MUCH GREATER RANGE THAN I HAD EVER IMAGINED. I HAVE ATTEMPTED TO LEAVE SPACE FOR THE READER TO JOIN ME AS I WALK THROUGH THE CITY STREETS, VISITING PALACES, MUSEUMS, AND STORAGE ATTICS, DISCOVERING COLLECTIONS, IMAGINING THE POSSIBILITIES OF UNEARTHING HIDDEN TREASURES THAT ONE MIGHT HAVE PASSED BY, OBLIVIOUS OF THEIR EXISTENCE. AS A DESIGNER, I AM A VISUAL PERSON. FROM ALL I HAVE SEEN, I HAVE LEARNED ONE LESSON: BE SKEPTICAL. THE APPROACH I TOOK, TOGETHER WITH THE PHOTOGRAPHER, WILL, I HOPE, BE VIEWED WITHIN THE REALM OF TRAVEL OBSERVATIONS, WHICH T.S. ELIOT DESCRIBED THUS: "THE FIRST CONDITION OF TRUE THINKING IS TRUE FEELING. THE FIRST CONDITION TO UNDERSTAND A FOREIGN COUNTRY IS TO BE ABLE TO ABSORB ITS AROMA." THE STORY OF THIS BOOK BEGINS ALMOST THREE YEARS AGO, WHEN I MET THE NEW YORK ANTIQUES DEALER KARL KEMP FOR DINNER AT IL CANTINORI, IN GREENWICH VILLAGE, NEAR HIS GALLERY. WE WERE TALKING ABOUT BIEDERMEIER, AND BY THE END OF THE EVENING WE HAD AGREED TO DO THIS BOOK TOGETHER. TIME PASSED. TIME WHICH WAS A CELE- BRATION OF BIEDERMEIER. DURING THIS WORK WE WERE NOT ALWAYS AWARE THAT IT WAS A CELEBRATION. BUT NOW WE HAVE NO DOUBT THAT IT WAS. LINDA CHASE

HISTORY

BIEDERMEIER IS A FANTASY. A CARTOON FANTASY,
TO BE PRECISE. IN THE FLIEGENDE BLÄTTER, A WEEKLY
SATIRICAL MAGAZINE, THE CHARACTER
GOTTLIEB BIEDERMAIER CAME TO LIFE. THE GRAPHIC DESIGNER
KASPAR BRAUN AND THE PUBLISHER FRIEDRICH SCHNEIDER
ENTERTAINED THEIR BOURGEOIS READERS
WITH THIS EARNEST, SMALL-MINDED, THRIFTY CHARACTER WHO
EPITOMIZED THE SELF-CONFIDENT MIDDLE-CLASS.
THE FICTIONAL GOTTLIEB BIEDERMAIER WAS PORTRAYED
AS A RECENTLY DECEASED SCHOOLTEACHER AND POET FROM
A SMALL VILLAGE IN SWABIA, GERMANY. THE NAME
GOTTLIEB (GOD-LOVING) AND BIEDERMAIER (COMMON, EVERYDAY MAN)
CAME FROM THE CHARACTER'S CREATORS, ADOLF KUSSMAUL,
A MEDICAL DOCTOR, AND LUDWIG EICHRODT, A LAWYER.
BIEDERMAIER WAS PARADED IN ISSUE AFTER ISSUE,
EXHIBITING AN UNEVENTFUL DAILY LIFE FILLED WITH ORDER,
FRUGALITY, AND SIMPLICITY.

HE CONTINUALLY PRAISED THESE VIRTUES in his naïve poems in this ongoing satire. Long after the creators' desire to retire their character and condemn his outdated thinking, he lived on. Eventually his name and the views characteristic of his one-horse world would become synonymous with a way of living. Finally his name came to be the label for an entire period in German culture. BiedermAier became BiedermEier. IT ALWAYS TAKES SOME TIME and distance before we can reflect on the past and reevaluate its qualities. At the beginning of the twentieth century, people started to look back nostalgically, with romantic reminiscences of the honesty and simplicity that seemed to characterize the first half of the nineteenth century, a period when glimmerings of democracy could be seen in Europe, and the turmoil of the Industrial Revolution was not far off. This fueled an emerging society's desire for a return to the "Good Old Days" in a "Home Sweet Home." BIEDERMEIER IS A TIME. A time known by many terms: the Pre-March Period, the Restoration, the Holy Alliance, Standstill, Throne and Altar, the Metternich Era, the Reign of Franz II(I), the Age of Goethe, and, for music lovers, the Age of Johann Strauss and his waltzes. Today historians still debate whether the arts of this period are classic or romantic. Each of these terms has its own relevance, and together they give a very telling view of the contrasts and changes occurring between the years 1800 and 1848. Contrary to the images often painted of an idyllic time, this was actually a period filled with political and socio-economic tensions. FOR MOST OF THE EUROPEAN POPULATION, life during the Biedermeier time was tremendously difficult. There was little population growth, the result of miserable living conditions: severe housing shortages, lack of hygiene, rampant epidemics, widespread unemployment, and too little agricultural production to feed the population.

Bureaucratic obstacles made it impossible for many couples to marry. In Austria, Germany, and France, priests were forbidden to marry couples who could not present proof of education, the financial means to provide for a family, and absolute loyalty to the government. In the face of these restrictions, about half of all couples lived together in common-law arrangements, their children classified as illegitimate. The average life expectancy was about forty years. Due to these enormous pressures in daily life, many held Cinemascope memories of the French Revolution, when the impossible had happened: a king had been beheaded by his own people. It was clear that changes were on the horizon, but the outlook was as bleak as city streets before gaslights. A GENERAL FROM CORSICA, Napoleon Bonaparte, crowned himself Emperor of France. His hunger for power drove all of Europe from one blood-soaked battlefield to another. The clear-sighted political fox Prince Talleyrand, a member of Napoleon's council, anticipated Napoleon's downfall. As early as 1808, he conspired with Czar Alexander I of Russia on the reorganization of Europe after Napoleon's defeat. Napoleon's final hour came on 31 March 1814, in Paris. He abdicated at Fontainebleau Palace. IN AN AMAZING EFFORT, the Peace of Paris was signed only a month later, on 30 May. The Czar and all the allied monarchs, most importantly the Habsburg Emperor Franz II(I) and King Friedrich Wilhelm III of Prussia, agreed to meet in Vienna within three months to discuss the future of Europe. The enormous diplomatic, economic, and logistical effort of organizing the Congress of Vienna fell into the guiding hands of Prince Clemens Lothar Wenzel von Metternich, Austria's leading statesman. While history portrays Metternich's luminous career as larger than life, his orchestration of the congress was truly brilliant. His greatest challenge was to convince the frugal and

deeply conservative Emperor Franz to spend extravagantly. After Austria's bankruptcy three years earlier, the emperor had reigned with a tight fist. The greatest expense associated with the congress would come from housing the visiting monarchs and diplomats in the Hofburg, the royal palace in the center of Vienna, and providing constant entertainment for them. The phrase "The Congress is dancing" would later express the popular reaction to the elaborate balls, the endless festivities, and the gala dinners. It is no surprise, given the anticipated expense of more than twenty million gulden, equivalent to five hundred million dollars today, that the emperor was at first reluctant. Yet in light of the long-standing reputation of the Habsburg dynasty, with all its power and glory, it was crucial that this be an unprecedentedly grand event. It turned out to be a superb investment in Austria's future. The stage was set. "THE CHIEF TASK OF THE CONGRESS was to reallocate Napoleon's conquests," as Hans Urbanski writes about the peacemakers' agenda in Vienna. "These covered a vast area that included Spain, Portugal, Belgium, Holland, Hamburg, Danzig, the left bank of the Rhine, the former kingdom of Westphalia, Switzerland, Piedmont-Savoy, and virtually the whole of Italy, Istria, Dalmatia, Carniola, and much else besides. Perhaps equally important was the task of reorganizing some kind of German political community, since Emperor Francis had laid aside the crown of the Holy Roman Empire in 1806. Certain questions had settled themselves in accordance with the legitimacy principle before the congress opened. The hereditary sovereigns had returned to Spain and Portugal, the pope to Rome, the Dutch king to Holland, and many of the German princes to the lands from which they had been expelled. AUSTRIA, too, had reoccupied most of the territories it had lost, with two striking exceptions: Belgium was not

reclaimed, but instead reunited with the kingdom of Holland—a surrender that is probably best explained in terms of the psychology of Emperor Frances, who for twenty years had been the sparring partner of the greatest military genius of all time. The emperor had finally had enough of defending possessions that were so distant and constantly in danger; to say nothing of being forced through those possessions into the role of a defender of Germany. Moreover, Belgium, with its privileges and despite its wealth, had never brought in much money; while in return for giving it up, Austria gained the vitally important alliance with Britain, which felt it could sleep easy only if Belgium were not in the hands of a great power. For much the same reason, the so-called Austrian Foreland extending up to the Rhine was not reclaimed either. Just as the individual finds it difficult in his own life to adhere unswervingly to a principle he acknowledges to be right, so at the level of international politics it proved difficult to apply the highly productive legitimacy principle in every case." THE LEADING POWERS OF EUROPE had very good reasons to play their parts well. At first appearance, everyone attended for the sake of reshaping the continent. The crowned heads, however, had their individual interest in securing their families' heritage uppermost in their minds. One of Emperor Franz's principles for ruling his empire was "Govern, and alter nothing..." This could very well have been the appropriate motto for the Congress of Vienna. It is understandable that those in power were prepared to defend this philosophy or risk everything. As the historian Robert Waissenberger points out in his essay *The Biedermeier Mentality*, the reality was more complex: "Europe was still reeling from the effects of the wars and social upheavals that had characterized the Age of Napoleon. The European nobility had followed with particular intensity the fate of

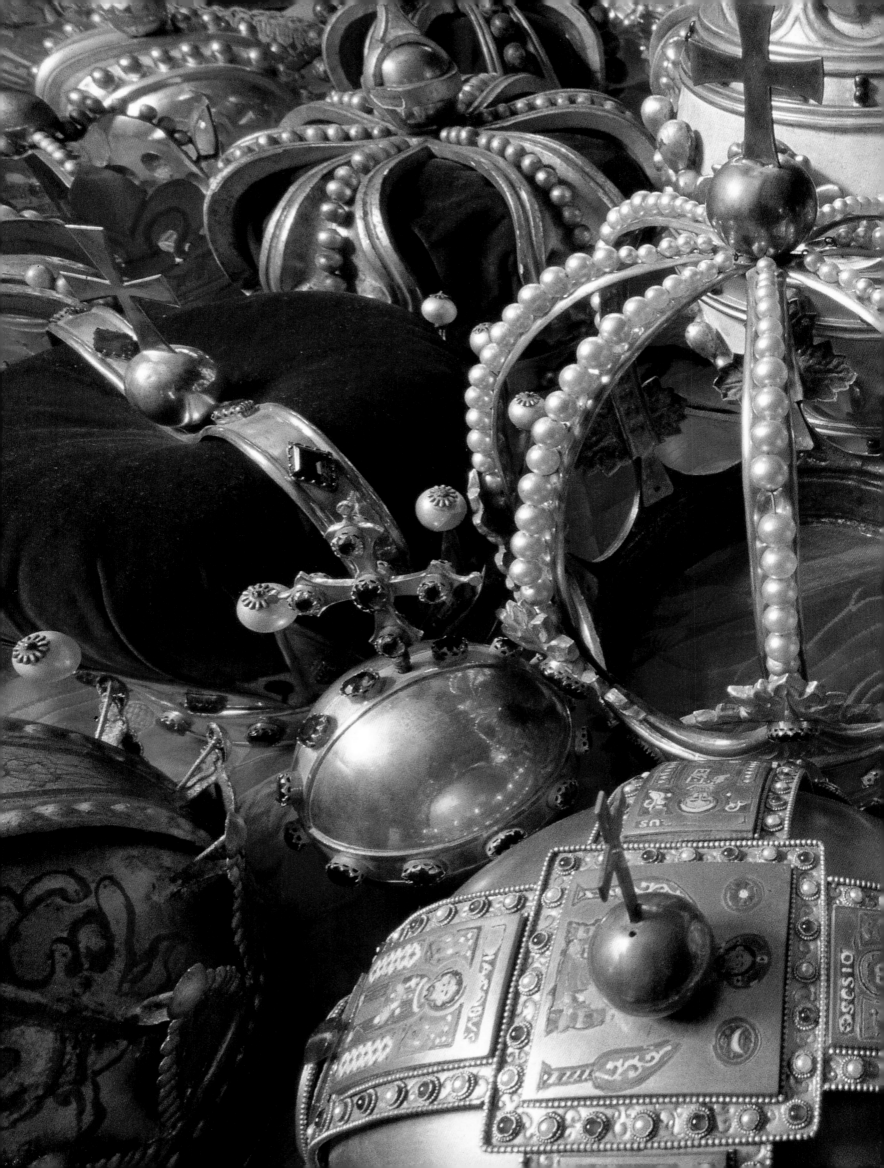

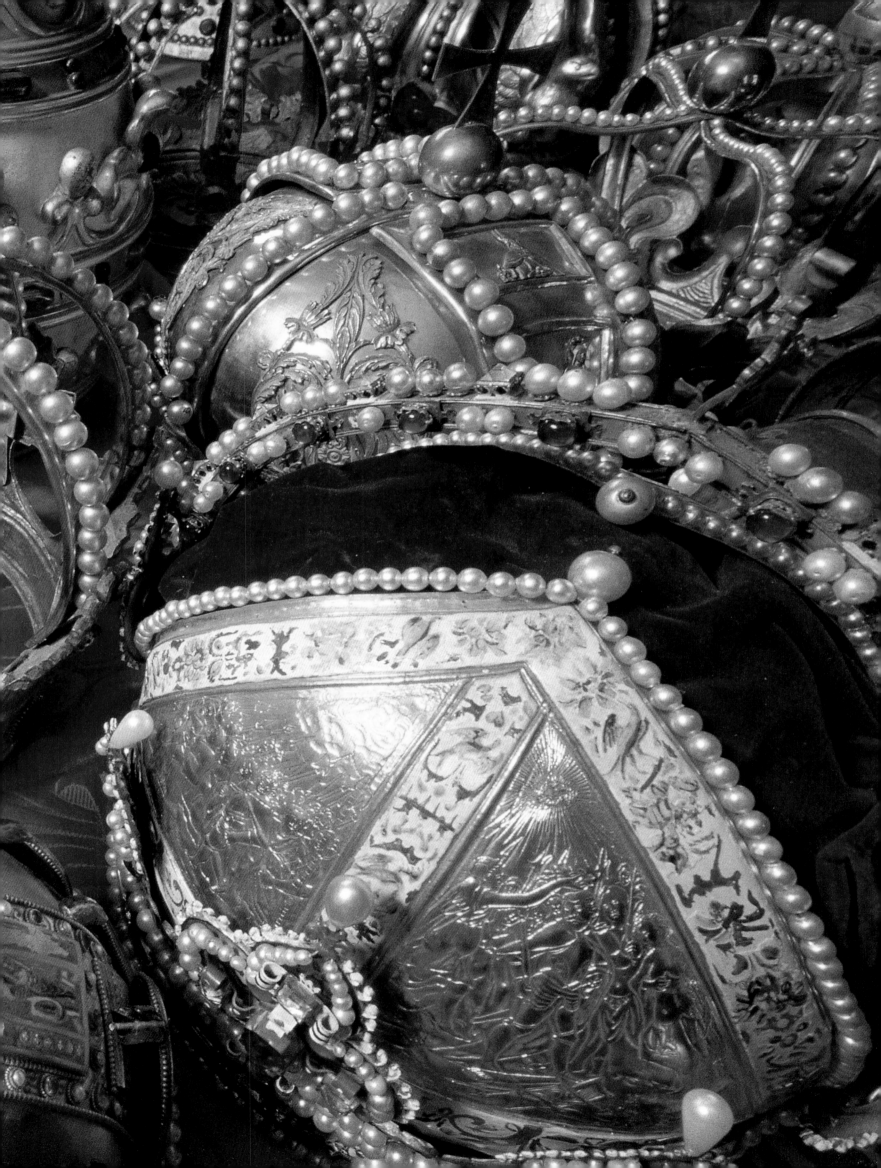

those members of the privileged classes who had come to grief during the French Revolution. From their point of view, it was only too natural that everything should be done to prevent further outbreaks of revolution and to block aspirations for social change. And, as always in such cases, the obvious instruments were unlimited use of the power of the state and deployment of police forces with their apparatus for coercion. No attempt was made—it never is—to tackle the evil at the root by improvement. Instead governments worked from the premise that they were already in possession of the best of all possible worlds." PEOPLE JOKINGLY DISCUSSED the outcome of the summit, saying, "If everyone is dissatisfied, the congress has done a good job," and that is exactly what happened. Nevertheless, the Congress of Vienna brought to Europe a new political order, and above all, it brought a certain peace on which the foundation of prosperity could be built. This did not come without an extremely high price: pervasive surveillance and severe censorship. As Prince Metternich so eloquently said, "No ray of light, whatever its origin, shall in future go unheeded and unrecognized in the monarchy... censorship is the right to block the manifestation of ideas that confound the peace of the state, its interests, and its good order." THE POLICE WATCHED CAREFULLY to thwart the smallest threat or remote possibility of a political uprising. Being an inform- ant became a thriving profession. The police enforced severe censorship to prohibit, or, at the very least, scrutinize the works of intellectuals. Students, and of course writers, including journalists and playwrights, did not escape their watchful eye. All books were examined by the *Bücherrevisionsamt*, the 'book examination office,' and police headquar- ters. Strict guidelines were even imposed on shopkeepers' signs and the inscriptions

[48] FUNERAL CROWNS, REPLICAS OF THE ORIGINALS USED BY THE HABSBURG MONARCHS, VIENNA FIRST HALF OF THE 19TH CENTURY. HOFMOBILIENDEPOT ATTIC.

on tombstones. SMALL WONDER that people looked for an escape, finding relief in the waltzes created by Johann Strauss, the pop star of Biedermeier. The theater director Heinrich Laube painted a picture of the passion and heated atmosphere Strauss created: "In the center of the garden is the orchestra, from which seductive siren sounds proceed: the new waltzes, the bane of our more erudite musicians, the new waltzes that like a tarantula's bite stir young blood into a turmoil. In the center of the garden, beside that orchestra, stands the present-day hero of Austria, Austria's Napoleon: the musical director Johann Strauss. What Napoleon's victories were to the French, Strauss's waltzes are to the Viennese. THIS MAN WIELDS ALARMING POWER. He may count himself particularly fortunate that in music all thoughts are possible, that censorship does not concern itself with waltzes, and that music speaks directly to the emotions. I don't know what he can do apart from making music, but I do know that the man could cause a great deal of mischief if he fiddled ideas like Rousseau's. The Viennese would go right through the *contrat social* with him in an evening. IT IS A REMARKABLE FACT that Austrian sensuality never looks nasty. The Austrian Eve is naïve and no sinner. Lust in Austria is sin before the Fall. The Tree of Knowledge has not yet made any definition necessary, any guile." APART FROM THESE INNOCENT ADVENTURES in public, the only place which was a truly safe haven was home. The members of the rising bourgeoisie were trapped between the efforts of the government to maintain the status quo and their serious yearning for progress. Between 1820 and 1830, the economy recovered from the depression that followed the wars. New technological advances and fresh investment capital led to initial successes. The first fruits of this beginning prosperity created new jobs. There were more items available at affordable prices than ever

before. This led to a more optimistic outlook for the future of the middle classes. Fortunes were made by entrepreneurs, speculators, and early industrialists. To be high-born was not the sole prerequisite for a good life. Money mattered. Wealthy bourgeois families enjoyed a new world, a world until now reserved for aristocrats. A world of culture, which accompanied a more relaxed lifestyle, opened up to those who could afford it, with all the accoutrements they desired. After twenty-five years of the continuous horrors of war and political unrest, people enjoyed peace. BUT THIS RESPITE proved to be temporary. The high hopes encouraged by the government turned out to be nothing but that. Disillusion was the consequence. As a result, many people were eager for a life of cozy privacy in the company of their families, where they could cultivate the respectability their middle-class values prized. This retreat into the home became known as *innere Emigration*—'internal emigration', or what today we might call cocooning. SOME REFER TO THE FINAL YEARS of Emperor Franz II(I) as Europe's last Sunday. Following this Sunday, the 'Good Old Days' were over. The dark side of this period became increasingly obvious. Hardest hit were again the poorest of the working-class people. Due to the expansion of industry, many individuals and workshops were forced out of business. By 1840 the sufferings and restlessness of the lower classes became as intolerable as the censorship officials themselves. ANGER AND DISCONTENT ultimately led to the days of revolution. In his essay *The Outbreak of the Revolution*, the historian Günther Düriegl describes the scenario: "On 24 February, 1841, the Second Republic was declared in Paris. Students, workers, and the National Guard had forced the Citizen King to abdicate. The forces of destruction against which the Metternich system was erected had made a crucial breach. Although the news of the

outbreak of the February Revolution was immediately suppressed by the Austrian government, the event could not be kept secret in the long run. IN VIENNA, ON 13 MARCH, more and more people began to gather; news of the first strikes came in from the factories in the suburbs, and in the early hours of the afternoon the army was ordered to clear the Herrengasse. After the troops had made several vain attempts to do this they advanced on the crowd with bayonets and rifles. The demonstrators fled in terror, leaving five dead behind them—a woman and four men. At this point a revolution broke out in earnest. Class barriers fell as, for the next several hours, proletarians, workers, students, and members of the lower and upper middle classes united in angry resistance to a government that had ordered soldiers to fire on unarmed people. PRINCE METTERNICH tendered his resignation. In his letter to that effect, addressed to the Emperor and written in his own hand that same evening, the chancellor acknowledged that a new age had dawned, the onslaught of which the old world, by now impotent, was no longer capable to withstand: 'I am resigning in the face of a higher power than that of the sovereign himself.'" Biedermeier, a time known by many terms, came to an end. BIEDERMEIER IS A STYLE. A style as well as a mental attitude. A style that evolved out of rebellion against the aristocracy, which, in conjunction with the church, had dominated society for so many years. The tastes and styles of the aristocratic old order were challenged by the emerging tastes of the bourgeoisie. This was a style of the middle classes, as they gained new prominence and power. It is interesting that regardless of the time in which one lives, one tends not to notice its significance in history. Those living in the Biedermeier era were unaware of the label their age would later receive. Most stylistic terms are created by the following generation, which somehow hates the style of its parents. It always takes

at least one generation before the value of a particular age is appreciated. More recently, this happened with Art Nouveau, and it is going on today with the styles of the 1950s, 1960s, and 1970s. For the same reason, each generation has seen Biedermeier differently. THE TURN OF THE LAST CENTURY was also a period of many changes. For the first time people started to look back to the Biedermeier period and its designs. In times of change, we are inclined to take inventory and reflect, not necessarily on where we are coming from, but on where we are going to. We attempt to redefine our values and give thought to the qualities that are most important to us. Around 1900, values were redefined through a return to honesty in expression. Biedermeier appeared honest to them. This was the last period in which design and execution had rested in the same hands, the last period of preindustrial production—and the first period to produce a democratic style. Whether this is true or not, people believed this. For them, Biedermeier was an authentic stylistic expression. Designing one's living area became a central concern of an era in which a gradual subdivision of living areas took place. Biedermeier gave birth to what we have come to know as interior design, as a form of self-expression. As Biedermeier became the accepted term for a lifestyle that existed between 1800 and 1848, intense interest in Biedermeier fashions, music, literature, painting, and furniture emerged. Around 1920, Biedermeier was even more en vogue. The designer Mies van der Rohe liked the austere and simple characteristics of Biedermeier furniture, which he used frequently. In the course of the twentieth century, we have been educated toward a more linear development in simplicity. Goethe said, "You only see what you know." Today we say, "You see what you want to see." Today we have our own appreciation of Biedermeier.

VIENNA: THE BEGINNING

ONCE UPON A TIME THERE WERE AN EMPEROR
AND AN EMPRESS. THEY LEFT A LEGACY TO THEIR CHILDREN
OF THOUSANDS AND THOUSANDS OF CHAIRS. OF COURSE,
SOME OF THEM WERE RICKETY. THE CHILDREN
WERE GOOD AND HONEST AND LIVED HAPPILY EVER AFTER,
KEEPING THE CHAIRS UNTIL TODAY, HAVING HAD MUCH JOY OF THEM
THEMSELVES. IN THE HOFMOBILIENDEPOT IN VIENNA,
THIS HERITAGE OF THE MONARCHY LEADS A MAGICAL AND PARTLY
SECRET LIFE. IN THE CENTER OF THIS MYSTERIOUS LABYRINTH
OF THE PAST, DIREKTOR MINISTERIALRAT DR. PETER PARENZAN
AWAITS MY VISIT. THE HANDS ON THE CLOCK
IN HIS OFFICE STAND STILL. "DEATH WORK OF A MIGHTY PAST,"
HE SAYS, "IT MAKES ONE FEEL A BIT MELANCHOLY. AND,
ALL AROUND ME—THIS CRAZY NUMBER OF FURNITURE
PIECES: ONE HUNDRED SIXTY-THREE THOUSAND OBJECTS,
ALL CRAMMED INTO SIX THOUSAND SQUARE METERS. JUST TO SHOW
YOU AROUND QUICKLY WOULD TAKE AT LEAST A DAY."

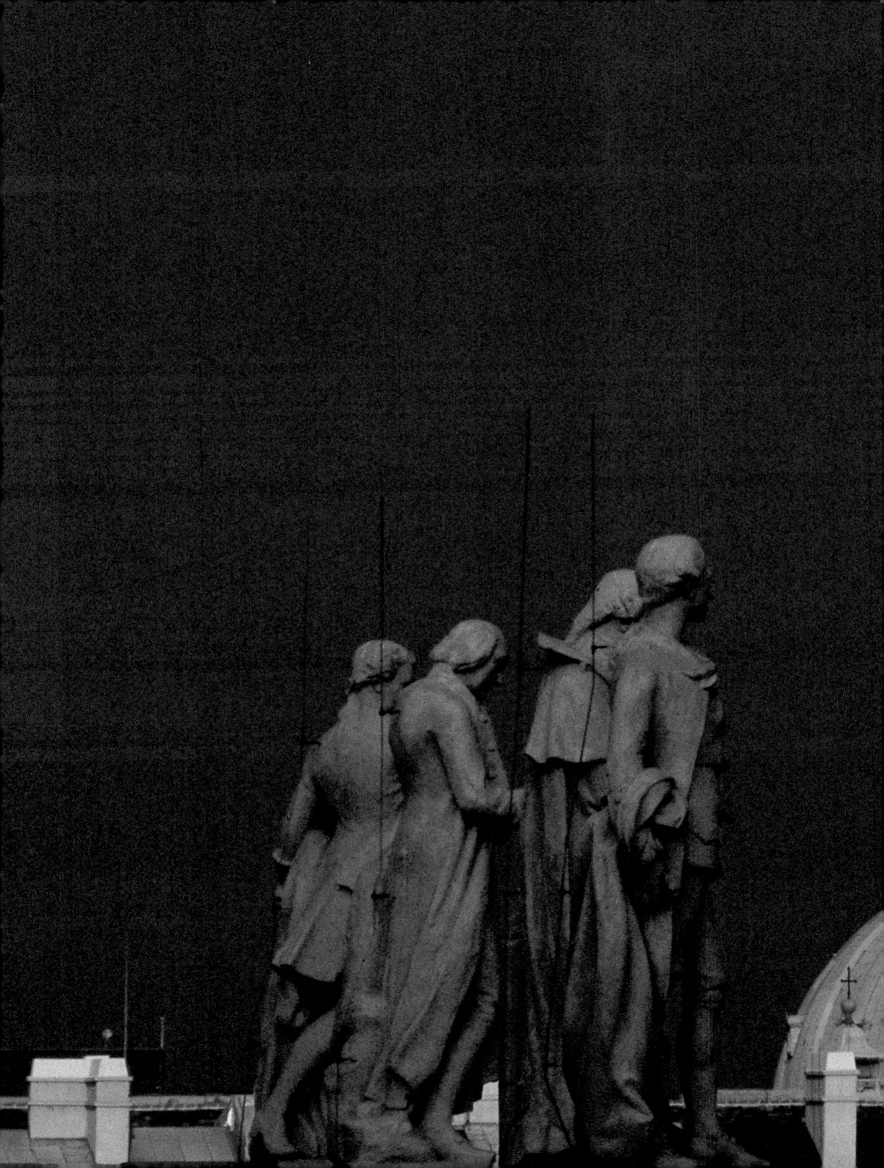

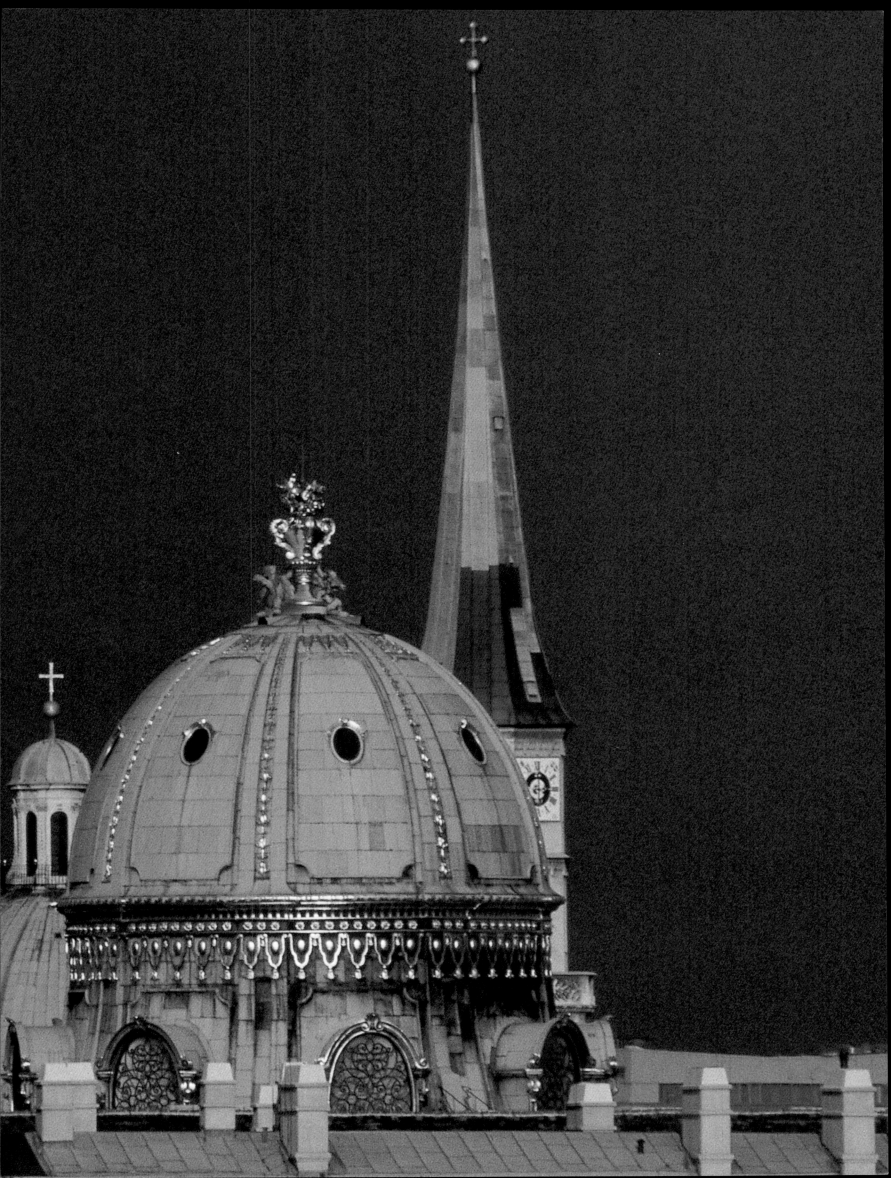

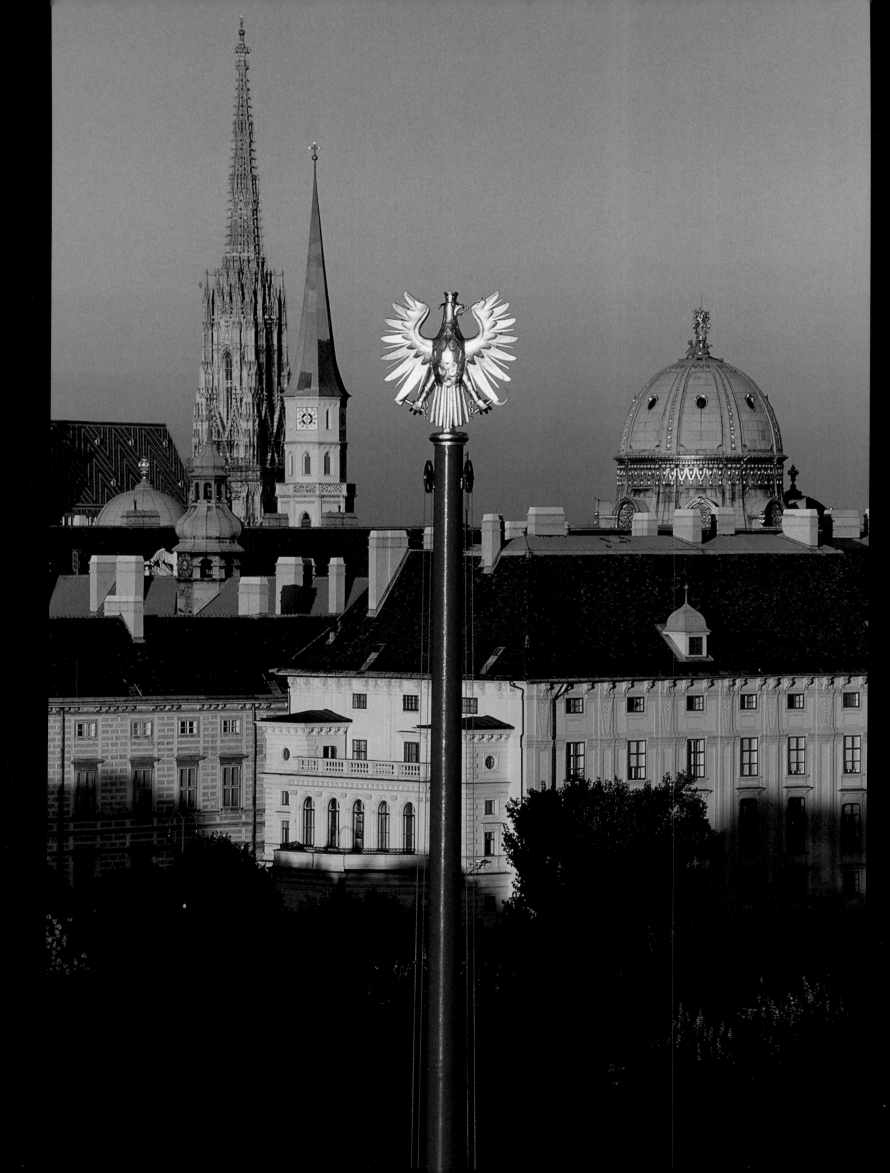

"AS FAR AS MY APARTMENT IS CONCERNED, MY DARLING, YOU KNOW MY WEAKNESS. THIS IS THE ONLY THING IN THE WORLD WHICH HAS NO SOUL, AND STILL PLEASES ME. I DO NOT DENY THAT THE COST WILL BE HIGH, BUT EVERYTHING WILL BELONG TO THE STATE, NOTHING WILL I REGARD AS MY OWN PROPERTY. I ONLY WANT TO ENJOY THE USE OF IT. WHAT IT COSTS YOU TO BUY FURNITURE FOR ME, YOU WILL PAY FOR HORSES, BALLS, AND DISTRACTIONS FOR ANOTHER WOMAN. I DO NOT WANT THOSE, BUT ONLY A BEAUTIFUL APARTMENT. YOU CAN LAUGH AT ME. I ALLOW YOU TO DO SO." MARIA LUDOVICA d'ESTE, IN A LETTER TO HER HUSBAND, EMPEROR FRANZ II(I), DATED 14 DECEMBER 1809

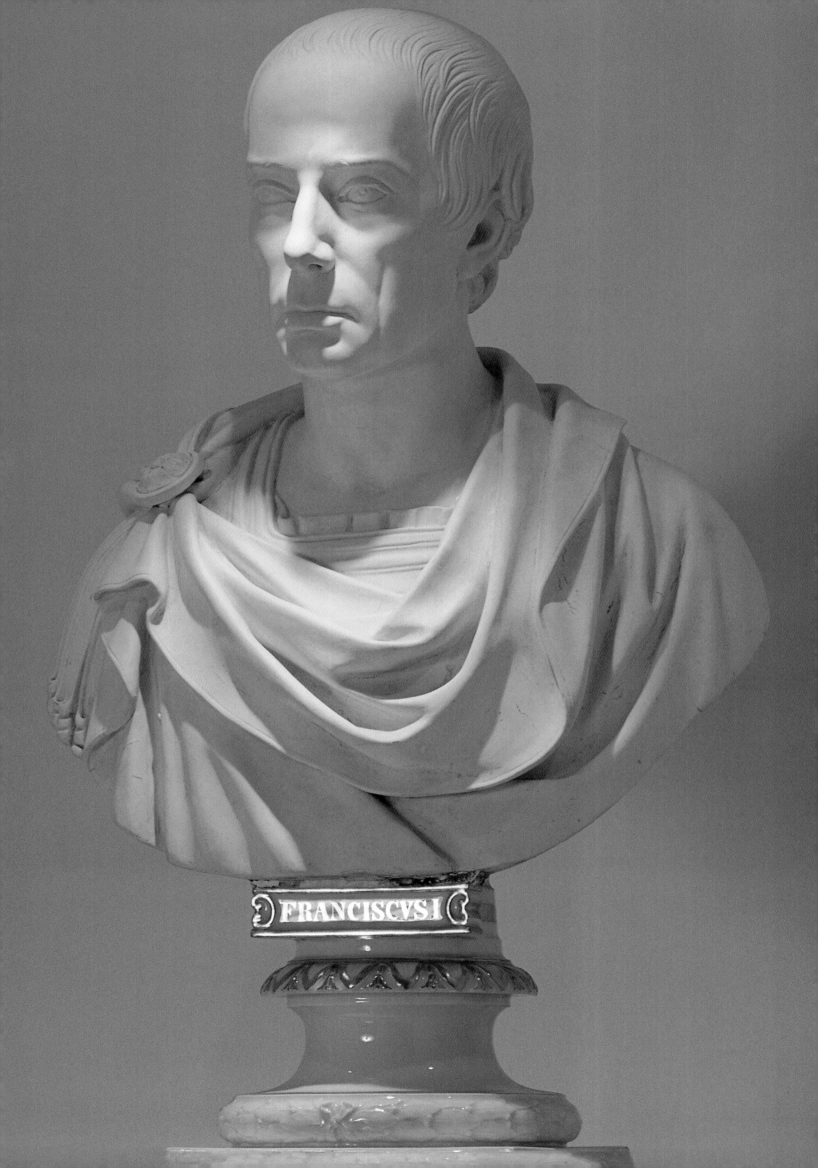

I HAD READ about this vast collection, and fortunately Dr. Parenzan did not know how long I planned to stay. While I was not yet ready to plunge into this vast legacy of the Habsburgs, this designer's dreamland of furniture, seemingly far away from the rest of the world, I asked Dr. Parenzan to put this collection in a contemporary perspective. "VIENNA, THE OLD RESIDENCE of monarchs and kings, is now the capital of a small democratic country, and is witnessing a new time, after two world wars and political roller-coaster rides of all kinds." Dr. Parenzan continues, "The European Union is integrating all the countries of Europe, save Switzerland, and placing Europe in the new position of a mighty political player. Comparisons to the atmosphere of the time around 1900 are absolutely appropriate. The countries of the Danube Monarchy, which subsisted in the eastern bloc as if in quarantine, are again felt presences in the city. And the Viennese respond to this multiplicity of cultures in the same way as before, when Vienna was the pulsing metropolis of a world power, an irresistible magnet for immigrants from many nations, at first at odds but after a little while somehow agreeing to coexist with one another. No longer in a wind-still corner of Europe, Vienna is suddenly catapulted into the center of an extremely controversial Europe, full of future possibilities. This fuels the fundamental anxieties of the Viennese: *Da könnte ja jeder kommen,* or 'who knows what lies around the corner?' On the other hand, it feels good to be in the limelight again, this time with neighbors

[58] STATUES ATOP THE MUSEUM OF NATURAL HISTORY LOOK TOWARD VIENNA'S CITY CENTER: THE CENTER CUPOLA IS PART OF THE HOFBURG PALACE, TO THE LEFT IS THE CUPOLA OF PETER'S CHURCH, TO THE RIGHT IS THE CLOCK TOWER OF MICHAELA CHURCH. [60] VIEW OF THE HOFBURG PALACE, MICHAELA CHURCH AND STEPHANSDOM, VIENNA. [62] VIEW OF THE CITY CENTER AND THE HOFBURG PALACE, VIENNA. [64] BISQUE PORCELAIN BUST OF FRANZ II(I), PROBABLY BY ELIAS HUTTER, MANUFACTURED BY VIENNA PORCELAIN FACTORY, VIENNA CIRCA 1815. SILBERKAMMER.

of equal rights. It is one of the most fascinating aspects of the Viennese character to encounter the new with touchy skepticism and distrust. As soon as they do gain confidence in the new, they start to defend it with fierce passion. This grouchy uneasiness, which opposes every new challenge, becomes, in the end, an energetic will to succeed. Vienna will need this ability more than ever once Prague and Budapest have regained their vitality and rediscovered their history-laden lust for urban rivalry. Vienna has learned to live with its unique heritage. Whether it be philosophical or political ideas, palaces in imperial yellow that attract tourists, or the world's largest Biedermeier collection, which we have here!" "DR. PARENZAN, can you please tell me how all this furniture ended up under one roof?" "Well, you see," he responds, "the vast Habsburg clan owned many, many palaces, castles, and villas. As times changed, their tastes and personal needs changed. They were constantly redecorating. These discarded furniture pieces were placed in the numerous storage warehouses throughout the empire. In 1747, Empress Maria Theresia's maxim, *bescheidener Haushaltsführung,* or 'restraint in housekeeping,' led to the creation of the post of *Hofmobilieninspektor,* or 'inspector of royal furniture.' This official was responsible for the inventory, maintenance, and transportation of the imperial furnishings, which included the seasonal changes of residence. Franz II(I) added the responsibility of purchasing to the already immense list of duties. Additionally, the emperor directed the inspector to give commissions to lesser-known cabinetmakers. This helped establish a more bourgeois lifestyle, which he much preferred. THE MANY MARRIAGES in the monarch's family, and, of course, the Congress of Vienna created an unprece-dented demand. I will give you an example of the metamorphosis of rooms at the

Habsburg court. Maria Ludovica d'Este, the third wife of Emperor Franz II(I), opposed to his iron rules of modest living, persuaded her husband to indulge her need for extravagance. She could not resist her passion for interior decoration and her love of furniture. The redesign of the twenty-four rooms in her apartment in the Hofburg was executed in the Empire style, a style she adored. The Egyptian, Chinese, and Turkish elements used there also demonstrated the exotic inspiration of the lifestyle at the time. This extravagant use of lavish decorations and expensive materials combined to create an unsurpassed elegance. Her apartment became one of the fanciest examples of an aristocratic way of life. This peaked with the decoration of the Egyptian Cabinet, a veritable masterpiece. THE WORK, which had begun in 1810 and took two years to realize, was enjoyed for only a short time. Maria Ludovica d'Este died in 1816. When Franz II(I) married Carolina Augusta, it was not long before Maria Ludovica's dream was retired to the depot, where it collected dust." "WHEN THE EMPIRE CEASED TO EXIST in 1918, and the Habsburgs abdicated, didn't the emerging democracy reject this aristocratic lifestyle? How did this furniture survive?" I ask. "This is a funny story indeed," Dr. Parenzan recalls the history. "We came very close to losing this furniture. When Karl I stepped down from the throne, in the Porcelain Room of Schönbrunn Palace, and the representatives of the monarchy were exiled, the first thing that was seized by the people was the kitchens. The local logic was, 'If they do not have a kitchen, they surely won't return.' Yet the democratic successors did little to avoid walking in the shoes of their precursors. Occasionally a few items were sold, but at the same time the new government's civil servants took over the management of the depot. Two hundred thousand items of furniture and

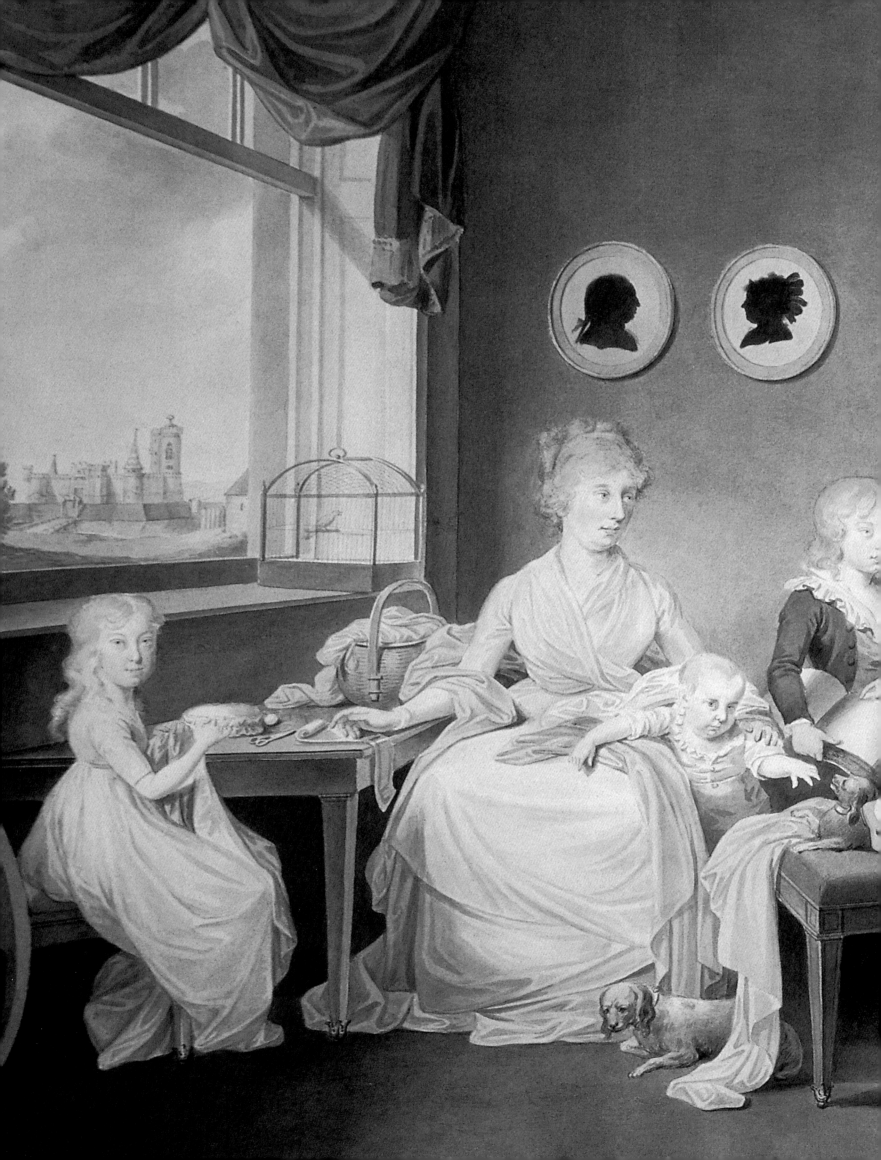

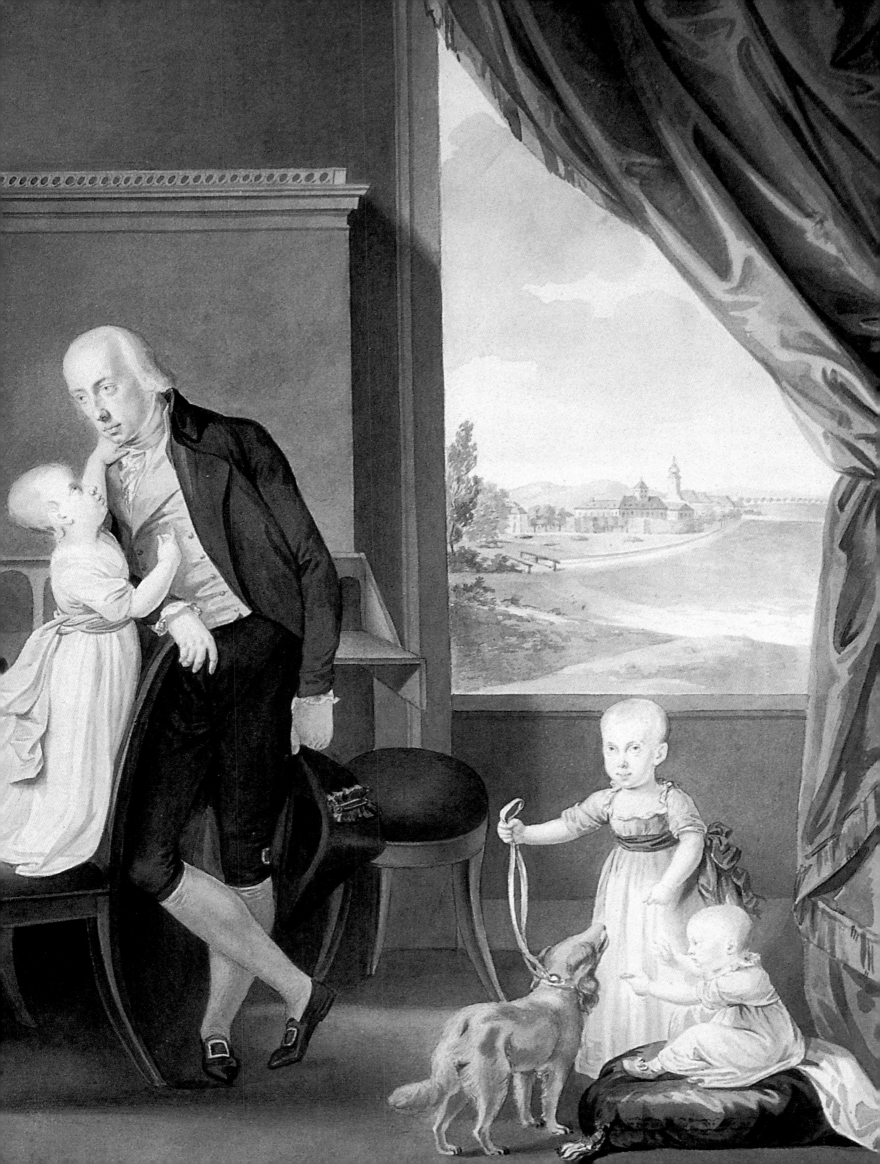

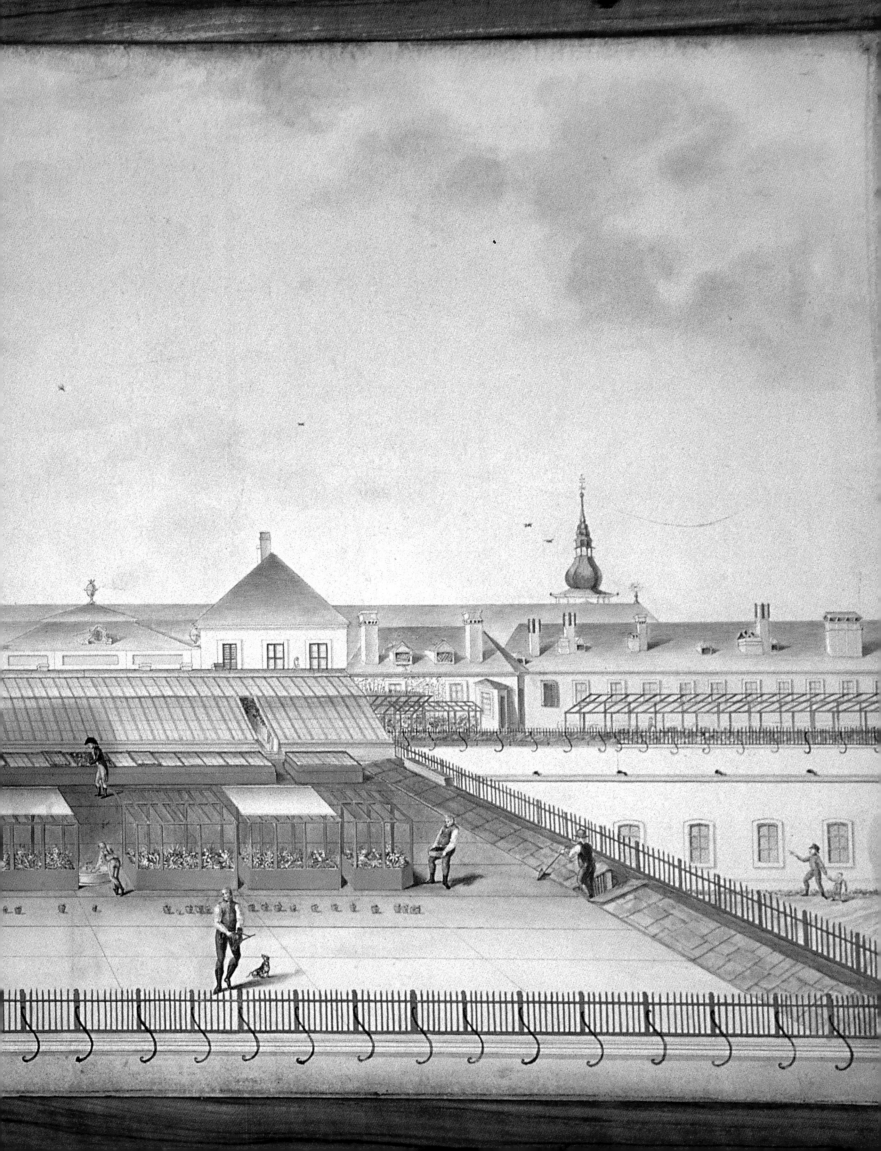

one hundred thousand pieces of porcelain, and table settings in silver and gold came into the possession of the new republic. FOR A SHORT TIME, a few members of the socialist party lamented the new republic's need for its own tableware, to strengthen its identity. Until recently, at official government receptions and dinners, the k.k. (imperial and royal) double eagle spread its wings on the plates and crystal. In the year 2000, the porcelain and crystal was replaced." "I ONCE HEARD A RUMOR, Dr. Parenzan. While no 'thefts' have taken place, it has been necessary after certain heads of state were entertained to make reproductions to replace the originals—for individual items that have been treated as 'souvenirs.' Is that true?" "No, I don't think that is true. It has been a rumor for a long time, and I am surprised that it traveled all the way to New York," he smiles. I SWITCH SUBJECTS. "If I understand correctly, Dr. Parenzan, you are the modern-day *Hofmobilieninspektor*. Before we go into the depot, may I ask what your favorite pieces are?" Without hesitation, he replies, "I am very proud of the fact that we have the largest collection of Biedermeier objects in the world. I am particularly fond of the cuspidors, because they reflect much of the humor that was indicative of certain designs from this period. I must warn you," he says, as we make our way into the depot, "Austria was the only country in Europe that kept everything! And I mean everything!" AS THE DOORS TO ONE OF THE HUGE ROOMS OPEN, I feel the winds of history brush my face. A Kafkaesque adventure begins. I pass through storerooms filled with trumeaus, paintings of all types and sizes, hundreds of clocks, washstands, textiles, carpets,

[68] GRISAILLE PORTRAIT OF EMPEROR FRANZ II(I) AND HIS FAMILY, CASTLE LAXENBURG, ANONYMOUS, VIENNA CIRCA 1807. HOFMOBILIENDEPOT MUSEUM. [70] WATERCOLOR DEPICTING THE PRIVATE GARDENS OF EMPEROR FRANZ II(I), VIENNA CIRCA 1810-1815. HOFMOBILIENDEPOT MUSEUM.

and urns. I walk past a Vasarely of bedsteads, reaching a forest of coat racks. Along an army of bedside tables, I pass beneath a sky full of chandeliers and reach, by way of an avenue of chairs, a pyramid of busts, arranged by chance like a family tree. The smells of old wood and naphthalene fill the air. Childhood dreams of expeditions to the attic come alive again as I discover pieces long ago put away. Imposing armoires in great numbers surround me, so large and massive that they appear somehow scary. A vitrine holds crowns, tumbled atop one another, once belonging to emperors and kings. These are not the originals, but funeral crowns, replicas made of wood and tin and adorned with worn gold leaf, simulated jewels, and glass beads. The Habsburgs used them in funeral processions to represent royal personages as present in spirit. The crowns include the papal crown, the Tiara, the Hungarian crown of St. Stephen, an archduke's headpiece, and also the crown of King Rudolf, the Habsburg dynastic crown. In one corner I spot the coffin in which the assassinated Emperor Maximilian of Mexico, archduke of Austria, returned home. In another corner I discover the gardening tools that belonged to Franz II(I), piled against the wall, with no garden to tend. We go up one staircase and down another: more rooms, another floor, a different attic, endless corridors. "Here in the attic," says Dr. Parenzan, "every day is like the one before, and believe me, many of these days are good." I CANNOT BELIEVE WHAT I SEE. It must be thousands and thousands of chairs. I can't help asking, "Dr. Parenzan, how many chairs do you have here?" "Actually, I do not know exactly; I would guess about thirty thousand. In any case," he adds, "there are enough to fill a stadium. And it is no surprise, because Biedermeier was the era of the chair. You must know that any discussion of Biedermeier furniture is probably going to

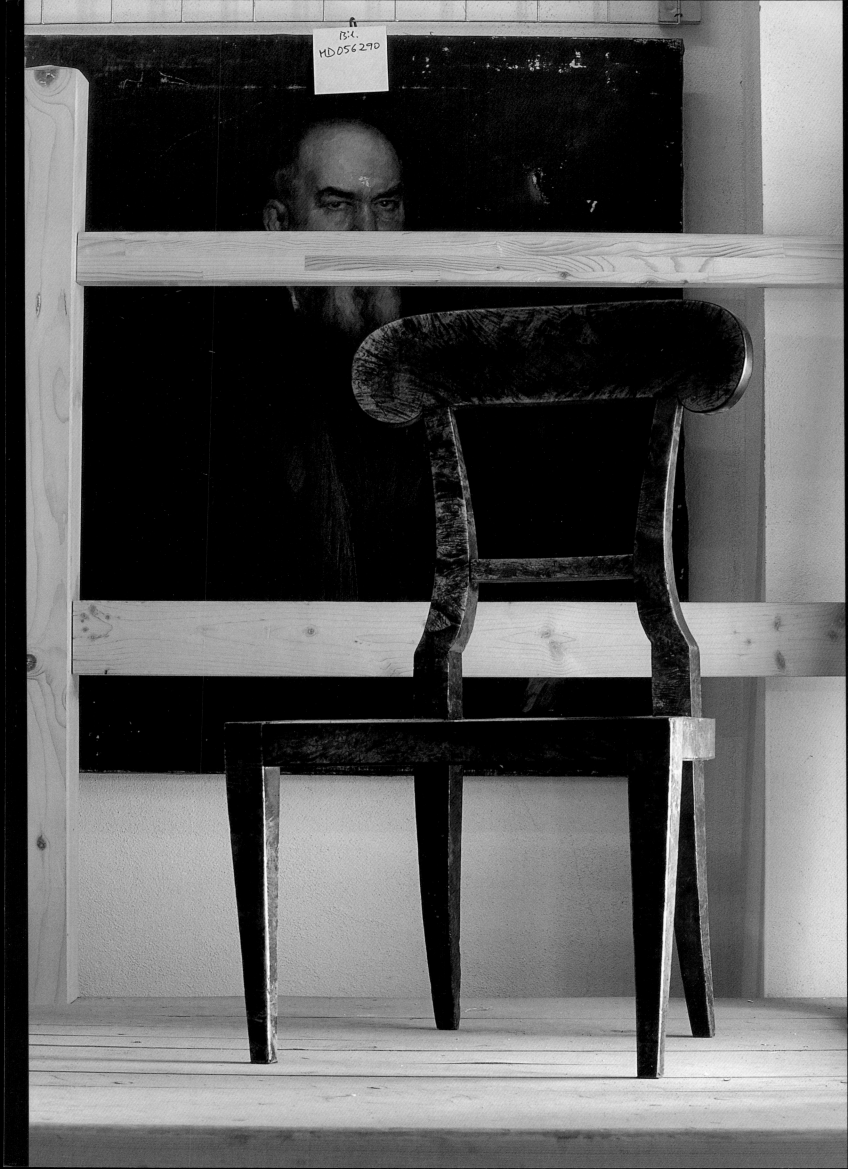

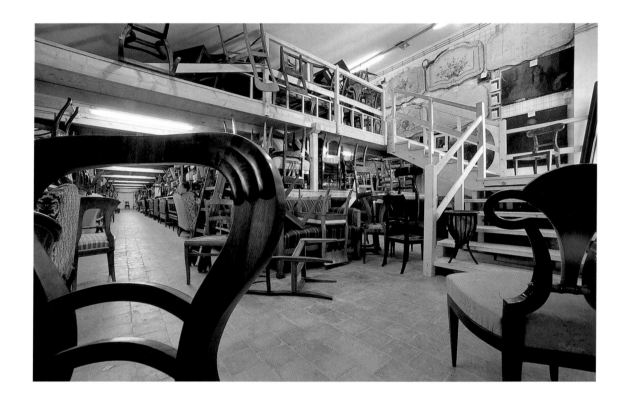

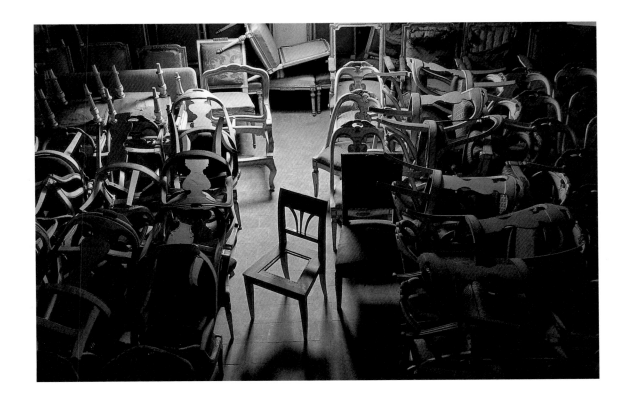

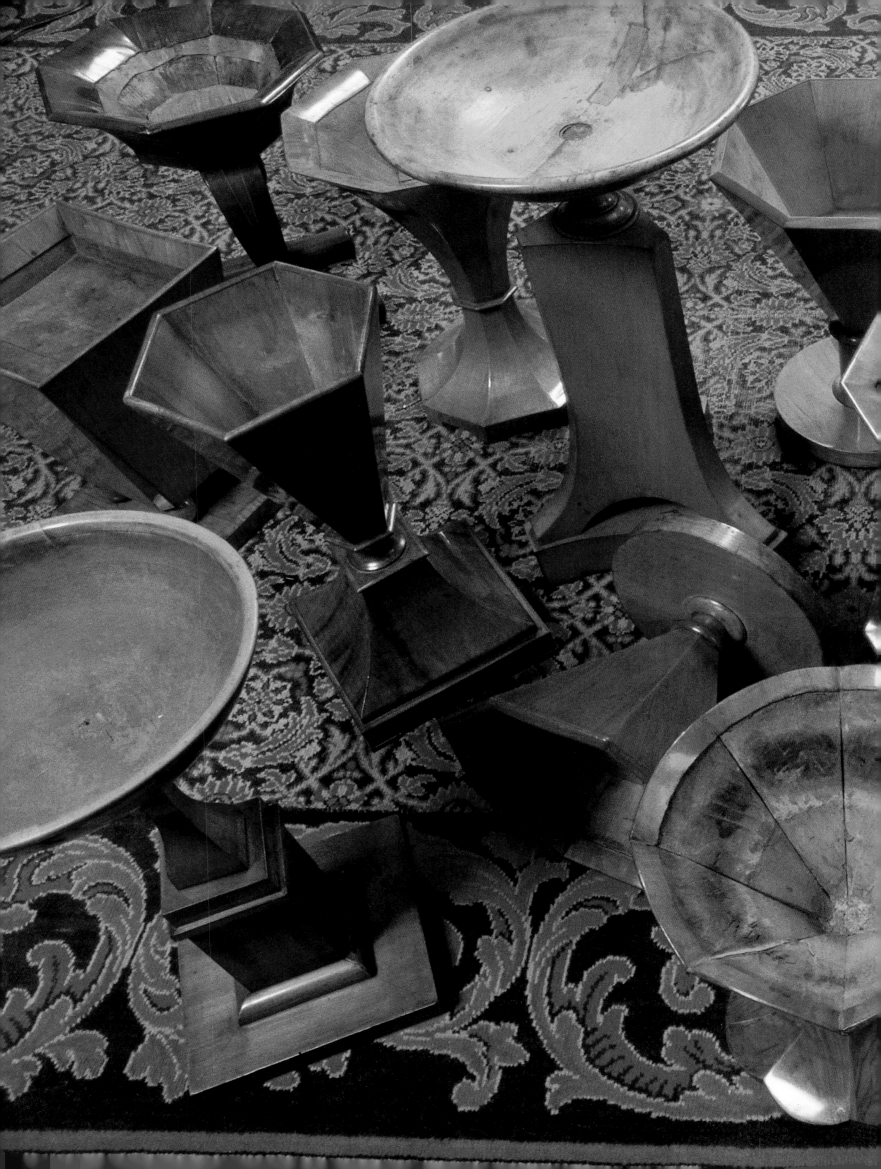

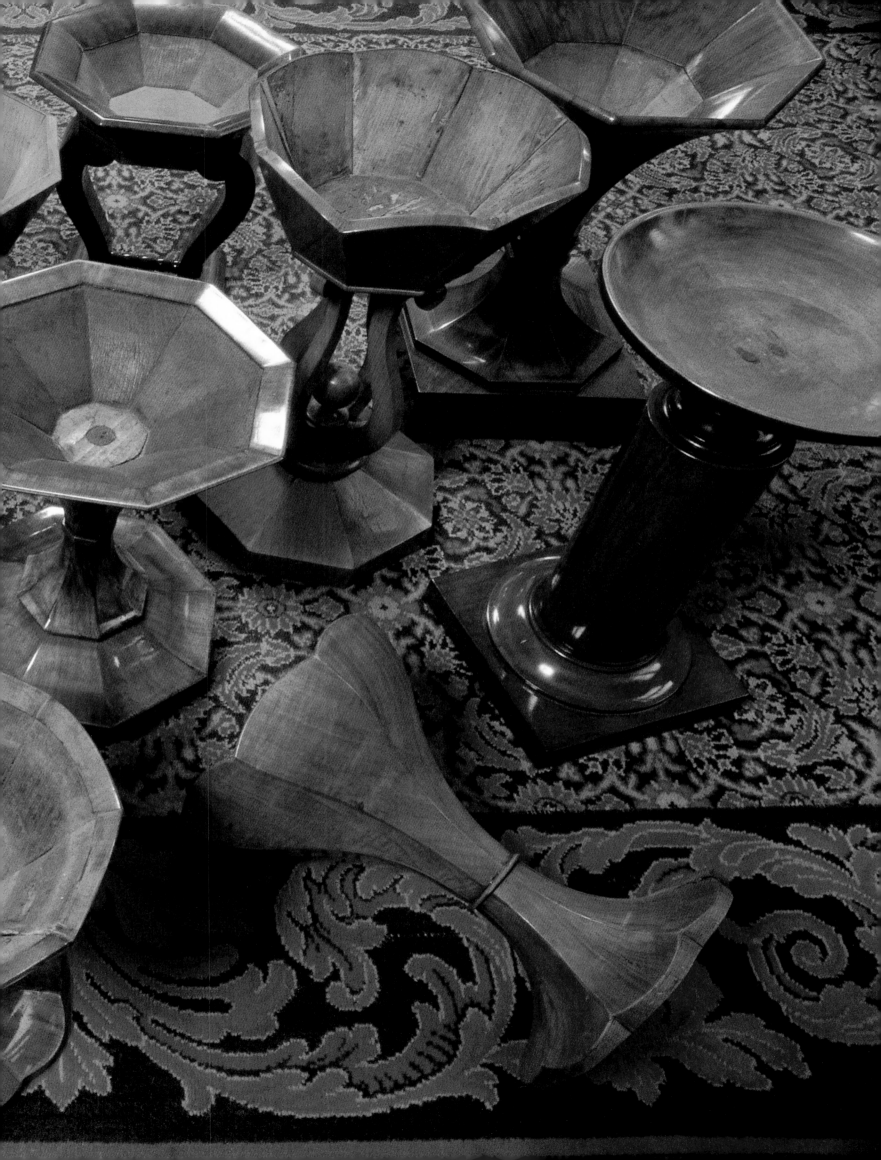

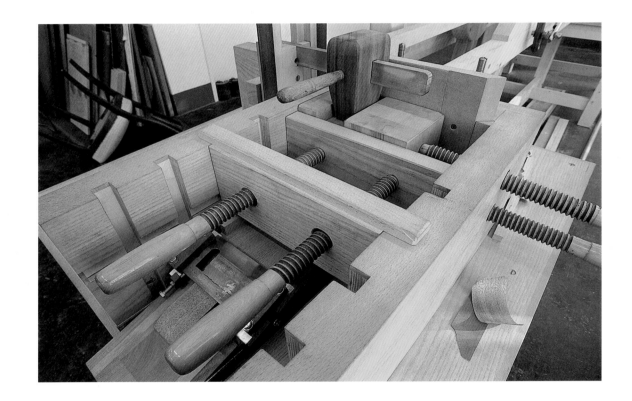

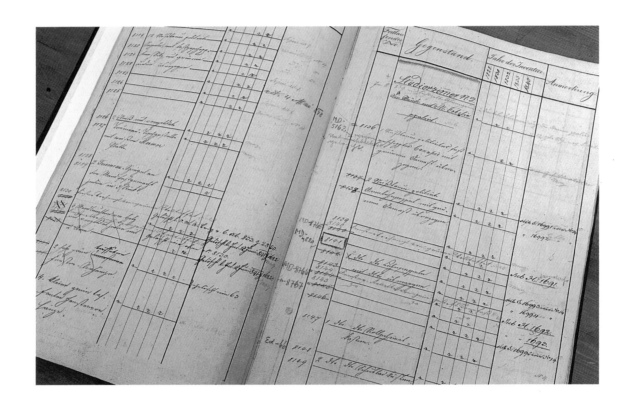

N.º 66.

Inventarium

Ernann in der Rechnung S.r Excellenz
des hoch P.t Preuß. Hofrat des durchl. Herrn
bzw. Frank Joseph, Grafen von
Bombelles, betreflichen Hofrats durchl.

center, if not on the chest of drawers, then on seating furniture, be it in the form of chairs or settees. No previous period produced such different types of seating. If we look at the surviving chairs, together with the designs that have fortunately been preserved in the different collections, we find an astonishing number of variations on the basic scheme of four legs, a seat, and a back. Over the space of fifteen years, cabinetmakers worked their way into an almost frolicsome richness of form that was without parallel. THIS NEW PLAYFULNESS in form was complemented, in a way, by the advent of machine-made furniture, which was able to accomplish veritable miracles of transformation with the aid of numerous hidden features. Biedermeier craftsmen discovered to their delight that a chair could be given literally hundreds of different shapes. This in turn gave a tremendous boost to the trade of the cabinet-maker. Just a moment, I will read something for you: 'The height of the seat is the first factor. It is the height that determines the depth of the seat. Crossbars between the legs are superfluous and impractical. Inevitably people will draw their feet under the chair, in which case crossbars, particularly between the front legs, will be a great impediment. Anyone with officers at home must pay special heed to this, because spurs easily collide with crossbars. The backs of dining room chairs should be as low as possible, in order not to impede serving. If the top of the chair back is at shoulder level, it is best straight. Then, when a person leans back, his shoulder blades will be pressed in, leaving his chest free. A chair whose back forms a curve around the shoulder blades will produce shortness of breath. If the chair back stops at the level of the small of the back, or anywhere below the shoulder blades, it is best given a curve. This type is unfortunately much neglected, and yet is among the healthiest and most

comfortable. In the case of easy chairs with a sloping back, much trying out is called for. One's easy chair ought to be made to measure, like a jacket. The most comfortable easy chairs have an adjustable back. With easy chairs, too, great importance must be attached to ease of breathing. In the case of upholstered chairs, care should be taken that the upholstery does not force the head forward while permitting the back to sink in; the slightest discomfort in this respect will, in the course of time, cause pain.'" DR. PARENZAN LOOKS AT ME as he closes the book *Biedermeier as Educator*. "I think that says everything about seating, wouldn't you agree?" I REMEMBER READING once that the problem of every interaction with the past is that myth and reality sometimes melt into one another. I recall this as practical advice, so to speak, reminding me of my own boundaries. But now I am sitting amid thousands of chairs in the afternoon of an attic. That makes the story quite complex. The truth is, this location is simply beautiful. I do not know why, but I had imagined it as more old-fashioned. Instead it feels vital and dramatic, as well as elegant and ironic. Colors are rare. But they are placed very well: local fruitwoods and mahogany for the furniture, white for the walls. To paint you a picture: I imagine that you cannot do better than to pick up a brown sheet of paper and write, with a chalk white pencil, the word mahogany one thousand times. WHILE I PAUSE, filled with thoughts, Dr. Parenzan continues his lecture. "The only thing that rivaled the importance of the design of the chair was the plain wooden board, the physical and philosophical mother of all Biedermeier furniture. The flat plane was the perfect body to which to apply veneer. The veneer, and its thickness, dominates the design of the final form. For the application of veneers to larger, flat areas, the veneers did not need to be split. This

advantage took precedence over all other aspects of design and construction. For this reason, most Biedermeier pieces can stand alone, without intricate mounts or further embellishment. The veneers were used vertically, imparting a certain importance and giving the illusion of height. This approach makes many pieces appear larger than they actually are. The veneers were symmetrically placed and matched beautifully, creating wonderful flame or wave patterns. This technique of matching veneers is called book-matching, which resulted in more cost for the individual piece. You see, this process was quite delicate and complicated. The veneers were applied over another less expensive wood, which is called blindwood. As the veneers were quite thin, it was extremely important that the blindwood be properly dried. If it was not, the veneers would develop cracks later on. The cabinetmakers took as much care with the processes they used to dry the wood as with the way they cut it. New techniques were developed during the Biedermeier period that enabled quicker drying. Of course, certain veneers were also more suitable for particular pieces. And some pieces, depending on the shape, required a great deal of preparation before the blindwood could receive the veneer. Slower growing trees such as cherry and other fruitwoods offered consistent veneers to cover surfaces in a uniform manner. These woods were used where continuity was desired. Sometimes local woods were stained to create different effects. This was also done to imitate ebony, which was less easily available and more costly. Over time, the use of strongly patterned woods became quite popular. Even the wood from the roots of diseased trees, which exhibited grotesque figuring, was en vogue. This developed into a real craze, creating a demand so great that searching for these roots was soon an occupation in itself. As you can

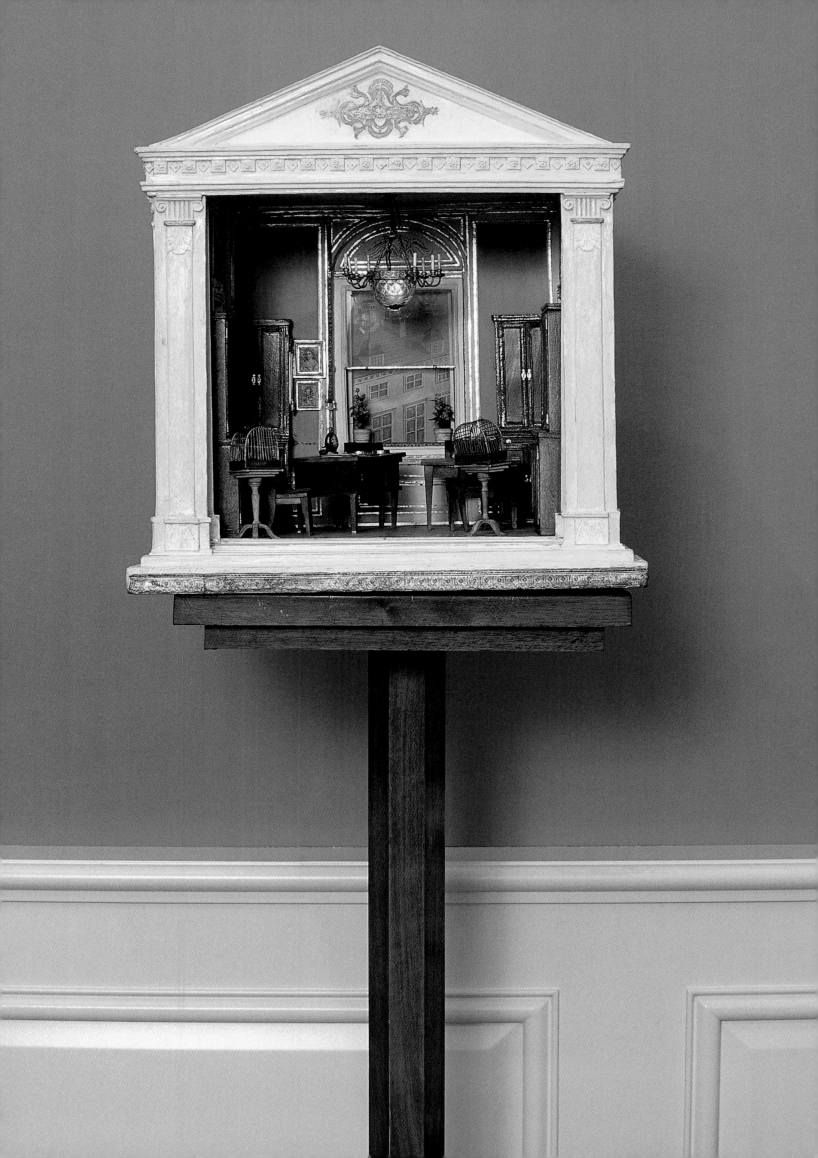

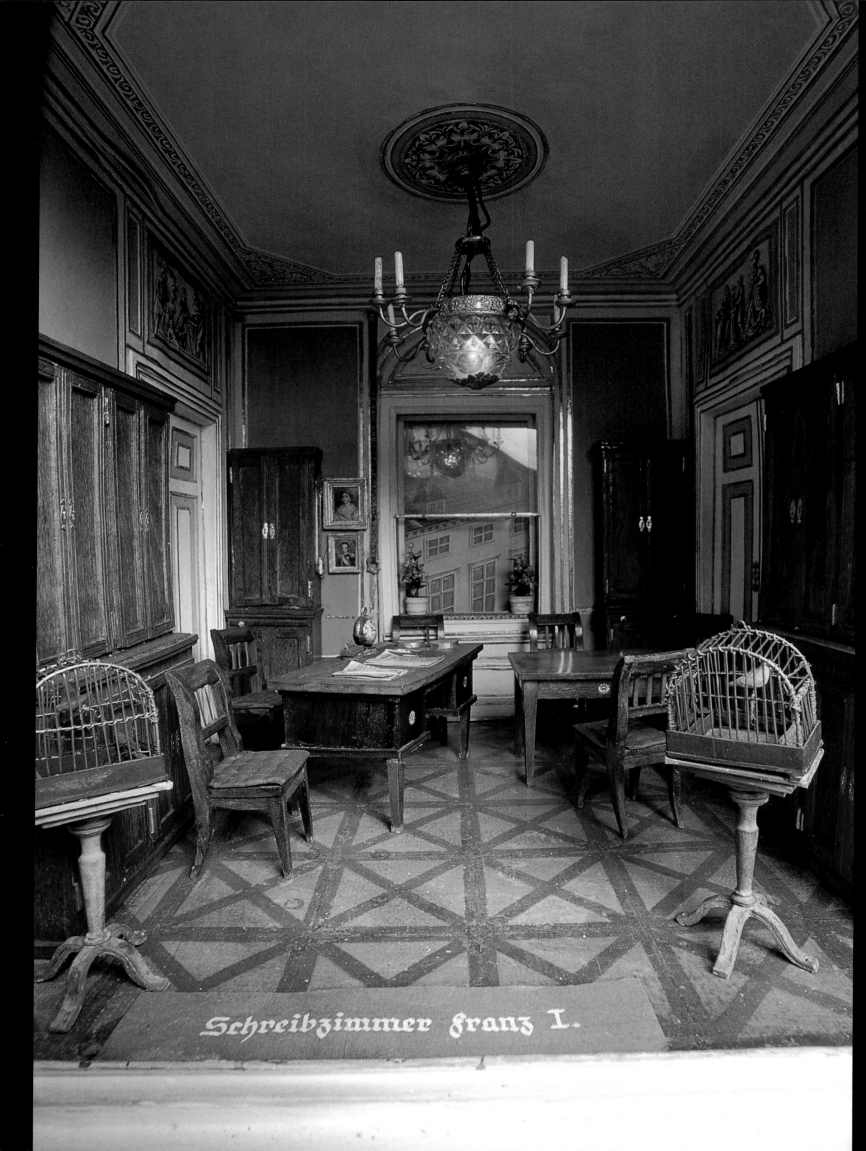

Schreibzimmer Franz I.

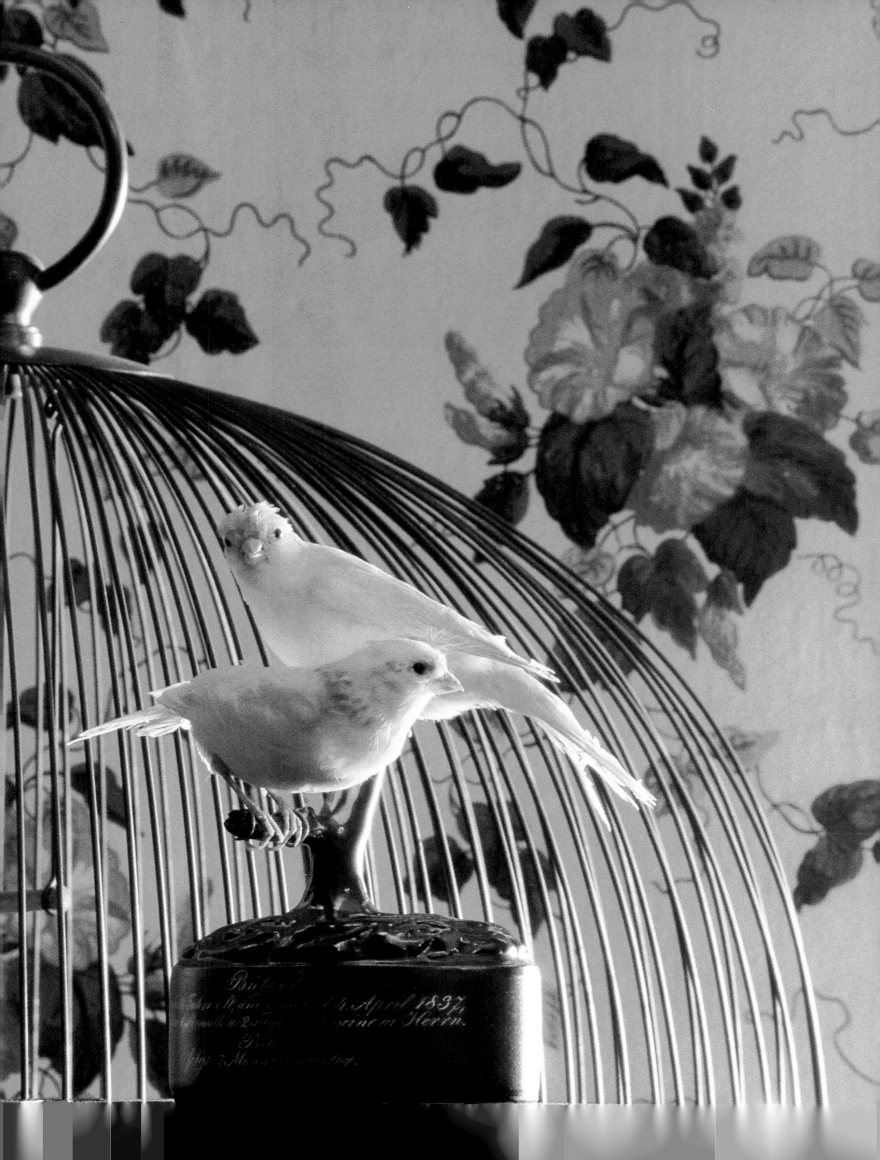

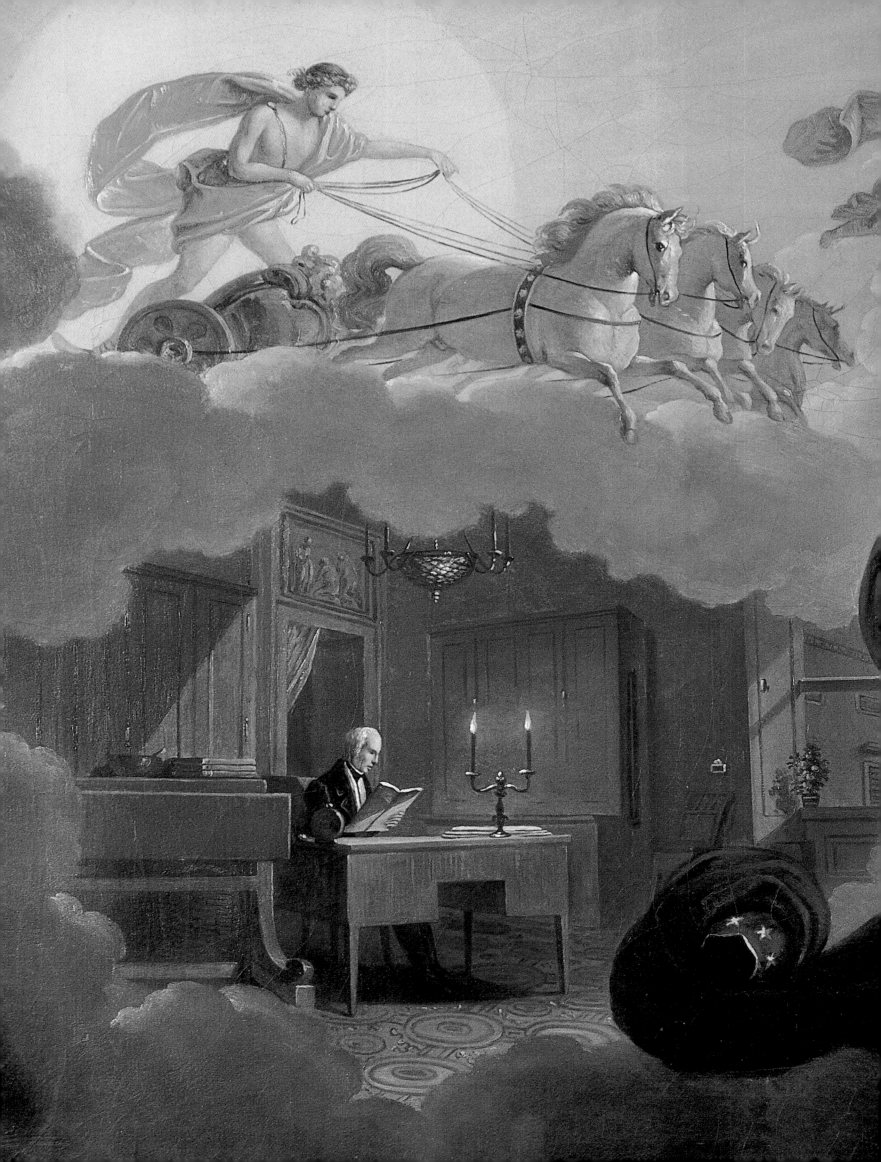

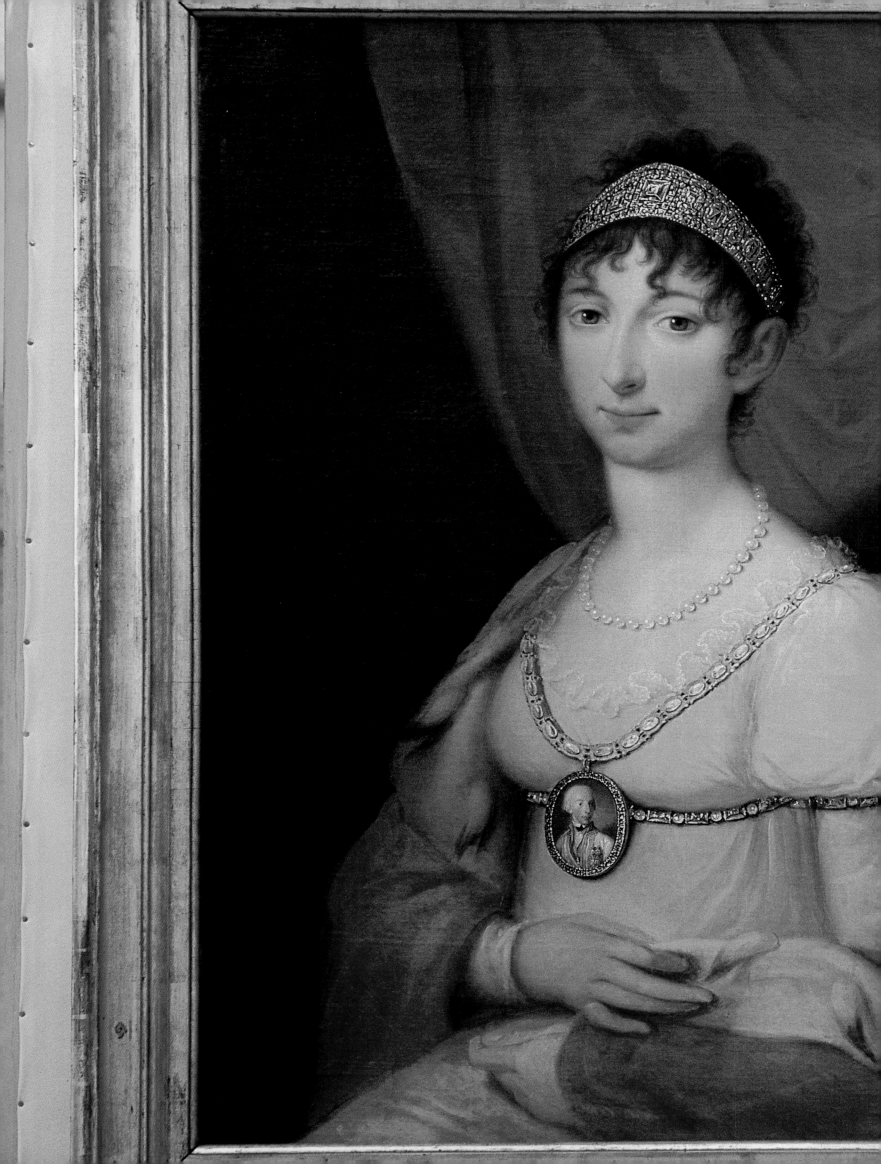

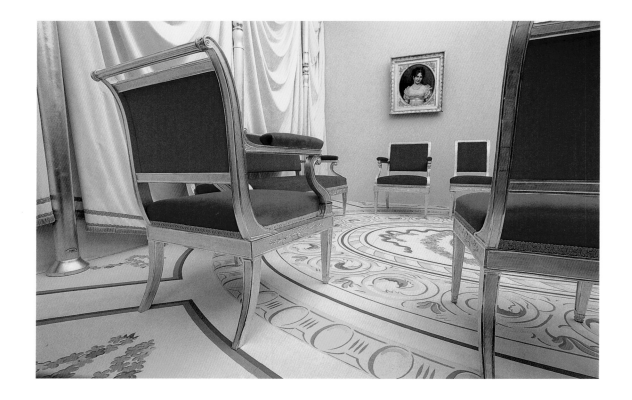

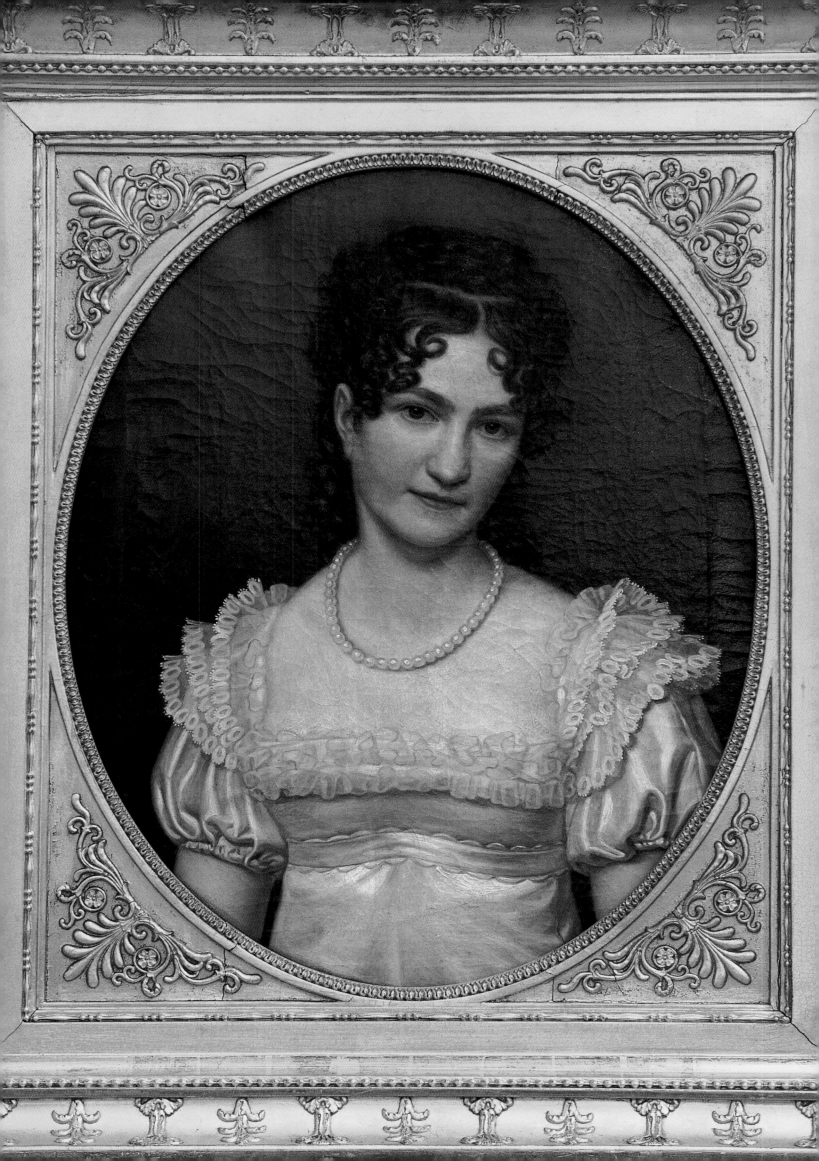

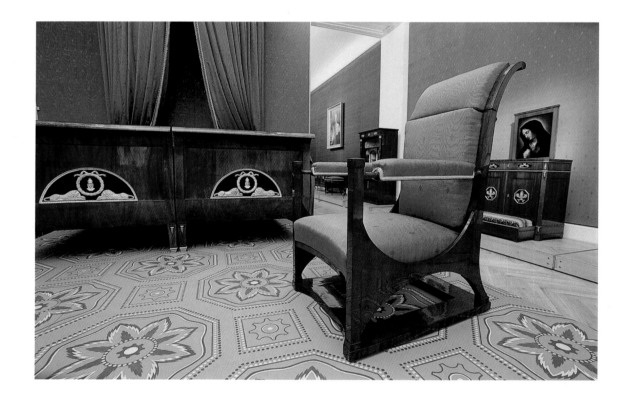

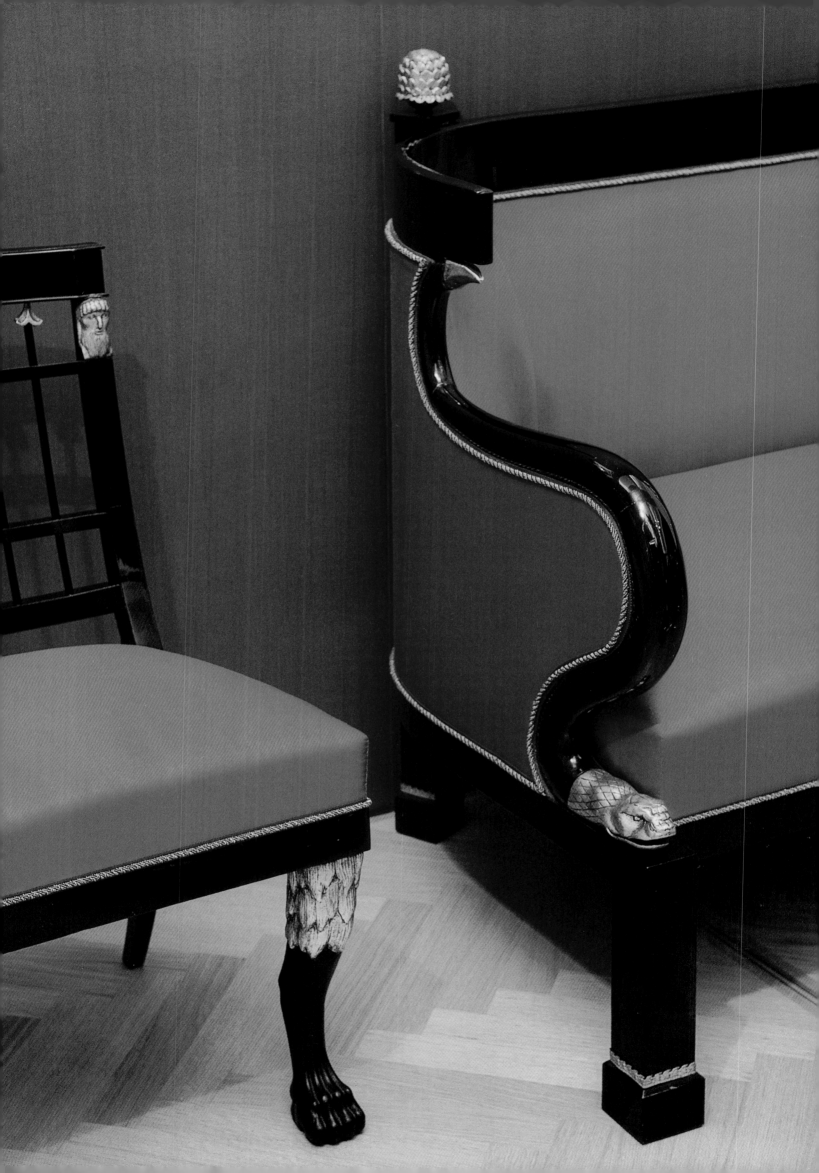

imagine, the almost endless possibilities of creating patterns with veneers kept cabinet-makers quite busy." "THIS IS PRETTY GOOD, Dr. Parenzan, I am very impressed," I smile. "What will you do for an encore?" "Well," he replies, "I can show you much more." As he walks away, I follow. We pass through rooms where all of the furniture comes together as harmoniously as the Vienna Philharmonic playing a symphony. A symphony of a lifestyle that we may all dream exists. "All my thinking revolves around furniture," Dr. Parenzan continues. "I know almost every piece, its hidden compartments, much of its history, the inventory number, its previous owners, and of course where and when it was made. But I must admit that we do not know very much about the makers. The Habsburgs did not allow makers' marks to be placed on any furniture they commissioned. Their oddities were not limited to cabinetmakers' stamps. Franz II(I) decreed which woods were to be used in which rooms. The exotic woods were reserved for reception rooms, and native fruitwoods were used in the making of furniture for the private quarters. Furniture for service rooms was made of oak." As Dr. Parenzan removes the stanchion before us, I am transported into an exotic musical paradise where a giraffe harpsichord holds court with music stands and a suite of chairs. "Why on earth a giraffe piano-forte, Dr. Parenzan?" I ask. "When the first giraffe was brought to Vienna in 1828, it created quite a sensation. This caused a strange outbreak of designs, which made their way to fashion, furniture, and even music. Composers celebrated this new arrival with new compositions that even included a giraffe waltz. This may have led to the name given the piano-forte." IN FACT, THE PARADISE IS A ROOM enveloped in a wallpaper fantasy. Palm trees stand below a golden sky, as jagged mountains appear randomly on the horizon. Lush

rain forest creates the backdrop for an expedition accompanied by Brazilian natives. A mahogany piano-forte with ink decorations forms a centerpiece against one wall. The lyre-shaped backs of mahogany chairs with gilt bronze mounts bring to mind the graceful shape of a violin. They circle a music stand made of walnut. Eight flying caryatids decorate a gilt wood chandelier. The enormous portrait of a family presides over the adjacent dining room. The pale green walls are bordered at the ceiling with a floral design. The furniture is comprised of a long-case clock in rosewood, decorated with gilt bronze mounts. A mahogany vitrine fitted with glass shelves holds porcelain and souvenirs popular at the time. Boxwood inlays decorate a mahogany cabinet that serves as a sideboard. Its finely chased mounts are gilt bronze. The ornate pedestal table is accompanied by highly stylized chairs with upholstered seats in cerise. Each fanback is comprised of narrow splays that unite at the center to hold an elaborate bronze medallion. The feminine legs of the chairs, so fluid and elegant, appear to float across the floor with the grace of André Perugia or Manolo Blahnik high-heeled shoes. All of this made in 1815. TURNING LEFT, we enter a bedroom. Cardinal red and emerald green predominate. It is interesting to see how many different types of furniture have been part of a Biedermeier bedroom. There is a bed, of course, and bed tables, too. A wardrobe, a dressing mirror, a washstand, a toilet, a sofa, an armchair, a footstool, as well as a table surrounded by a suite of chairs. And for a Catholic aristocrat, the inevitable mahogany prayer stool decorated with intricate inlays. All this set against the soft light of a gilt wood chandelier. This furniture was designed for Emperor Ferdinand by Johann Nepomuk Geyr. The wide, massive bed is considerably shorter than one would expect. Dr. Parenzan catches the puzzled look on my

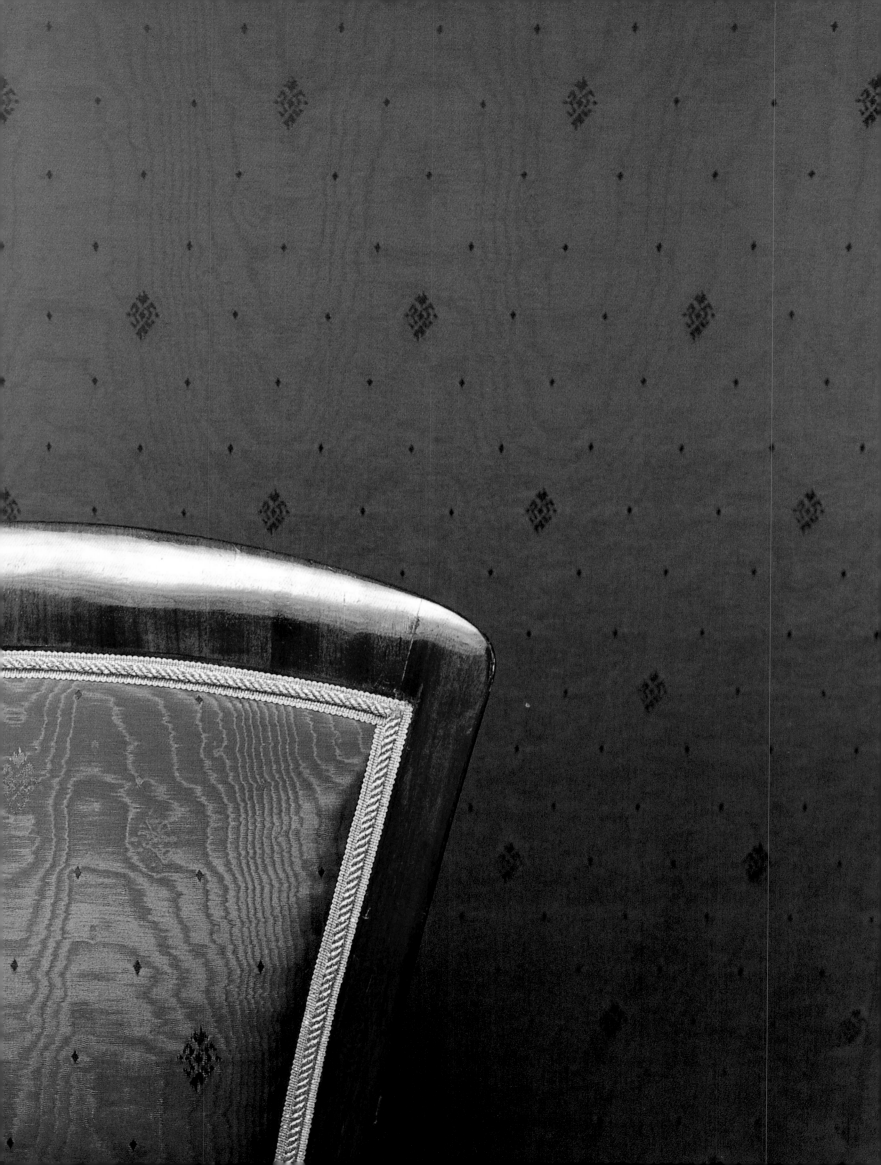

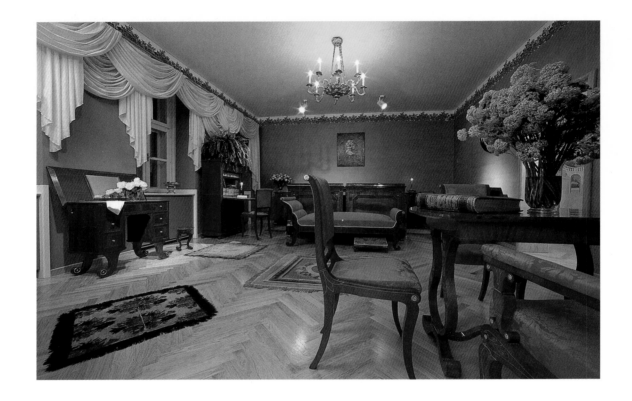

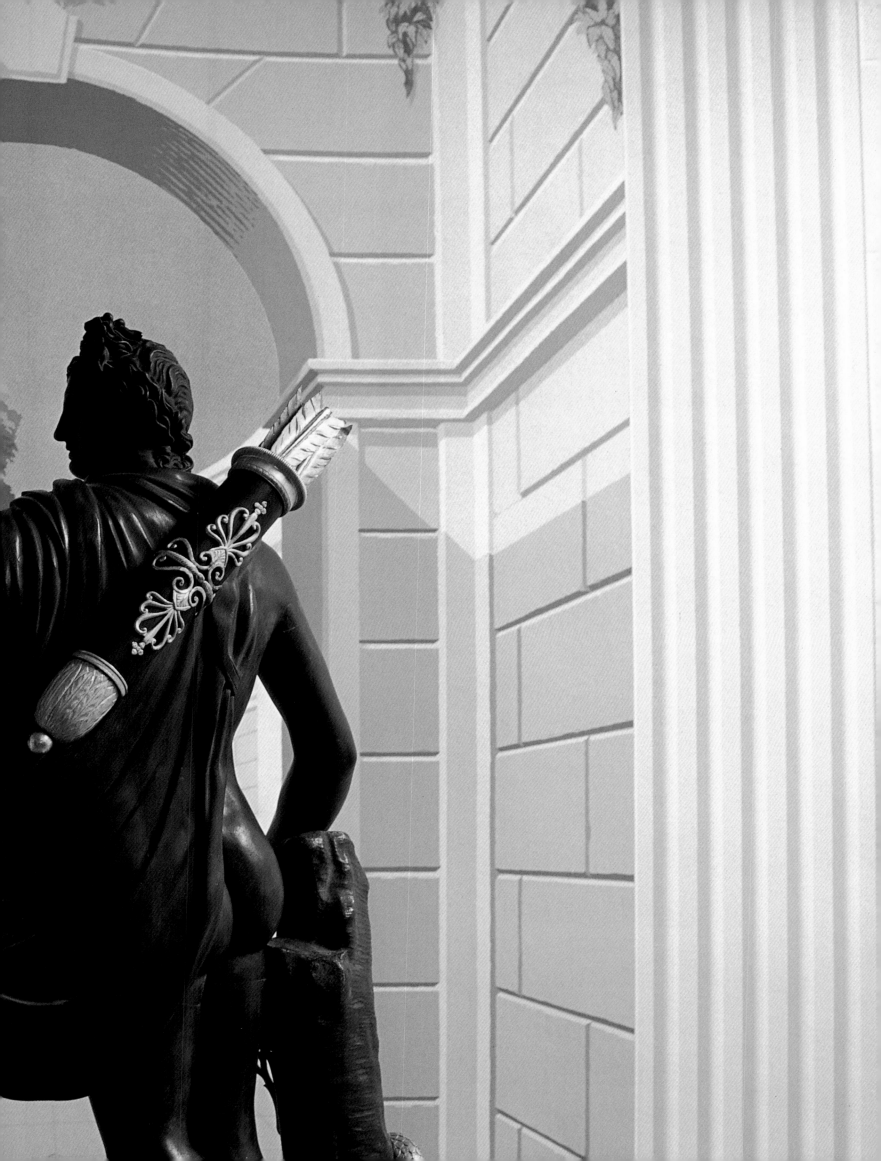

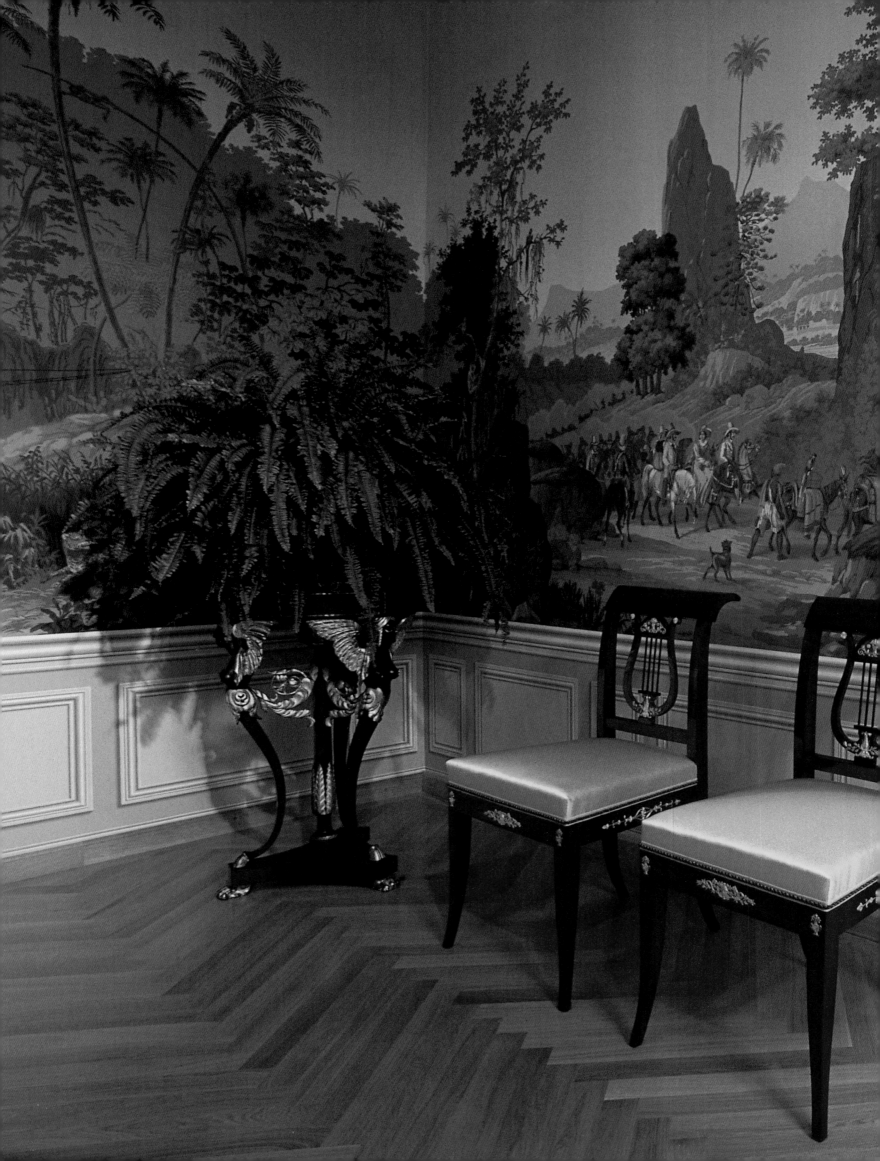

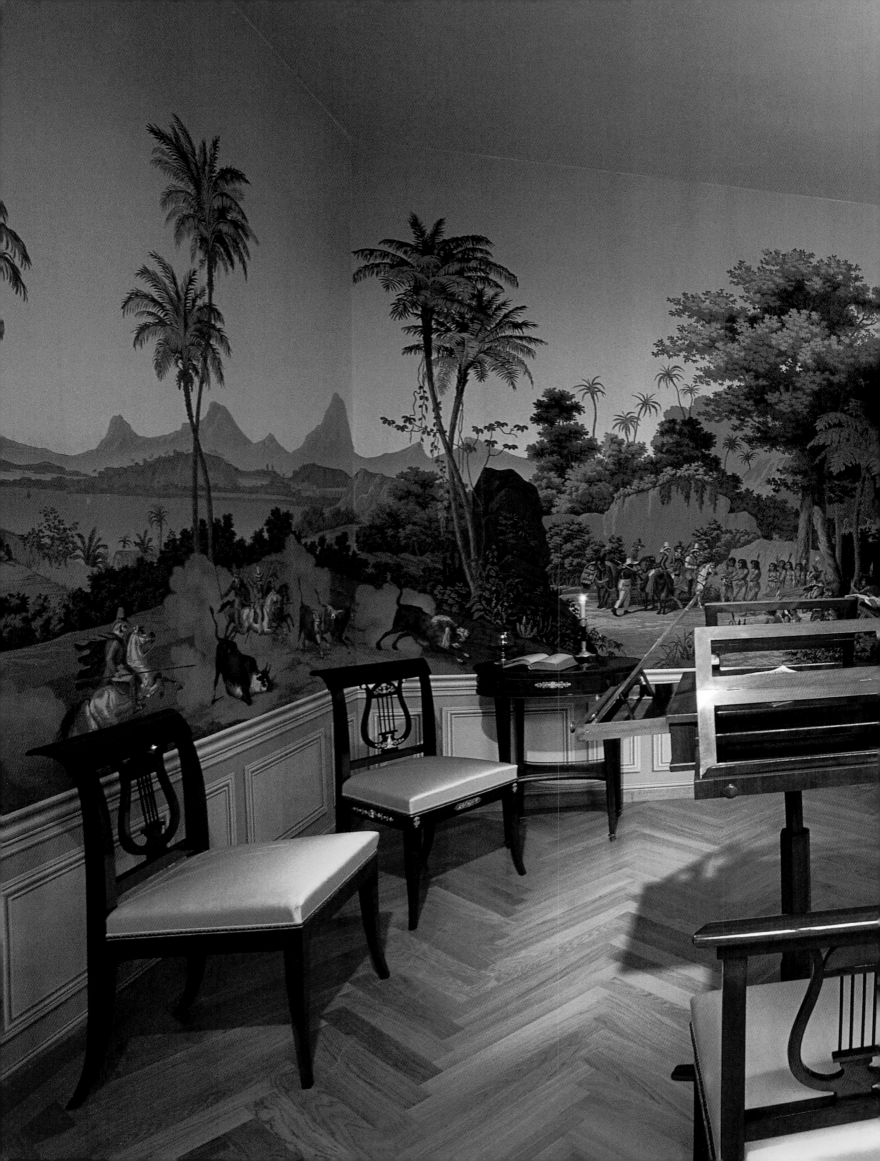

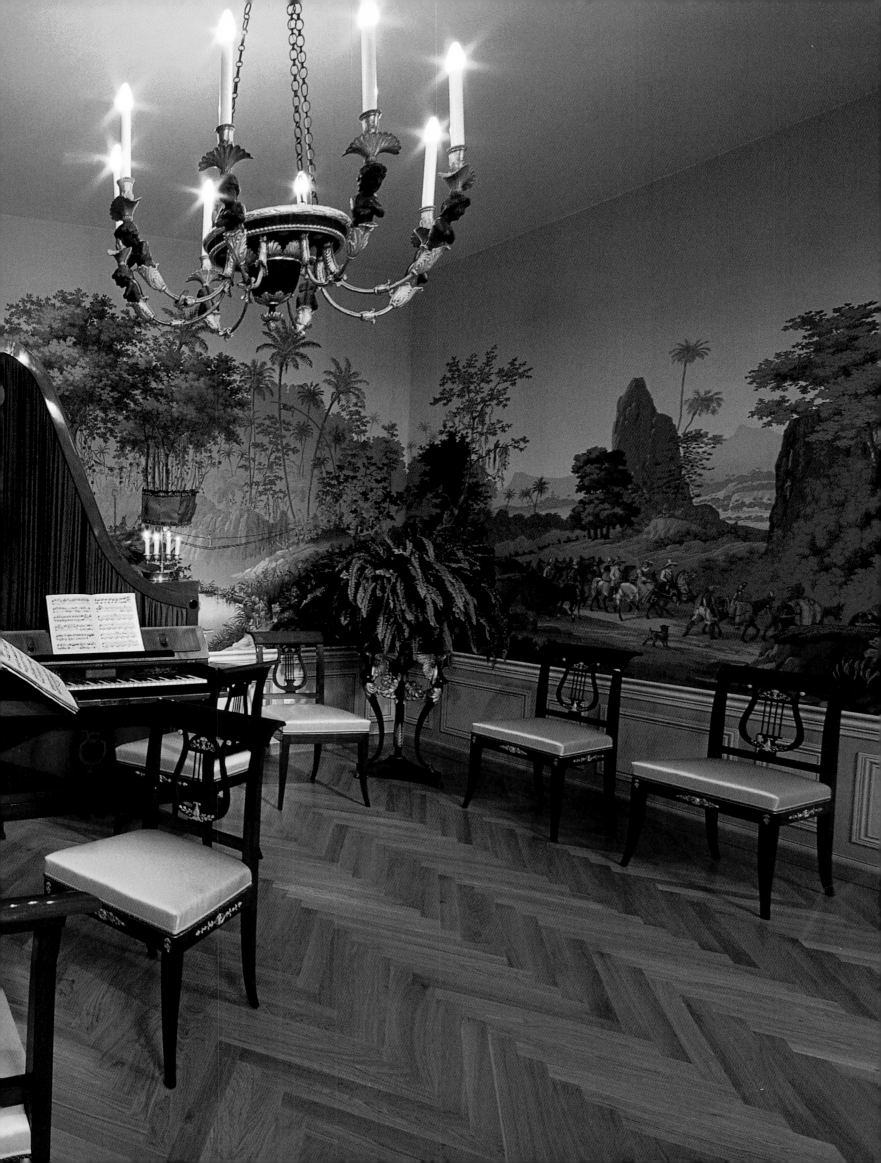

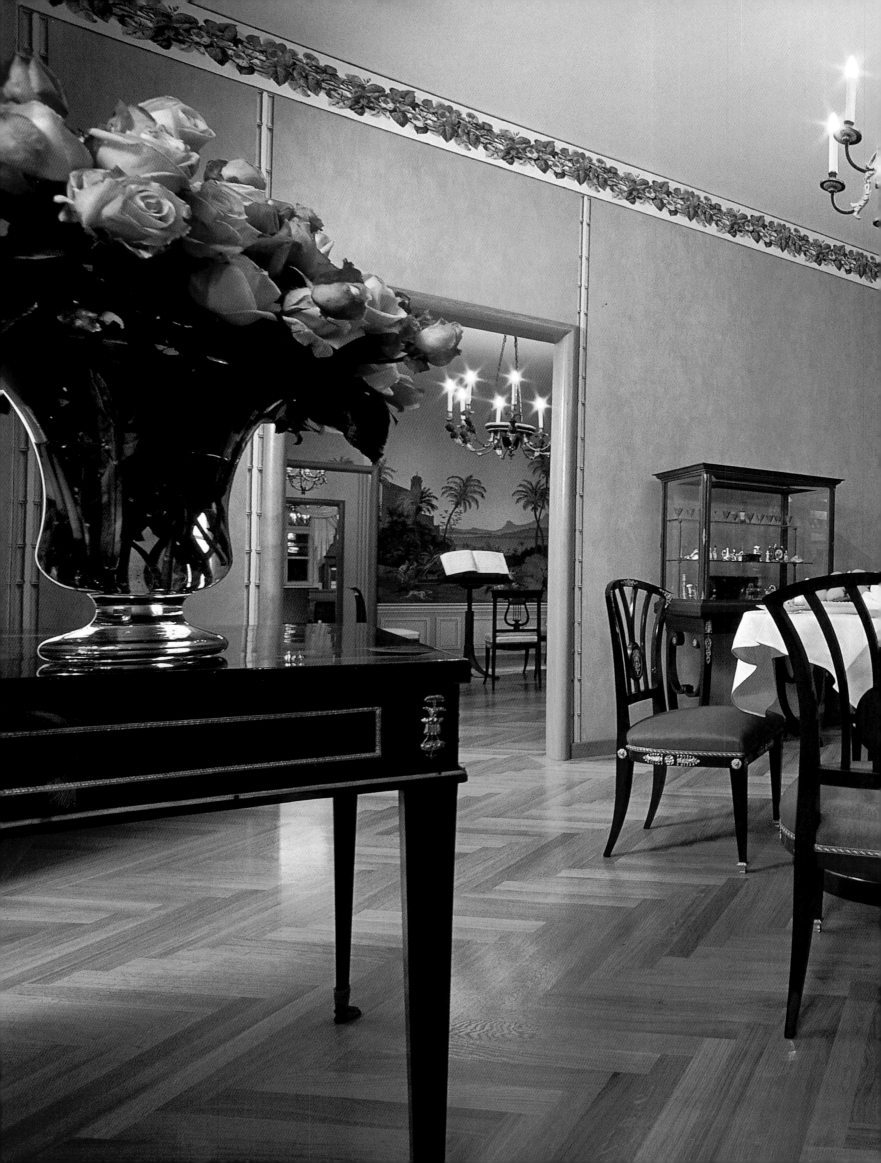

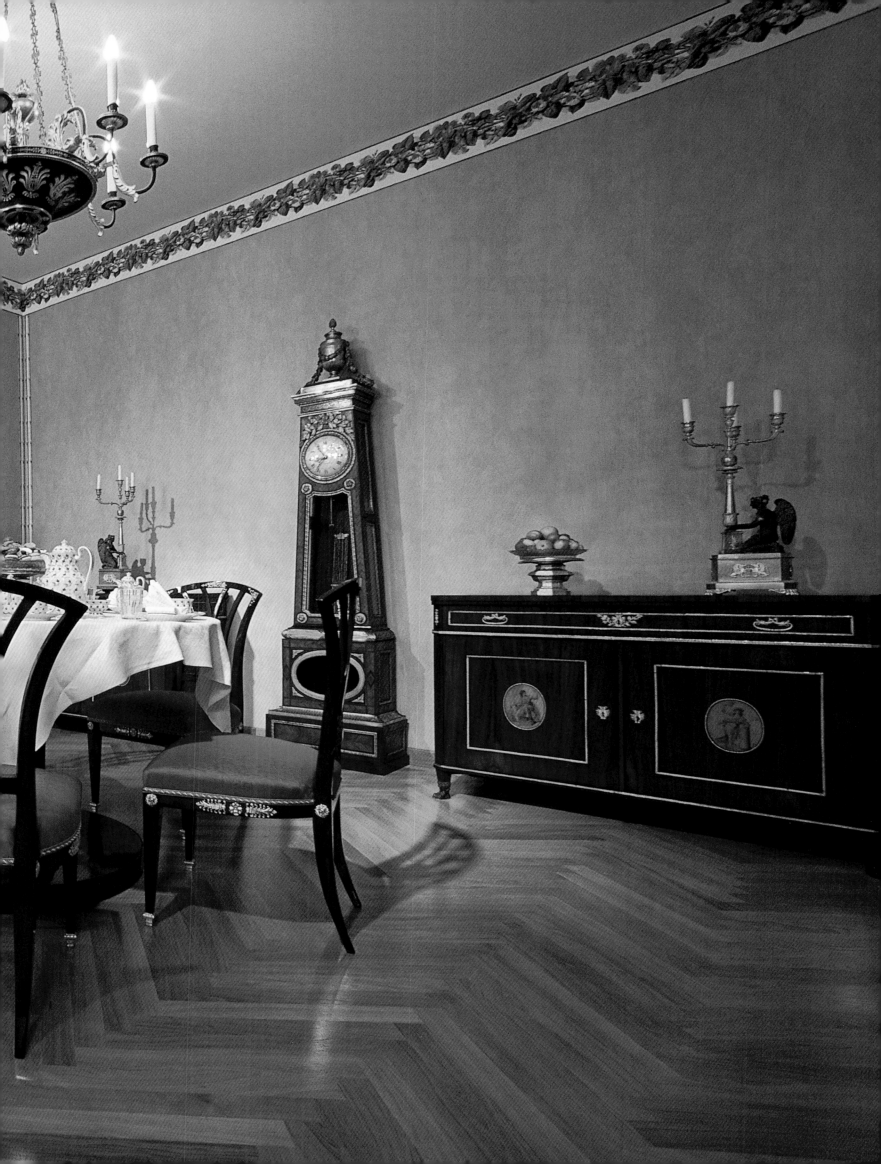

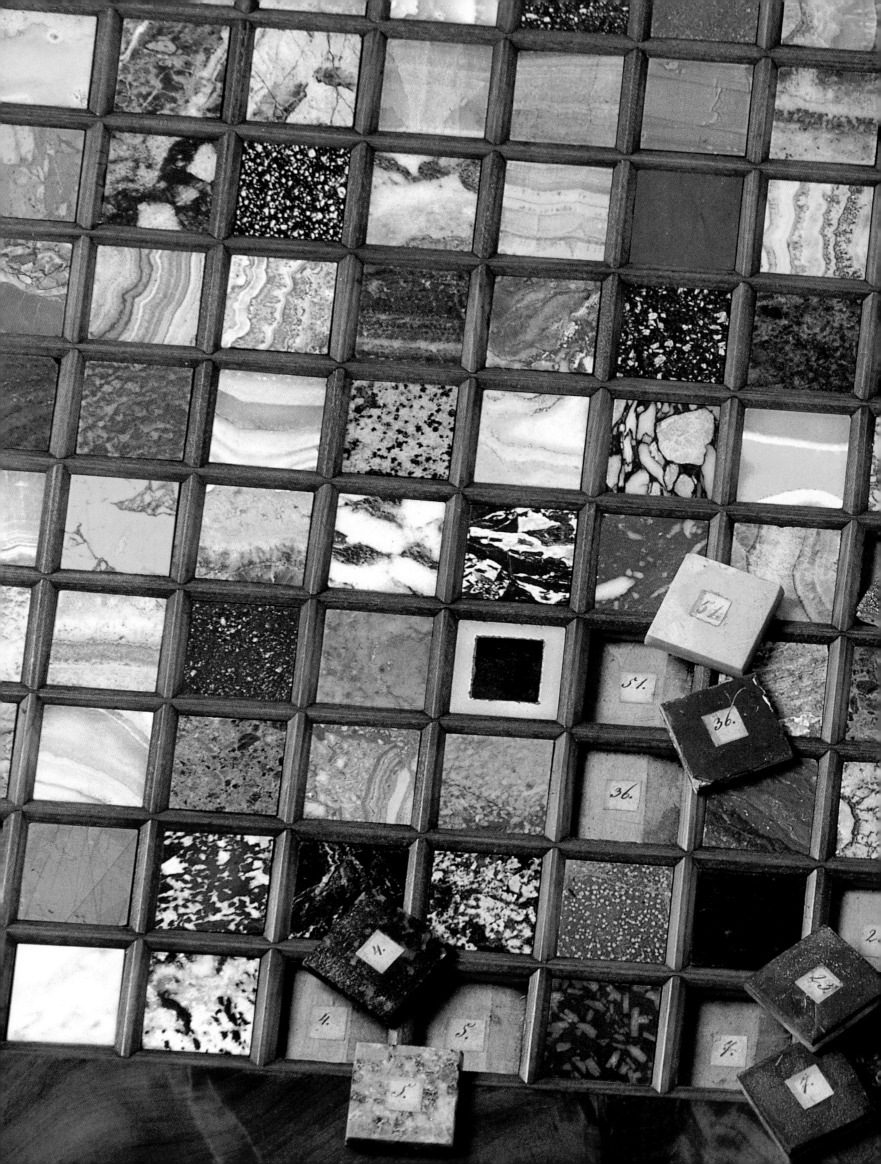

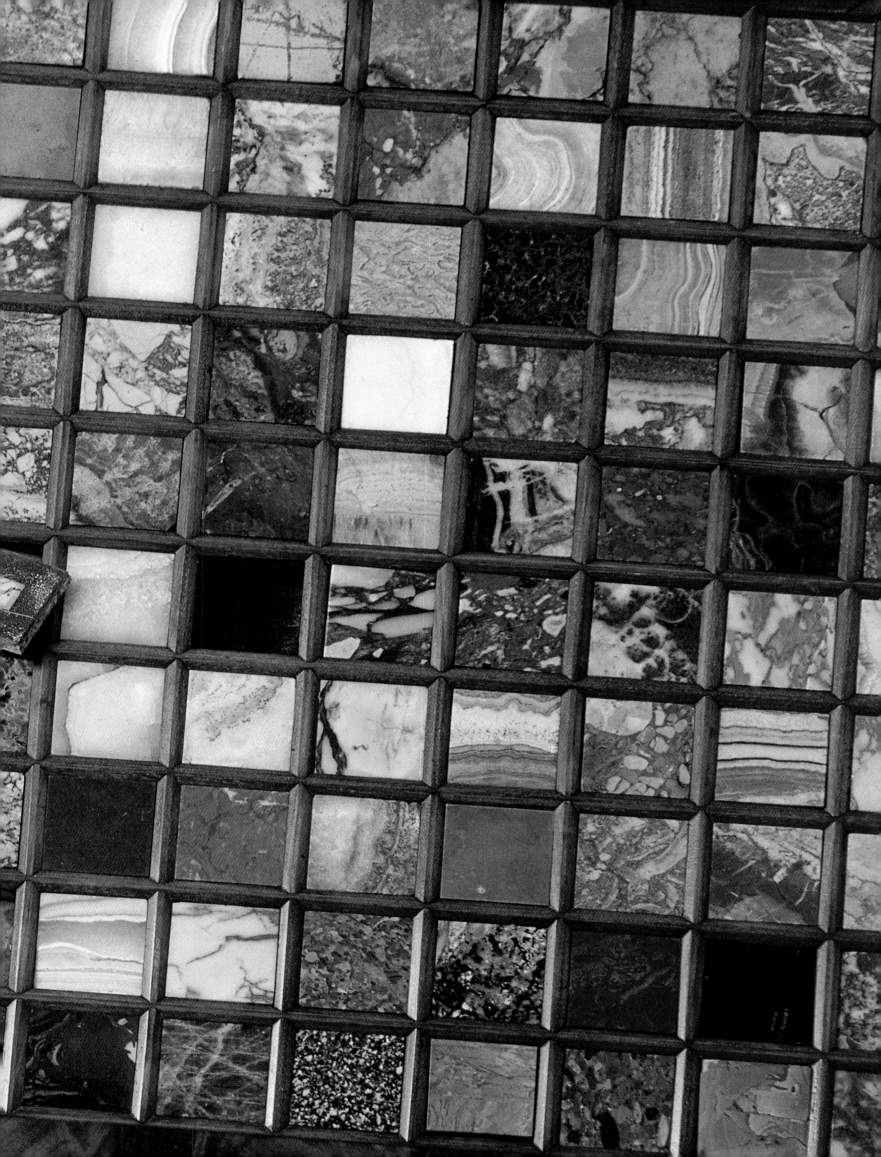

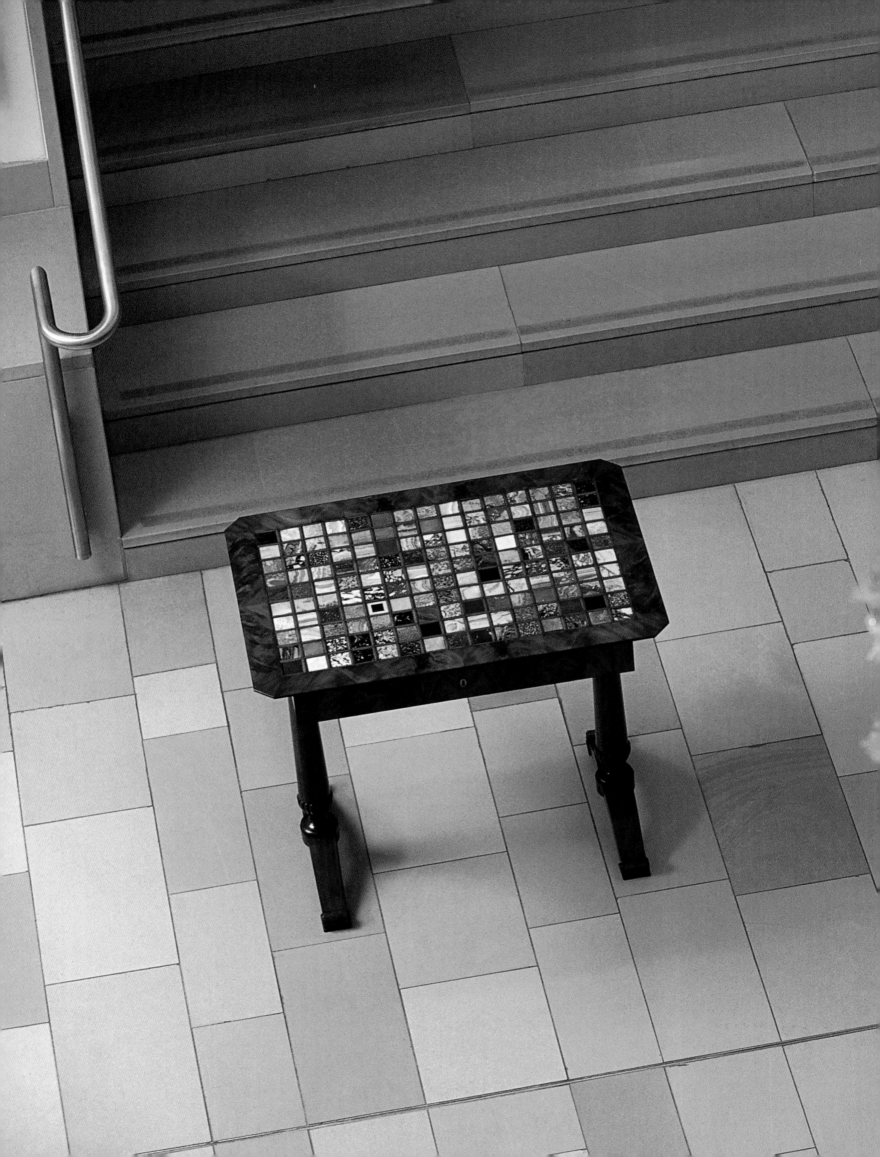

[74] OIL ON CANVAS, PRINCE CLEMENS LOTHAR WENZEL VON METTERNICH BY JOHANN ENDER, VIENNA CIRCA 1835. HOFMOBILIENDEPOT. [76] BIEDERMEIER CHANDELIER. HOFMOBILIENDEPOT, VIENNA. [77] NAÏVE EXAMPLE OF A SIDE-CHAIR, AUSTRIA CIRCA 1820. HOFMOBILIENDEPOT ATTIC, VIENNA. [78] [79] SOME OF THE THIRTY THOUSAND CHAIRS ARRANGED BY INVENTORY NUMBERS, MANY OF THEM BIEDERMEIER. HOFMOBILIENDEPOT ATTIC, VIENNA. [80] AS-SEMBLY OF CUSPIDORS, VIENNA CIRCA 1815-1830. HOFMOBILIENDEPOT MUSEUM, VIENNA. [82] [83] REPRODUCTION OF A 19TH CENTURY MACHINE USED BY CABINETMAKERS TO PLANE VENEERS. WORKSHOP OF THE HOFMOBILIEN-DEPOT, VIENNA. [84] [85] INVENTORY #66 LISTING THE CONTENTS OF THE APARTMENT OF COUNT BOMBELLES, THE INSTRUCTOR OF EMPEROR FRANZ JOSEPH I, AT THE HOFBURG PALACE, VIENNA 1826. HOFMOBILIENDEPOT. [89] [90] MODEL OF THE STUDY OF EMPEROR FRANZ II(I), VIENNA 1896. HOF-MOBILIENDEPOT MUSEUM. [91] INSTALLATION OF THE STUDY OF EMPEROR FRANZ II(I), VIENNA CIRCA 1820. HOFMOBILIENDEPOT MUSEUM. [92] BIBI AND BÜBERL, THE FAVORITE BIRDS OF EMPEROR FRANZ II(I), PRESERVED, VIENNA CIRCA 1840. HOFMOBILIENDEPOT MUSEUM. [94] OIL ON CANVAS DEPICTING EMPEROR FRANZ II(I) IN HIS STUDY, VIENNA FIRST HALF OF THE 19TH CENTURY. HOFMOBILIENDEPOT MUSEUM. [96] OIL ON CANVAS, EMPRESS MARIA LUDOVICA d'ESTE, VIENNA CIRCA 1810. HOFMOBILIENDEPOT MUSEUM. [98] GILDED FRUITWOOD FURNITURE, VIENNA CIRCA 1816. HOFMOBILIEN-DEPOT MUSEUM. [99] OIL ON CANVAS, SOPHIE OF BAVARIA BY JOSEPH STIELER, VIENNA CIRCA 1825. HOFMOBILIENDEPOT MUSEUM. [100] FURNITURE FROM THE BEDROOM OF EMPEROR FRANZ II(I) AND EMPRESS CAROLINA AUGUSTA. HOF-MOBILIENDEPOT MUSEUM, VIENNA. [101] FURNITURE FROM THE BEDROOM OF EMPEROR FRANZ II(I) AND EMPRESS MARIA LUDOVICA d'ESTE. HOFMOBILIEN-DEPOT MUSEUM, VIENNA. [104] EBONIZED PEARWOOD FURNITURE, VIENNA CIRCA 1808. HOFMOBILIENDEPOT MUSEUM. [106] MAHOGANY CHAIR, VIENNA CIRCA 1816. HOFMOBILIENDEPOT MUSEUM. [108] DOCUMENT REPRODUCTION SILK MOIRÉ. HOFMOBILIENDEPOT MUSEUM, VIENNA. [110] FURNITURE FROM THE BEDROOM OF EMPEROR FERDINAND. HOFMOBILIENDEPOT MUSEUM, VIENNA. [111] FIGURED MAPLE TABLE, VIENNA CIRCA 1811. DOCUMENT REPRODUCTION WALLPAPER BY ZUBER, RIXHEIM, FRANCE. HOFMOBILIENDEPOT MUSEUM. [112] EBONIZED PEARWOOD SEWING TABLE, VIENNA CIRCA 1810. DOCUMENT REPRODUCTION WALLPAPER. HOFMOBILIENDEPOT MUSEUM. [113] MAHOGANY AND WALNUT TILT-TOP TABLE, VIENNA CIRCA 1827. DOCUMENT REPRODUCTION WALLPAPER. HOFMOBILIENDEPOT MUSEUM. [114] BRONZE SCULPTURE "APOLLO" BY JOHANN GEORG DANNINGER, VIENNA CIRCA 1840. HOFMOBILIENDEPOT MUSEUM. [116] [118] [120] FURNITURE FROM THE APARTMENT OF EMPORER FRANZ II(I): INSTAL-LATION OF A MUSIC ROOM AND A DINING ROOM, VIENNA CIRCA 1815-1830. HOFMO-BILIENDEPOT MUSEUM. [122] [124] MAHOGANY TABLE WITH REMOVABLE NUMBERED STONE SPECIMENS, VIENNA CIRCA 1815. HOFMOBILIENDEPOT MUSEUM. [127] PATINAED BRONZE VASE CLOCK, VIENNA EARLY 19TH CENTURY. GEYMÜLLER-SCHLÖSSL.

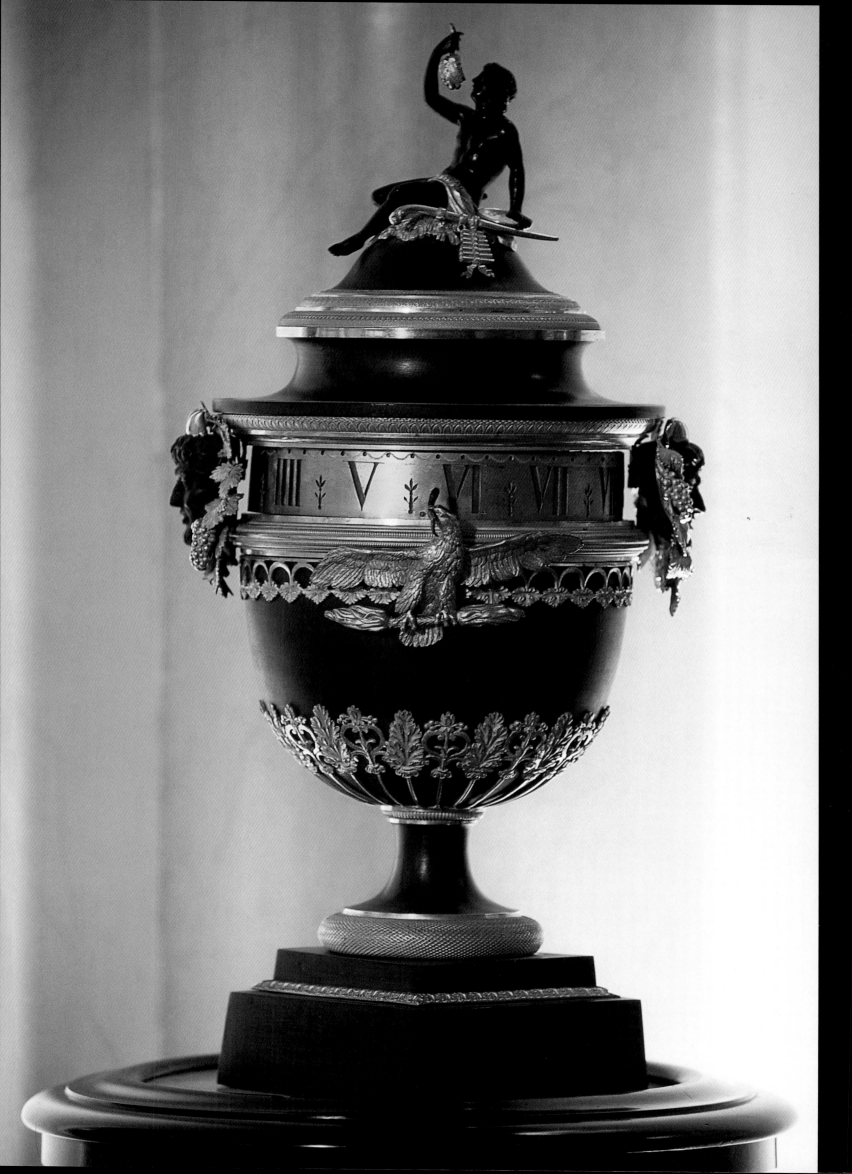

face: "There was no need for a longer bed. When people reclined, they used many pillows, which were angled at the headboard. The cushions enabled them to sleep in a more upright position, and served two purposes: sleeping did not interfere with their coiffures, and, more importantly, they thought that sleeping in a semi-upright position would help prevent tuberculosis, a disease that terrified them. This room was recreated to give people an idea of how one may have lived during the Biedermeier period. You, as a designer, know that the decision made about a room is a commitment. The room installations that we have here are based on the information we have been able to gather from room paintings, called *interieurs,* executed during the time. They are mostly watercolors, which give us not only perspective views of the rooms but detailed information as well. They are so accurate that we have been able to reconstruct room concepts of the period. The arrangements for Biedermeier rooms were based on harmony and repetition. Symmetry was foremost in the balance of rooms, which explains the many pairs of matching chests, vitrines, cabinets, and smaller tables. This quest for symmetry went further, too. It determined the place-ment of matched veneers, corresponding fabrics, and complementary decoration of the walls. Today these combinations would be considered disharmonious because of the combination of very strong colors. Nevertheless, it was so clear a concept that if we have only one or two pieces of furniture, we can get a pretty good idea of how a room came together." AS WE TALK AND WALK deeper into the realm of Vienna's Biedermeier, we pass a huge painting of Prince Metternich by Johann Ender, done in 1835. "He looks quite pleased with himself, doesn't he, Dr. Parenzan?" I ask. Dr. Parenzan nods: "Yes, yes, he definitely looks like a man who enjoyed his share of

power—and certainly lived and loved position and intrigue." The artist depicts the diplomatic mastermind in all his glory, adorned with the Order of the Golden Fleece. "There is another historical footnote that is not without irony," Dr. Parenzan continues. "This highest order of decoration awarded by the Habsburgs can still be bestowed today, by the hands of Otto von Habsburg, because it is the private order of the Habsburg family. But I would like to return to what I was saying before. In order to help you understand how room designs may have evolved, I must give you more background information regarding the emperor's thinking. Franz II(I) once said, 'Preserve unity in the family and regard it as one of the highest goods.' The emperor's reference to the family was to some extent dictated by dynastic consider-ations. It also echoed the spirit of the age, and everything the romantic mind associated and continues to associate with the family. A WELL-RUN HOUSEHOLD, it was thought, was the framework within which it was possible to produce so positive a moral effect upon a person—by the exercise of the bourgeois virtues of thrift, diligence, and orderliness—that he would develop sufficient resources to be equipped in the struggle for existence. The effect of this attitude was nowhere so clear as in the furnishing of the domestic environment. DURING THE PERIODS OF ROCOCO AND CLASSICISM, a gradual subdivision of living areas took place. There was a move away from the all-purpose room. Living, cooking, eating, and sleeping were each relegated to separate rooms. Among the upper classes, this development corresponded to the distinction now drawn between the reception rooms and living quarters. THE AUSTRIAN IMPERIAL FAMILY provided a perfect example of this movement away from a public style of living toward a more private one. The

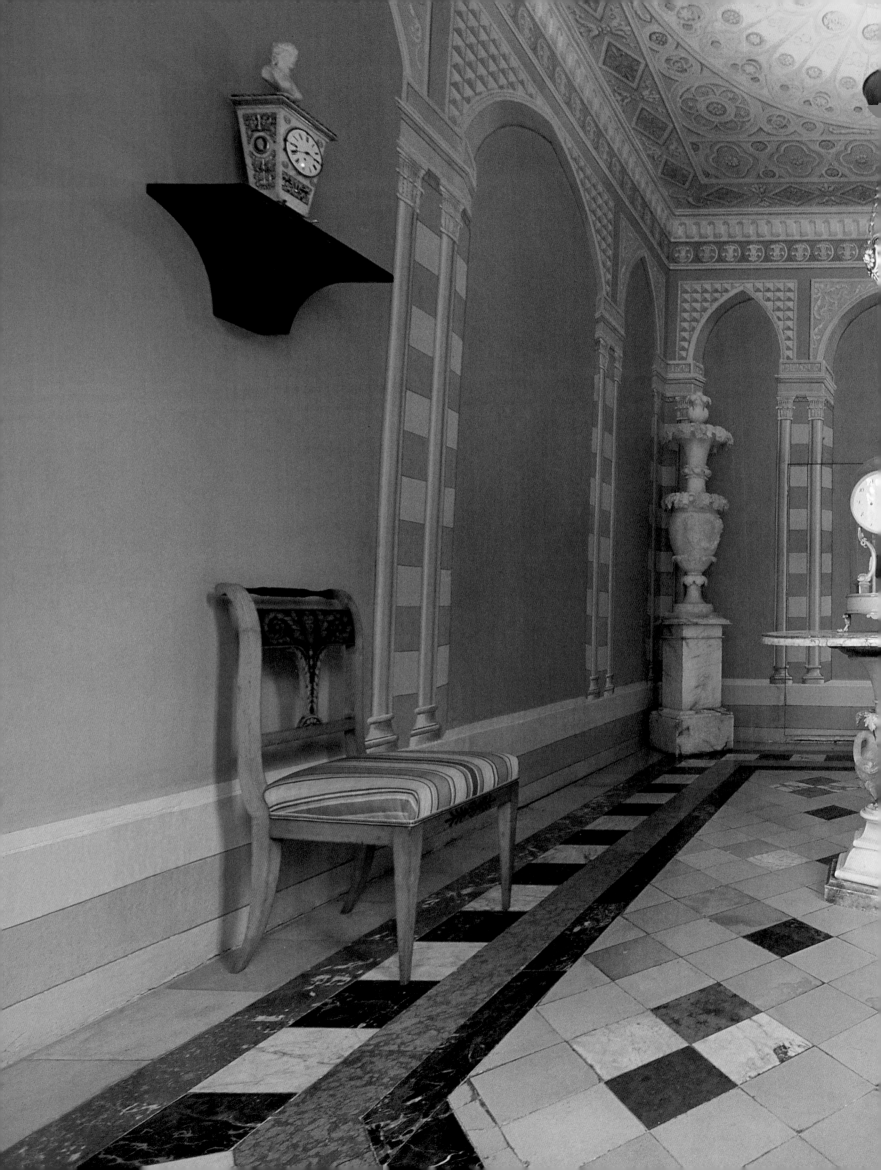

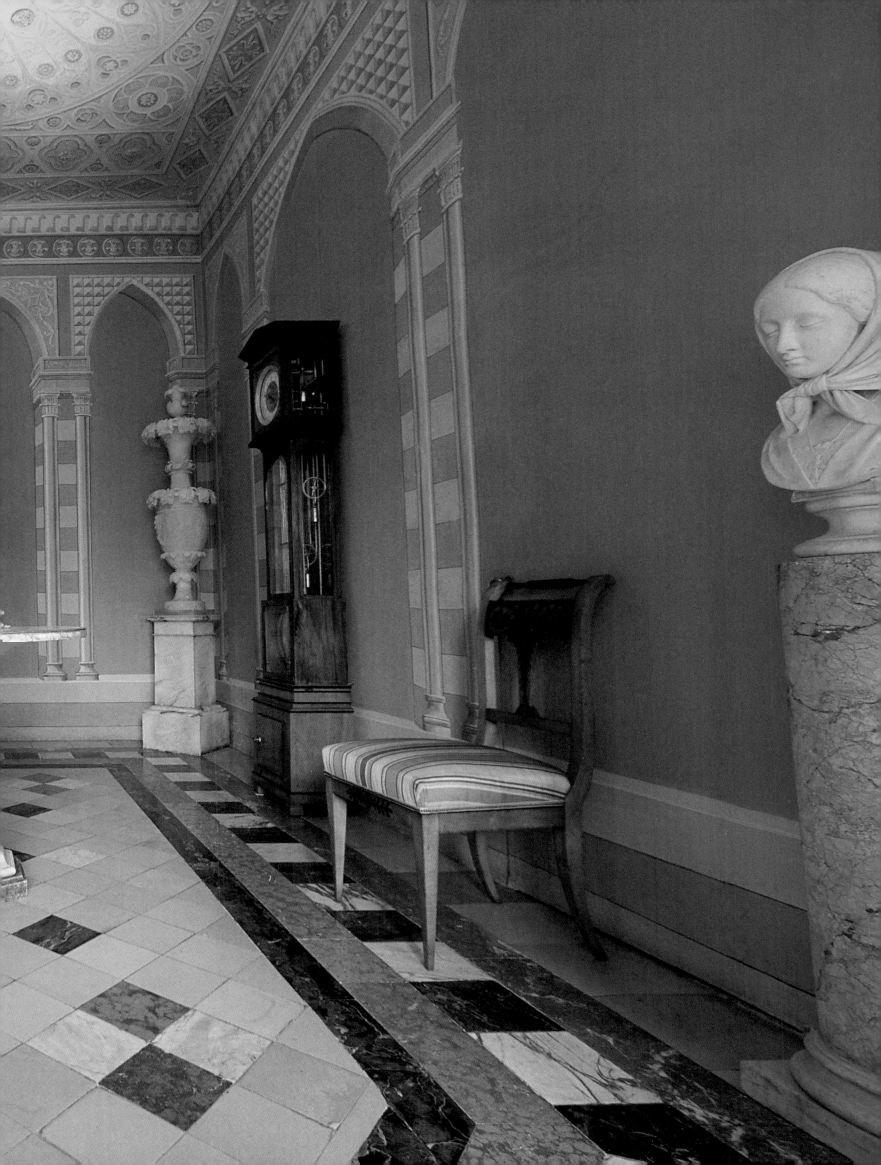

differentiation between the various spheres of domestic activity inevitably led to the invention of individual types of rooms: dining room, music room, billiards room, library, study, writing room, bedroom, reception room, drawing room, boudoir, salon, and so on. In middle-class homes, where separate rooms were usually not present in such profusion, the idea of having different types of rooms was maintained in the so-called *Wohninsel*, or 'living island.' This made it possible to perform a number of activities within one room. Writing, sewing, music-making were characterized by different furniture, and quite deliberately separated from the others. THE GRADUAL EVOLUTION of domesticity, and the growing number of rooms with their own special significance meant that appropriate pieces of furniture also needed to be provided. The emancipated bourgeoisie, not content with simply aping the earlier aristocratic culture, grasped these opportunities with an extraordinary degree of creative enthusiasm, and began to give shape to an entirely personal style. This was the beginning of what we now refer to as interior design and decoration." AFTER MILES AND HOURS of unsurpassed beauty, we reach the heart of the Hofmobiliendepot: the Study of Emperor Franz II(I). The furniture for his daily use was functional and almost without decoration. Only the writing table and high desk of walnut are embellished with a few gilt bronze mounts. Two tables, six chairs with canework, an armchair, and a pivoting oak riding chair with leather upholstery complement thirteen cabinets and two spittoons. I take notice of the unusual-sized filing cabinets with lacquerwork and embroidery, and I imagine what kinds of wonderful papers and documents must have rested within.

[130] MOSQUE INSPIRED BALCONY ROOM WITH SPECIMEN MARBLE FLOOR, PAINTED WALL DECORATIONS, VIENNA FIRST HALF OF THE 19TH CENTURY. GEYMÜLLER-SCHLÖSSL.

Everything is elegant yet simple. There is

so much thought in the craftsmanship, nothing appears to be forgotten, no details left unattended to. Even the waste-paper basket constructed of wicker is carefully draped with swags of fabric. Only the large number of personal items originally kept here were truly valuable, or at least unique, like the many pieces of handiwork made by the emperor's children and his brothers and sisters. In this ambiance, Emperor Franz spent most of his day writing. His favorite birds, Bibi and Büberl, small yellow canaries, offered him some distraction. Büberl lived to be fourteen years old, and died on 4 April 1837—two years, one month, and two days after his master. Bibi followed him seven months later. These favorite birds have been preserved, and sit together today in their original cage upon a bronze pedestal. The inscription reads, "Büberl and Bibi, fortunate birds, with your songs you amused the best of all emperors. His friendly eyes smiled at you. Sometimes you had the privilege of resting on his sacred head." I LEAVE AN EMPEROR, his very special birds, Dr. Peter Parenzan, and his world of Biedermeier. Outside it's a dark and cold winter's night. I eat, drink, and sleep Biedermeier. THE NEXT MORNING, 15 February, I breakfast at the Café Bräunerhof, in the shadow of the Hofburg. I take notes: The Biedermeier lifestyle was, in part, the bourgeois reaction to the Metternich system. Because of this, it is an important part of Vienna's history. It is unfortunate that not even one example of a Biedermeier house remains open to the public today. However, there is the Geymüller-Schlössl, an unexpected time capsule. Its history is marked by the illustrious careers of the brothers Johann Heinrich and Johann Jakob Geymüller, successful Swiss bankers. To be successful at this time, it was not unhelpful to please the House of Habsburg. Between 1805 and 1809 the empire had to pay enormous

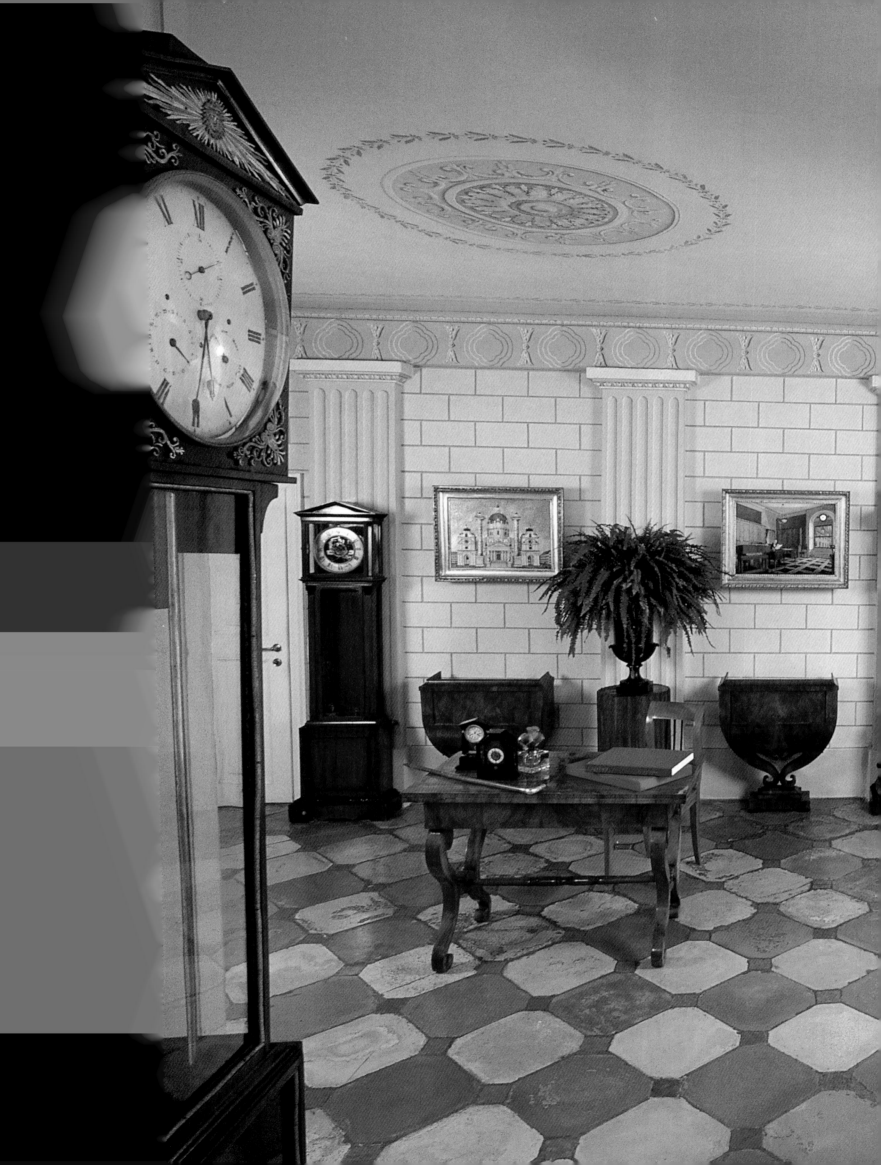

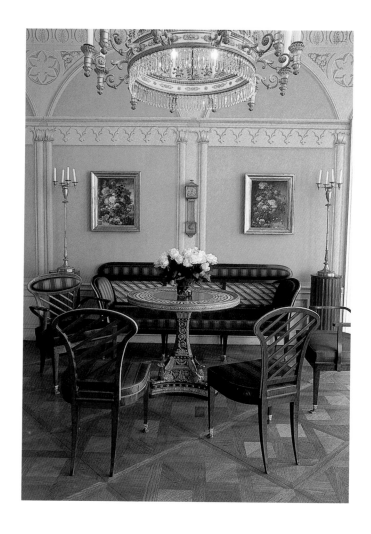

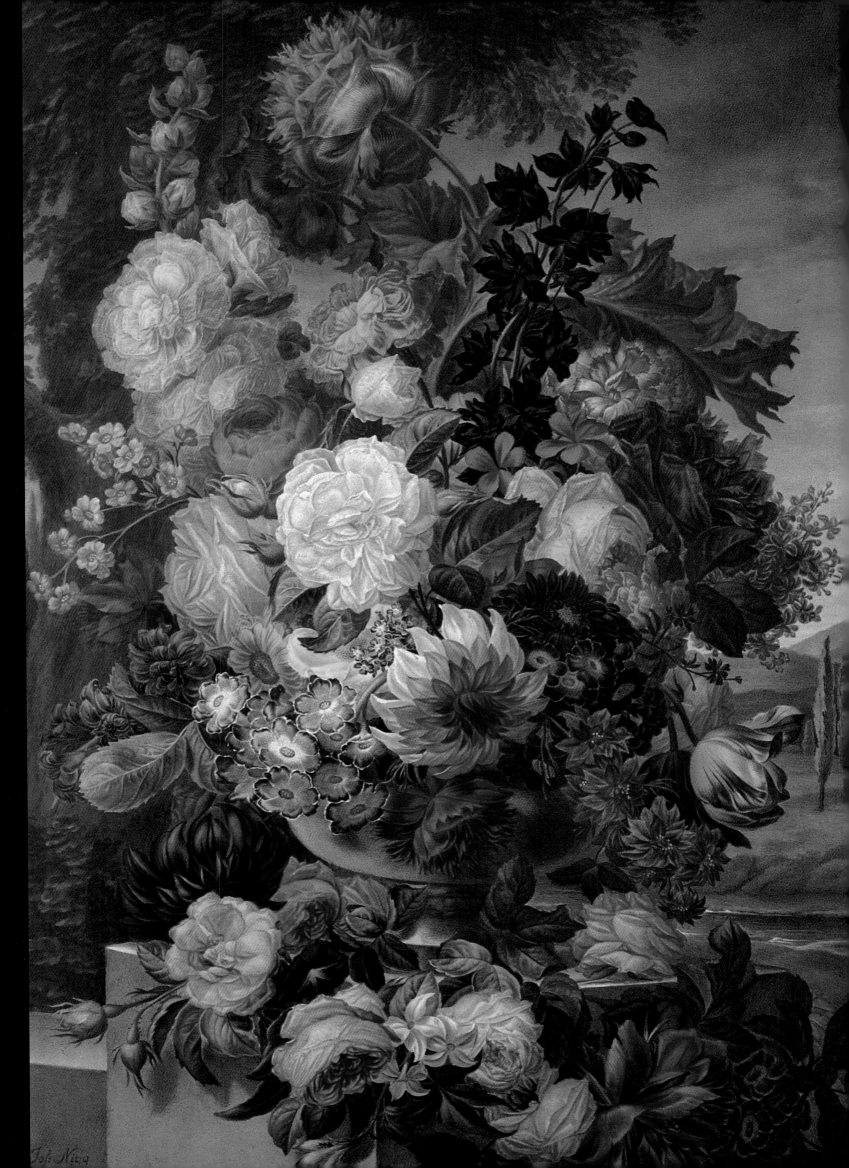

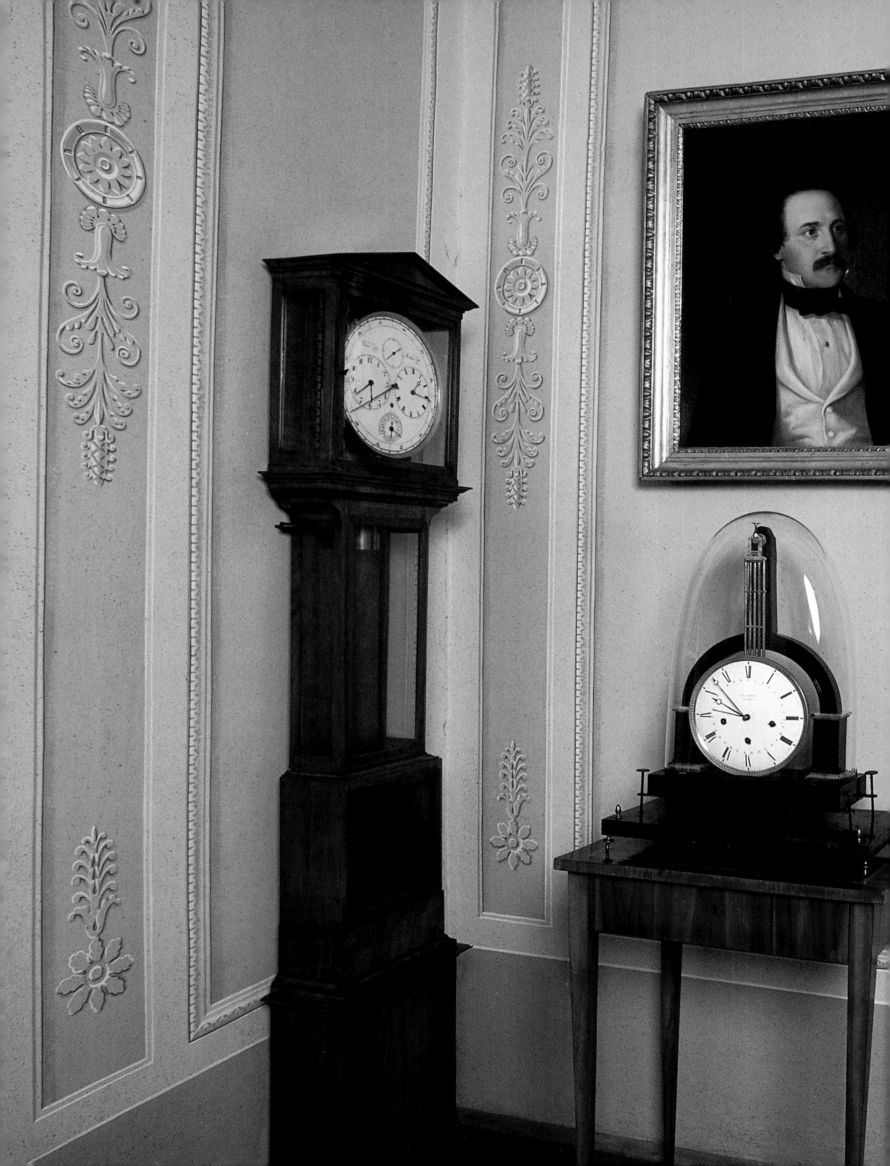

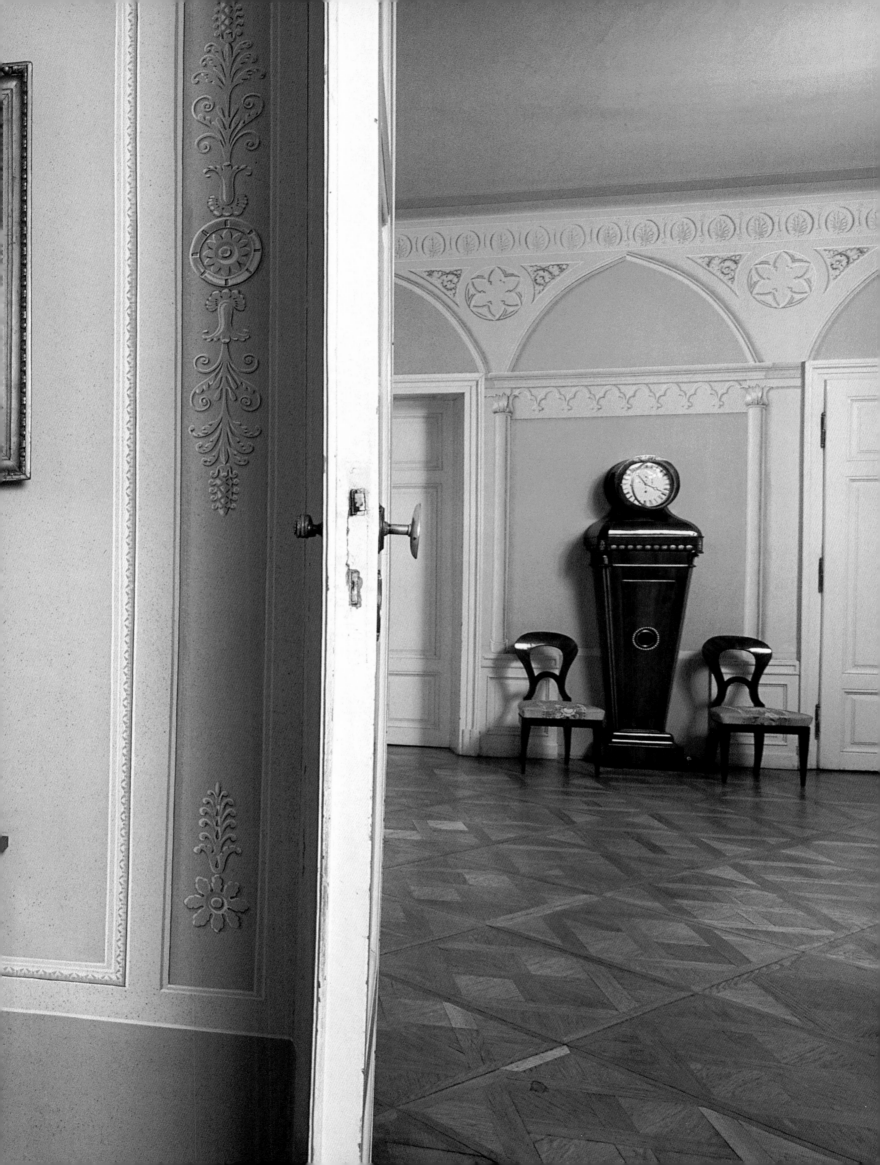

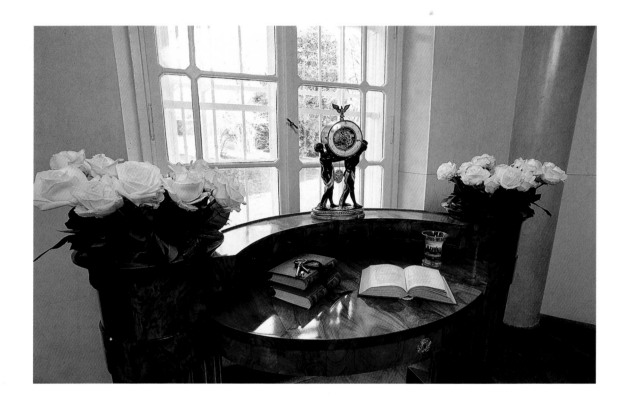

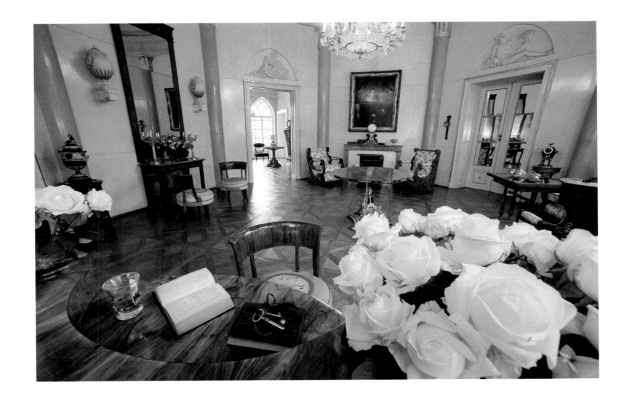

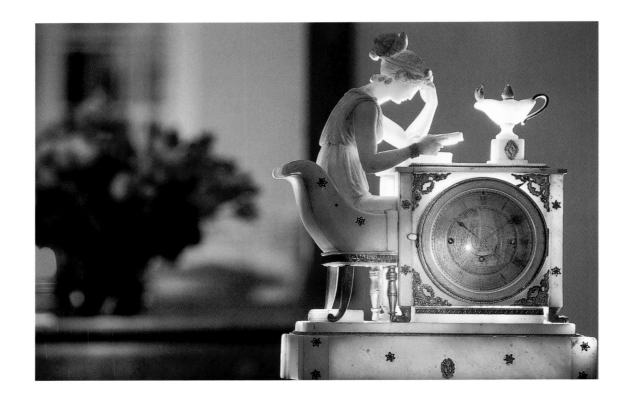

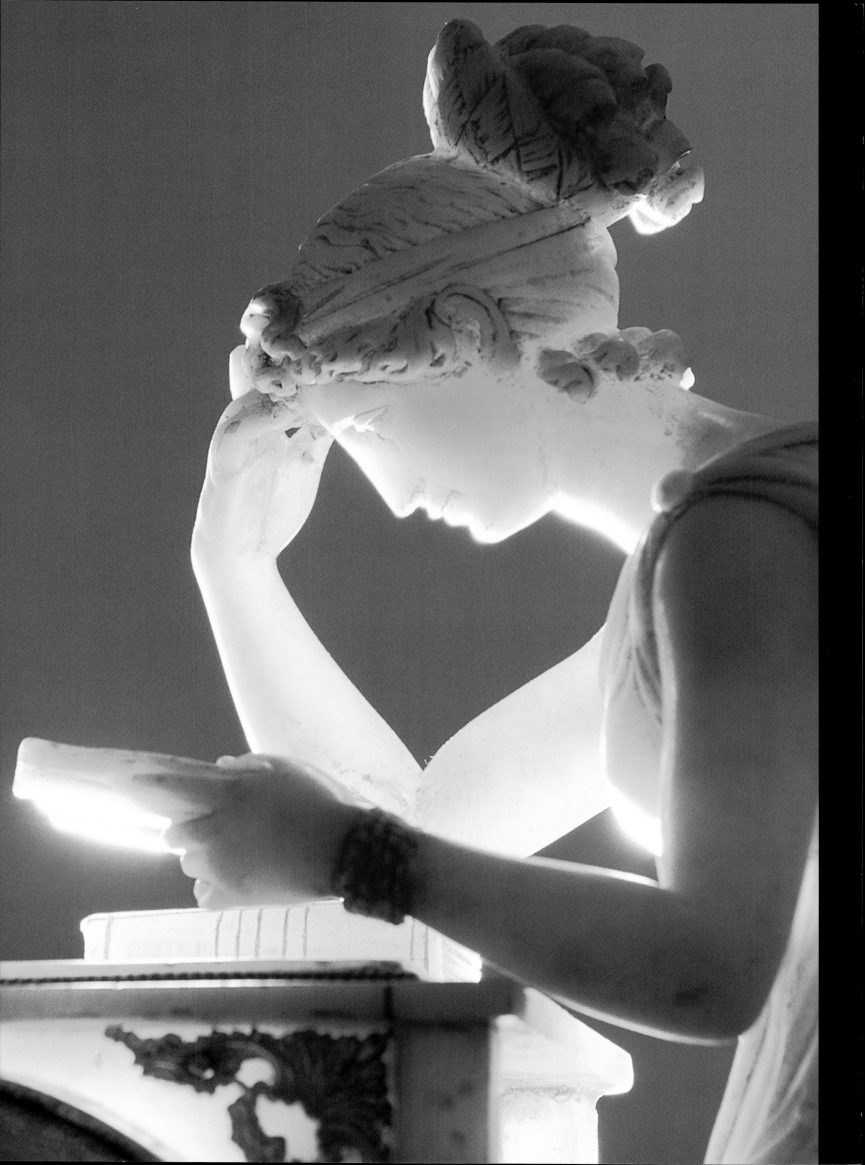

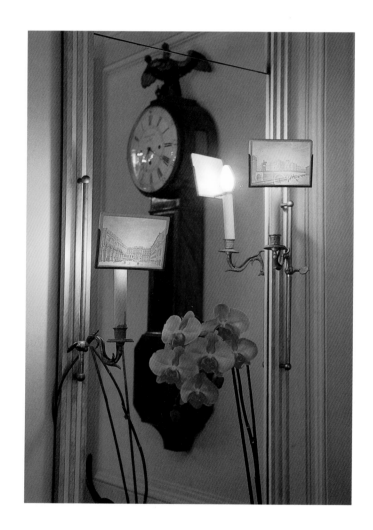

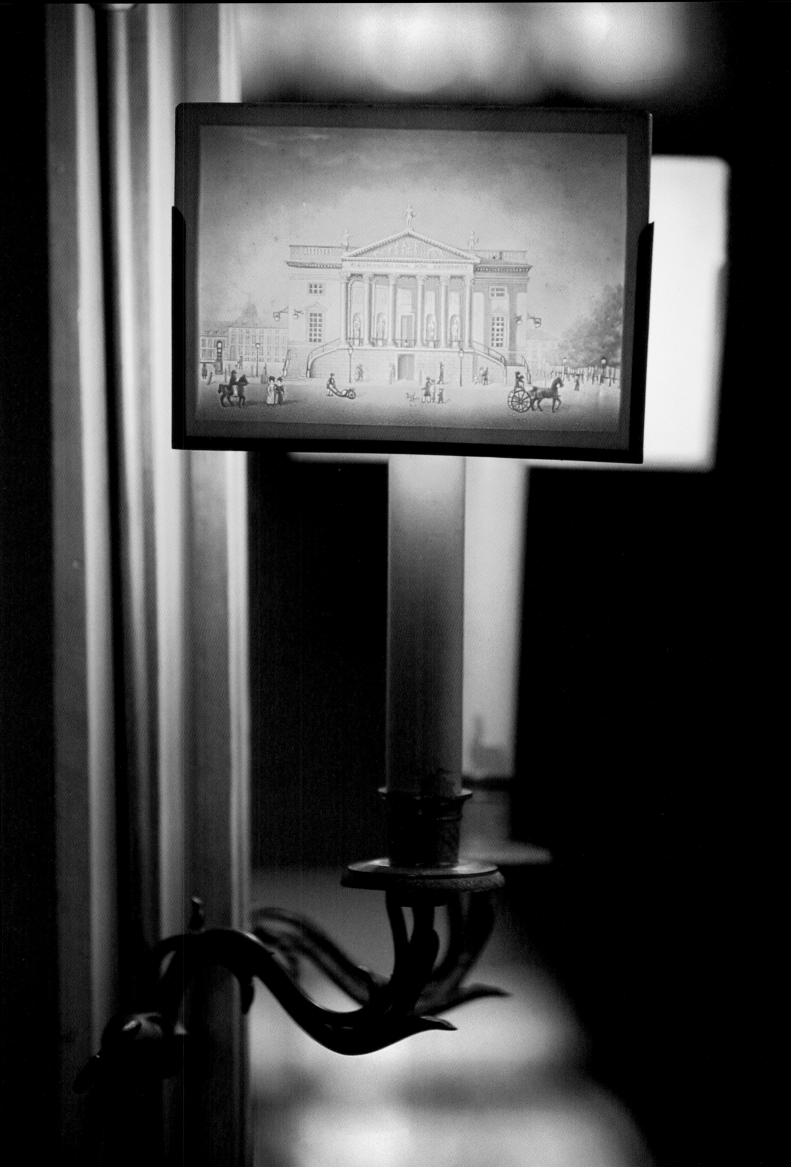

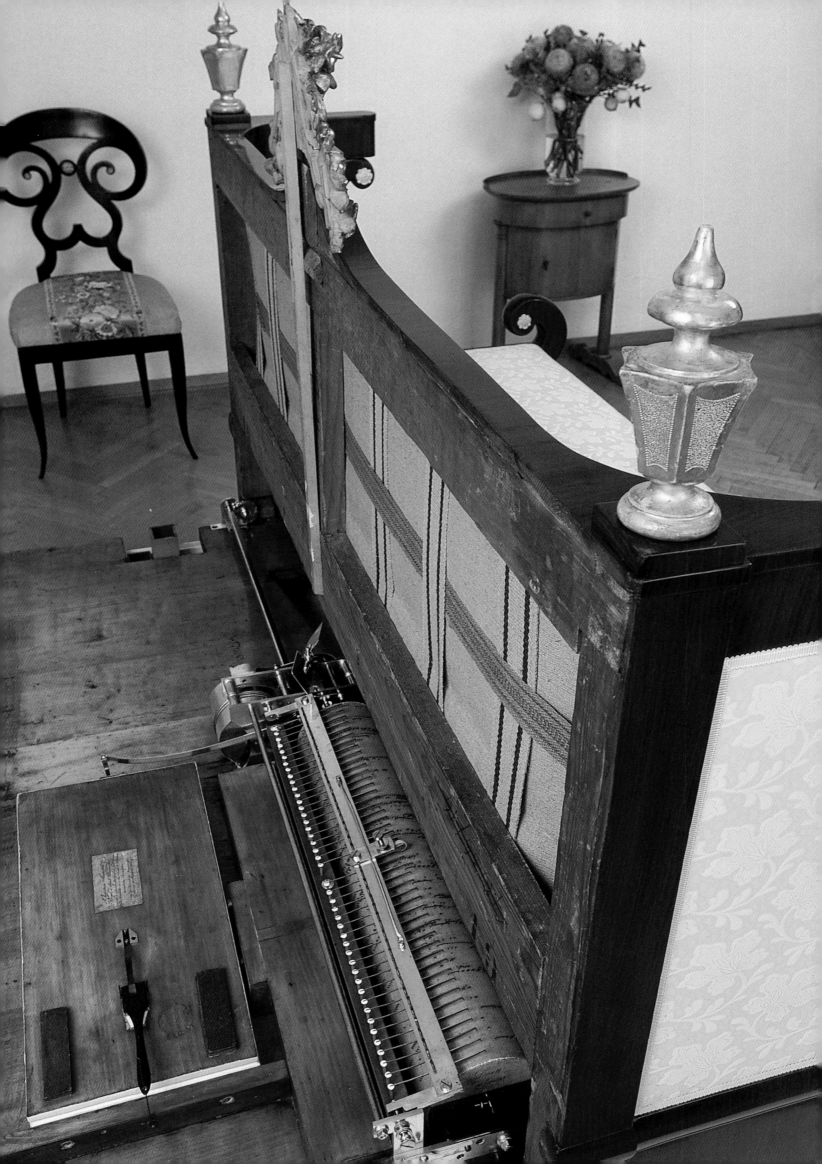

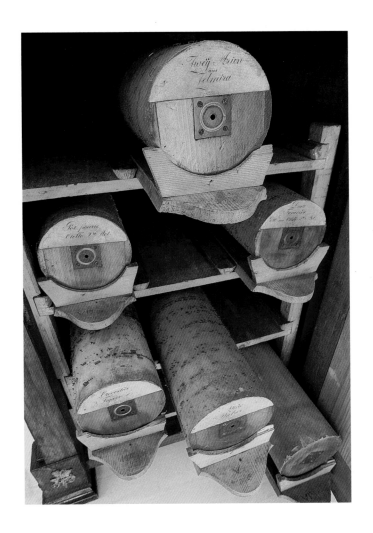

Ouvertür
Figaro

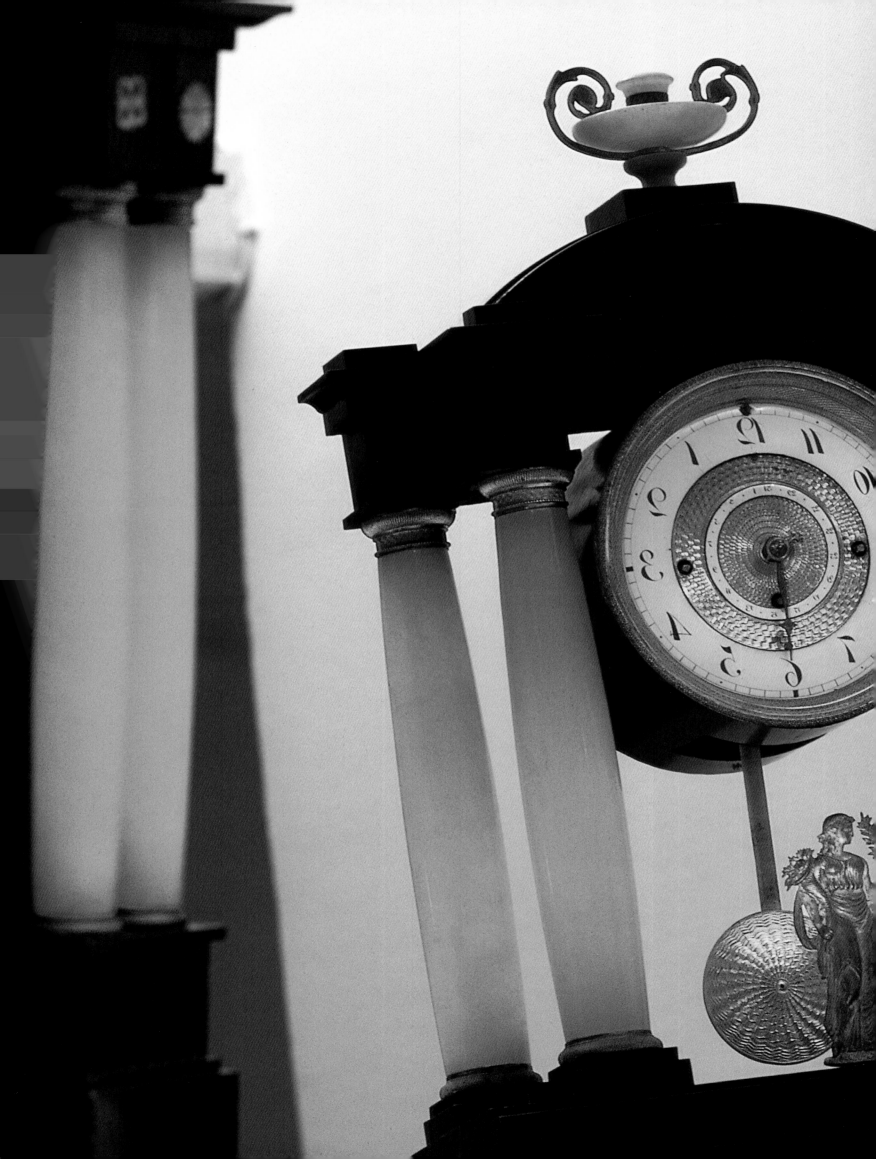

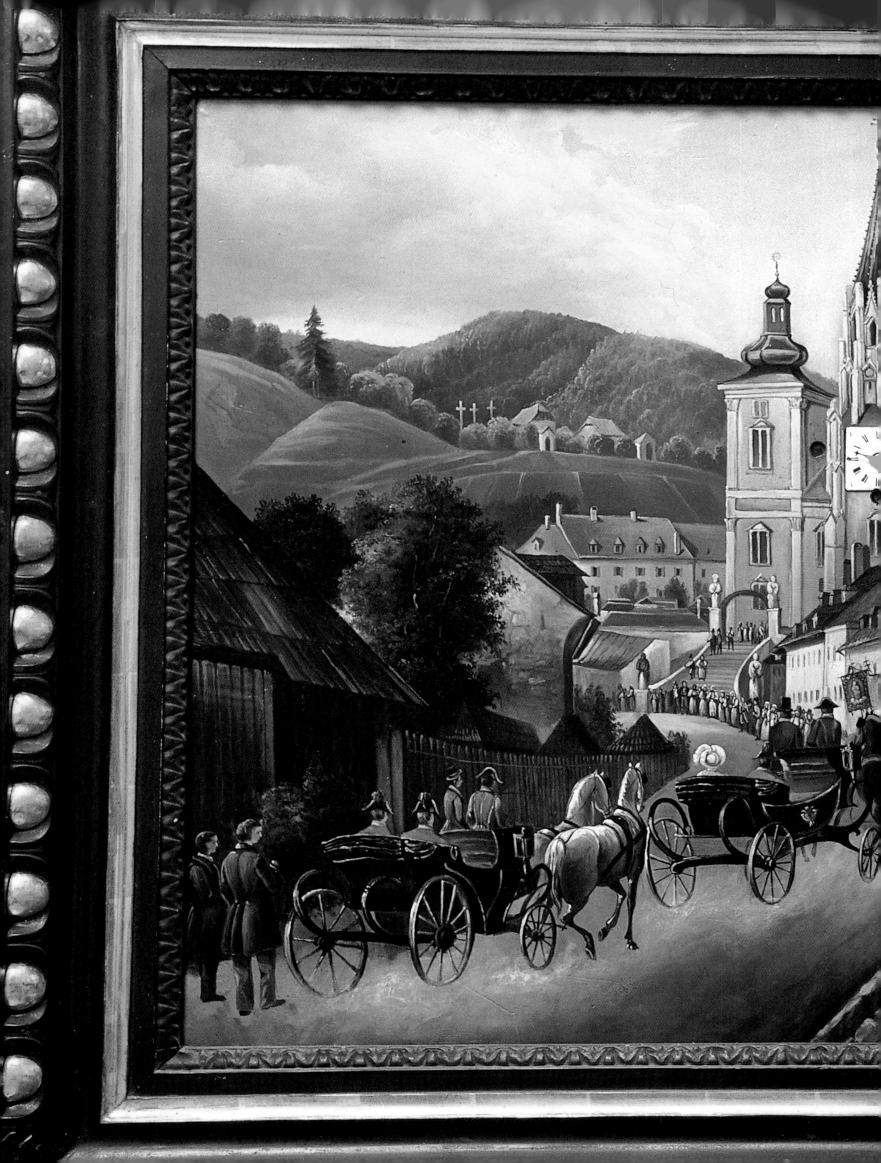

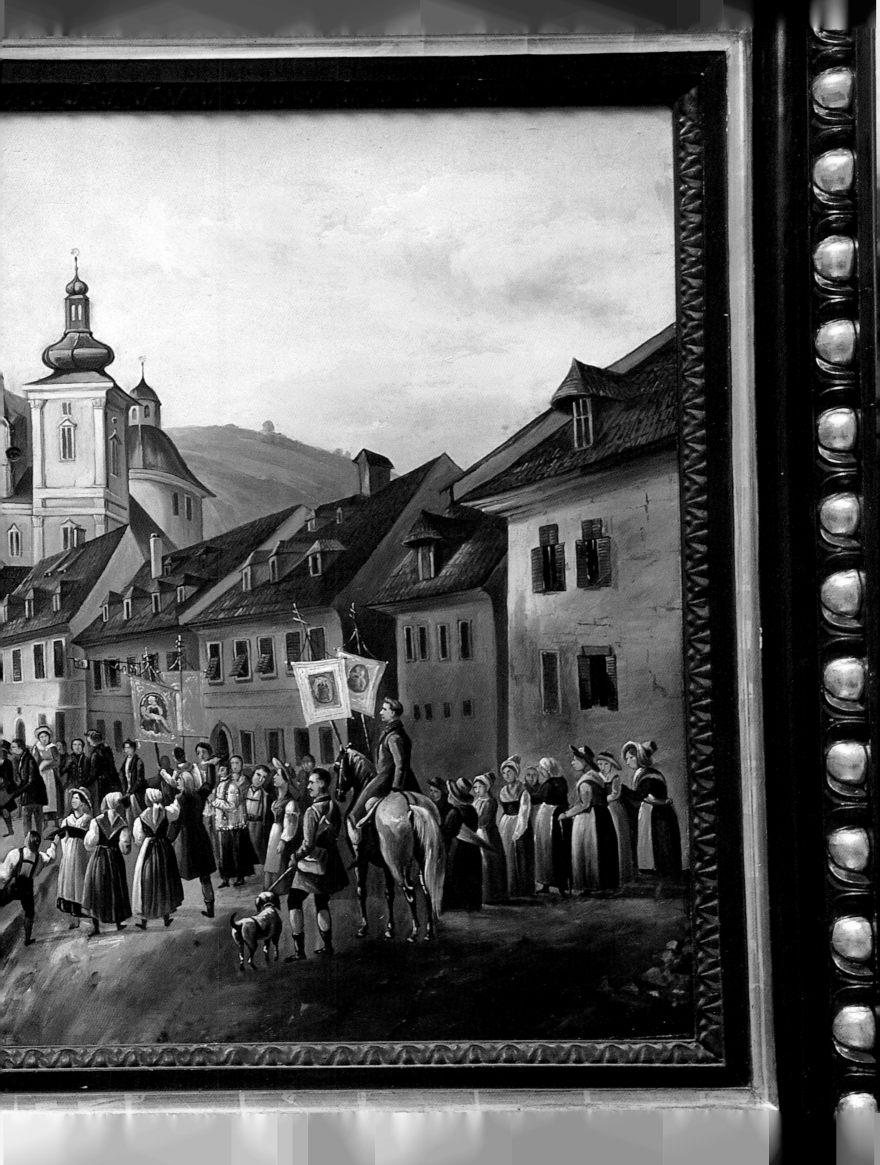

sums to the victorious French as mandatory compensation resulting from the Napoleonic Wars. The Geymüllers played a key role in loaning the moneys needed, and the role they played was generous. This led to the award of aristocratic titles. As barons, they became part of the emerging elite, the newly respected *Geldadel*, or 'aristocracy of wealth.' They owned several mansions: a palais in the city and a large estate in Pötzleinsdorf. Finally Johann Jakob built the Geymüller-Schlössl, in the romantic style popular at the time, as a summer residence near the Vienna Woods. The Geymüller-Schlössl is typical of 18th-century castles. The architect's drawing shows a Baroque design with a floor plan oriented toward the gardens. The two-story castle boasts four columns, their capitals adorned with palmettes. Egyptian and Gothic elements abound. An adjacent mosque, which previously led to a minaret, is situated alongside the castle's delicate gardens. UNTIL 1842, the castle was owned by the Geymüllers. It changed hands several times, until in 1938 the Deutsche Reichsbank bought it, with the intention to demolish it and build apartment buildings on the grounds. Just in time it was saved through the efforts of a concerned public, who got it declared a historic monument. Their protests were among the first in the history of historic preservation. After World War II, the castle was acquired by Franz Sobek, the director of the Austrian State Printing Office. An extensive redecoration and modernization took place. With the addition of fireplaces, the castle was converted to a year-round residence. Sobek was an affluent businessman with a love of collecting. Almost one hundred years after the Biedermeier era, his sensibilities

[152] EBONIZED PEARWOOD MANTLE CLOCK, ANONYMOUS, VIENNA CIRCA 1840. GEYMÜLLER-SCHLÖSSL. [154] PICTURE CLOCK BY DUSCHEK, VIENNA 1850. GEYMÜLLER-SCHLÖSSL.

and discerning eye led to an assembly of period furniture and objects, creating so

authentic an atmosphere that one can truly imagine the lifestyle of the time. In 1965, Franz Sobek donated the Geymüller-Schlössl to the Museum for the Applied Arts. The donation included not only the building but also the furniture and an outstanding collection of one hundred and sixty-six clocks, dating from 1769 to 1850. AFTER MY THIRD GROSSER BRAUNER, my favorite Viennese coffee, I look at my watch and notice it is time to meet Dr. Christian Witt-Döring, Curator of Furniture and Woodwork at the Museum for Applied Arts in Vienna. Upon entering the castle, I realize this home is filled with timekeepers: long-case clocks, wall clocks, mantel clocks, cartel clocks, bracket clocks, night clocks, organ clocks, vase clocks, altar clocks, even clocks in the shape of hanging lamps; Zapplers and double Zapplers, calendar clocks, free-swinging clocks, mysterieuse clocks, which are lit at night, and finally painting clocks. True collectors seem to live in the spirit of passion. Each one of these clocks is truly unique yet together they can be almost too dominant for one house. WITH THIS IN MIND, I ask Dr. Witt-Döring, "How did you turn this house into a museum?" "Well, this was a difficult task," he responds. "It is so much my baby. I completely redid the interior. When I took over this project, the last redecoration had been done in the 1950s. For example, we brought out the original wall decorations by removing layer upon layer of new, fake, Biedermeier. Whenever I had proof, as with the walls, I could bring the original back. As you might imagine, this was a very, very slow process. But I loved doing it. The problem was not so much what it looked like originally, but where do you get your materials? When I was looking for cotton trim for one of the bed coverings, there was nothing close to the original available. It just did not exist. YOU MUST KNOW, we do not have any information that tells us

how the Geymüller-Schlössl was furnished during Biedermeier—we don't even know the function of the rooms. I did not even attempt to get close to the original because it was an impossibility. To give you an idea of what I mean, I will show you an example in what is now the bedroom. It was obvious to me that a bed would fit lengthwise within the niche, but I was unable to find one that was the right size. In our storage facilities, I came across a very nice piece, which I was able to use by placing the headboard in a perpendicular position. I wanted to show it because it is such a fine example from the period. What I have here is kind of a strange situation. It is neither fish nor fowl. The furniture does not belong to this house. Therefore it is not authentic. But it has become a combination: a museum display of period pieces within a living situation. Strangely enough, it works." "Is this because the forms found in Biedermeier integrate so well?" I ask. "Of course, we know this since Mies van der Rohe used Biedermeier in the 1920s. At the Geymüller-Schlössl we needed to make decisions about what we were interested in focusing on. What we concentrated on here is upholstery, to show people how it was done at the time. Let me give you another example: whether or not an arm of a chair was draped, depended on budget. If one could afford more fabric, they draped the arms as in previous periods to distinguish rank. At this time, the social status was established not only by birth but also by how much money one had. What is interesting in the use of Biedermeier textiles is that the upholstery is an integral part of the design of the chair. This is something that has become important again in the last fifteen years." "THERE IS ONE QUESTION I WANT TO ASK all of the experts, Dr. Witt-Döring. What is your

[158] EXAMPLE OF A MACHINE-MADE CARPET, MANUFAC-TURED BY THE ROYAL IMPERIAL LINZ WOOLEN FABRICS AND CARPET FACTORY, LINZ FIRST HALF OF THE 19TH CENTURY. HOFMOBILIENDEPOT MUSEUM, VIENNA.

opinion of Empire furniture and its place in the Biedermeier period?" "We must be very careful with these terminologies," answers Dr. Witt-Döring, "because one thing is quite clear: people want security, yes? It is part of human nature to look for labels. We create a box, then we fill this box, only to find that we have problems. This is because it never belonged in the box to begin with, and does not belong in any box at all. We only see what we want to see. We have learned that Empire came first, followed by Biedermeier, with all its simplicity. Then came the eclectic period, and so on. Now, during the post-modern period we have learned to accept different possibilities of equal rank. So we see now, for the first time, that Empire and Biedermeier were happening simultaneously. What this really meant in both styles is 'I dare to express myself.' This was something very new. Of course, it had nothing whatsoever to do with good taste. What I find fascinating is this: one thing has an established value, yet in a different context its value is changed. That has been my approach with respect to the restoration of this house. It has not been about the restoration, but about the process of finding out and discovering exactly what a detail means. I will give you another example; let's take a gimp. (Author's note: A gimp is the ornamental braid that trims many upholstered furniture pieces.) If we take a modernist approach to life and examine it, the gimp is not decoration. If we take a post-modern approach to life and examine the same gimp, we can accept the gimp as a function. Our reality is that the gimp is both, because it is structural. If you look at this sofa upholstered in chintz, the gimp articulates the design, explaining the seat. I have learned about basic things in life. It is never about the chair or the upholstery. It's about understanding life. That is how I see my work here at the Geymüller-Schlössl."

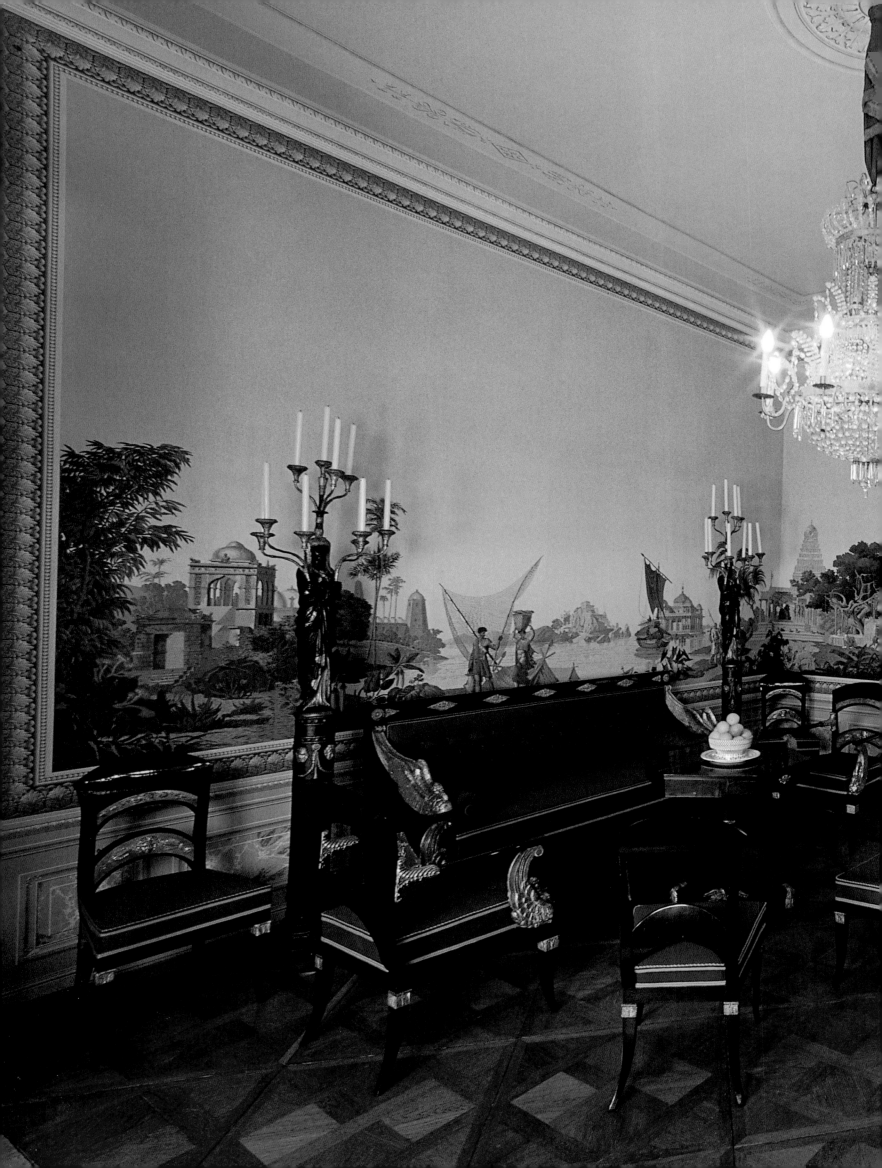

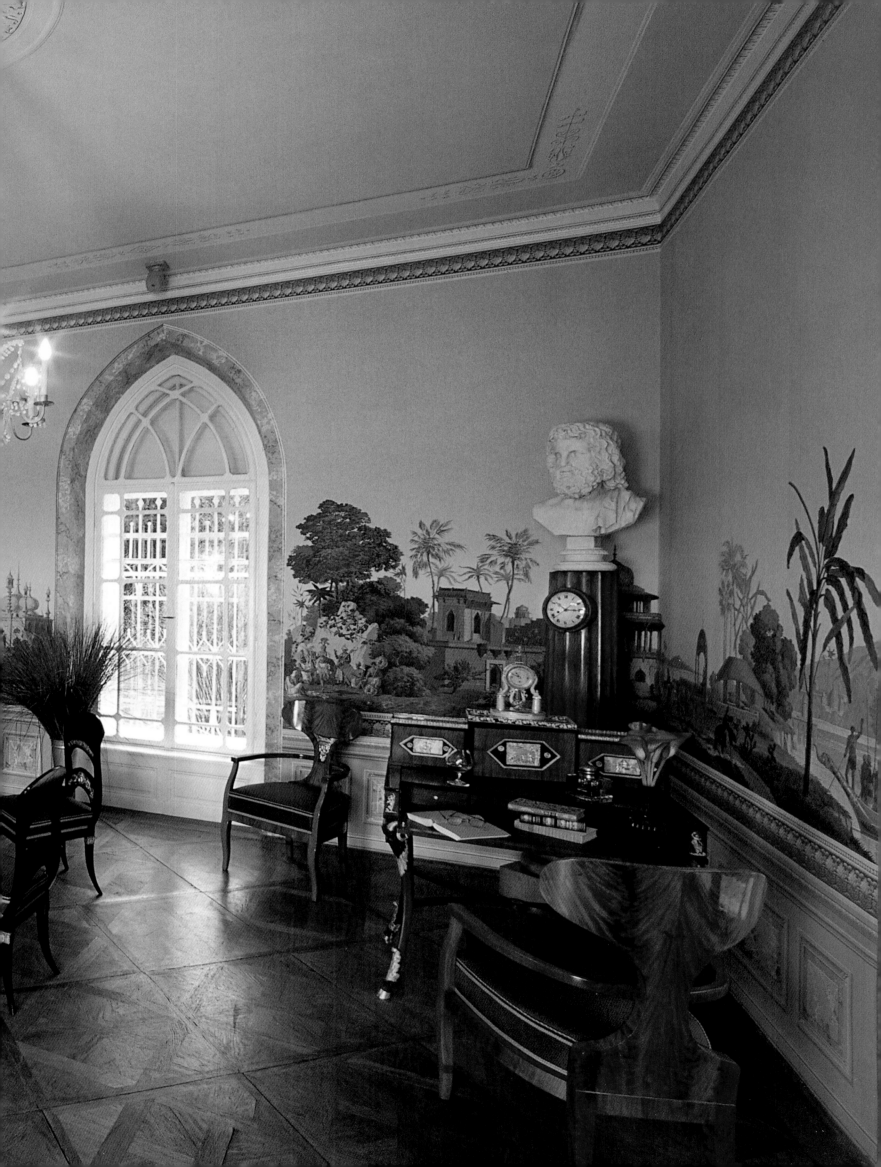

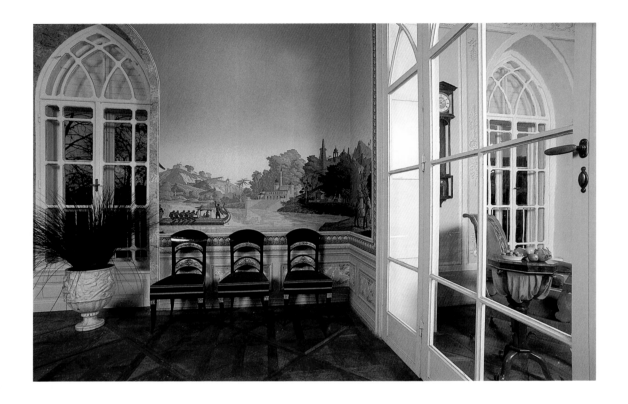

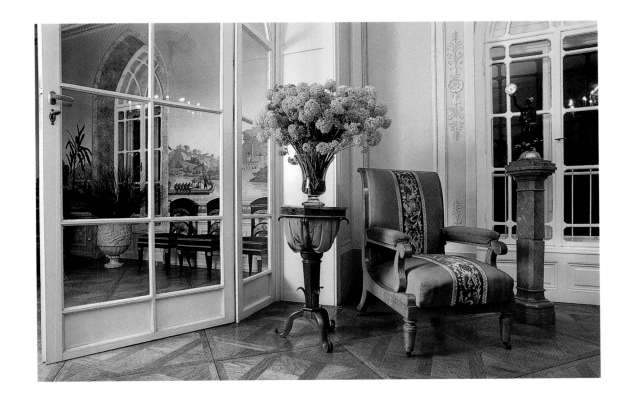

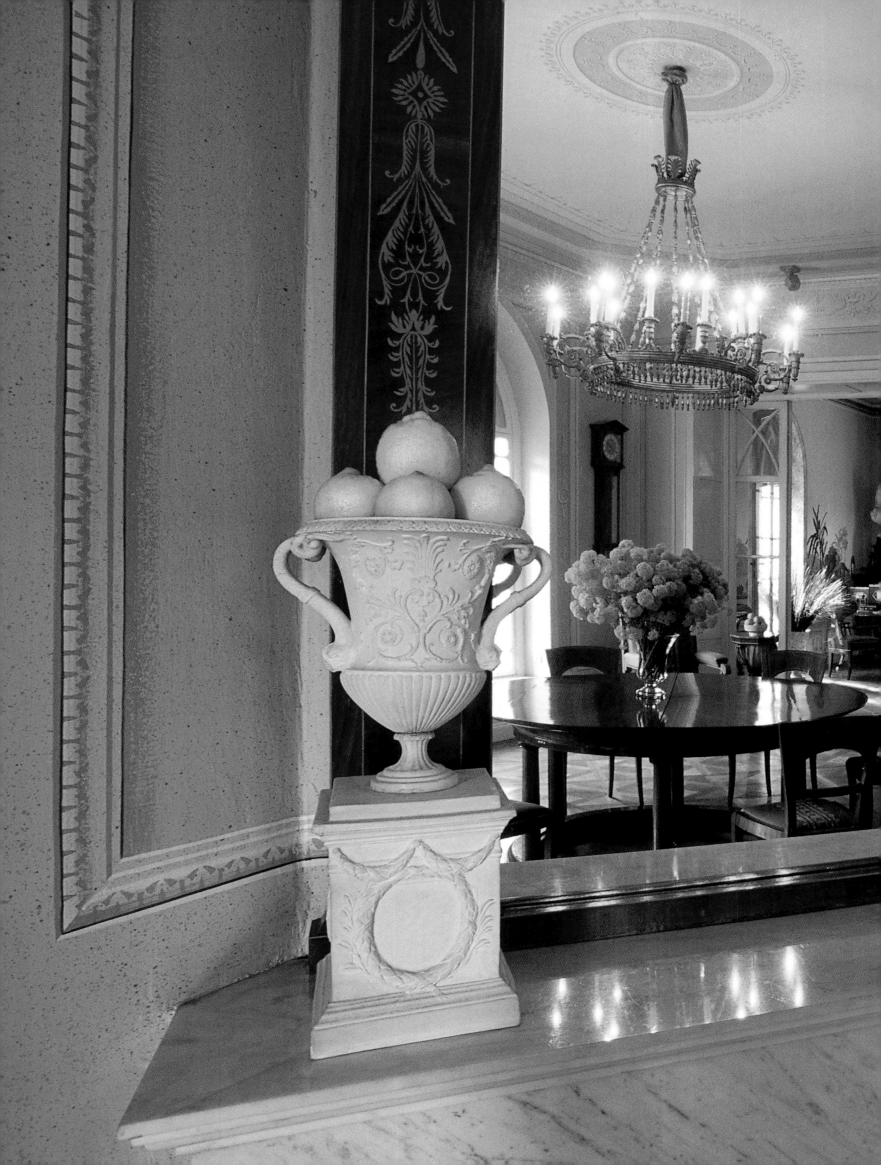

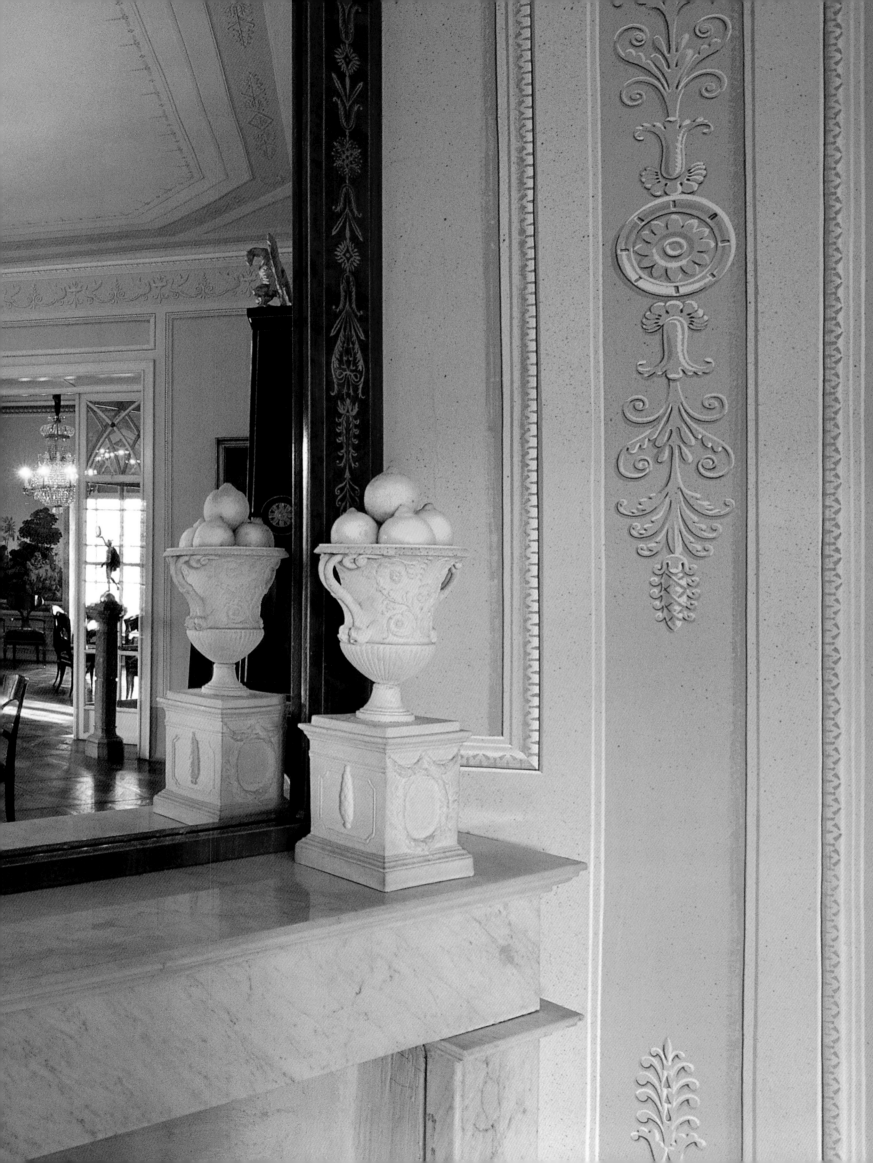

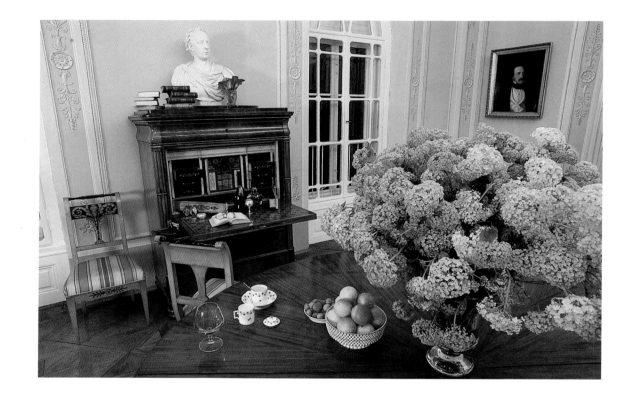

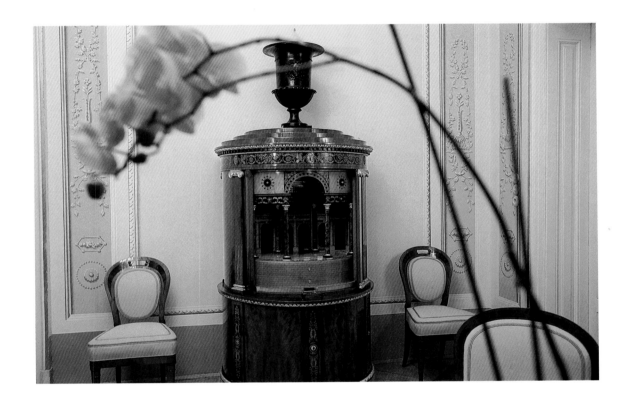

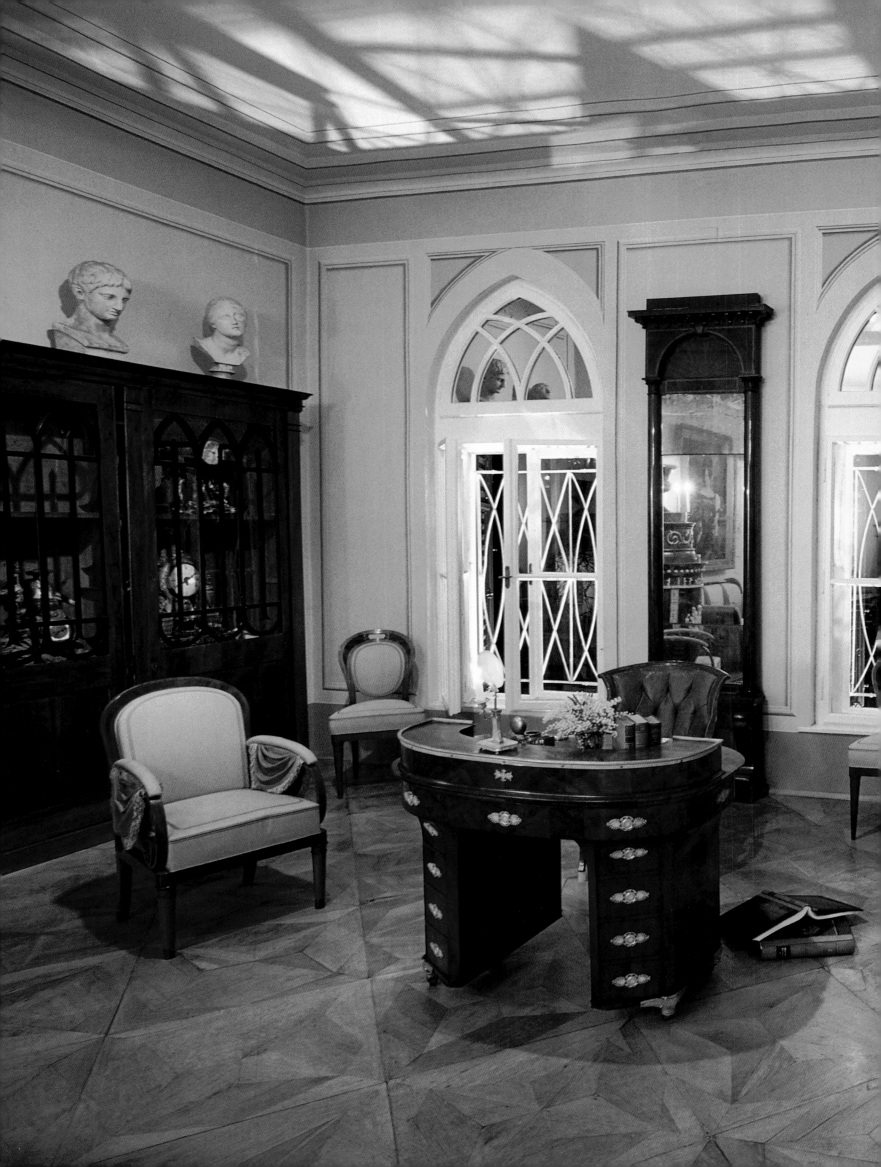

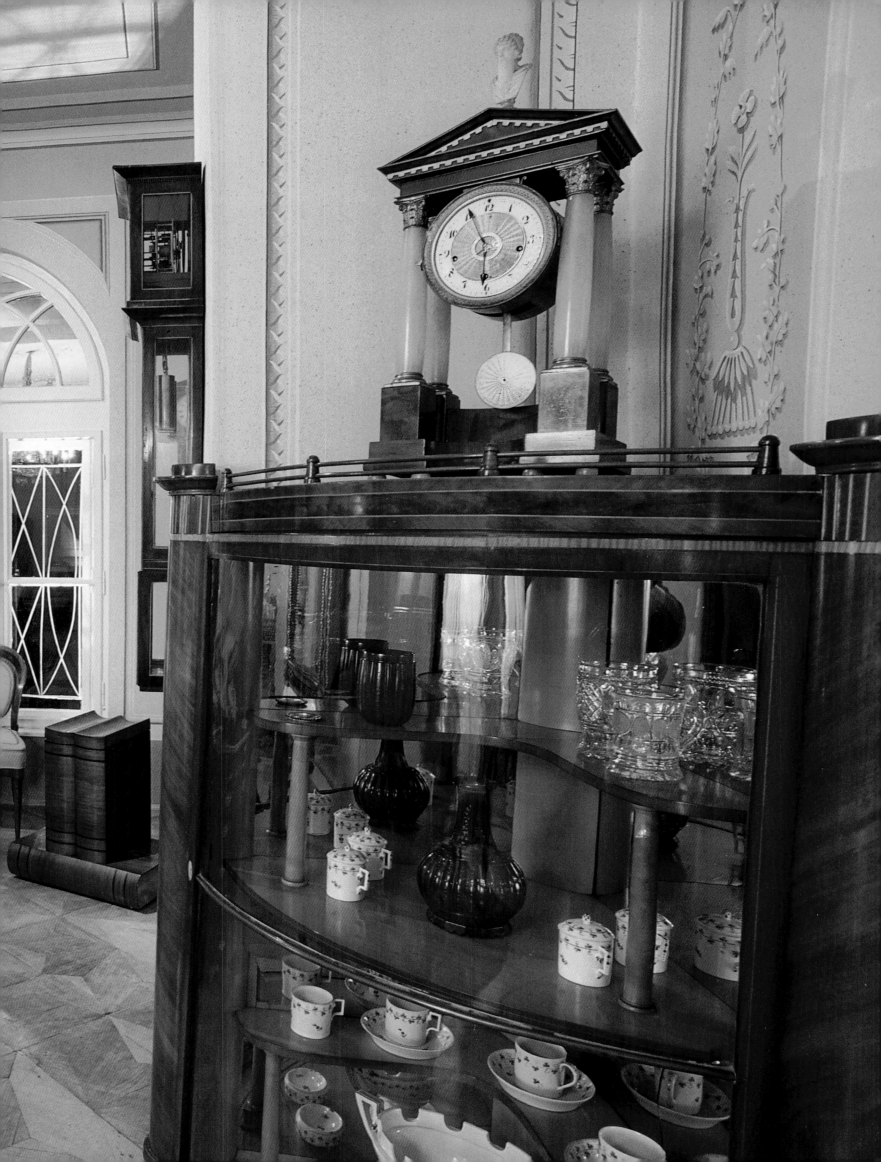

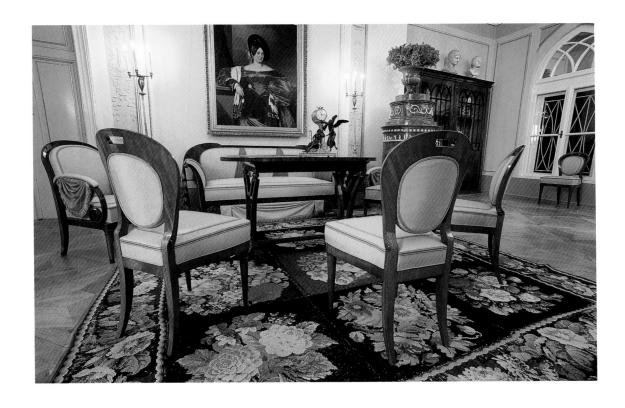

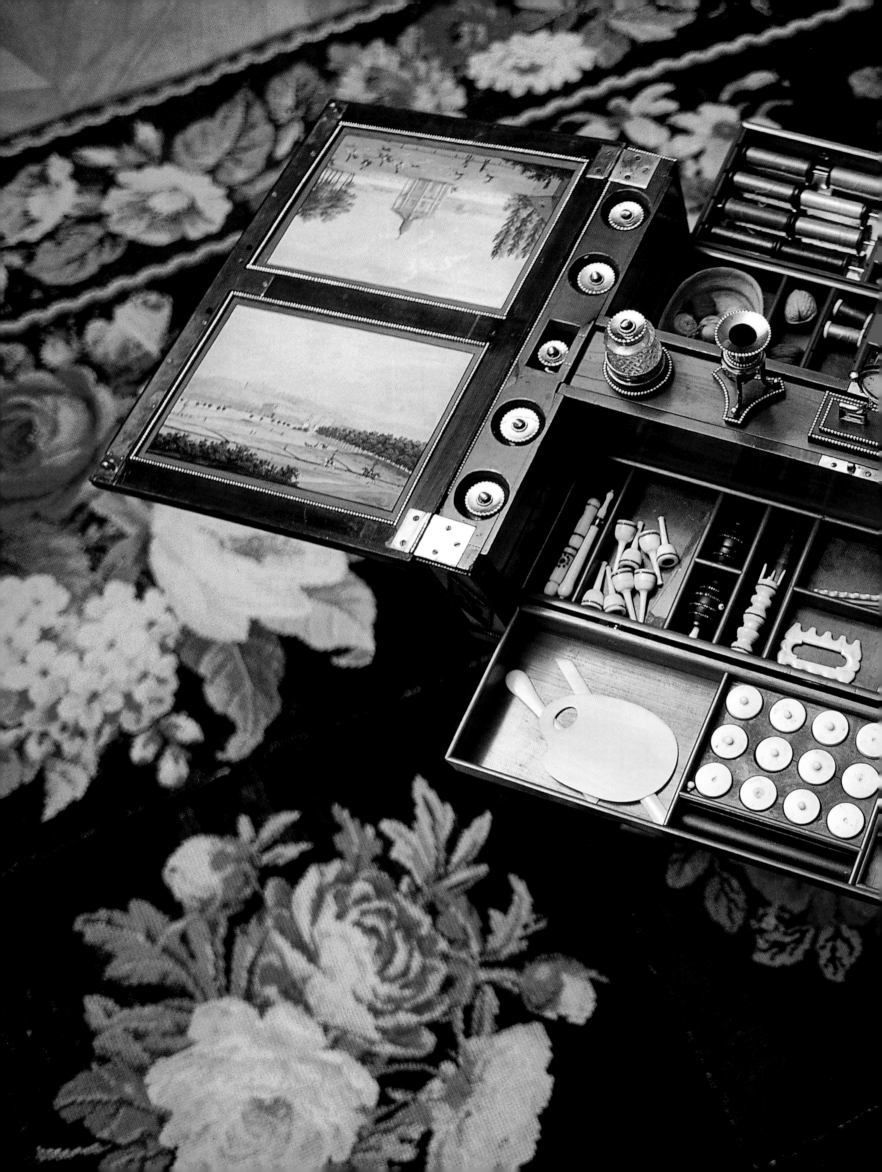

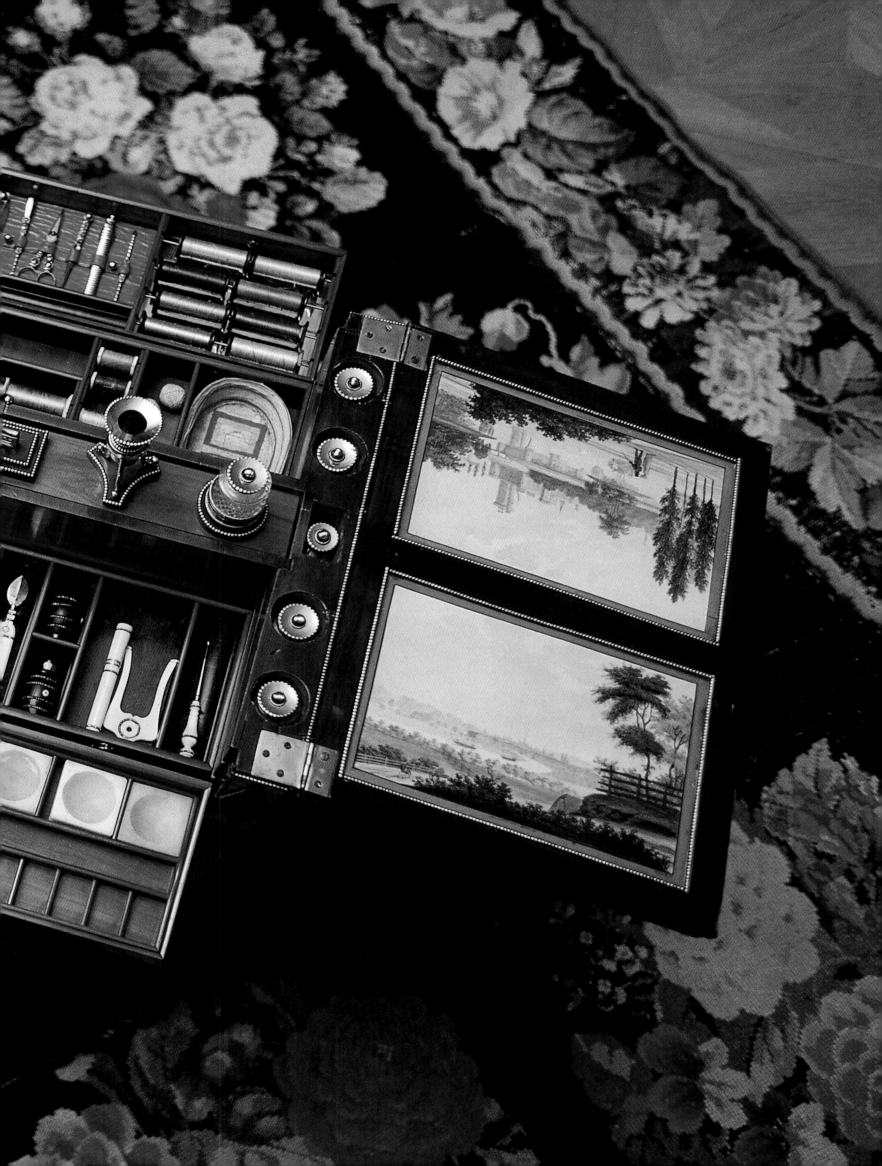

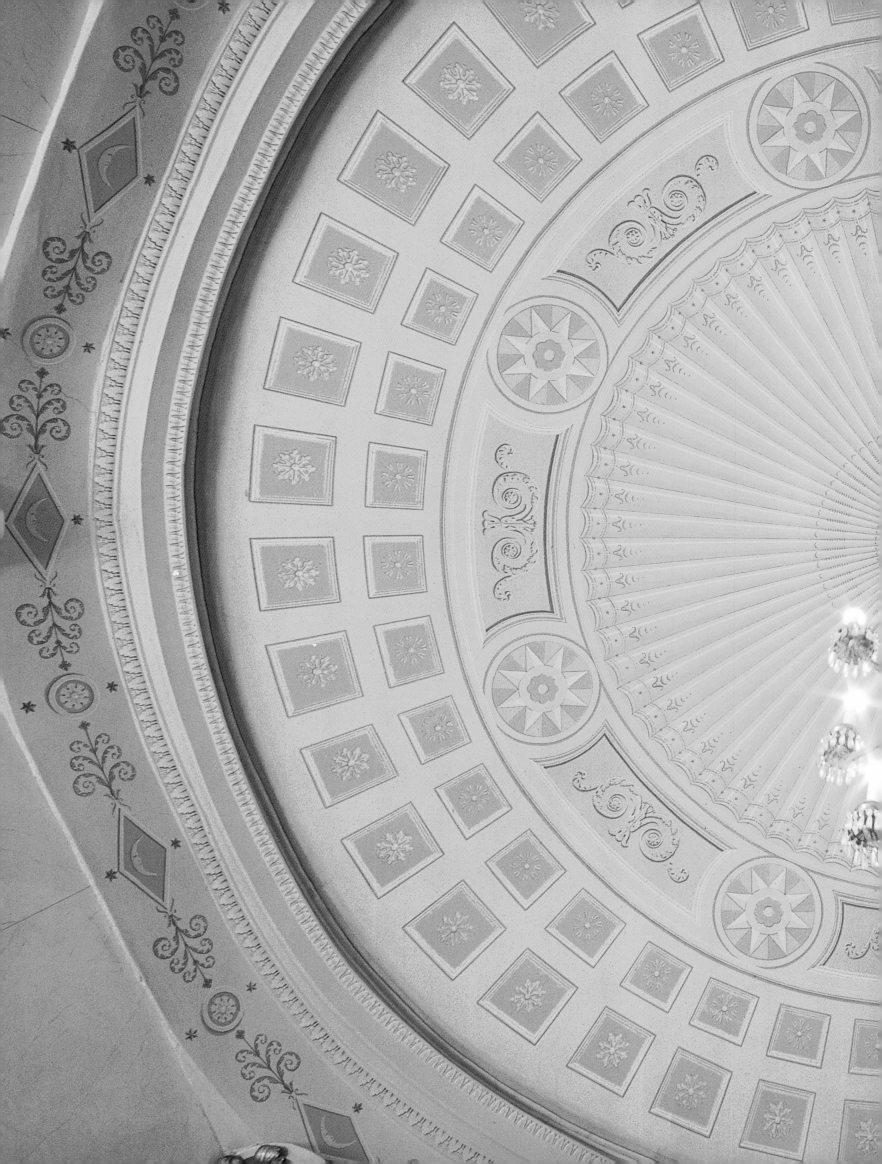

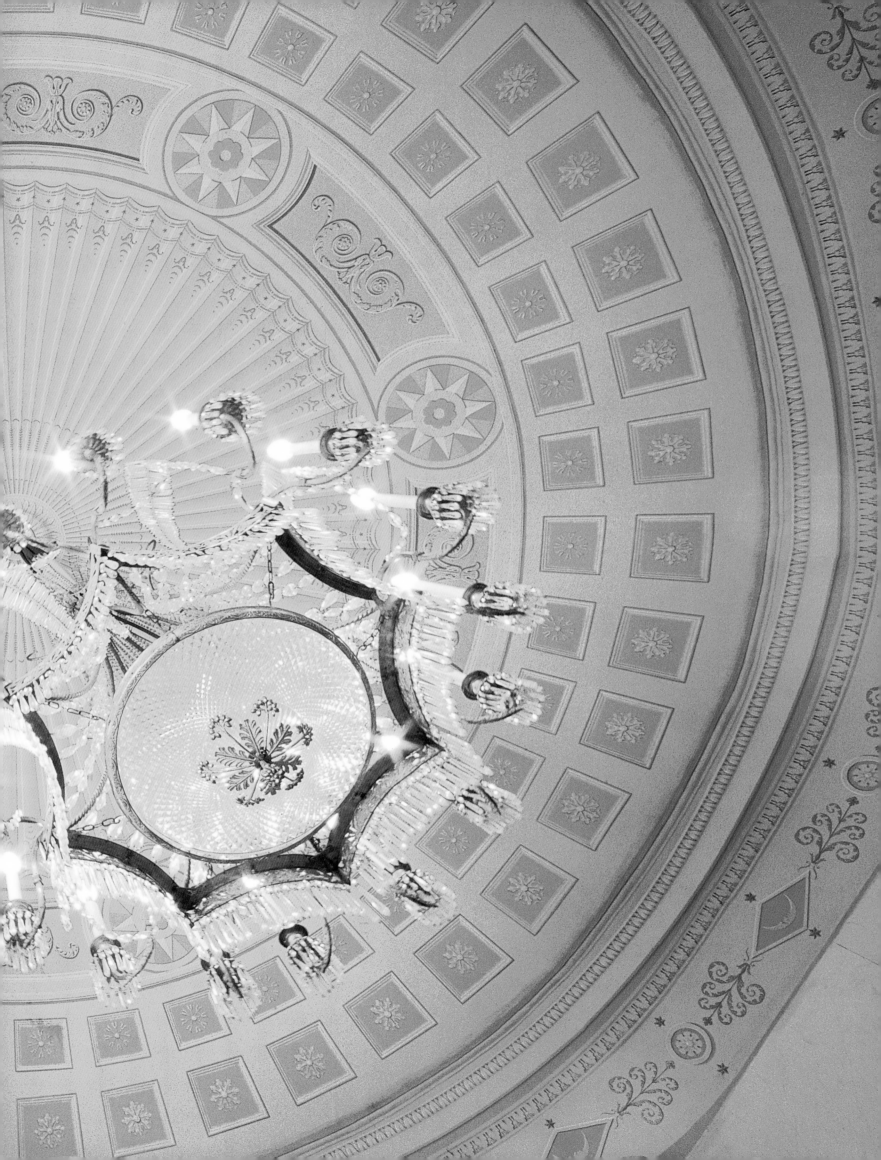

[134] VIEW OF THE VESTIBULE. GEYMÜLLER-SCHLÖSSL, VIENNA. [136] RECEPTION HALL FEATURING A SUITE OF MAHOGANY FURNITURE, VIENNA CIRCA 1811. GEYMÜLLER-SCHLÖSSL. [137] FLORAL STILL LIFE BY JOSEPH NIGG, VIENNA CIRCA 1820. GEYMÜLLER-SCHLÖSSL. [138] VIEW FROM THE EXISTING DINING ROOM TO THE RECEPTION ROOM. GEYMÜLLER-SCHLÖSSL, VIENNA. [140] DETAIL OF WALNUT DESK, PROBABLY BY JOSEPH ULRICH DANHAUSER, VIENNA CIRCA 1820. MANTEL CLOCK BY CHRISTIAN FEDERL, VIENNA CIRCA 1820. GEYMÜLLER-SCHLÖSSL. [141] VIEW OF THE CUPOLA ROOM. GEYMÜLLER-SCHLÖSSL, VIENNA. [142] MANTEL CLOCK PROBABLY BY CASPAR KAUFMANN, VIENNA 1824. GEYMÜLLER-SCHLÖSSL. [143] DETAIL OF [142]. [144] GILT WOOD MIRROR WITH BRASS CANDLE-HOLDERS SUPPORTING A BISQUE PORCELAIN PLAQUE, VIENNA CIRCA 1820-1830. MAHOGANY BRACKET CLOCK, VIENNA EARLY 19TH CENTURY. GEYMÜLLER-SCHLÖSSL. [145] DETAIL OF [144]. [146] MAHOGANY SETTEE WITH BUILT-IN FLUTE WORKS BY CHRISTIAN HEINRICH, RENEWED UPHOLSTERY, VIENNA CIRCA 1830. EBONIZED MAHOGANY SIDECHAIR BY JOSEPH ULRICH DANHAUSER, VIENNA CIRCA 1830. CHERRYWOOD BEDSIDE TABLE BY JOSEPH ULRICH DANHAUSER, VIENNA FIRST HALF OF THE 19TH CENTURY. GEYMÜLLER-SCHLÖSSL. [148] BACK VIEW OF [146]. [149] DETAIL OF STORAGE CABINET WITH MUSIC CYLINDERS FOR SETTEE [146], VIENNA CIRCA 1830. GEYMÜLLER-SCHLÖSSL. [150] DETAIL OF TWO ORIGINAL MUSIC CYLINDERS. GEYMÜLLER-SCHLÖSSL, VIENNA. [162] VIEW OF THE BLUE SALON DESIGNED BY JOSEPH ULRICH DANHAUSER, VIENNA CIRCA 1815. GEYMÜLLER-SCHLÖSSL. [164] DETAIL OF [162]. [165] DETAIL OF EXISTING DINING ROOM AND BLUE SALON, VIENNA CIRCA 1815. GEYMÜLLER-SCHLÖSSL. [166] REFLECTED VIEW OF THE EXISTING DINING ROOM AND THE BLUE SALON. GEYMÜLLER-SCHLÖSSL, VIENNA. BLUE SALON SEE [165]. [168] MAHOGANY HAMBURGER SEKRETÄR OR SECRETARY IN THE HAMBURG STYLE BY VINZENZ HEFELE, VIENNA 1840. GEYMÜLLER-SCHLÖSSL. [169] PYRAMID MAHOGANY SECRETARY BY ANTON HAERLE, VIENNA 1813. THREE MAHOGANY SIDECHAIRS MANUFACTURED BY DANHAUSER'S K.K. PRIV. FURNITURE FACTORY, VIENNA CIRCA 1820. GEYMÜLLER-SCHLÖSSL. [170] VIEW OF THE EXISTING LIVING ROOM. GEYMÜLLER-SCHLÖSSL, VIENNA. [172] [173] MAHOGANY SUITE OF FURNITURE BY DANHAUSER'S K.K. PRIV. FURNITURE FACTORY, VIENNA CIRCA 1820. OIL ON CANVAS, PORTRAIT OF AN UNKNOWN LADY BY SCHROTZBERG, VIENNA CIRCA 1838. NEEDLEPOINT CARPET, VIENNA FIRST HALF OF THE 19TH CENTURY. GEYMÜLLER-SCHLÖSSL. [174] BURL WOOD CRAFT TABLE WITH HINGED TOP WHICH OPENS TO REVEAL FOUR MOUNTED WATERCOLORS DEPICTING VEDUTAS (LANDSCAPE VIEWS) BY BALTHASAR WIGAND, VIENNA CIRCA 1810-1815. GEYMÜLLER-SCHLÖSSL. [176] VIEW OF THE BEDROOM AND THE CUPOLA ROOM. GEYMÜLLER-SCHLÖSSL, VIENNA. [178] DETAIL OF THE CUPOLA ROOM WITH SIXTEEN-CANDLE CRYSTAL CHANDELIER, BRONZE ORNAMENTS, VIENNA CIRCA 1808. GEYMÜLLER-SCHLÖSSL, VIENNA.

THE EMERGENCE OF A STYLE

IF THE CULTURE OF DOMESTICITY REFLECTING

MIDDLE EUROPEAN SENSIBILITIES RESIDES ANYWHERE, IT RESIDES

AT THE SILBERKAMMER MUSEUM IN THE HOFBURG.

LOCATED IN THE HEART OF VIENNA, THE MUSEUM HAS

AMONG ITS TREASURES THE WORLD'S LARGEST COLLECTION OF

OBJECTS THAT REFLECT THE ART OF FINE DINING.

PIECES COMMISSIONED BY THE HABSBURG FAMILY SIT

SIDE BY SIDE LIKE JEWELRY AT BUCCELLATI ON ONE GLASS SHELF

AFTER ANOTHER. A GLIMPSE THROUGH THE LAST REMAINING

18TH-CENTURY WINDOW IN THE HOFBURG REVEALS

AN EXQUISITE TABLE SETTING PRODUCED FOR THE

CORONATION DINNER OF EMPEROR FERDINAND I, IN MILAN.

ALL IN GOLD. THERE ARE GOTHIC-INSPIRED BOTTLE COOLERS,

MANUFACTURED OF THE FINEST PORCELAIN THE VIENNA

PORCELAIN FACTORY COULD PRODUCE. THE DEPICTIONS

OF THE HABSBURG ANCESTORS THAT ADORN THEM ARE A PROUD

REMINDER OF THE FAMILY'S LONG REIGN.

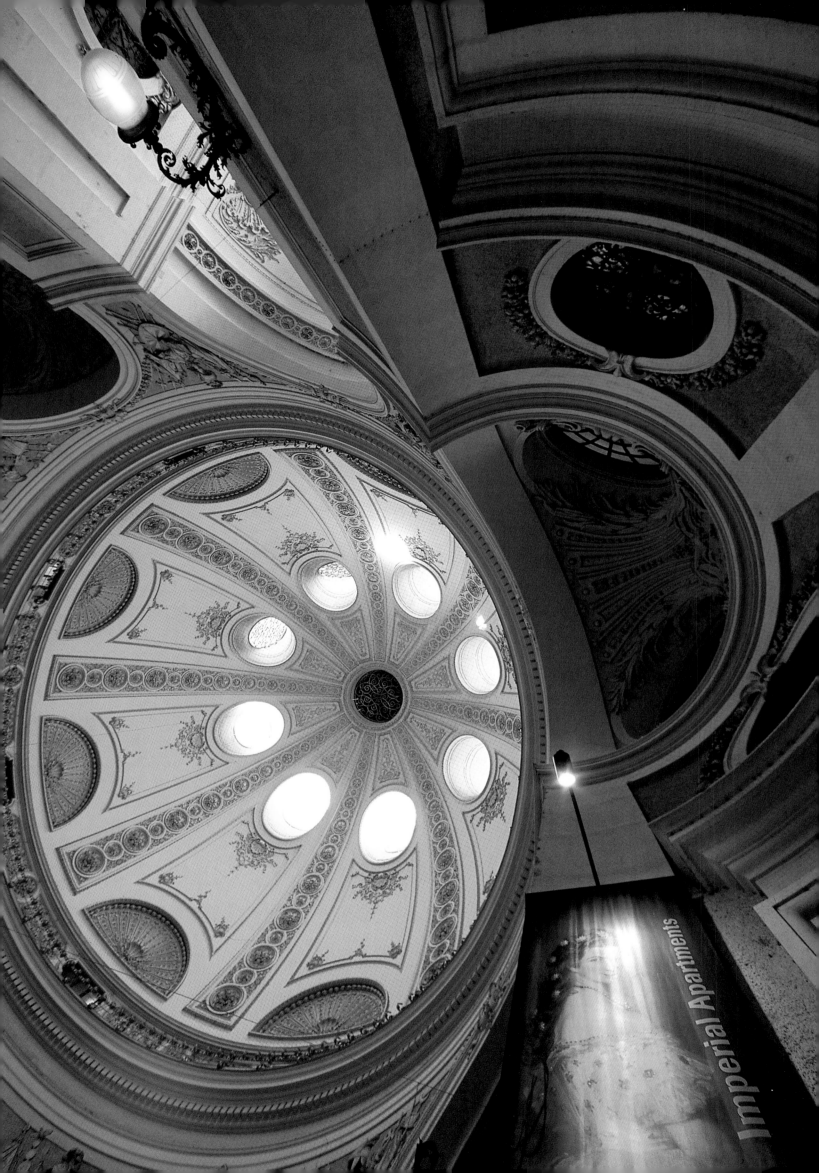

Imperial Apartments

"THE SITUATION IS HOPELESS, BUT NOT SERIOUS." KARL KRAUS

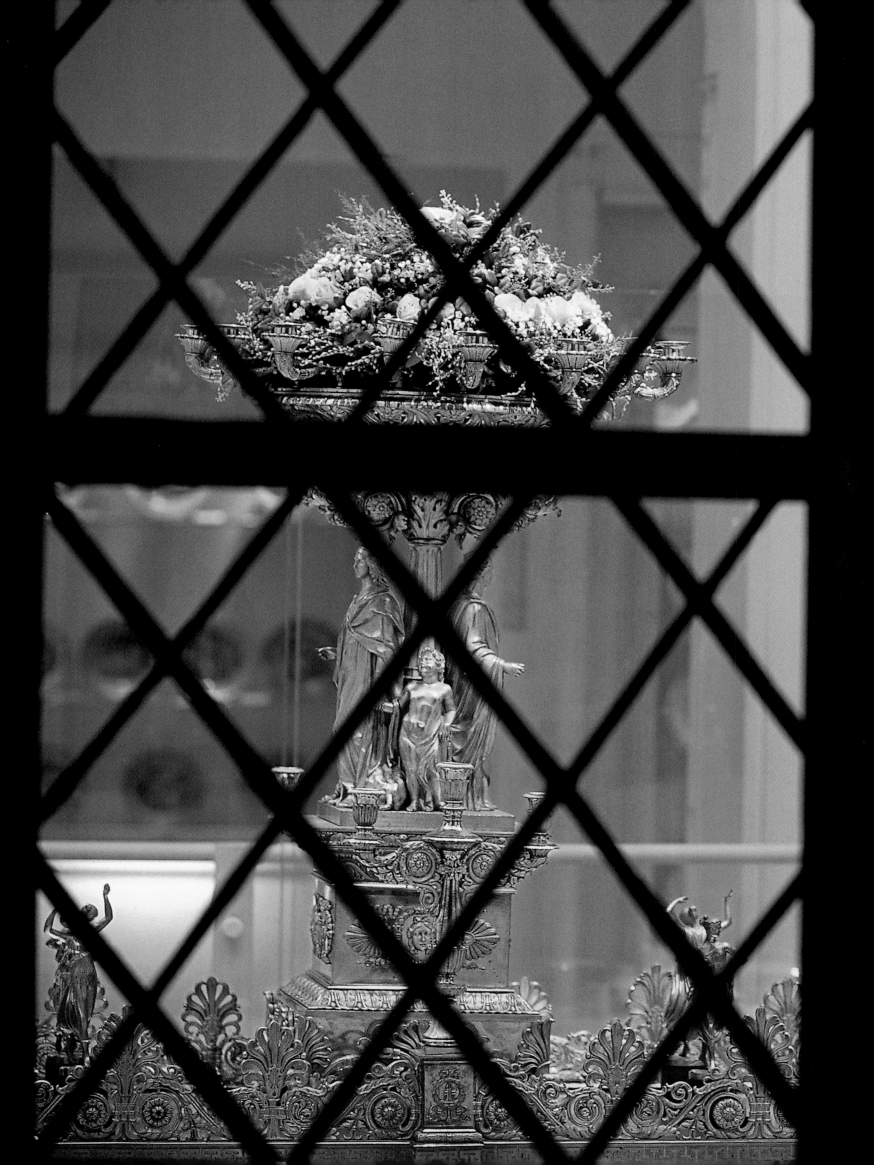

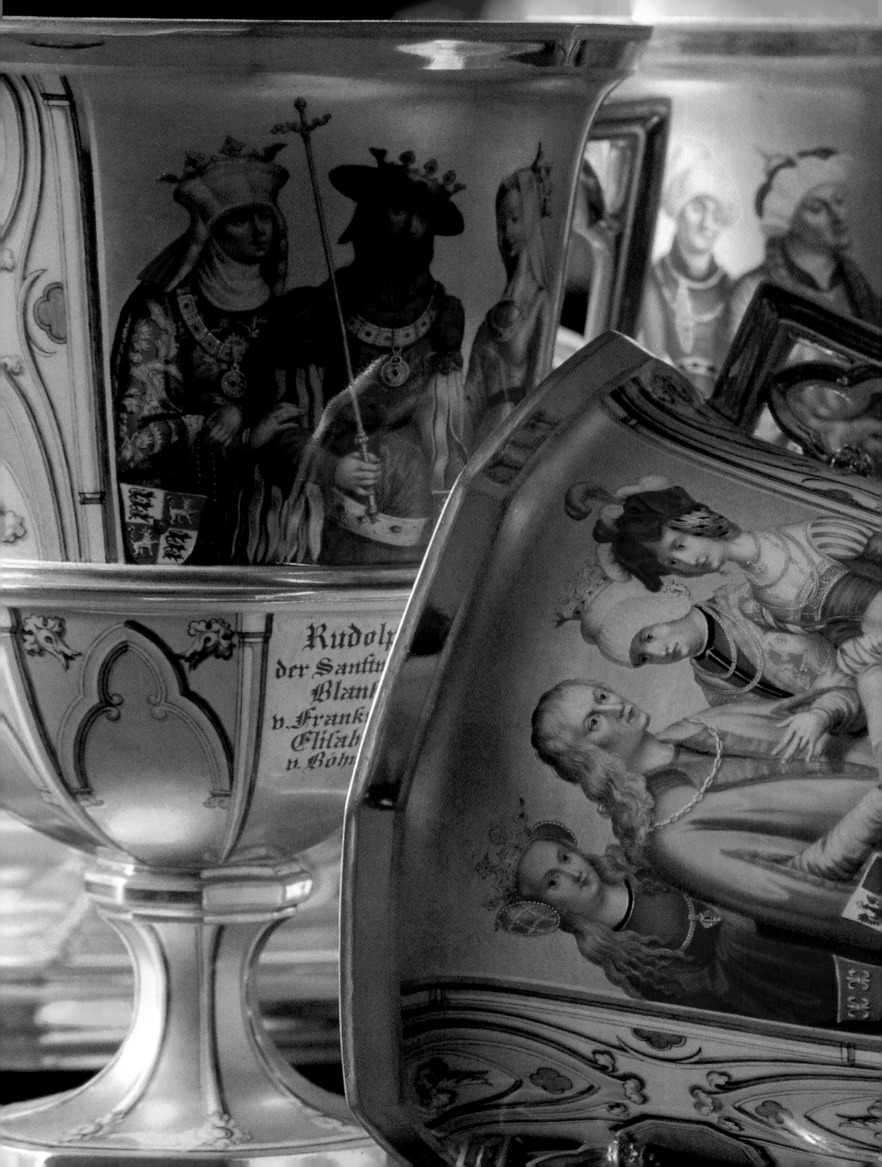

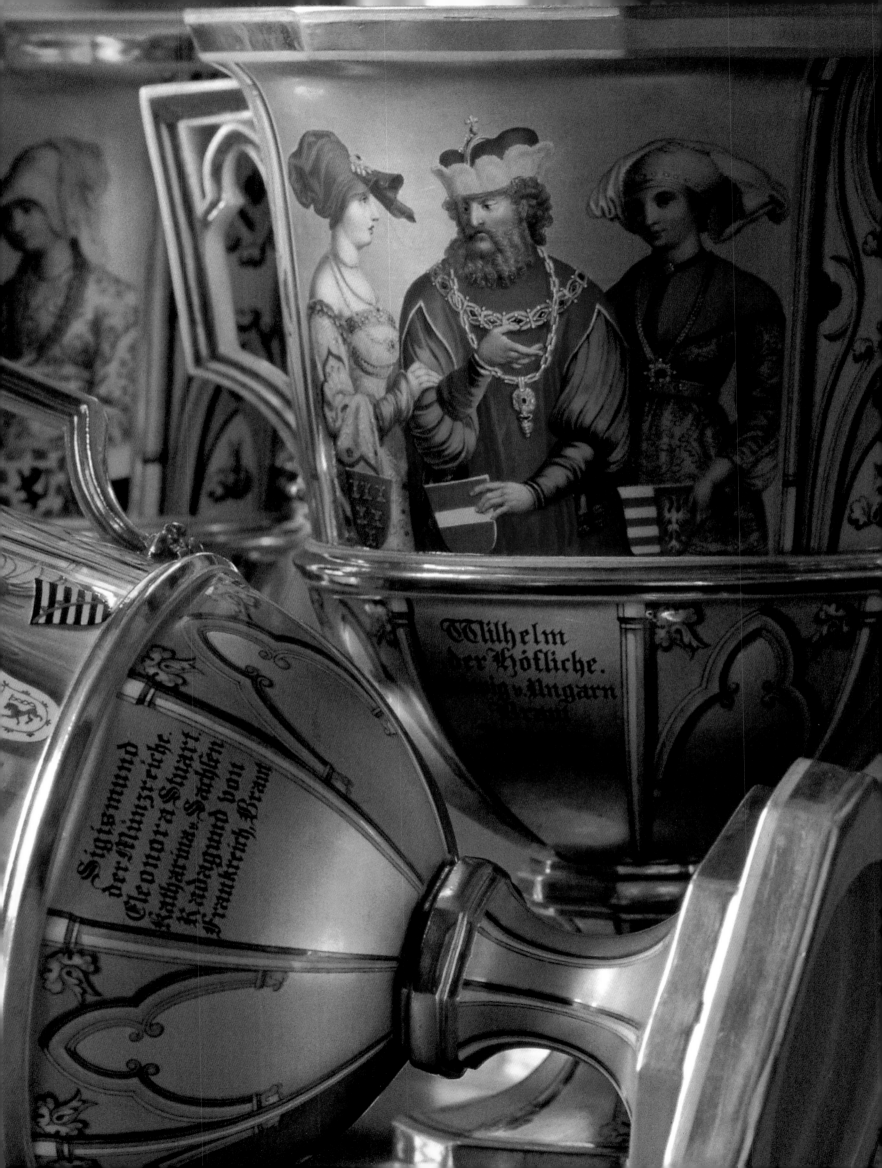

Wilhelm
der Höfliche.
...v. Ungarn
...

Sigismund
der Münzreiche.
Eleonora Stuart
Katharina v. Sachsen
Kunegund von
Frankreich. Braut

ROW UPON ROW of dessert plates display painters' allegorical fantasies, mythological scenes, landscapes called vedutas, and, above all, flowers and botanicals. Emperor Franz II(I) loved gardening and ordered one plate after another. "A love that for him came second only to his passion for fathering children," says Dr. Peter Parenzan, who guides me through the museum. In addition to presiding over the furniture collection of the Hofmobiliendepot, Dr. Parenzan is responsible for the Silberkammer holdings. On a porcelain hot-chocolate cup we witness the suicide of Dido after being abandoned by Aeneas, and we admire how gracefully Iris hovers in a stormy landscape upon a porcelain dessert plate. "Thanks to advancements in chemistry and experimentation with the colorings of glass," explains Dr. Parenzan, "new, vivid pigments were created. Opaque glass in colors never before available was introduced. Translucent paints that imparted richness and depth gave more realistic impressions to decorated glass. The best known glass manufactures in Vienna were Gottlob Samuel Mohn and Anton Kothgasser, who created absolute masterpieces. Their *Ranftgläser*, a type of goblet that narrows toward the base, and *Freundschaftsgläser*, or 'friendship tumblers,' were the most exquisite of collector's items. IN THE BIEDERMEIER PERIOD, salon and living room vitrines were filled with small objects and mementos. People were extremely concerned about their own time's being forgotten. You must know that the Viennese have a penchant for melancholy. We refer to it as *Tränenseligkeit*, or 'basking in misery'. This explains why we have so many forget-me-nots and keepsake books from this time." I asked Dr. Parenzan whether this trait was uniquely Viennese: "I remember reading

[184] VIEW OF THE CUPOLA IN THE HOFBURG PALACE. VIENNA. [186] VIEW THROUGH THE LAST REMAINING 18TH CENTURY WINDOW IN THE HOFBURG PALACE: TABLE SETTING DESIGNED AND FABRICATED BY LUIGI MANFREDINI, MILAN 1838. SILBERKAMMER. [188] PORCELAIN BOTTLE COOLERS MANUFACTURED BY VIENNA PORCELAIN FACTORY, VIENNA 1826. SILBERKAMMER. [190] IMPERIAL NAPKIN WITH KAISERSEMMEL ON A PORCELAIN DESSERT PLATE MANUFACTURED BY VIENNA PORCELAIN FACTORY, VIENNA 1807. SILBERKAMMER.

that Napoleon's favorite book was *The Sorrows of Young Werther*, by Goethe. The genius of the author was to let his hero revel in the sweet pleasures of melancholy without ever expressing despair. To truly live rather than pretend to live took all his effort and determination." "This may be true," Dr. Parenzan answers, "but in Vienna these emotions were indulged as nowhere else. PEOPLE SOUGHT SOLACE from the dark side of life in food, drink, dance, and music. Celebrations and festivals helped them to forget their everyday worries. Easter, and the *Brigittenkirchtag*, the church festival dedicated to St. Bridget, were the most popular festivals of the time. *Fasching*, or 'carnival', of course was a time when everyone looked forward to dancing, in which the Viennese took their greatest delight. Newly established ballrooms became the arenas for waltzing to exhaustion. Hours of swirling around and around put people under a spell. Dancing allowed a certain freedom, dancing was ecstasy. Considering the political and social situation of the time, this craze was, in fact, not unlike dancing on a volcano. PUBLIC LIFE WAS EXTREMELY RESTRICTED. The emperor expected his subjects to accept without question what the government declared right or wrong. People soon became frustrated and no longer believed in politics. Their focus turned inward to the domestic sphere, where they could enjoy what little freedom they had within their own four walls. Entertaining at home helped insure privacy. It was pure escapism. Writing, music-making, and handicrafts were enjoyed by many. Painting became a serious occupation for almost everyone, talented or not. Gardening was another favorite pastime. Those who could afford one maintained a small garden. The love of gardening literally grew new blossoms. Cultivating hybrid flowers, especially roses, became a popular hobby. This romantic response to nature drew people to the countryside and villages surrounding Vienna. The Vienna Woods emerged as an attractive alternative to life in the city. Baden, a village to the south, developed into a prominent

health resort where the more affluent of the middle class spent their summer months. These holidays soon became known as *Sommerfrische*, or 'going to the country.' IN VIENNA IN THE LATE 1820S the nucleus of all outdoor recreation was the Prater. Only half an hour's stroll from the city center, this former hunting ground of the Habsburgs became a fashionable amusement park. Puppet theaters, bowling alleys, swings, and a merry-go-round entertained the pleasure-seekers. Given Vienna's population of approximately 280,000 in 1825, the over fifty taverns, coffee houses, and restaurants within one park is astonishing. The Prater also gained a reputation for pickpockets and prostitutes, who plied their trade in the evening hours. It is documented that as many as twenty percent of adult women made a living through prostitution. I think this tells us a good deal about the economic circumstances of those in the lower social strata." IN MIDDLE-CLASS HOMES, the interest in outdoor activities and the love of nature manifested itself as a much more cultured presence. Floral and botanical motifs were favorites and made their way into the designs for wallpaper, carpets, and fabrics. Carpets often displayed leaf and vine designs as well as geometric shapes, which sometimes contained floral decorations. Carpets were used mostly in the winter months, due to the tremendous problem of dust during the summer. Fitted carpets, which were used year-round, were reserved only for the rich. Window treatments were usually lighter-weight fabrics styled in a somewhat formal way, with soft valances and jabots tied back to one side. Upholstery draping became popular, used to conceal sleeping furniture and to protect against bed bugs, insects that transmitted disease. The use of fabric draping on the arms and backs of chairs and settees was an indication of how affluent a family was. "During the Biedermeier period, people used materials as a language," Dr. Parenzan continues. "The use of a particular fabric meant something to them. If a substitution was made, it indicated a lack of means for something finer. If a family could

afford mahogany furniture, for example, it designated their social and economic position. People could read and speak this language of materials. If people decorated their walls with panoramic wallpaper ordered from Zuber in Rixheim, they were obviously extremely wealthy." Panoramic wallpapers featured exotic landscapes, historic events, expeditions and trompe l'oeil designs; but the real sensation was Zuber's invention named the "Iris Effect." This innovation enabled Zuber to print colors graduating from light to dark, giving the appearance of fading skies. People applauded this invention with a wonderful expression: they called it "melted air." Other less expensive wallpapers displaying repeating patterns with stripes, oriental motifs, flowers, fruits, and other stylized forms from nature became favorites. The most widely used wall decoration was paint. Painted walls could easily be decorated with elaborate borders and intricate stencil designs to give added importance. And, of course, painting was less expensive. I RECALL MY MEETING WITH DR. HANS OTTOMEYER, the director of the German Historic Museum in Berlin. We were discussing color schemes in the decoration of rooms, and he remarked: "Complementary color schemes, in which two contrasting colors are used together, became the dominant practice during this period. The notion that harmonious color effects could be achieved by pairing opposites had been recognized since the late 18th century. It was left to Johann Wolfgang von Goethe to derive a principle from such experiences with artistic color composition, which he did in his Theory of Color of 1810. Let me read for you what he wrote: 'The three primary colours are Red, Blue, and Yellow. The eye will not be satisfied by one of these alone, but will demand, when it has seen one, that it see the others as well, which then appear co-mingled... Accordingly, the principal formula is as follows: Yellow demands Red-Blue, Blue demands Red-Yellow, Purple demands Green, and vice versa. To perceive this totality, to satisfy itself, the eye seeks, adjacent to every colorful

space, a colorless one to cause the desired color to emerge by way of contrast. And herein lies the natural law determining all harmony among the colors...' THE ACCEPTANCE OF THIS THEORY OF COLOR manifests itself in practice as follows: two complementary primary colors are accompanied by the non-color white, which provides the neutral element essential to any perception of color. In the color scheme of Biedermeier décor, the two complementary shades are used throughout all the constituent elements; we find them repeated in the colors of furniture and woods, upholstery and draperies, wall coverings and borders, with the intention of preserving unity, consistency, and balance in a room. A passage from a novel written in 1835 by Adalbert Stifter, titled *Nachsommer*, shows what a high degree of sensitivity to the domestic environment developed during this period; in this novel, a sensuous dream of a flawless and precious space is presented: 'THE LITTLE CHAMBER WAS MOST LOVELY. The walls were covered entirely in soft, rose-colored silk, with drawings in a slightly darker shade. Against this pale, rose-hued silk, a banquette upholstered in light green silk banded in dull green hugged the wall. Chairs of the same sort were placed casually about. Their silk upholstery, gray stripes on gray, stood out softly and sweetly from the walls, creating an effect like white roses next to red. The green banding was reminiscent of the green foliage of rose bushes. In a far corner of the room was a fireplace of gray stone, a darker shade, with green streaks in the mantel and very narrow gold moldings. Before the upholstered banquette and the chairs stood a table whose top consisted of gray marble, in the same color as the fireplace. The table's and chairs' feet, as well as the fittings of the banquette and the other objects, were made of lovely violet-blue amaranth wood, but so delicately fashioned that the wood never seemed overwhelming. By the window, its draperies done in gray silk, which looked out onto the landscape and the distant mountains through the green arches of trees, stood a small table of the same wood and

a richly upholstered easy chair and footstool. The floor was covered with a silky green carpet, whose simple color stood out only slightly from the green of the trim. No feature in the chamber suggested that it was inhabited. No object was out of place, the carpet showed not a wrinkle, the draperies had not a fold awry.' THE DOMESTIC ARTWORK evoked in this passage goes back to a literary genre that can already be found before 1800 in the *Journal of Luxury and Fashion* published by Justin Bertuch. This magazine took it upon itself to describe the ideal room. Subtle imagination and the economic reality of lacking the means to execute one's conceptions led to the compromise of capturing the ideal in words. The colors described for this and other rooms reveal once more the successful formula for all good interior decoration, namely the combination of two contrasting colors, which determine and define each other and strengthen each other's effectiveness, specifically in conjunction with a non-color such as white, black, or gray, as well as with a metallic color such as silver, gold, or bronze. In the complicated chemistry of wish and reality that is so characteristic of the Biedermeier, the translation of high ideals into actual décor took on much more banal form." NOT ALL ROOMS WERE AS SIMPLY DECORATED as the ideal Stifter describes. Highly sophisticated pieces had their place as well. Beautifully designed and technically perfect, certain pieces reached a pinnacle of design, combining form and function. Dr. Parenzan comments, "Seen from the standpoint of 'function produces form,' we find spectacular examples, like the secretary in the 'Hamburg' style by Vinzenz Hefele. This masterpiece became so famous that Hefele traveled from town to town by coach, demonstrating its amazing mechanical features by the push of a button. Picture a secretary with a lower cabinet that contains three drawers. A roll-top sits above it, and, when opened, reveals three additional drawers to either side. There you discover two pigeon holes and two supplementary drawers with hidden compartments behind letter

dividers. To the left are thirty-two more hidden compartments. Two drawers can also be turned around, displaying contrasting woods, changing the colors of the drawer faces. A miniature tabernacle in palisander, decorated with intricate inlays and filigree work, is situated in the center. Inside, one of the sides is mirrored and framed in maple. Opposite appears a Byzantine temple with a movable mirror, which conceals five additional miniature drawers. Isn't it amazing?" EVEN MORE UNEXPECTED IS A SETTEE that not only offers a comfortable place to sit, but also plays music. Walter Früwirth, the technician who maintains Sobek's collection of automata and clocks at the Geymüller-Schlössl, demonstrated for me what Christian Heinrich created in 1830. This remarkable mahogany settee shows built-in flute works containing forty-four open Viennese flutes. Music rolls can be inserted in a compartment located in the back of the piece. "This piece is a wonderful historical document," Herr Früwirth explained. "Not only is it one hundred and seventy years old, but it plays music the way the composers intended. There is no possibility for a conductor to interpret the piece." It is beautiful to see the music roll turning slowly sideways, rotating six and a half times for three minutes of music. A specialty cabinet was designed to accompany the settee, and holds the assortment of music, which ranges from Mozart Overtures to the waltzes of Müller. CREATIVE FANTASIES were not only expressed through forms in furniture design, but also inspired decorations that we still use today, unaware that they originated during the Biedermeier. Hearing about a custom in rural Germany, two prominent and affluent ladies set a trend that changed the look of Christmas forever. Fanny Arnheim and Henriette von Nassau-Weilburg—the latter was married to Archduke Karl, the brother of Emperor Franz II (I)—elevated the simple decorated fir tree to a bejeweled spectacle, which almost everyone quickly copied. From their famous salons, the Christmas tree made its way around

the world. A little later, in 1848, Herr Winter made his first appearance. Today we know him as Santa Claus. A more profane development occurred when Prince Metternich almost went bankrupt. His excessively grand lifestyle included numerous mistresses and splendid fêtes of Renaissance proportions. These circumstances eventually forced him to sit down for dinner with the banker Arnstein to resolve his financial dilemma. Historians believe this dinner marked the acceptance of Jewish banking into the elite of high finance. AFTER THE CONGRESS OF VIENNA, everyone looked to the city as the place to be. It was a melting pot, it was rich, and it was vital. Vienna became the shopping metropolis of Europe and the Mecca for fashion. Until approximately 1850, even Paris ranked second in importance. The *Wiener Modezeitung* was the *Vogue* of its day. Smartly dressed ladies set the style for the rest of the wealthy bourgeoisie. Plunging décolleté, the *Kopfmantel*, or 'headwrap,' cashmere shawls, and folding parasols were all the rage. Biedermeier marked the end of colorless dresses. The first trousers for women found their way into wardrobes, along with designs inspired by new inventions such as stretch fabrics. By the end of the 1820s, animal motifs dominated the streets, and in the 1830s the Far East made fashion. For men, the most important statement was the waistcoat, and the cuts changed so frequently that it was not uncommon for a gentleman to own as many as fifty or more. The importance of the waistcoat was rivaled only by that of the cravat, and leaving home without a top hat was uncommon. The style of hair and the absence or presence of a beard determined whether a man was a conformist or a revolutionary. "IT IS VERY CLEAR," says Dr. Parenzan, "that the Viennese compensated for their distaste for politics by turning enthusiastically to the arts. In music, for example, the Strauss brothers were kings. Johann Strauss's 'Blue Danube Waltz' became what we would call a 'smash hit.' Today this tune is considered Austria's secret national anthem; it will most

likely close the Vienna New Year's Eve concert at the Musikverein forevermore. It is said that this concert, performed by the Vienna Philharmonic, reaches a worldwide audience rivaled in numbers only by telecasts of the Olympic Games. Ludwig van Beethoven's work, which was ahead of its time, was respected, but appreciated by only a few. Nowadays, he is a titan in classical music. The extremely talented Lieder composer Franz Schubert died young, sharing Beethoven's tragic destiny of posthumous fame." WHILE LITTLE WAS TAKING PLACE in painting and in architecture, literature reaped a rich harvest during Biedermeier. Goethe in Germany and Franz Grillparzer in Austria left their brilliant marks in history. Controversial and difficult as the time was for everyone, the writers lived in an even more challenging situation. Walter Obermaier describes this in his essay *Literature in the Biedermeier Period*: "It was a period of exceptionally richly talented individuals, whose processes of literary creation operated in a field of tension between the distinctly pro-writer mentality of old Austria, on the one hand, and what those concerned felt to be an oppressive system of censorship on the other. The fact that censorship—like every other external pressure—can also be turned to good account in the creative process is no justification for its existence. Nevertheless, forgetting all its irony for a moment, Heinrich Heine's sarcastic remark in 1848 on the occasion of the abolition of censorship in Germany (where, in any case, it was much more restrained than in Metternich's Austria) needs to be examined in this respect too: 'How, when a person has known censorship all his life, is he to write without it? All style will be at an end, all grammar, good usage!' In Austria, Johann Nestroy said something very similar in his satire on the Revolution of 1848, *Freiheit in Krähwinkel*, 'Freedom in Sleepy-town': 'Writers have lost their favorite excuse. It wasn't a bad thing, after all, when you'd run out of ideas, to be able to say to people: 'God, it's awful! They won't let you do a thing'."

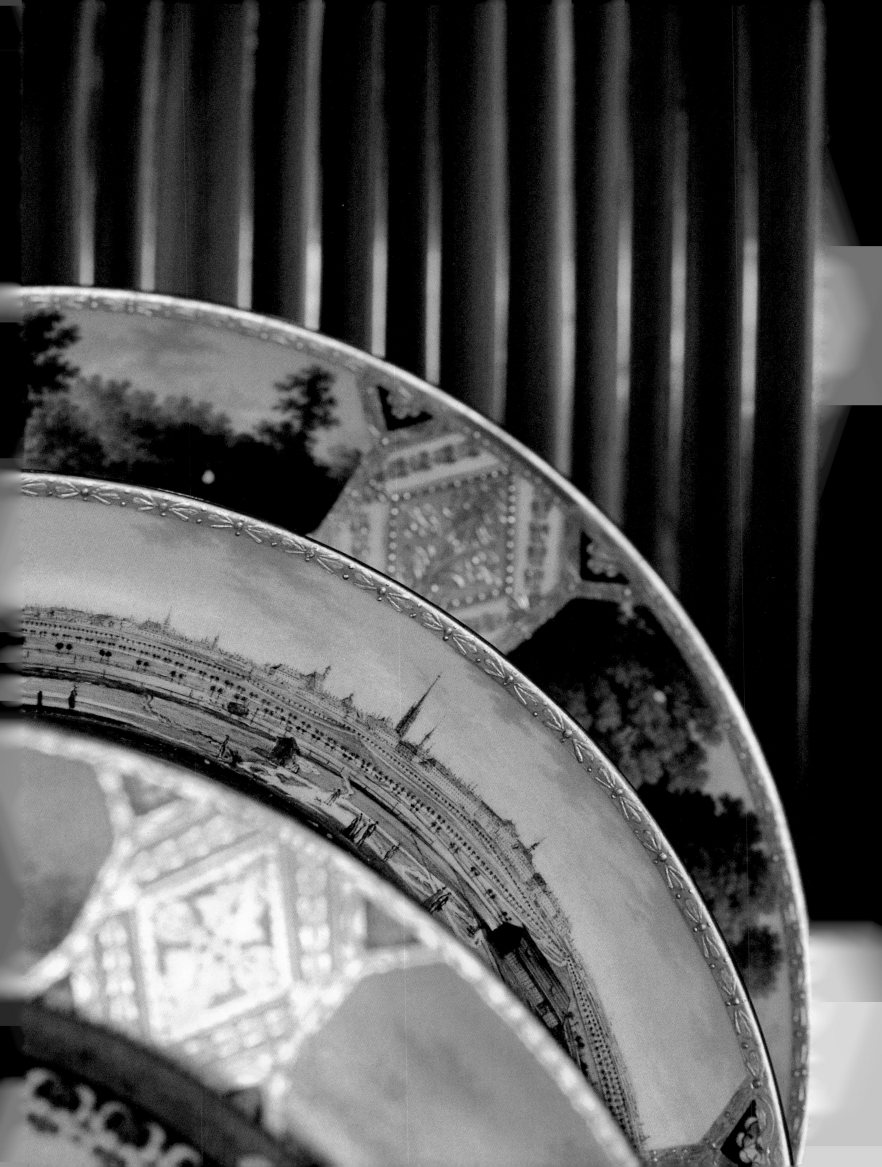

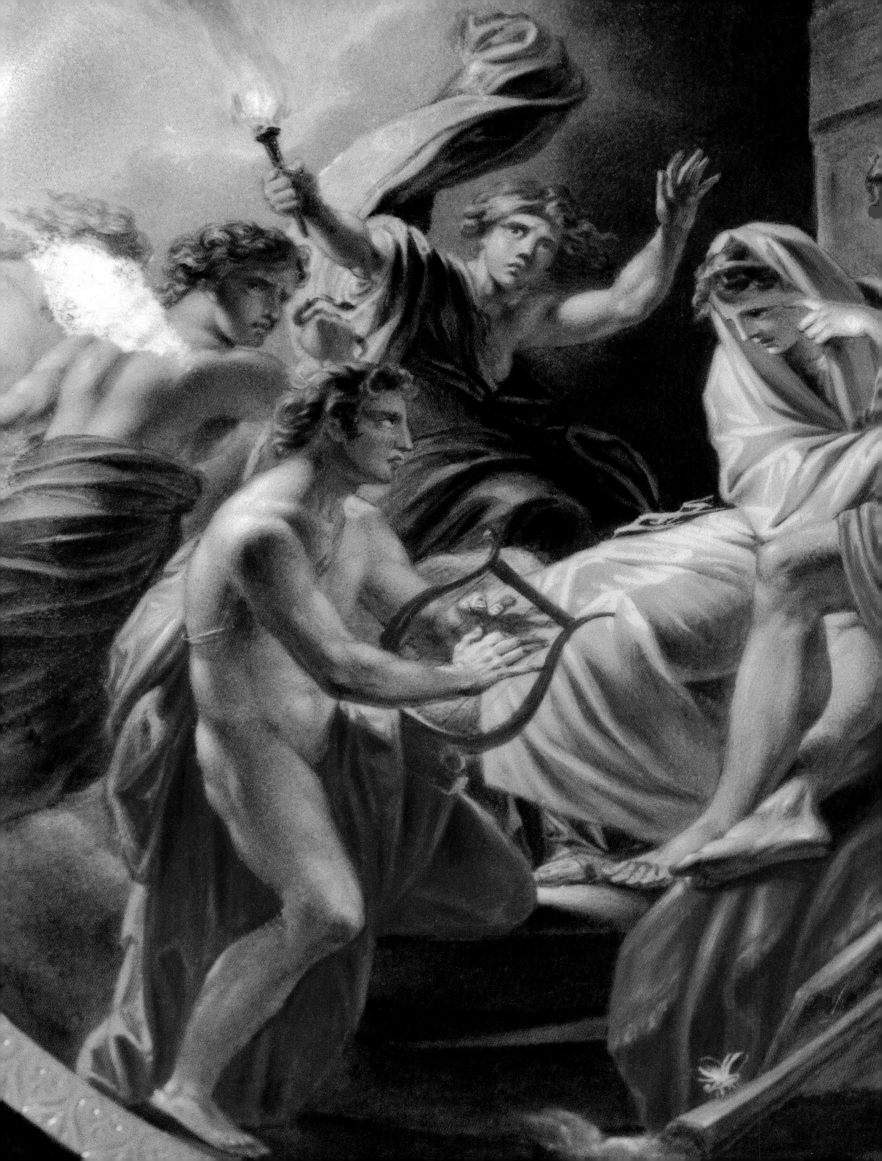

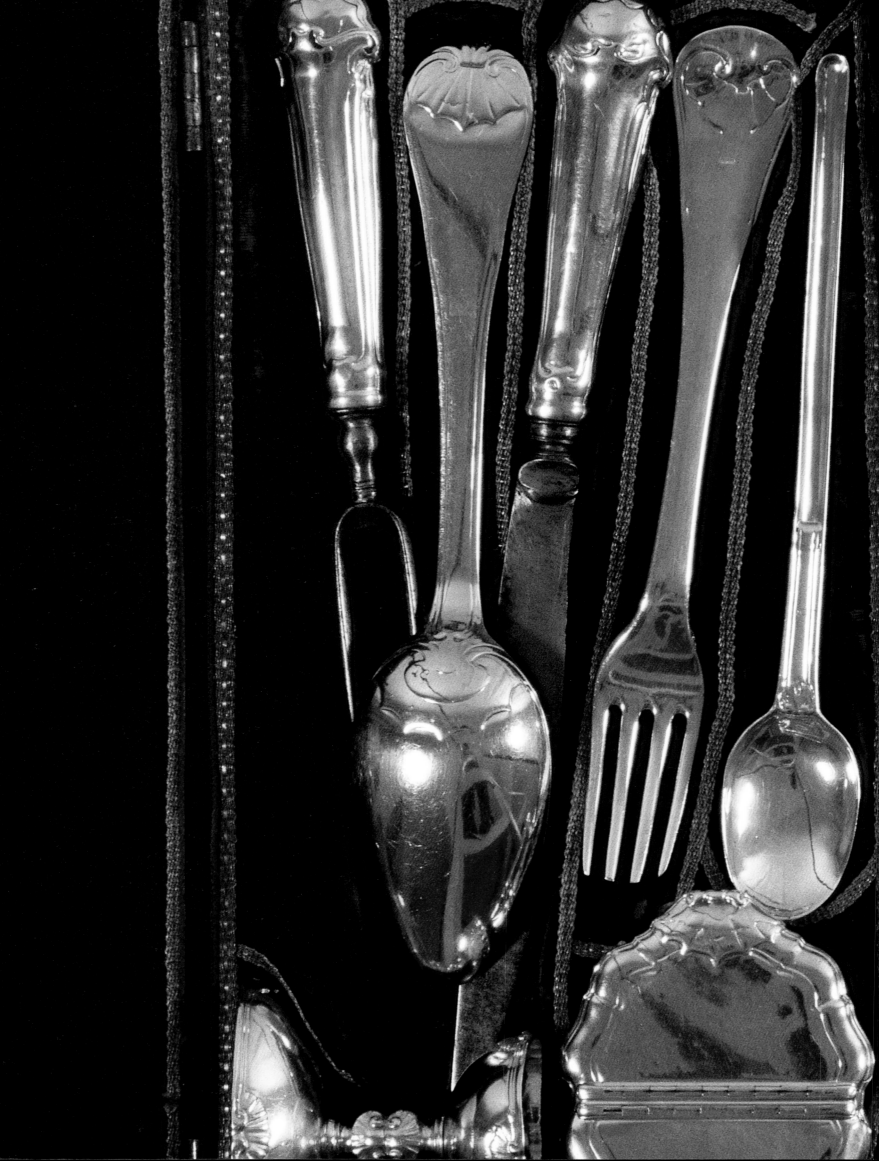

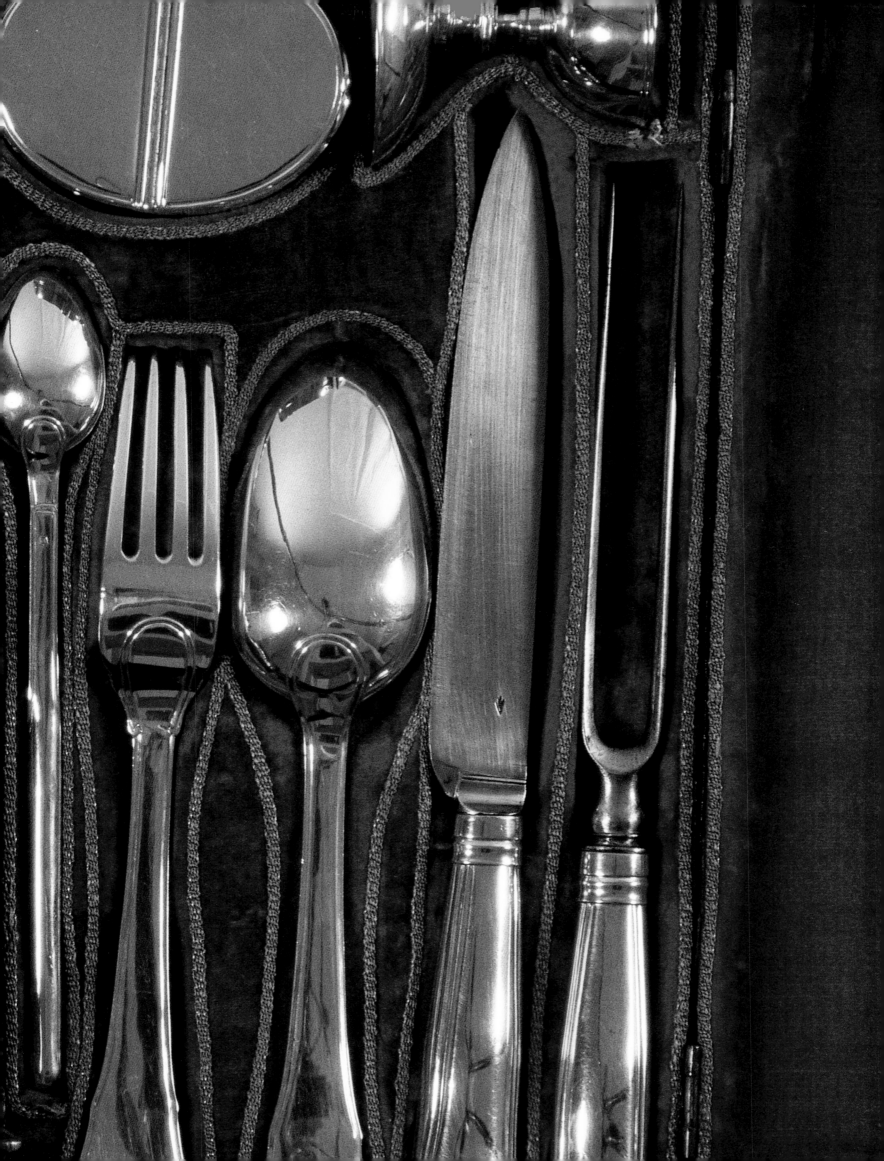

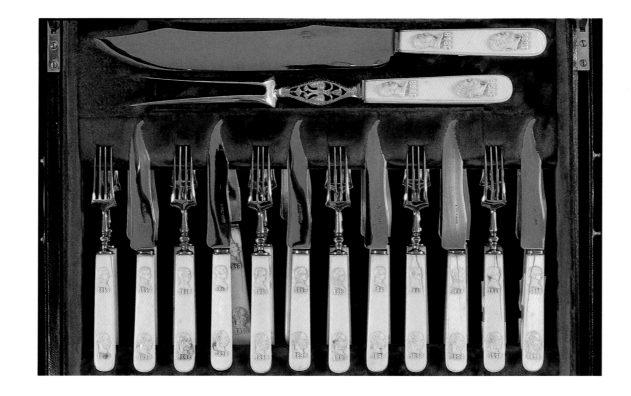

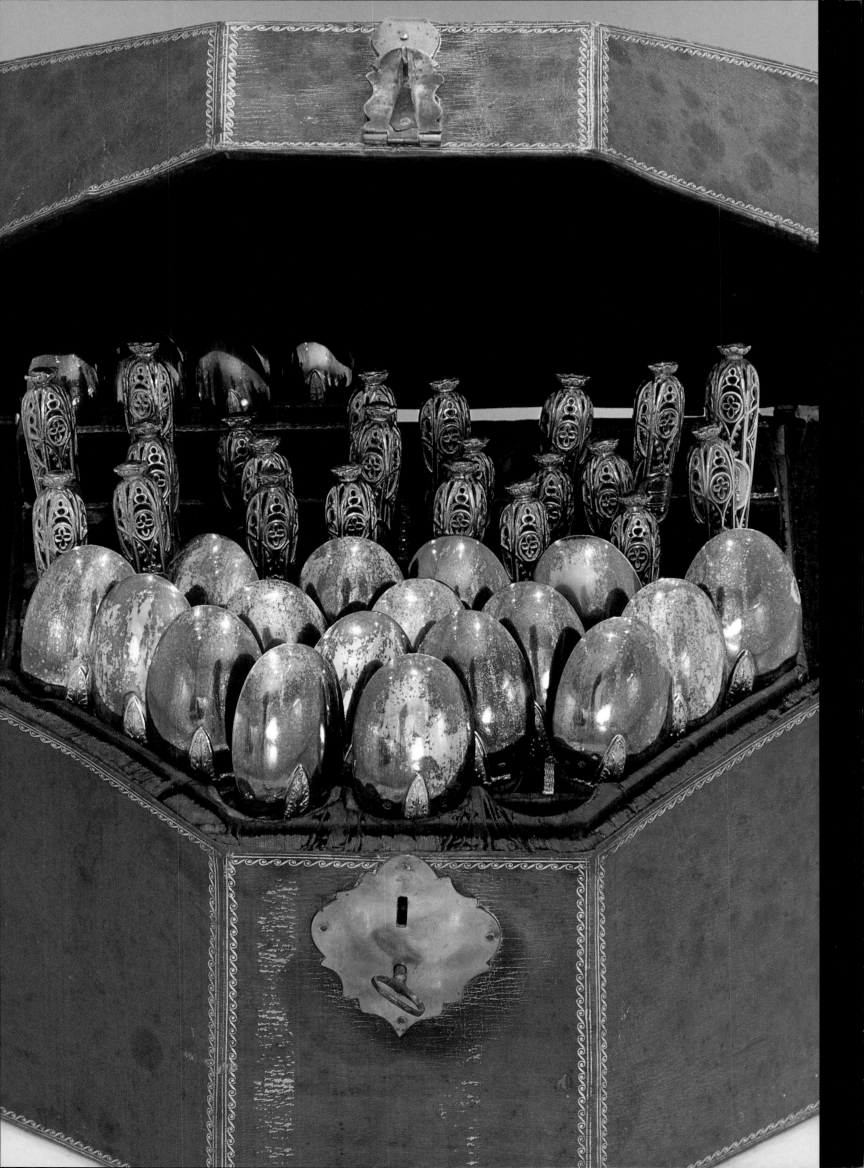

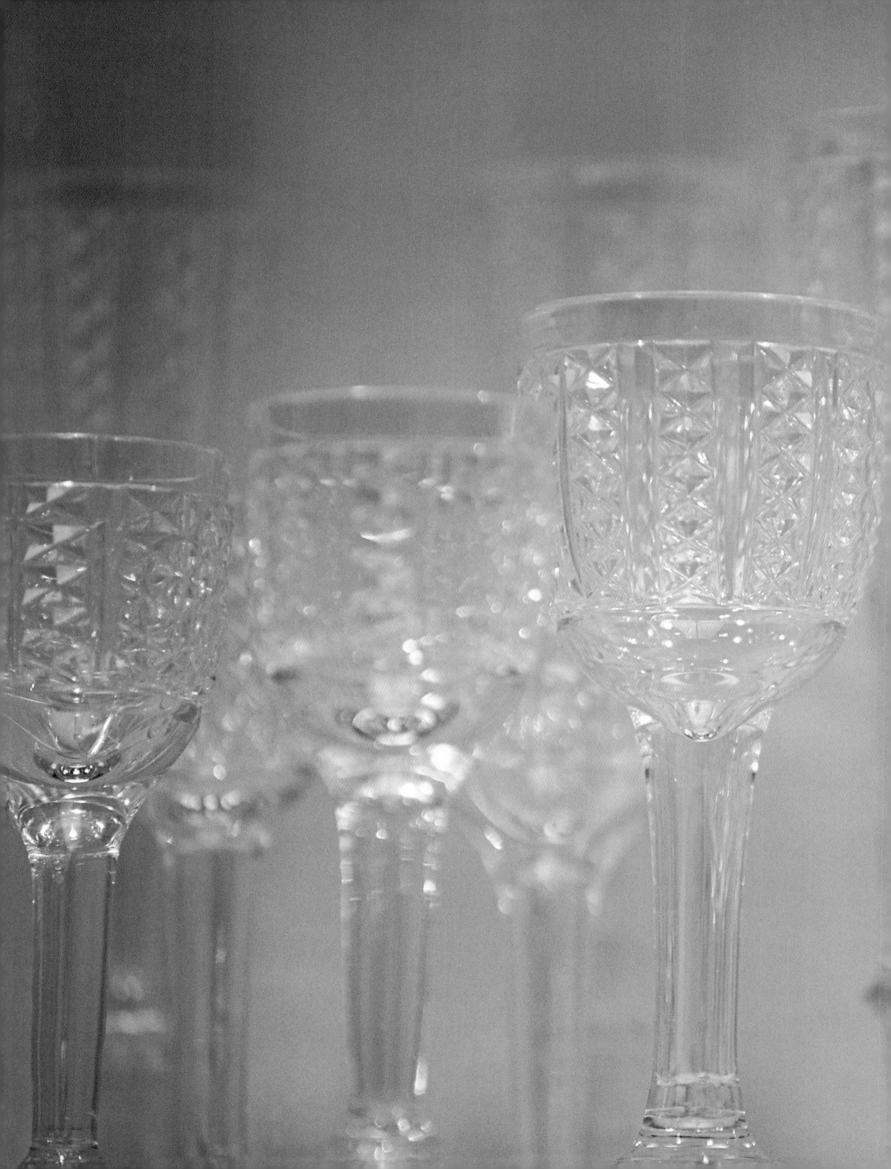

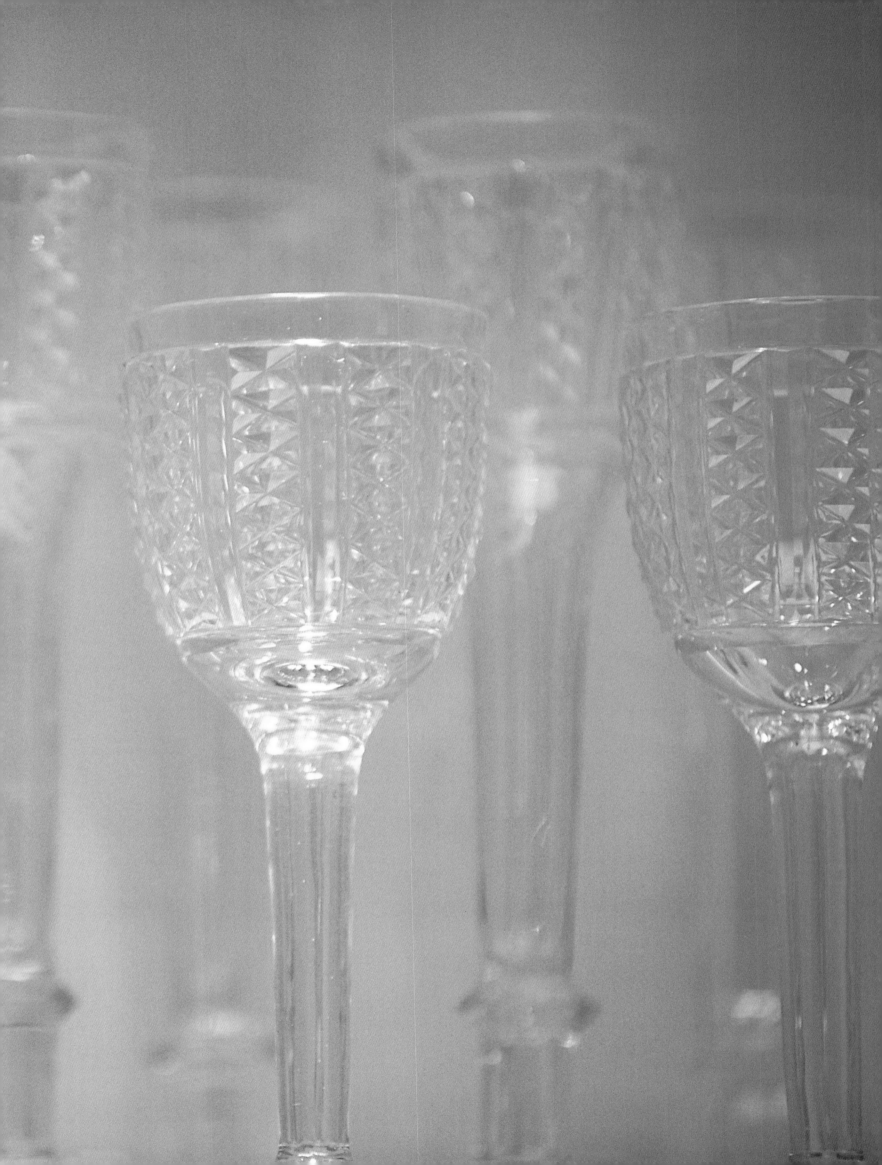

[201] PORCELAIN SOUP PLATES MANUFACTURED BY VIENNA PORCELAIN FAC-
TORY, VIENNA CIRCA 1804-1806. SILBERKAMMER. [202] DETAIL OF PORCELAIN
DESSERT PLATE MANUFACTURED BY VIENNA PORCELAIN FACTORY, VIENNA 1807.
SILBERKAMMER. [204] DETAIL OF PORCELAIN DESSERT PLATE MANUFACTURED
BY VIENNA PORCELAIN FACTORY, VIENNA 1807. SILBERKAMMER. [206] DETAIL
OF PORCELAIN DESSERT PLATE MANUFACTURED BY VIENNA PORCELAIN
FACTORY, VIENNA 1806. SILBERKAMMER. [208] PORCELAIN CHOCOLATE CUP
MANUFACTURED BY VIENNA PORCELAIN FACTORY, VIENNA 1807. SILBER-
KAMMER. [210] TWO SOLID GOLD TABLE SETTINGS, VIENNA CIRCA 1750, VIENNA
CIRCA 1780. SILBERKAMMER. (SEE AUTHOR'S NOTE IN REFERENCE) [212] IVORY
AND STAINLESS STEEL HUNTING CUTLERY MANUFACTURED BY WEITTMANN,
VIENNA 1898. SILBERKAMMER. (SEE AUTHOR'S NOTE IN REFERENCE) [213] SILVER
CUTLERY BY FRANZ WÜRTH, CASTLE LAXENBURG 1801. SILBERKAMMER, VIENNA.
[214] CUT CRYSTAL MANUFACTURED BY HARRACHSCHE HÜTTE, BOHEMIA
CIRCA 1825-1830. SILBERKAMMER, VIENNA. [216] PRISM CUT CRYSTAL MANUFAC-
TURED BY JOSEPH ROHRWECK, BOHEMIA CIRCA 1828. SILBERKAMMER, VIENNA.

BERLIN: SCHINKEL'S REALM

IT IS LUNCHTIME, AND I AM MEETING A FRIEND,

ALEXANDER SMOLTCZYK, A WRITER AND A BERLINER BY BIRTH,

AT THE CAFÉ EINSTEIN, LOCATED ON UNTER DEN LINDEN.

"BERLIN TODAY, TELL ME ABOUT IT!" —

"THE POET BERTOLT BRECHT," ALEXANDER BEGINS,

"ONCE WROTE THAT HE PREFERRED BERLIN TO ANY OTHER CITY

'BECAUSE IT CONSTANTLY CHANGES.'

DURING THE PAST TEN YEARS, SINCE THE FALL OF THE WALL,

THE CITY HAS CHANGED MORE THAN EVER.

TWO RADICALLY ESTRANGED CITIES, EACH WITH OVER

A MILLION INHABITANTS, EAST AND WEST BERLIN,

HAVE FORMED A PERFECTLY NEW CITY,

ONE WHOSE CITIZENS NOW ASK THEMSELVES WHETHER BERLIN

HAS FINALLY BECOME A METROPOLIS,

OR MERELY AN OVERBLOWN PROVINCIAL TOWN OR

'PARVENOPOLIS,' AS THE POLITICIAN WALTER RATHENAU

REFERRED TO IT.

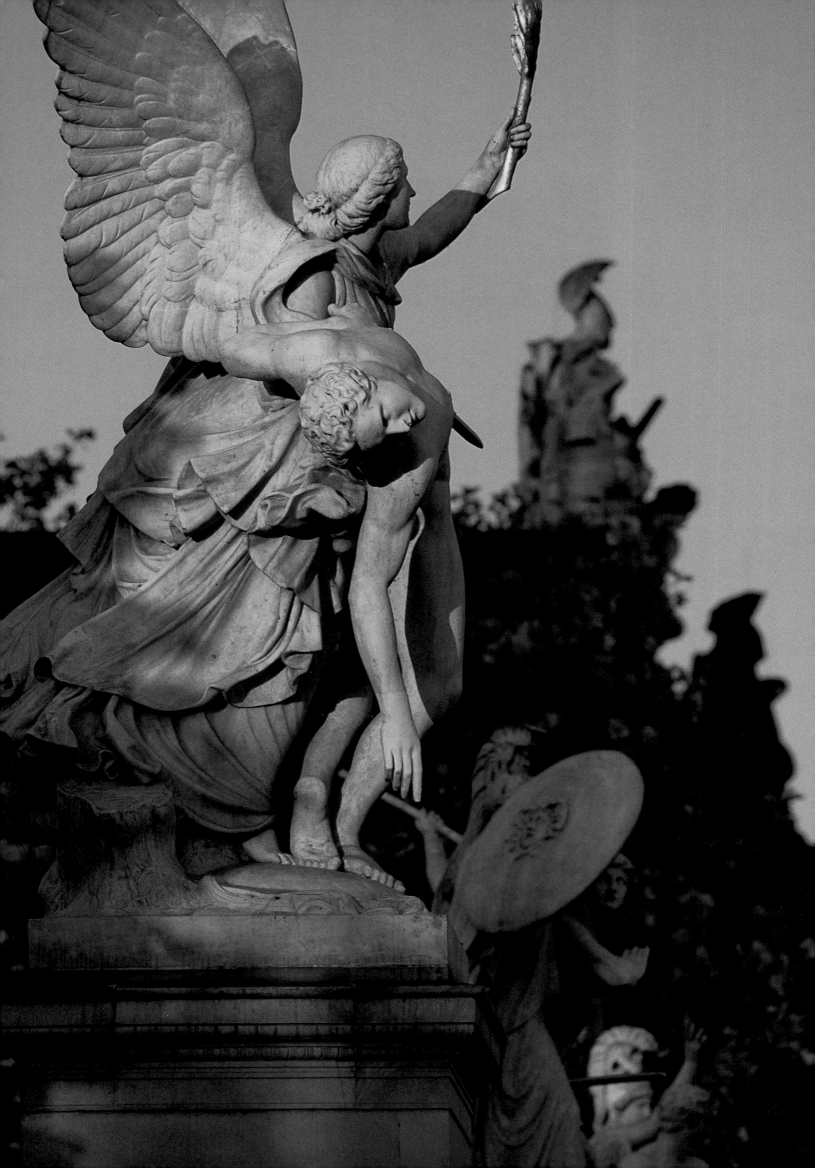

"I CONSIDER IT DISLOYAL TO BE MORE THAN ONE ACTUALLY IS. THE SPHERE OF ARTISTIC ENDEAVOR, WHICH IS THE ONLY THING THAT APPEALS TO ME, HAS SUCH AN INFINITE SCOPE THAT ONE LIFETIME IS MUCH TOO SHORT. I AM SADDENED TO KNOW THAT UNDER DIFFERENT CIRCUMSTANCES I WOULD HAVE ACHIEVED MORE AS AN ARTIST, AND I AM TORN TO PIECES BY THE THOUGHT OF DOING WORK WHICH TAKES TIME AWAY FROM MY ACTUAL VOCATION." KARL FRIEDRICH SCHINKEL

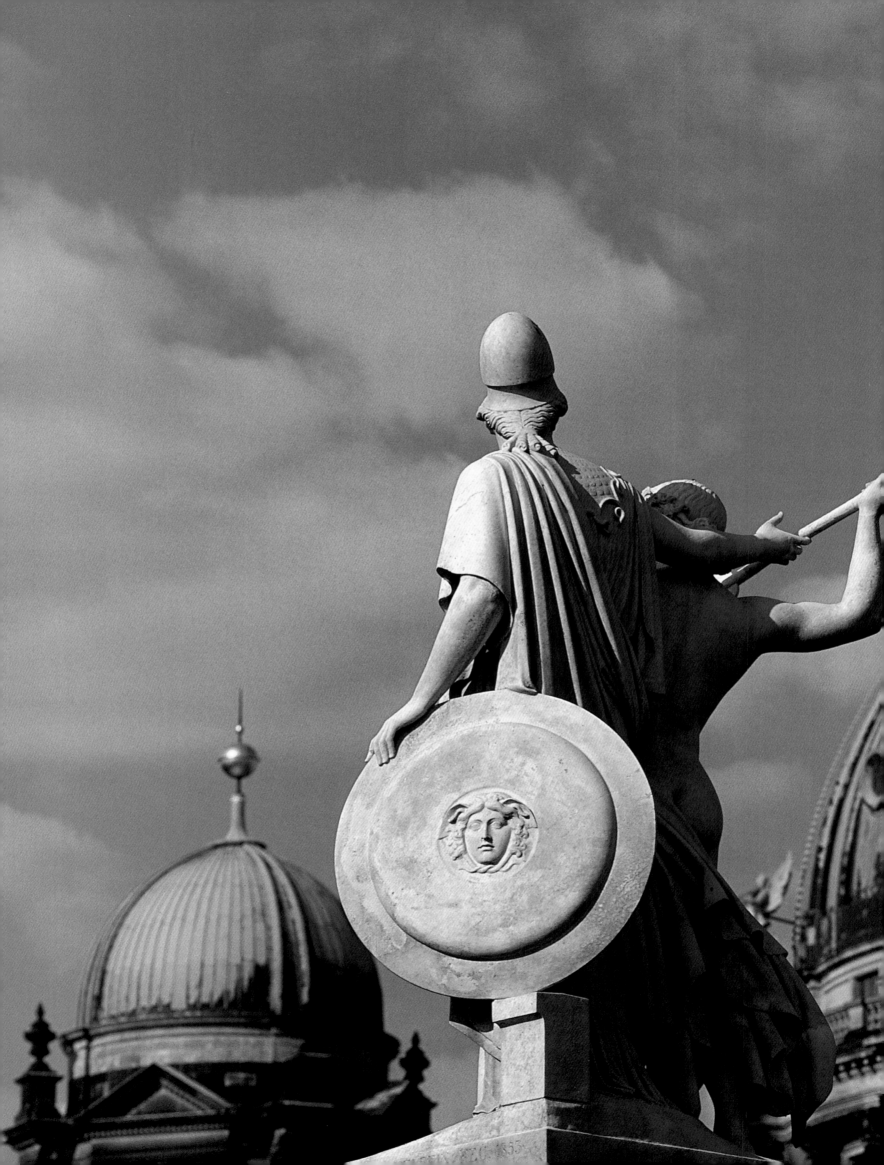

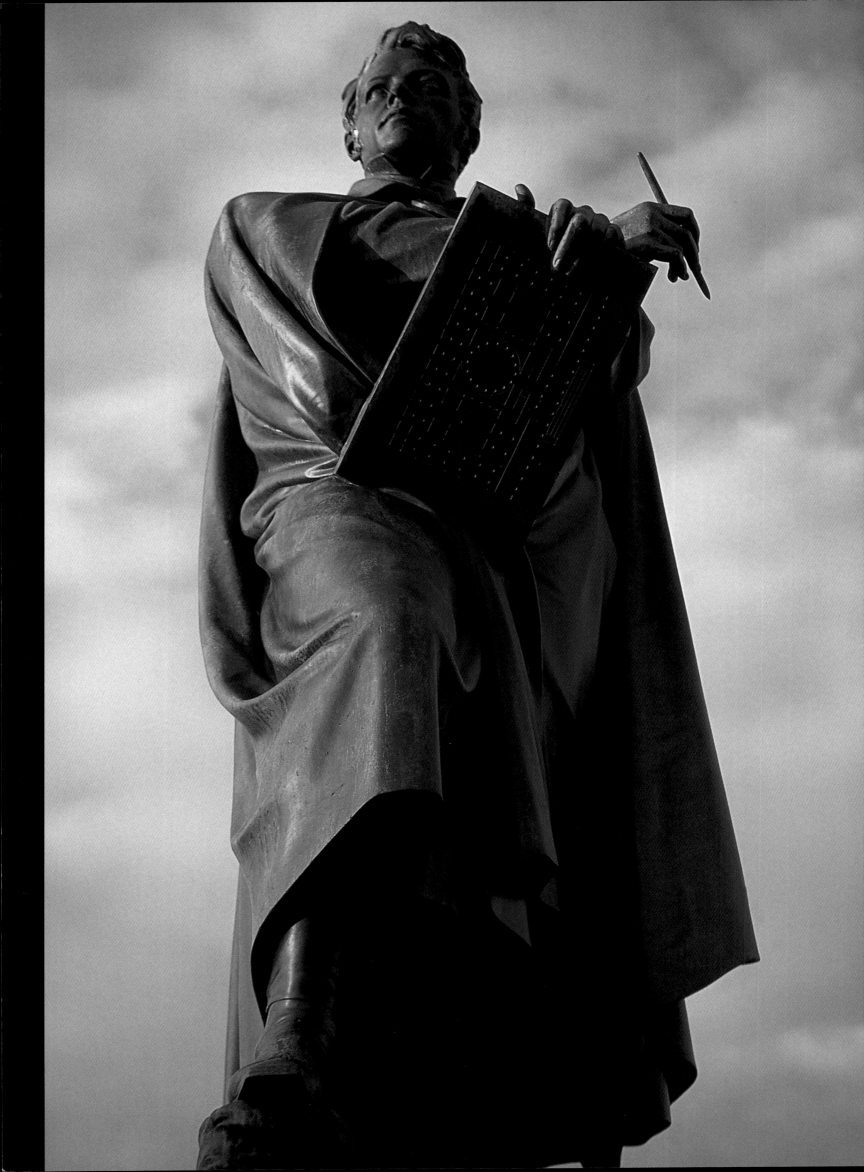

SELF-DOUBT is as much a characteristic trait of the Berliners as their cheeky glibness. The government in Bonn," Alexander continues with a bit of irony in his voice, "planned the move to Berlin for eight years, and the intellectuals of the city welcomed the move, but thought it impossible to accomplish. With the opening of the Chancellor's office in April 2001, they reached their goal. The urban district around Friedrichstrasse, which had been run down during the era of socialism, has been totally redeveloped. The old Jewish quarter has become the Tribeca of Berlin. In the new salons, literary clubs, and intellectual hangouts, the debate goes on, night after night, whether or not Berlin now has a classy society and a cultured bourgeoisie, as in the days of the writer Rahel Varnhagen and during the Roaring Twenties. While they are talking, design furniture stores spring up like mushrooms out of the sidewalks of Kantstrasse in Charlottenburg, and in Potsdam they are restoring one villa after another. You would love it, Linda. In any case, Potsdam, which in the days of the socialist GDR was a sad garrison town, has become the Versailles of the city. That's where people with real class and money have their houses, in the immediate vicinity of Sanssouci Palace. YOU MUST KNOW, Berlin has always been a stage on which everyone could try his luck. Nothing was impossible, and centuries-old, painstakingly acquired style is just as absent as lineage, social status, and established unspoken rules. This may be the reason why in recent years people from Paris, Moscow, Prague, and the Baltic countries have been moving to Berlin.

[222] PANORAMIC VIEW OF THE SCHLOSSBRÜCKE BUILT BY KARL FRIEDRICH SCHINKEL, BERLIN 1822-1823. [224] DETAIL OF THE SCHLOSSBRÜCKE: STATUES DESIGNED BY KARL FRIEDRICH SCHINKEL, ERECTED 1853-1857. BERLIN. [226] DETAIL OF THE SCHLOSSBRÜCKE: VIEW OF A VICTORY STATUE AND THE BERLINER DOM. [228] STATUE OF KARL FRIEDRICH SCHINKEL (1781-1841) IN SCHLOSS SQUARE. BERLIN.

Believe me, it's good to live in a city that is in the making." IT SEEMS TO ME that in Berlin this was always the case. In the nineteenth century a man named Karl Friedrich Schinkel dominated the world of architecture in Prussia. On my birthday, March 13th, one hundred and seventy-five years before my own first scream, Schinkel was born. Already as a child he displayed an artistic temperament. He developed an early talent for painting, sketching, and music, but theater was his real passion. It is no surprise that this love led him to the design of theatrical sets. He approached the theater icons Iffland and E.T.A. Hoffmann with his ideas for simplifying what he saw as the excessive Baroque stage sets popular at the time, which disgusted him. His innovative suggestions went unheard and it is no surprise that Schinkel's pursuit of the stage took place after Iffland's death. The National Theater burned down in 1817 and was replaced by the Neues Schauspielhaus. Here, finally, Schinkel had his triumph, with his designs for Mozart's *The Magic Flute*. His creations were a sensation. LOOKING BACK, one can see that it was his meeting with the prominent architect David Gilly that helped shape Schinkel's career. At seventeen years of age, Schinkel was in awe of the architect's work. Soon Gilly realized the extraordinary talent of this young man, who effortlessly filled sketchbook after sketchbook with renderings. Gilly took Schinkel on as an apprentice architect, and under Gilly's guiding hand Schinkel began to form his own energetic signature. In March 1803 he traveled to Prague, Vienna, Triest, Venice, Bologna, Florence, and finally Rome, where he spent the winter. His impressions of Italy, and of Rome in particular, stimulated his feeling for Romanticism and Classicism. Returning to Berlin, after visiting Paris and

attending the coronation of Napoleon, he was mature and had developed confidence and his own sense of style. WHILE NAPOLEON was setting much of Europe on fire, there was little work for a young architect. Schinkel turned to his friend Wilhelm von Humboldt, whom he had met during his travels in Rome, for help. And of course Humboldt was instrumental in securing him employment at the Bauakademie, where he became responsible for the approval of new buildings in Berlin. With this new position, his social status was elevated. He married, fathered three children, and saw his career take off. TO UNDERSTAND HOW a young architect was commissioned to redesign royal palaces, I need to tell you about a king and a queen. For insight into the complexities of this history, I meet with the expert Dr. Burkhardt Göres, Director of Prussian Castles in Berlin and Brandenburg. Dr. Göres is a very verbal man, a magical storyteller to whom one listens with anticipation. As we walk through Charlottenburg Palace, he illuminates the past: "In 1797, when Friedrich Wilhelm III, married to Luise von Mecklenburg-Strelitz, ascended to the throne, the ideas of monarchic representation had been transformed due to the Enlightenment and the French Revolution. The young couple led a simple life. Their apartments in Charlottenburg, above all that of the king, were of bourgeois simplicity. QUEEN LUISE made use of the recently completed winter chambers of her late father-in-law on the upper floor of the new wing, while her husband occupied the ground floor of the apartment of Elisabeth Christine, and got rid of the now unpopular Rococo decorations behind coats of paint and wallpaper. The furnishings frequently consisted of existing pieces. THE ROYAL COUPLE had nine children, which contributed to

their personal happiness. A marked change occurred only as a result of the Napoleonic Wars. After the devastating Prussian defeats at Jena and Auerstedt in 1806, Friedrich Wilhelm III and his family fled to Memel. This allowed Napoleon to march into Berlin without battle. He immediately took quarters at Charlottenburg Palace. A BASIC RESTRUCTURING of individual rooms in the new wing came about in 1810, after the return of the royal family from their East Prussian exile. At this time, the young architect Karl Friedrich Schinkel was commissioned to design a bedroom for Queen Luise. This was the beginning of Schinkel's working collaboration with the royal couple." SCHINKEL first proposed a scheme that drew inspiration from his fantasies of the night; he imagined a starry sky decorating the ceiling. Queen Luise much preferred the dawn, with a soft, rosy pink appearing on the horizon. To realize her vision, Schinkel covered the walls with white voile over pink wallpaper, giving the illusion of the first flush of dawn. This romantic evocation of atmospheric effects became stronger with the draping of the fabric to imitate the rays of the rising sun breaking through early morning clouds. THE QUEEN'S BED, with its simple and individualistic form, shows little decoration, yet is delicate and feminine. The flower tables are fitted with containers to hold the queen's favorite violet cornflowers. The design for the carving at the tops of the tables is inspired by Corinthian columns—a strong concept for such delicate pieces, which exhibit many of the sensibilities of design at the end of the eighteenth century. Seeing my enthusiasm, Dr. Göres adds, "The queen's bed and her flower tables, made of pearwood, are considered by me and many others to be the finest examples of furniture ever designed by Schinkel."

I agree. I remember reading that Schinkel referred to this period as his happiest. UNFORTUNATELY, the queen was not to enjoy the room for long. She died at the young age of thirty-four. "The grieving widower," Dr. Göres continues, "had a mausoleum built at one of the queen's favorite places in Charlottenburg Park, at the end of the avenue of fir trees. The small monument, styled in the fashion of a Doric temple, was created after an idea by the king. Schinkel designed the mausoleum and supervised the work which was executed by Heinrich Gentz." AFTER QUEEN LUISE'S DEATH, the king avoided the rooms she had occupied in the new wing. In 1824, following his second marriage, to Auguste, princess of Liegnitz, he once again commissioned Schinkel, this time to build a small summer residence, as a private haven, on the River Spree. The New Pavilion is a two-story building with a flat roof. Almost cube shaped, each facade is completely designed. The plan view reveals that it is not, in fact, a perfect cube. Schinkel concealed this subtle difference with his placement of columns and pilasters within the loggias of the side elevations on the upper floors. The New Pavilion's four French doors on the ground floor allow direct access to the gardens. A surrounding balcony completes this replica of the Villa Reale Chiatamone. The king had stayed at that villa in 1822, and Schinkel later visited it on his second trip to Italy in 1824. UPON ENTERING the New Pavilion, I ask Dr. Göres to tell me what he thinks of Schinkel's work during the period known as Biedermeier. "True, this is the Biedermeier period," he responds, "but Schinkel simultaneously designed Neo-Gothic furniture, numerous decorations and even complete palaces. Actually it is very difficult to agree about Schinkel's being a Biedermeier architect. At the

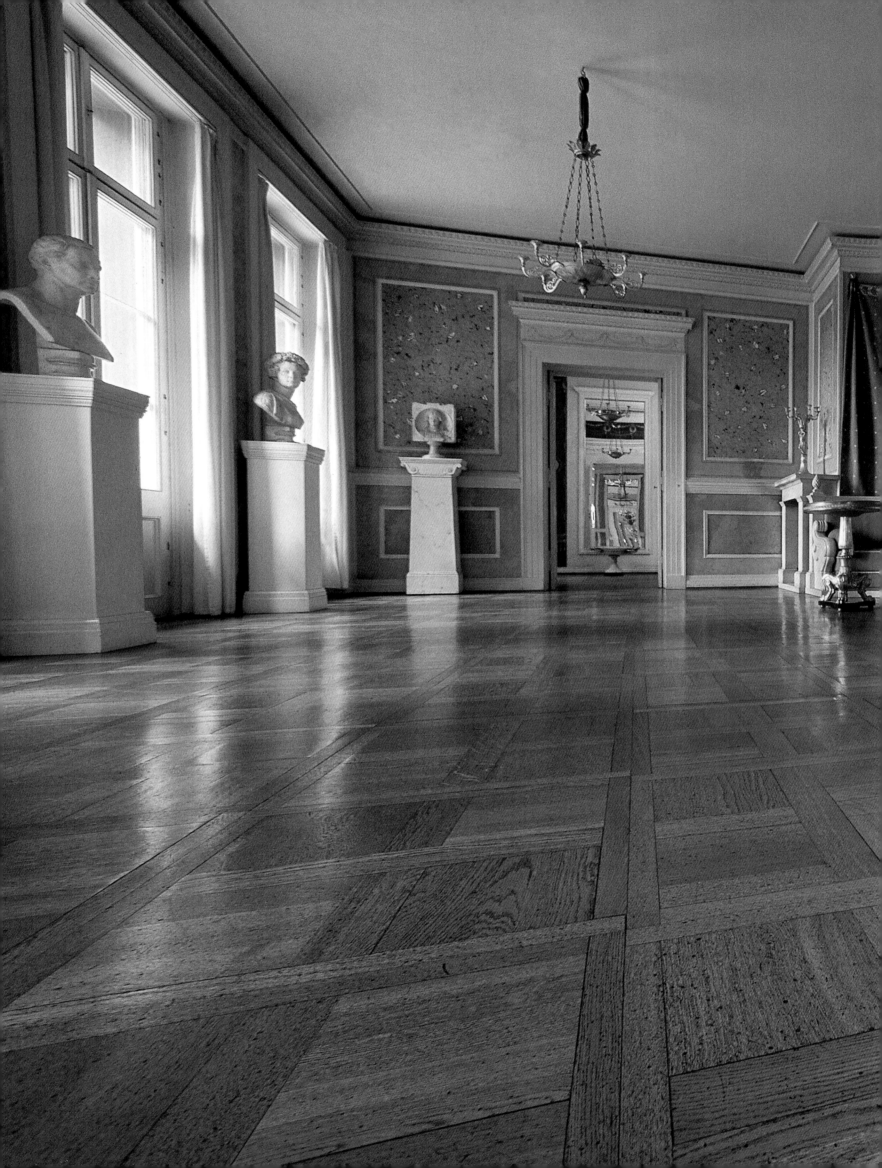

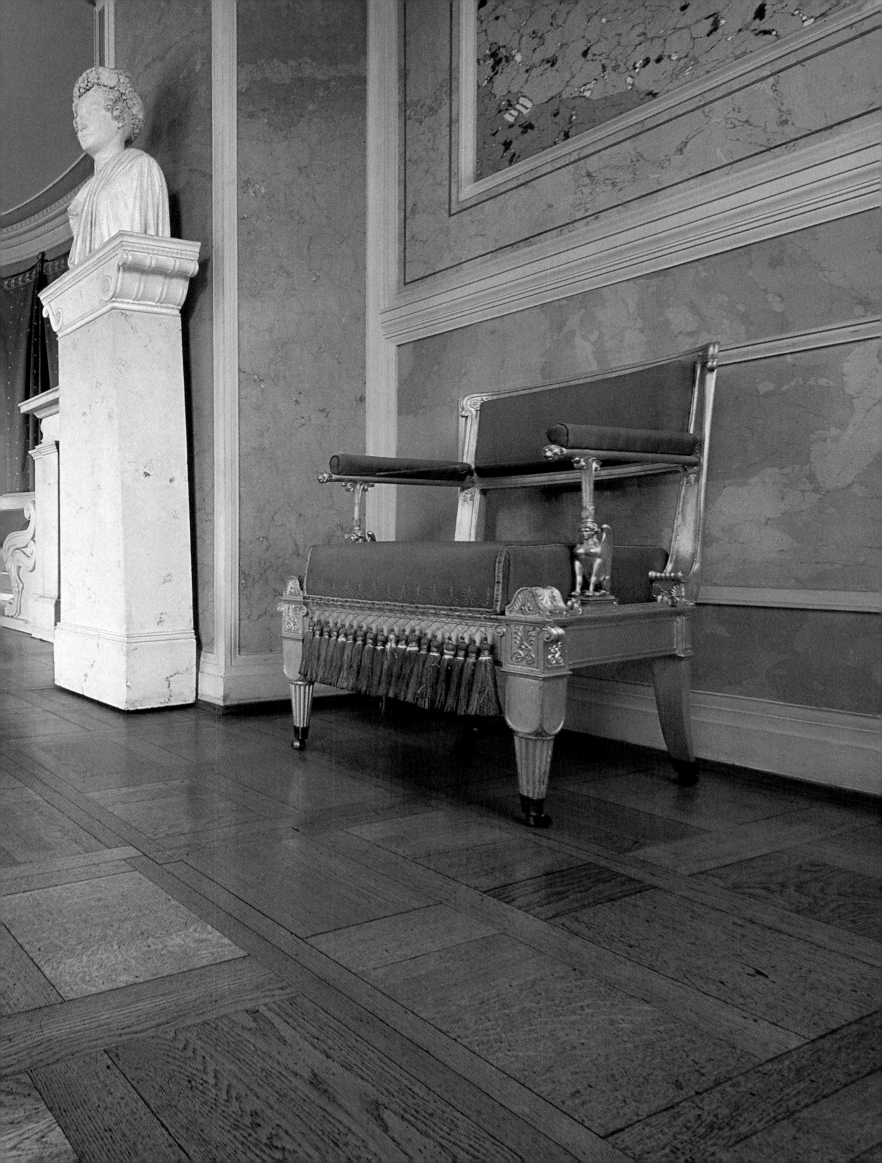

museum we like to think of Schinkel as a unique designer and architect, because his range was so great. Schinkel was a genius, and it is impossible to classify his work as fitting into a single category. He was at least a hundred years ahead of his time, and his contemporaries could capture only a glimpse of his real capabilities." Knowing how long the Germans had needed to appreciate the full importance of Goethe, I was not surprised at what Dr. Göres told me. "What Schinkel did at this Pavilion we can accept as Biedermeier, yet his work clearly reflects his client's attitudes with respect to the great number of styles available. Today, it is expected of Frank Gehry and other famous architects that they come up with an exceptional new idea. At the time that the New Pavilion was planned as an Italianate residence, it was the crown prince's wish, and that is all there was to it. That is why Schinkel had to propose a suitable idea. Schinkel was able to maintain his own vision, at least to a certain degree, within these boundaries, which testifies to his brilliance." THE VESTIBULE on the ground floor inside the New Pavilion feels cool yet inviting. "Before I show you around"—Dr. Göres's voice fills the elegant room—"I want to point out that during the air raids on 23 November 1943 the Pavilion was destroyed by fire, and almost all the original furniture and much of the interior was lost. Only some of the major pieces were rescued. The reconstruction and, in part, the redesigning started in the early 1950s with the use of actual fragments, as well as original documents and later photographs. When, in individual cases, no copies could be made, contemporary artists were commissioned to produce

[234] GARDEN ROOM DESIGNED BY KARL FRIEDRICH SCHINKEL, BERLIN CIRCA 1826. MARBLE BUSTS DEPICTING MEMBERS OF THE ROYAL FAMILY BY CHRISTIAN DANIEL RAUCH, BERLIN CIRCA 1824. SCHINKEL PAVILION.

recreations. Upon completion in 1970, the building became a museum that has been renamed the Schinkel Pavilion." AS I LOOK AROUND, the walls are divided panels with arabesques painted on paper. The originals were processed by Julius Schoppe in Berlin, as instructed by Schinkel. The stairs are clothed in oak, with a mahogany banister. The amazingly modern balusters are made of polished brass. On a paneled oak floor stand two monumental terra-cotta candelabras, which have been painted to give the impression of patinaed bronze. Dr. Göres's earlier comment comes to mind: "Schinkel was at least one hundred years ahead of his time." TURNING LEFT, we enter the Garden Room, which is decorated throughout with stucco marble. Soft gray-blue panels bordered in white are juxtaposed with light green inserts, giving the large room a cool, elegant feeling. The richness of the warm wooden floor offers an unexpected contrast to the semi-circular painted banquette in white, with marquetry inlay. Above the banquette I see draped decorations in gray-blue silk. Eight gilded rosettes adorn the bottom, with golden stars completing the design. BEYOND THE GARDEN ROOM is the Red Room. The walls are covered in a dark red velvet wallpaper, bordered at the bottom with ornate tassels. Ribbon designs containing figurative Pompeian motifs cascade vertically, with a formal stylized border. This reconstructed wallpaper was undoubtedly inspired by French examples. Percier and Fontaine's influence is somehow felt in Berlin. Sculptures by Johann Gottfried Schadow and his pupils complement the room's design to sheer perfection. I PASS THROUGH THE GREEN ROOM, the Chamois Room, and finally the servants' chamber, which displays Biedermeier furniture donated from the collection of Professor Johannes Sievers,

who compiled in the 1930s a unique documentation on Schinkel's work. UPSTAIRS, after strolling through the Bedroom, the Study, and the White Room, we are now in the Recital Room, and Dr. Göres gives me an inside view of the art of iron furniture. "In Prussia during the late eighteenth century, we had a foundry in Gleiwitz, Silesia, and in 1804 another was established in Berlin, the Royal Iron Foundry. A happy symbiosis developed. As the quality of the iron was superb, the material became the choice of a large number of leading sculptors and architects. Initially they designed decorative objects. Shortly thereafter, hardware for furniture, vases, figurines, smoke vessels, and similar items was produced. Their focus then turned to tombstones, as a result of the Napoleonic Wars. In our archives we even keep New Year's cards from the Royal Iron Foundry that feature the most important products created during the previous year. Later the foundries manufactured winding staircases like those we find in England, and large candelabras for gas lighting. Everything was made of iron, and of course everything was molded and cast exquisitely. We always ask ourselves how it was possible to achieve this level of excellence. Today it is almost impossible to produce such flawless work without enormous finishing or chasing, which is normally not done with cast iron. The foundries developed a technology that enabled them to achieve a standard that nobody can duplicate today. We are proud to show some world-class examples like this Schinkel chair in front of us. By the way, another interesting fact is that these works in iron were considered to be manufactured from patriotic materials. This also applies to the woods they used. During exhibitions held at the academies it was emphasized that the furniture

creations were crafted of local woods. For instance, with furniture it was specifically pointed out that they were made of patriotic woods, and no longer of mahogany. This trend became very important." DR. GÖRES wished me luck with my interview in Potsdam and hurried off to give a lecture to a waiting group of students. I sat alone, surrounded by Schinkel's achievements. I was in awe of his richness of fantasy and his paramount creative power. Yet I remembered reading that Schinkel himself had bemoaned the incessant rush of his fantasies, against which he fought constantly. NEXT MORNING: POTSDAM, in the park of Sanssouci. It is early, the air is crisp, and the rays of the sun dance above the small classical palace of Charlottenhof, named after one of its former owners, Marie Charlotte von Gentzkow. At first sight it has the charm of a weekend retreat for lovers. Small and intimate, this palace exudes a rare personality: it is somehow earthy, like a farmer, and at the same time as elegant as a gentleman dressing for the opera. WAITING FOR ME at the door is Frau Ulrike Zumpe. "Miss Chase, I see you found your way." As we turn to go indoors, I ask, "What is life like in the day of a palace manager?" "Well," she answers, "I manage palaces. This includes not only Castle Charlottenhof, but also the Roman Baths, the Chinese Pavilion, and the Steam Engine House." "Is it possible to begin with the palace, to keep things simple?" I ask with a smile. "Of course. On Christmas in 1825, Crown Prince Friedrich Wilhelm IV received Charlottenhof as a gift from his father. Karl Friedrich Schinkel and Peter Joseph Lenné were commissioned to make the structural and landscaping changes necessary for the summer house, which was no easy task. They had previously collaborated on the plans for the Glienicke Palace and Park

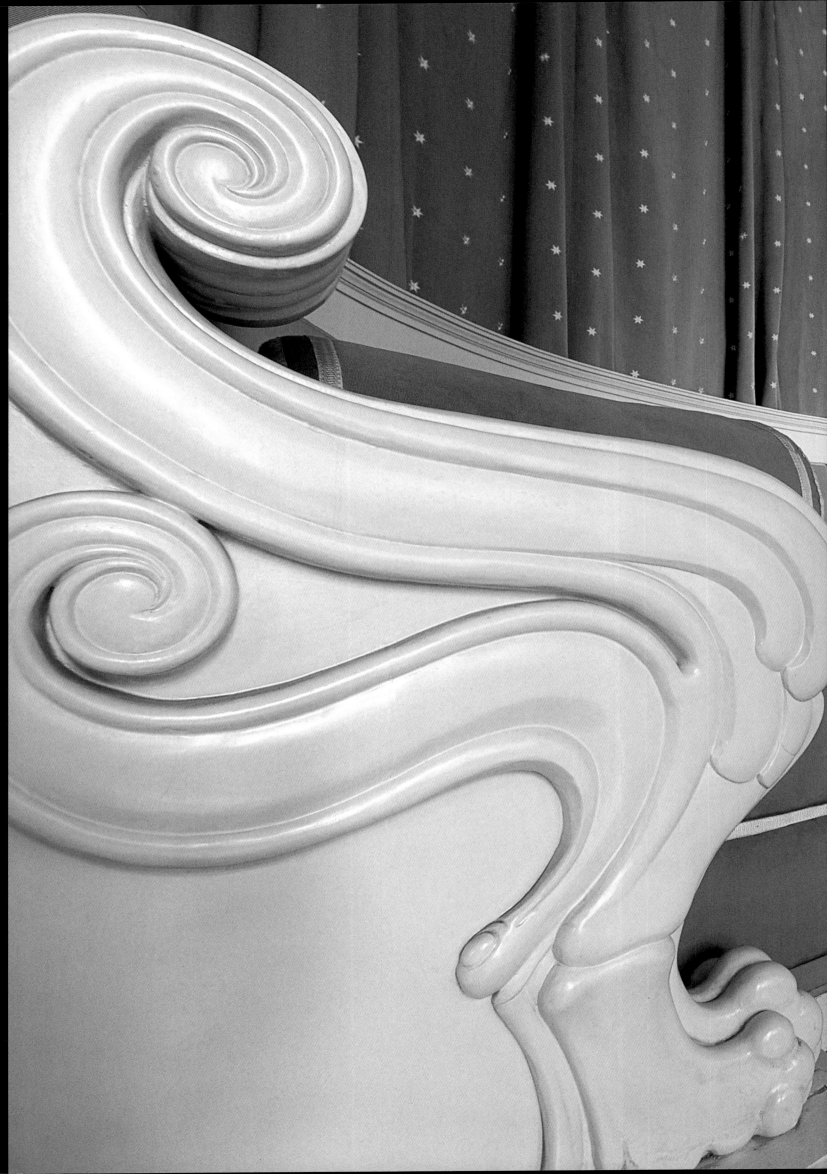

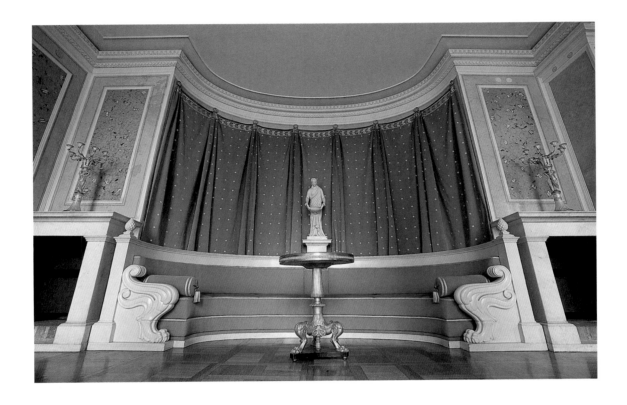

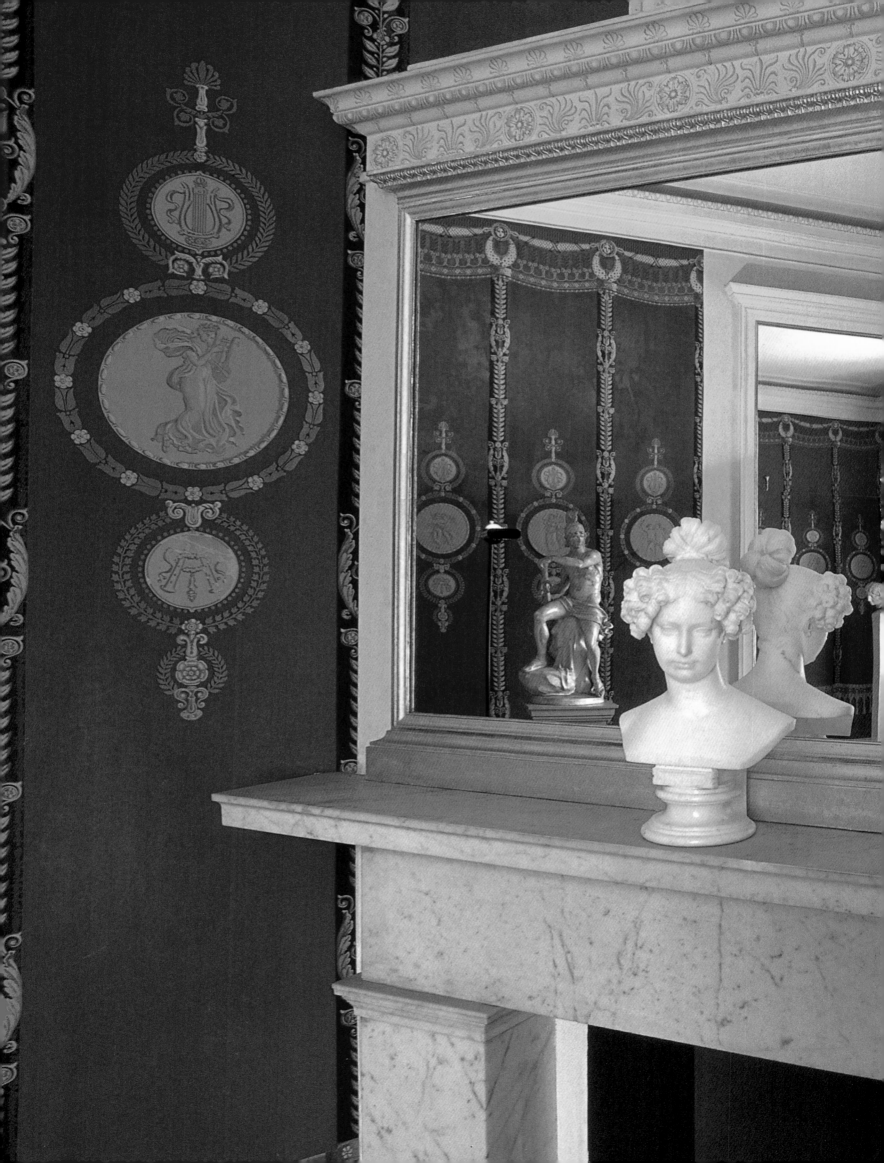

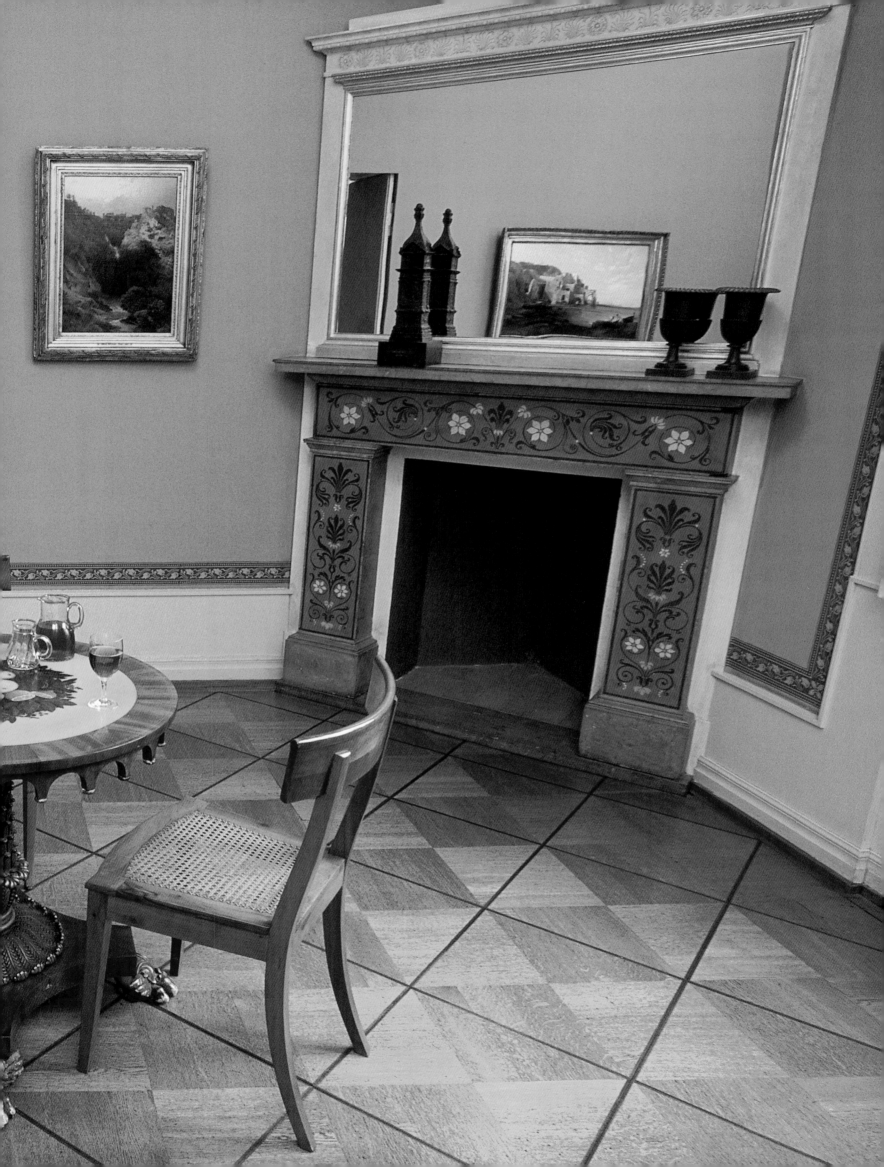

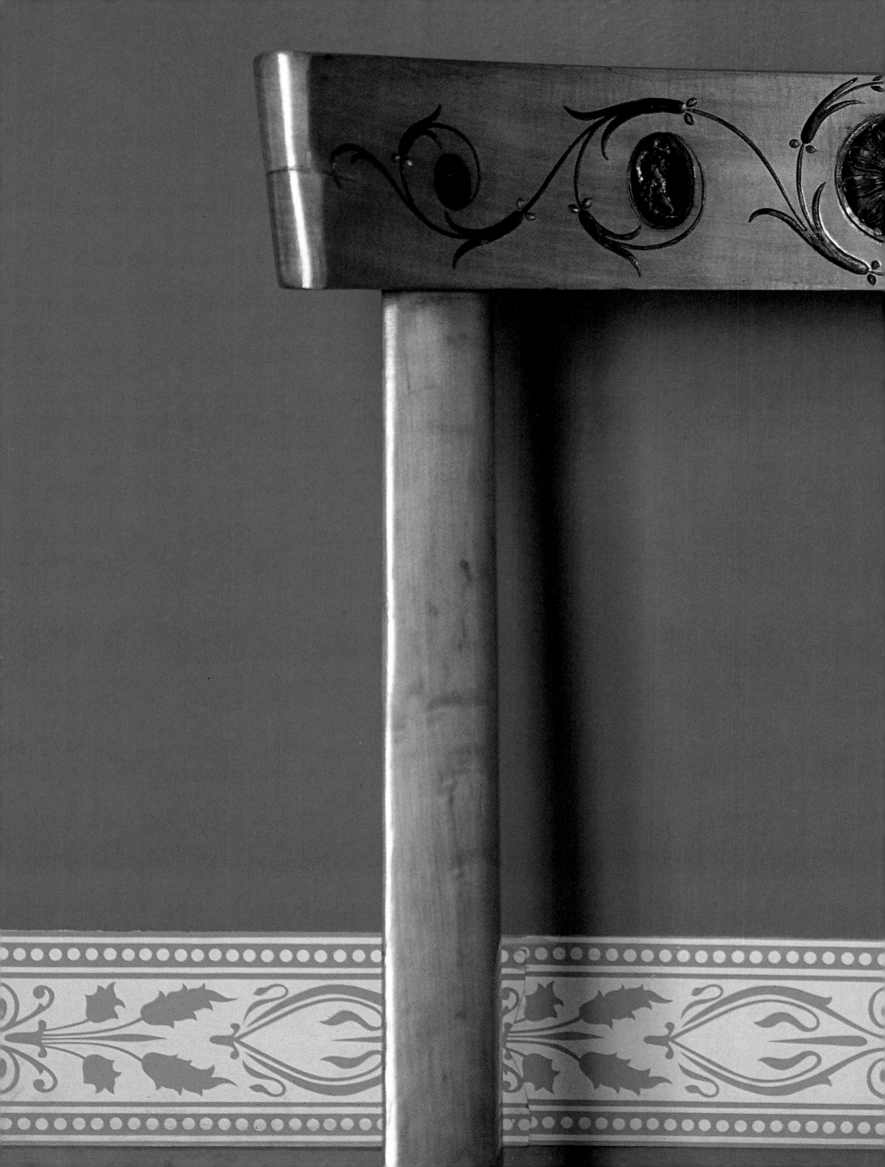

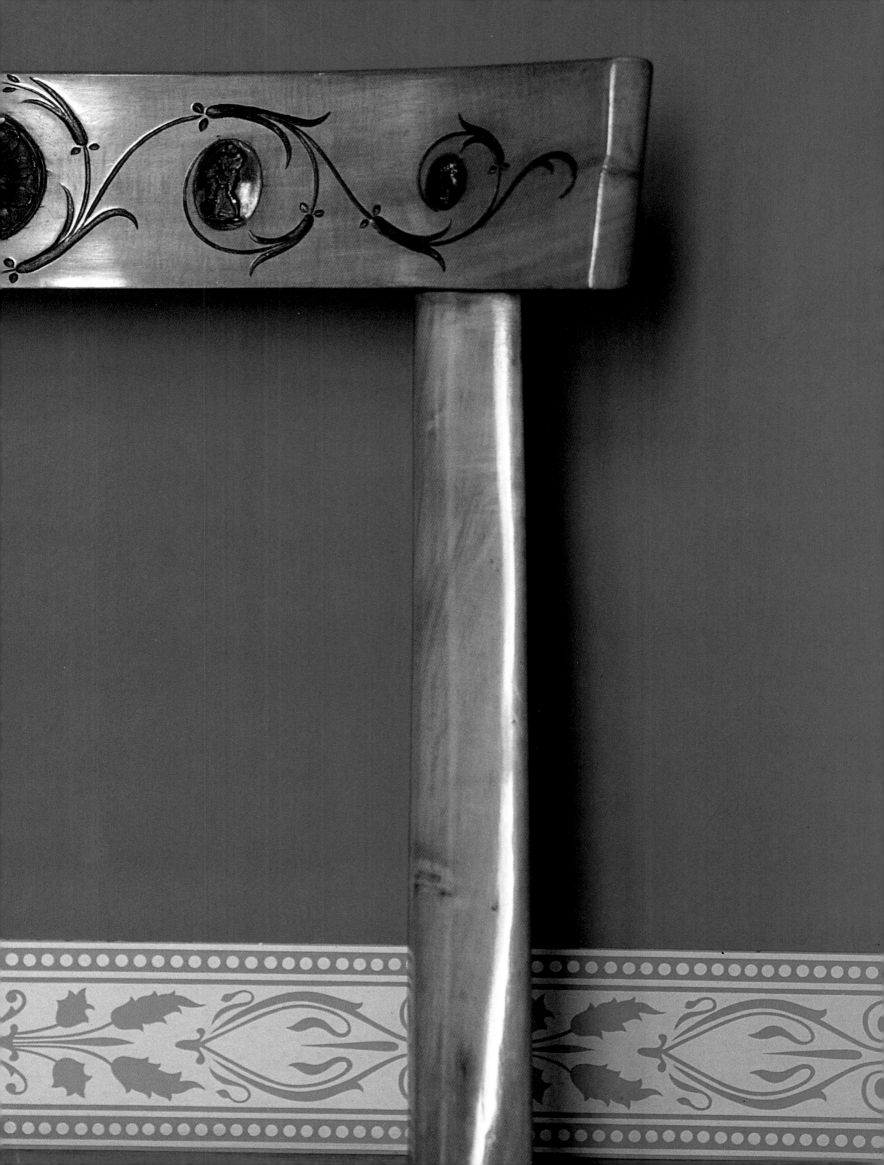

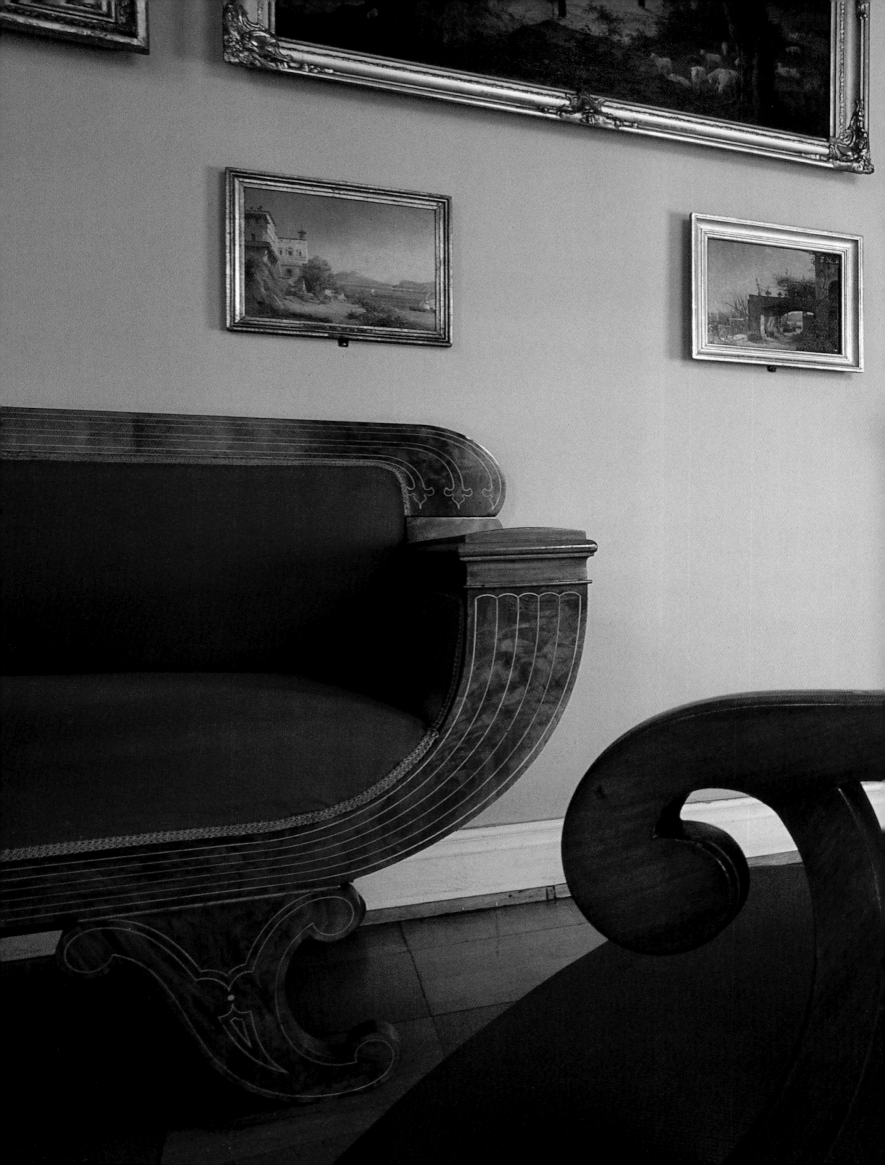

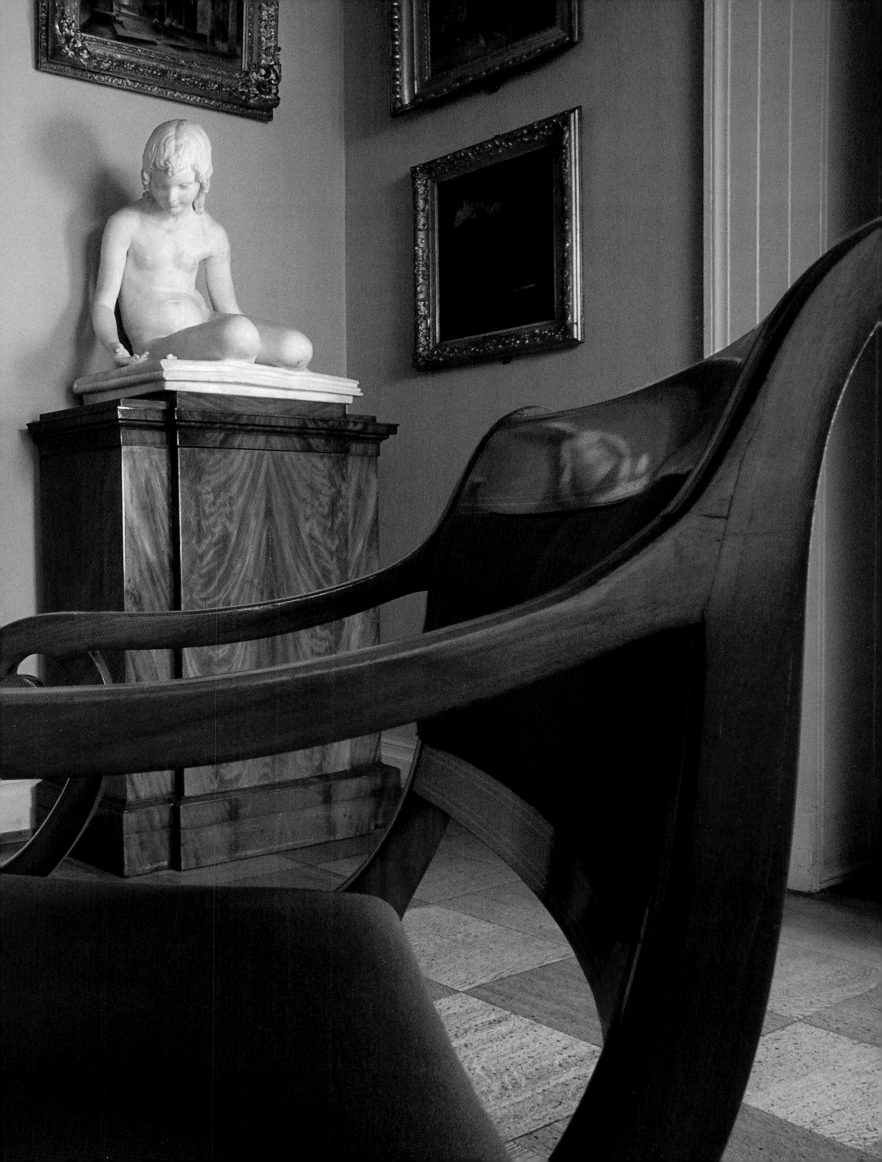

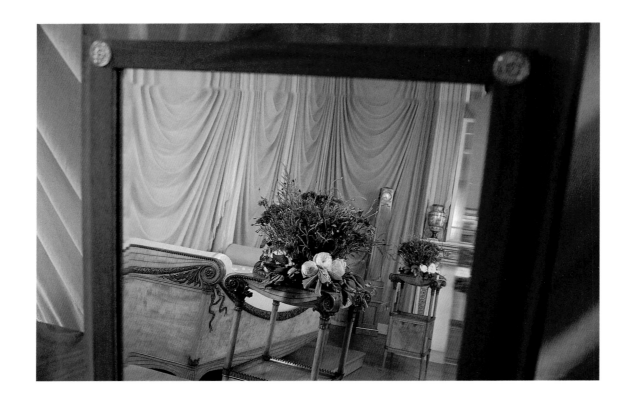

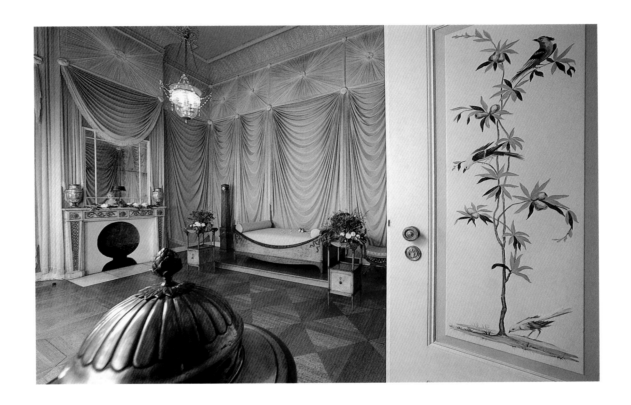

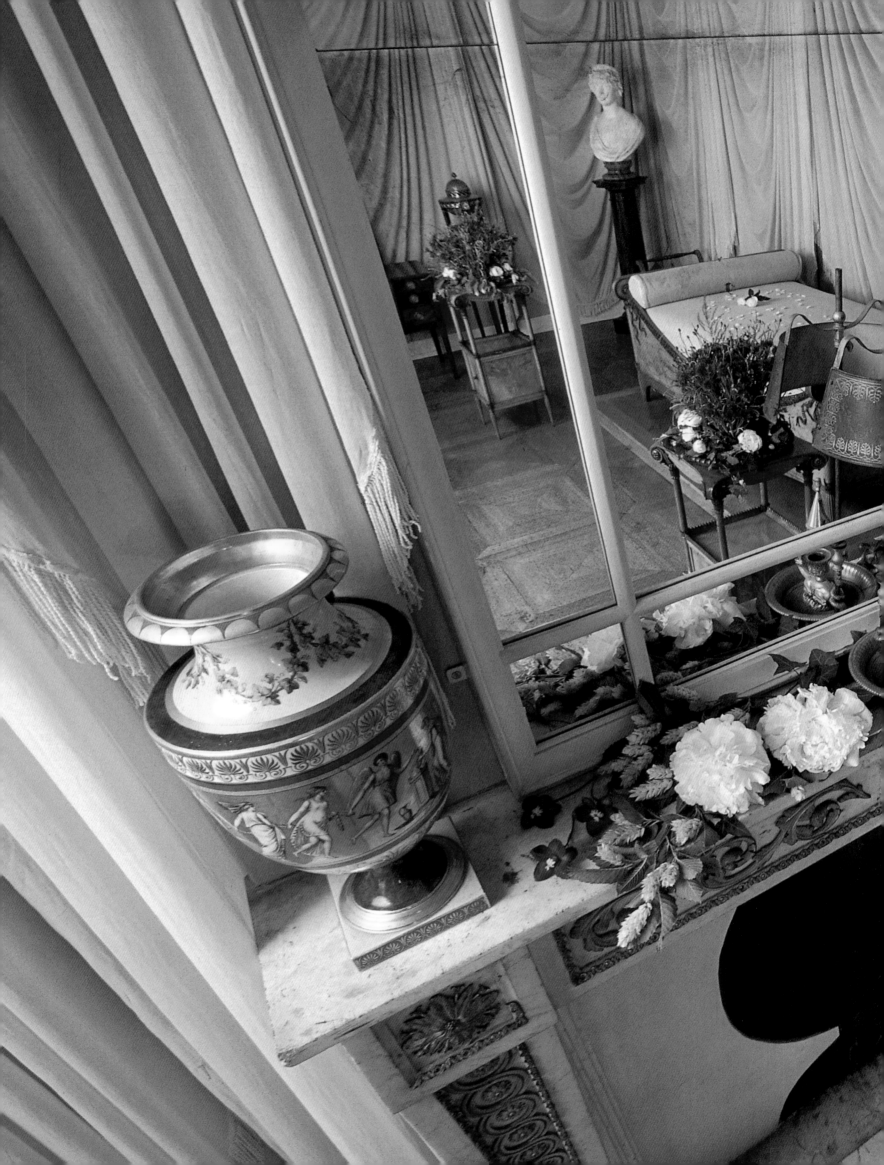

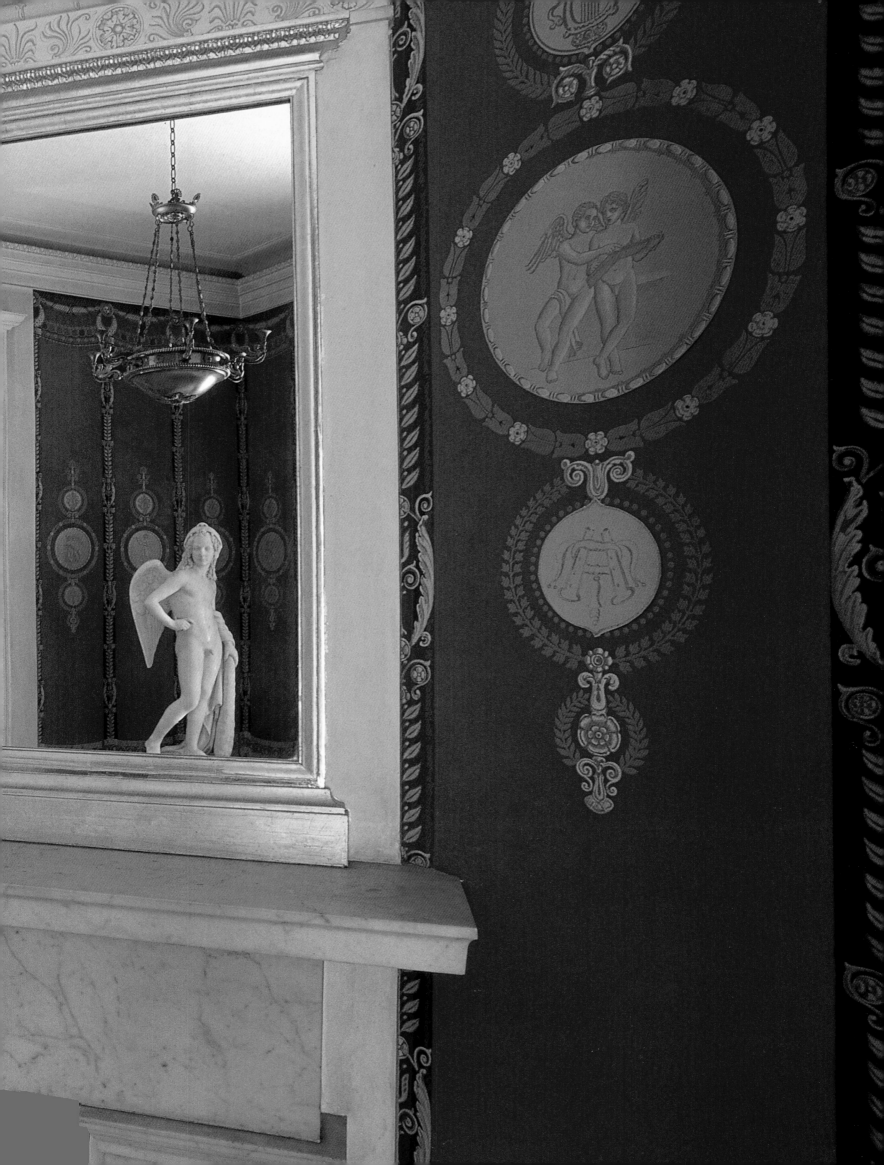

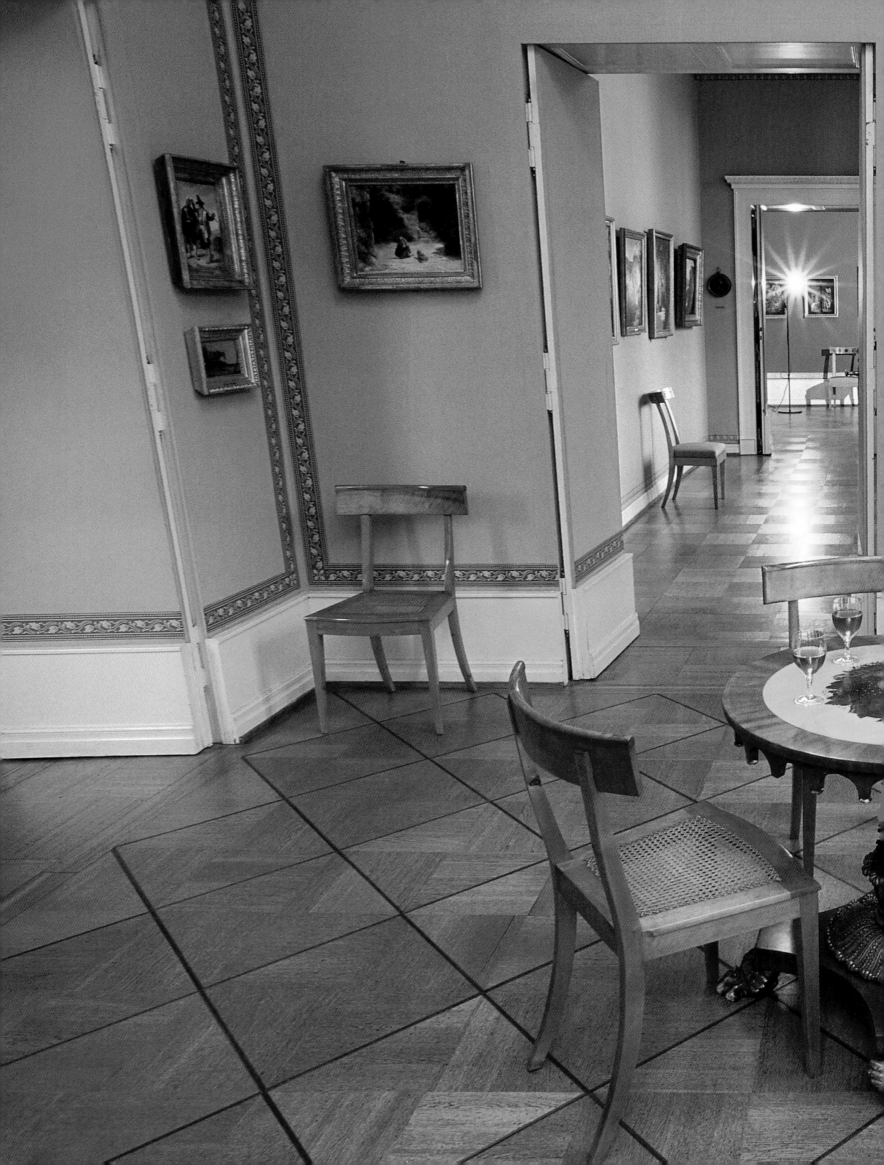

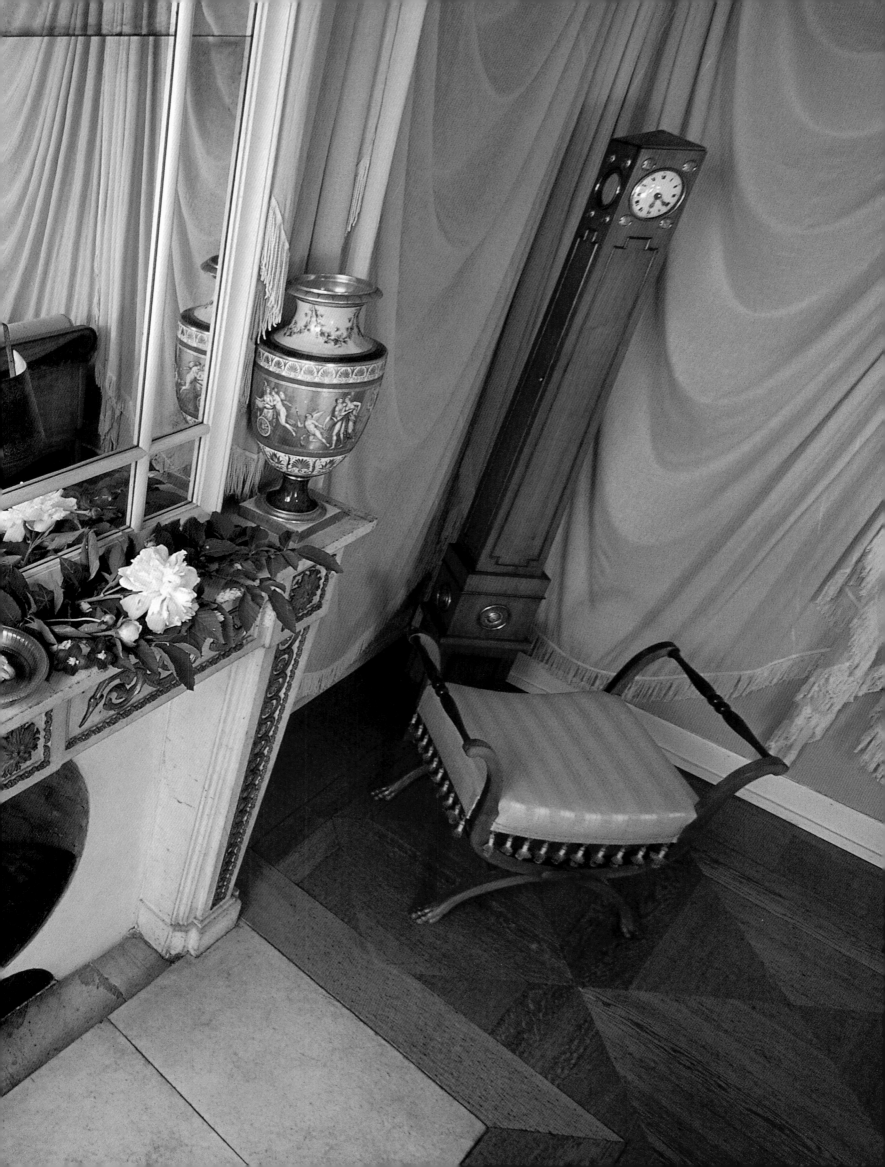

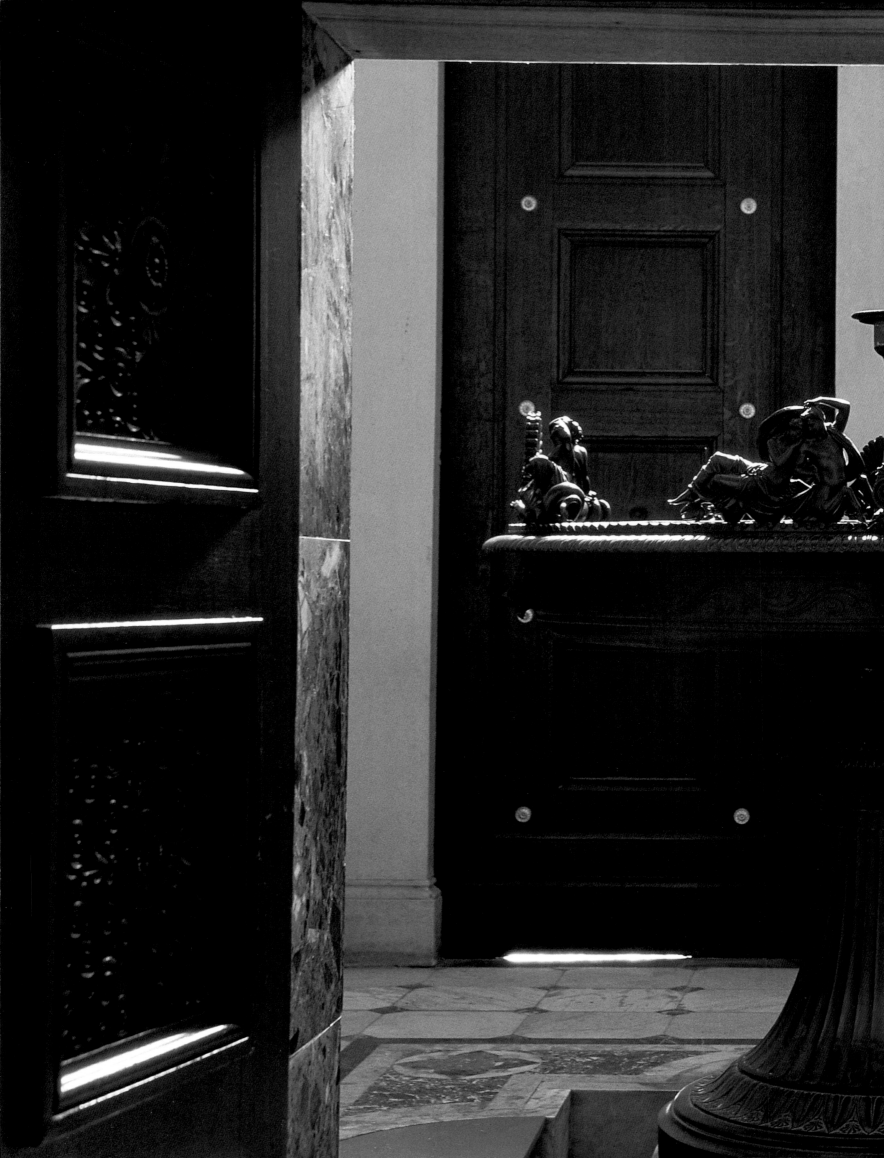

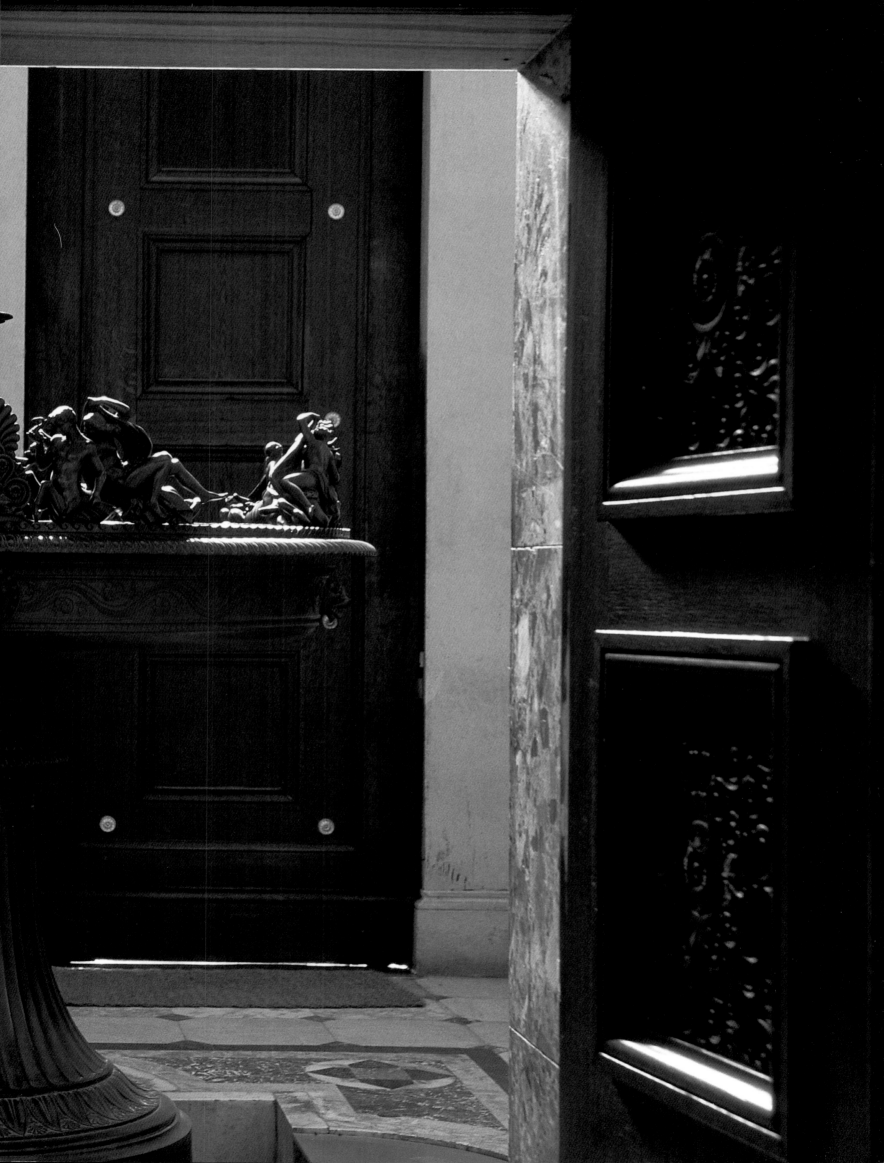

[240] DETAIL OF A GILT WOOD CHAIR BY KARL FRIEDRICH SCHINKEL, BERLIN CIRCA 1825. SCHINKEL PAVILION. [242] DETAIL OF SEMI-CIRCULAR WHITE LACQUER BANQUETTE BY KARL FRIEDRICH SCHINKEL, BERLIN CIRCA 1826. SCHINKEL PAVILION. [243] GARDEN ROOM DESIGNED BY KARL FRIEDRICH SCHINKEL, BERLIN CIRCA 1826. SCHINKEL PAVILION. [244] RED ROOM DESIGNED BY KARL FRIEDRICH SCHINKEL, BERLIN 1826. SCHINKEL PAVILION. [246] RECITAL ROOM DESIGNED BY KARL FRIEDRICH SCHINKEL, BERLIN 1826. SCHINKEL PAVILION. [248] DETAIL OF A CHERRYWOOD SIDECHAIR BY KARL FRIEDRICH SCHINKEL, BERLIN CIRCA 1810. SCHINKEL PAVILION. [250] MAHOGANY FURNITURE, SETTEE WITH MAPLE INLAYS. ALL DESIGNS BY KARL FRIEDRICH SCHINKEL, FABRICATED BY KARL WANSCHAFF, BERLIN CIRCA 1824-1826. MARBLE SCULPTURE BY KARL REINHARDT, BERLIN 1837. SCHINKEL PAVILION. [252] [253] [254] BEDROOM OF QUEEN LUISE DESIGNED BY KARL FRIEDRICH SCHINKEL, BERLIN 1810. CHARLOTTENBURG PALACE. [256] VESTIBULE DESIGNED BY KARL FRIEDRICH SCHINKEL, BERLIN 1810. SCHINKEL PAVILION. [258] BRONZE PEDESTAL FOUNTAIN DESIGNED BY KARL FRIEDRICH SCHINKEL, CASTLE CHARLOTTENHOF 1827, INSTALLED 1843. POTSDAM. [261] DETAILS OF THREE DOORS DESIGNED BY KARL FRIEDRICH SCHINKEL, FABRICATED BY MASTER CABINETMAKER FREUDEMANN, CASTLE CHARLOTTENHOF CIRCA 1825. POTSDAM.

for the crown prince's brother, Prince Carl. The crown prince, considering himself both artistic and creative, contributed to the redesign of the palace and gardens with his own design drawings. He named his summer residence Siam, and jokingly referred to himself as 'the Siam House Architect.' Friedrich Wilhelm IV wanted to realize his vision of an ideal environment in his exotic dream kingdom of Siam, which at that time was interpreted to be the 'Land of the Free.' However, the 'Land of the Free' should not be too costly, as Schinkel later reported. 'By putting much thought into this project, Lenné and I achieved, with very little money, something very characteristic and charming.'" I REALIZED how little times have changed. In spite of how well conceived an architect's or designer's plan may be, we are somehow guided by the whims and wishes of the person who is paying us. Given these circumstances, Schinkel was extremely successful. His best work clearly reflects his ability not only to integrate his ideas with the existing surroundings, but also to bridge his own visions and his patrons' fancies, and to realize for himself an artistic ideal. Charlottenhof is one of these. As a matter of fact, the result became a jewel-box piece within the parks of Sanssouci. I see this palace as a kind of utopian island that tells us stories about Schinkel's philosophy. AND THE STORY BEGINS: "The vestibule extends over both floors of the palace and is, in terms of square footage as well as sheer volume, the largest room. It gives access to the upper floors via two lateral staircases leading to a landing. The stringers at the staircase and the lower portion of the walls are decorated with natural stone. Verde antico marble rests atop a black marble baseboard. The upper walls are received by a frieze of ringed genies. The bronze fountain in the

center of the room was installed later, in 1843, but is based on Schinkel's original design. Blue glass with yellow stars fills the skylight window. As the palace stands on an east-west axis, the setting sun floods the room with a mystical blue-violet glow. I believe," adds Frau Zumpe, "that Schinkel intentionally installed the starry sky to give this room a cathedral-like light." PASSING THROUGH the Reception Room, I notice the gilded profile cornices, painted deep red lines, and stenciled friezes imitating classical antiquity that dress the walls. The crown prince's Study is a corner room cloaked in Schweinfurt green, a bright green invented by a certain Herr Stattler then living in Schweinfurt. To fill the walls, Schinkel selected copperplates depicting Italian vistas from the crown prince's collection. "The prince's collection of these Italian landscapes is evidence of his perpetual longing for Italy," explains Frau Zumpe. He was always looking wistfully in the direction of the Alps, to the land which to him seemed a world of perfection and beauty." The crown prince's writing table and armchair, with a mounted reading lectern, complete the room. ENTERING THE BEDROOM of the royal couple, I feel instantly at ease. This reaction does not surprise me, for I know that they were very much in love and lived in perfect harmony. Interestingly, he had to fight for her because she was a Catholic and he a Protestant. "Weren't there any real intrigues amidst all this love and harmony, Frau Zumpe?" I ask. "No, no, intrigues were not common at the Prussian court. This was not Paris." Schinkel expanded the bedroom by adding a semi-circular niche accentuated by elongated windows at the north side of the room. The windows offer three views, which complete a panorama of the landscape. Green silk drapery supported by gilded candelabras sporting Prussian

eagles creates a private alcove for the bed. Given the size of this otherwise perfect room, the bed is quite imposing. Above the bed a rendition of the last Raffael painting, *The Transfiguration of Christ*, displays the power of belief. Frau Zumpe points toward the windows: "When you look out, you see a small mound on which a tombstone stands, the so-called Tyrolean Mountain. Somehow the couple felt a connection of life and death between these two antipodes, which was very important to them. Friedrich Wilhelm IV was a very religious man and believed in the kingdom conferred on him by God." IN EVERY OTHER RESPECT it becomes clear to me that the lifestyle here has become somehow simpler. The spaces are not as grand in size as before and are furnished rather modestly for a crown prince. There is no longer a need for excessive, pretentious display, but rather a certain lust for fantastic recreations to provide amusement and enjoyment. OPENING THE DOORS from the Bedroom to the Princess's Study, I catch sight of the most wonderful silver-leaf doors, with a fanciful arabesque relief design. This small corner study sits like a gem on the ring of rooms, glistening with silver strands of pearls, astragals, and palmettes against pink and moss green. Twenty Pompeian dancers and a winged genie adorn a wall frieze that is suspended above perfectly scaled furniture designed by Schinkel. Each room in this small castle boasts doors of a different design, every one of them made by the master cabinet-maker Freudemann. If you search long enough, on one of them you will find a little Schinkel joke. "This doorknob," Frau Zumpe reveals, pointing to a round knob, "appears as though you would turn it, but instead you have to push it down for it to open." THE SITTING ROOM is filled with furniture that is Biedermeier in

the most apparent sense. "There are many art historians who believe that this is Biedermeier at its best, but in this house we refer to it as strictly Schinkel. We prefer to classify it as classicistic." There is the typical large round mahogany table on casters, which is surrounded by a suite of upholstered pieces displaying the handicraft of cross-stitching. "Our textile restorers took three years to bring them back to life." I wonder what this restoration would cost in Manhattan, or which workroom in that city would ever spend three years restoring needlework. These restorers had done a remarkable job. THE COLORS in the Dining Hall vibrate in carmine, gold, white, and blue. David and Ganymede sit beneath a starry sky, bringing to mind Schinkel's set design for the scene in the Hall of Stars of the Queen of the Night. The blue upon which the gilded stars rest within the niches may be the same theatrical blue that Schinkel used for Mozart's *Magic Flute*. THREE FRENCH DOORS lead to the garden terrace. "You see, this palace was intended as a summer residence," Frau Zumpe's story about Schinkel goes on: "Documents often mention, 'We are traveling to Charlottenhof to take tea there in the afternoon.' This implies that they met here for several hours, rather than spending days or weeks here. We have no evidence that the couple ever slept here. Only some of the rooms have fireplaces. There are no armoires for clothing, or any indication of books, and the lighting is beautiful but spare. If, in the evenings, you wanted to read or enjoy conversation, you would need more lamps. Bourgeois furnishings were conceived in a way that there were no large dining-hall tables, and meals were served much as a buffet would be today. People enjoyed their meals in a relaxed manner, and if the weather was nice they dined on the

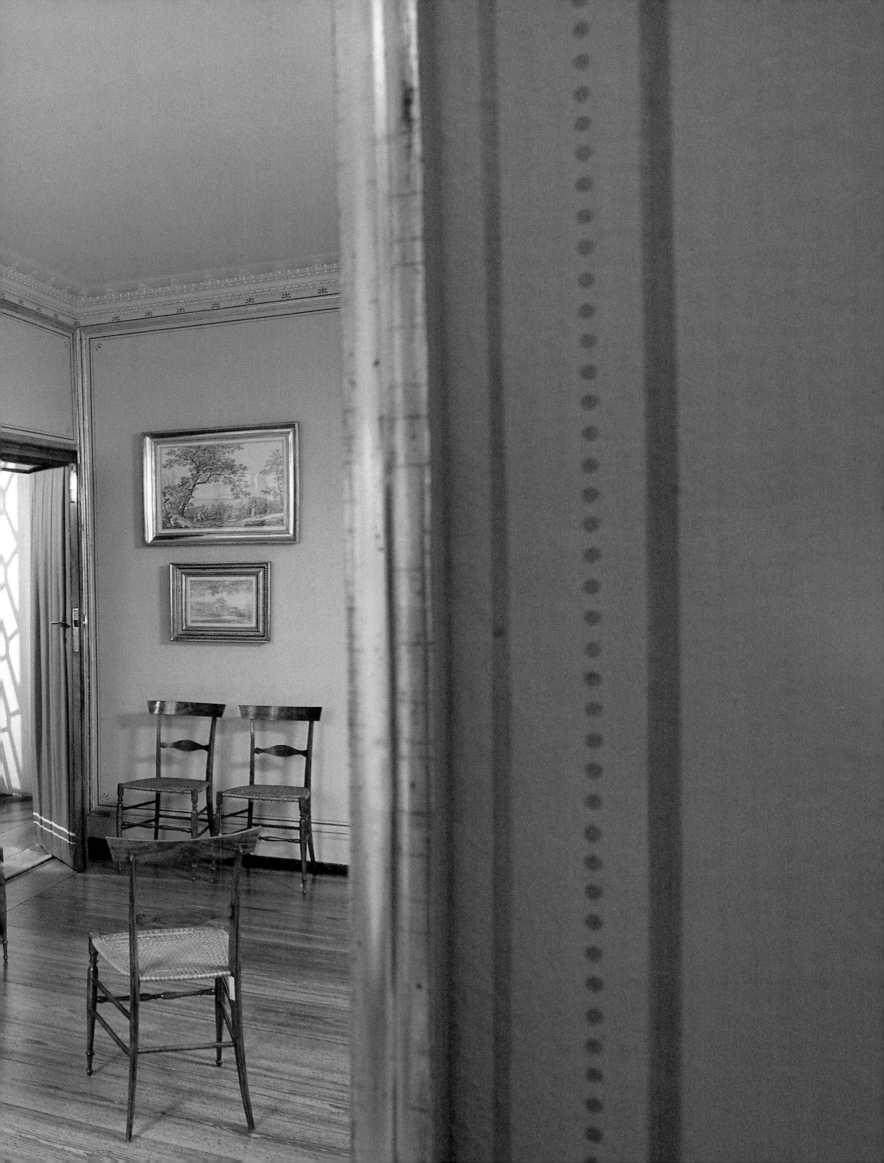

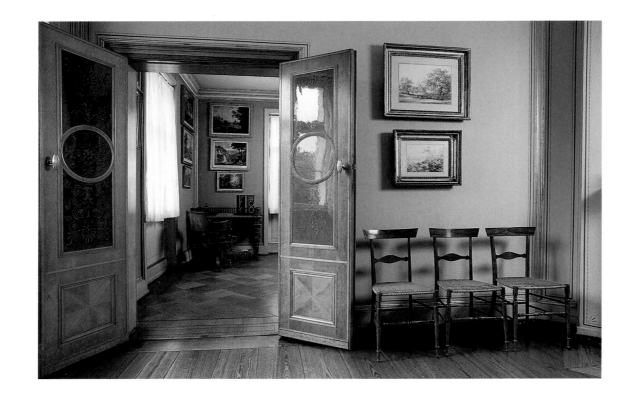

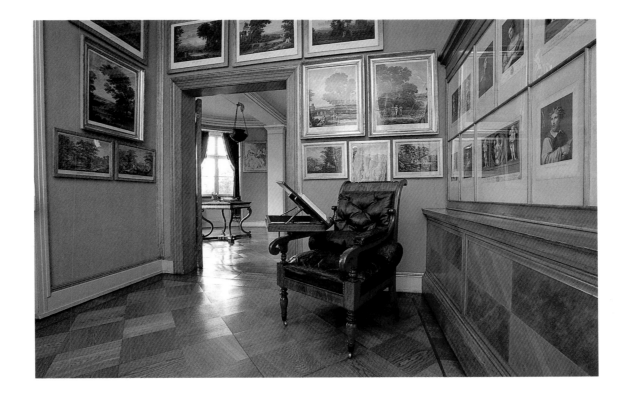

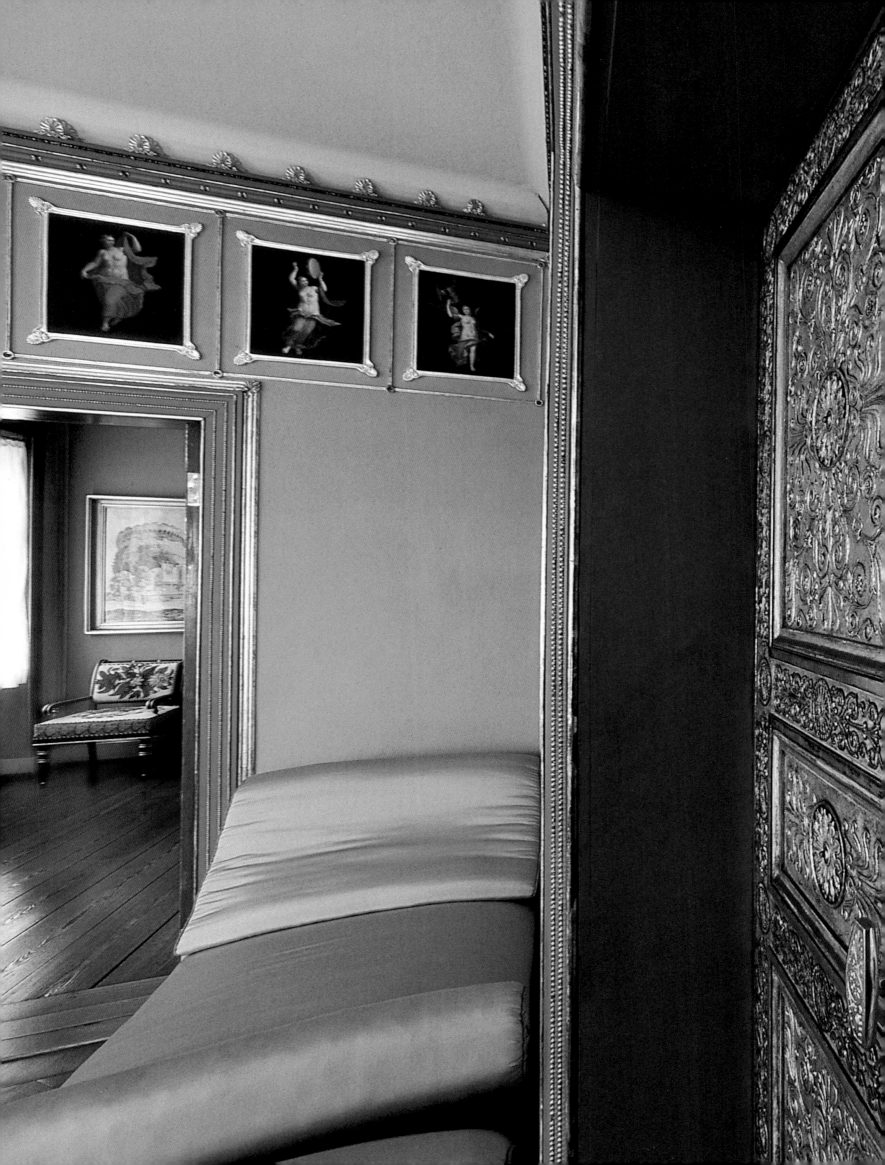

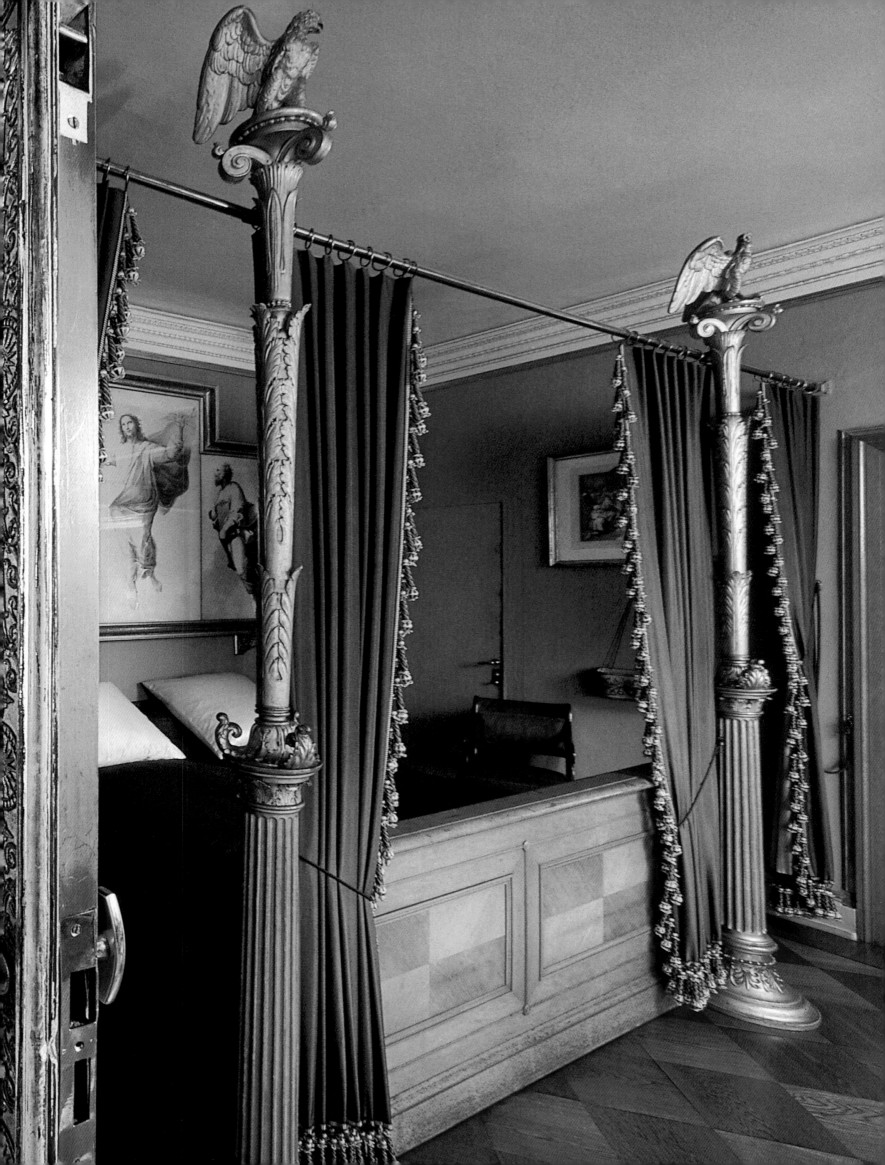

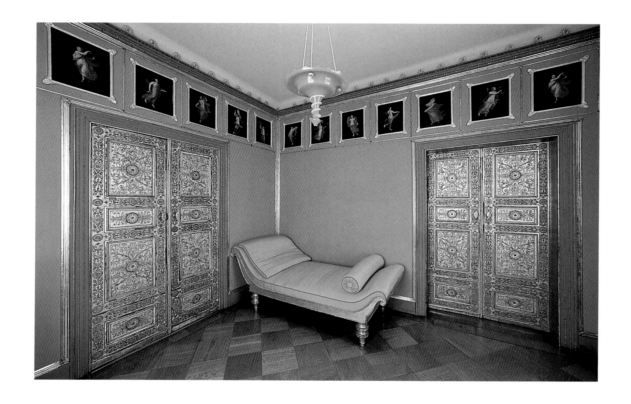

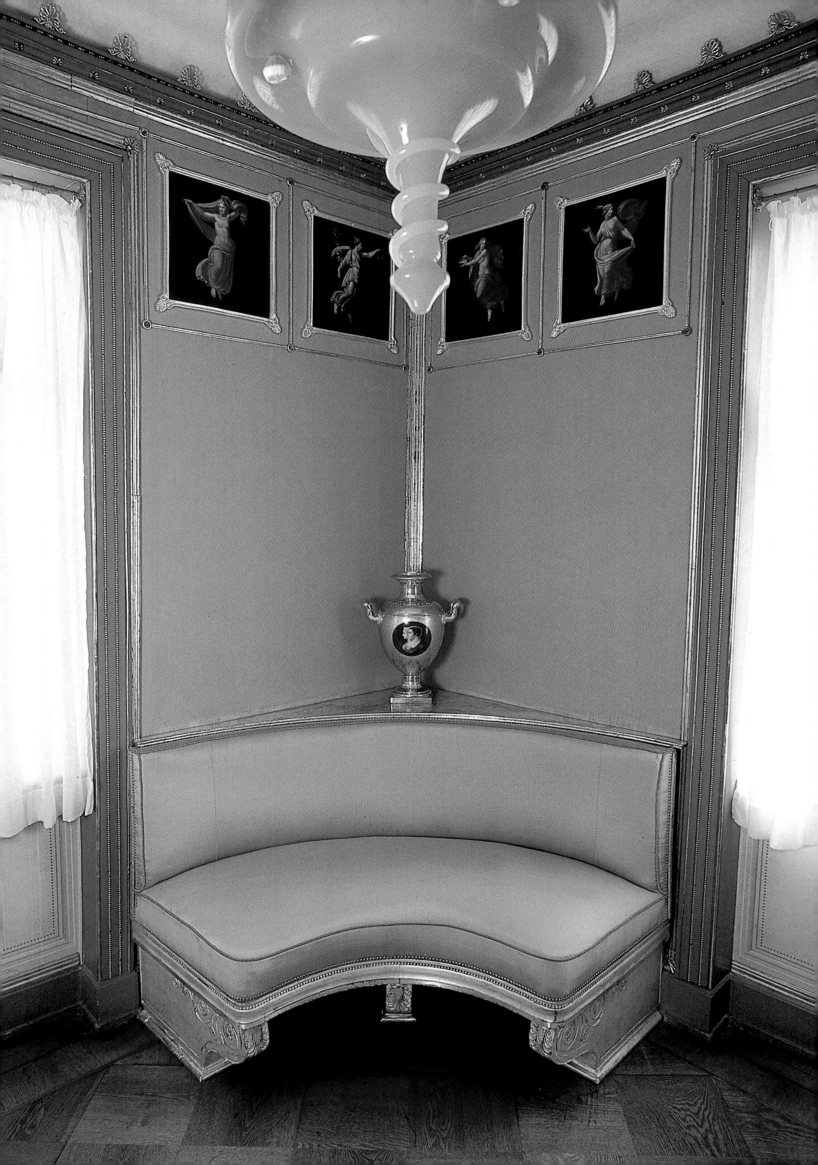

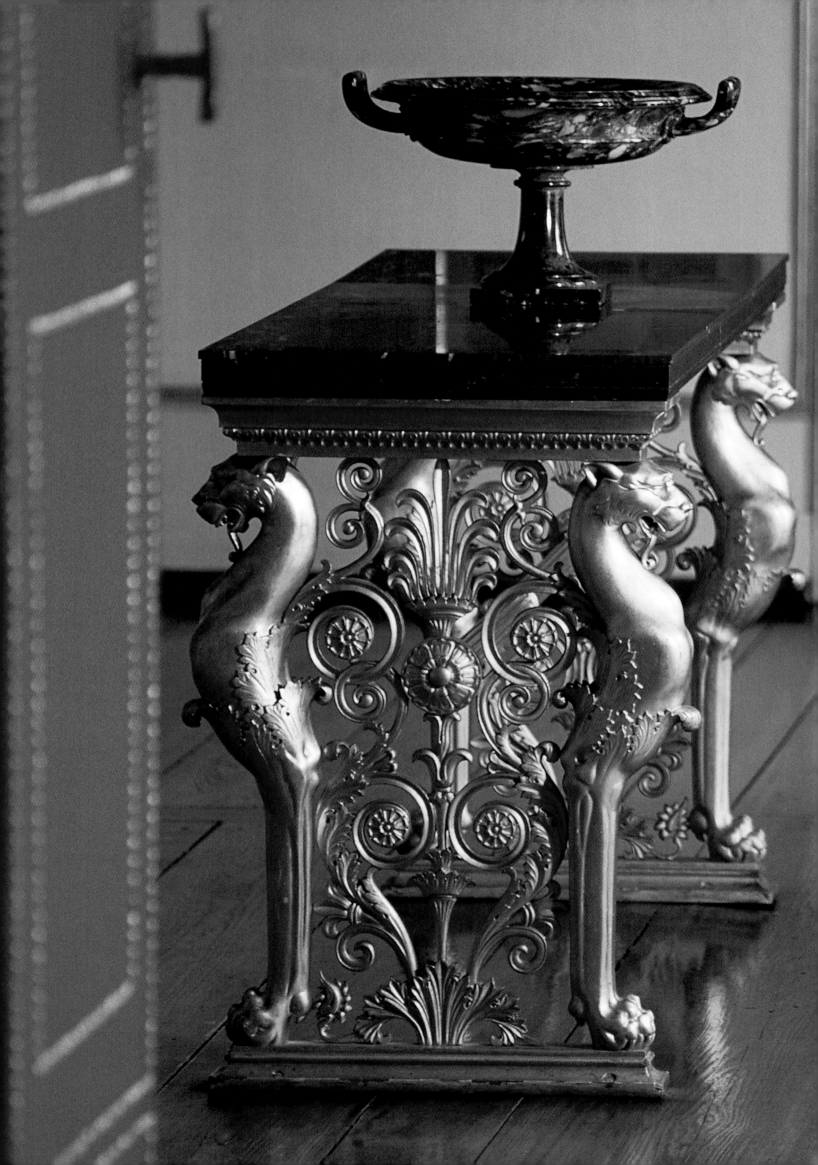

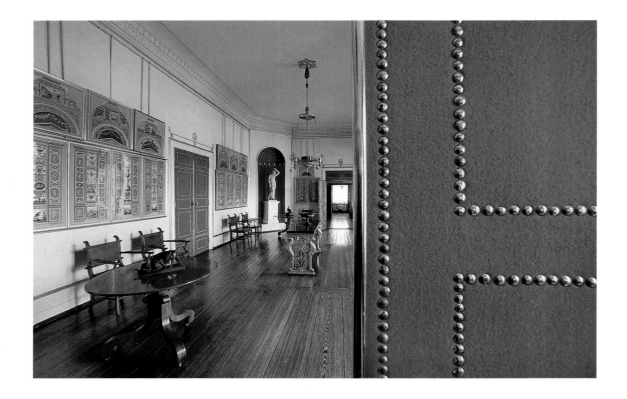

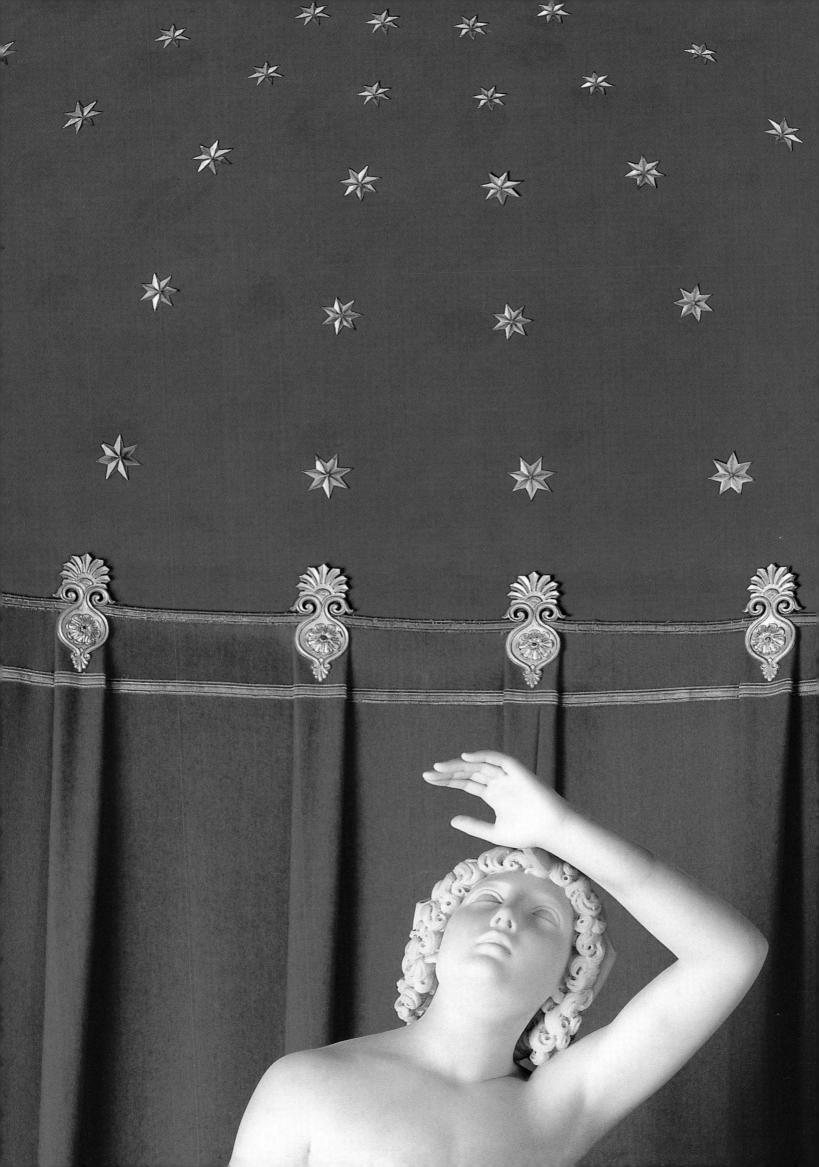

terrace." THE ADJACENT ROOM is an unexpected combination of chair-lined walls filled with copperplate prints in Italian High Renaissance style. They cover the gray-green walls in organized groupings contained within gold frames that meet the ceiling for another fête de complet. As I gaze into a simply framed mirror surrounded by stenciled ornaments, the experience doubles. MORE CARMINE RED accompanies us through the Corner Room. Passing another one of these fabulous doors, we reach the Tent Room, a world of bold blue and white stripes, which envelope us from all sides. Schinkel's interpretation of what Percier and Fontaine realized at Malmaison is redesigned in the style of Roman military tents. "Schinkel was a purist, and the unique furniture he realized for this tent-like room is transportable. Folding chairs, folding stools, and bed frames that are easily dismantled all form part of his vision." Frau Zumpe adds, "This room was intended as a bedroom for the princess's ladies-in-waiting or guests. It is said that once the German scientist Alexander von Humboldt stayed here and wrote *The Cosmos* on this small travel secretary. But I don't believe it. This secretary is rather small, and *The Cosmos* would require considerably more universal space." AFTER PASSING THROUGH the ethereal light in the vestibule again, we leave. Outside there is nothing more to do but walk. As one looks back from the path leading to the Roman Baths, Schinkel's interpretation of a classical villa seems almost to float above the earth. The garden walls and their continuation as a pergola conceal the ground floors. This fancy play of terraced soil and classical architecture shows the perfect collaboration between Schinkel and Lenné, giving the structure grace and elegance. Through their shared vision, the palace and the gardens unite into a

self-contained masterpiece. THE MANICURED PATH leads us deeper into the gardens of Sanssouci. It seems to me like a magical tour. Still in Potsdam, we reach Tuscany after a few minutes. It looks like it, feels like it, and I have to tell you, it's real. We are at the crown prince's so-called Roman Baths. What is now a compound of buildings in a variety of unexpected Italian styles began with the construction of the house for the court gardener, Hermann Sello. This happened in 1829. One year later the crown prince added the Tea Pavilion in the style of a small Roman temple. Finally the Orangerie and the actual Roman Baths were built. As plans changed frequently to indulge the wishes of the crown prince, these buildings are interconnected in a random manner. A leafy shelter known as the Grosse Laube and arcade arches covered in a flowering Chinese vine give me a sense of tranquillity. Here I feel at home. WHY A ROMAN BATH?" I ask Frau Zumpe. "During this time, everything Italian was fashionable," she explains. "Everyone had the desire to go to Italy, and above all, as I mentioned earlier inside the palace, the crown prince adored everything Italian. Schinkel was the dedicated follower of his dreams. But in this case Schinkel did not dream alone. He worked closely with one of his pupils, Persius, who became the executive architect of the project. The crown prince often sketched new ideas, one after another, which are apparent today. If you examine the Roman Baths more closely, you will see that they are actually bastard replicas of antique structures. The arrangement of these rooms is not totally in keeping with the Roman style. At the entry we see the Atrium, then suddenly there is the Impluvium, the main room of the Roman Baths, which is connected to the Apodyterium. However, the Roman

sequence is quite different. A classical bath does not have an atrium; atriums exist in Roman villas. What I find truly exciting is that in one of Schinkel's drawings he shows a design for an aquarium in the center of the Impluvium, where the rainwater basin is currently situated. His idea was to have an aquarium centered in the ceiling, where one could walk below and enjoy the fish swimming above." The Atrium is flooded with natural light coming from two cross-vistas, the Impervium and the Arcade. Ionic columns divide the space. The room is adorned with replicas of wall paintings, which Schinkel adopted from Pompeian examples in a red that the doyenne of fashion Diana Vreeland would have been very much at home with. It is a fantastic interpretation of Pompeii, accompanied by sheer eroticism. I feel lost in time and space. I WILL TELL YOU something interesting," Frau Zumpe adds. "About ten years ago I had this restored. In reviewing old documents, we found that only two years after construction there were complaints about rising water. When Northern European people apply Italian architectural principles, something always goes wrong. This is a bath that is open in the center. When it rains, it collects water; that's logical, but in our region it's quite unsuitable. Decisions needed to be made carefully with the restoration work on the friezes as well. It is always very difficult to determine how extensive a restoration should be. We ultimately decided not to bring it back to its original condition, but to stabilize it. It's funny to look at the frieze now. You

[280] [281] GILDED SOFTWOOD ORNAMENTS DESIGNED BY KARL FRIEDRICH SCHINKEL, CASTLE CHARLOTTENHOF CIRCA 1825-1830. POTSDAM. [282, 283] DETAIL OF SKYLIGHT WINDOW IN THE VESTIBULE DESIGNED BY KARL FRIEDRICH SCHINKEL, CASTLE CHARLOTTENHOF CIRCA 1825-1830. POTSDAM. [284] [285] FLOOR DETAILS IN THE TENT ROOM AND SITTING ROOM OF THE PRINCESS'S LADIES-IN-WAITING, CASTLE CHARLOTTENHOF CIRCA 1825-1830. POTSDAM.

can clearly see where the work began and when the decision was made to change how much should be done. It has a weathered effect, which, it turns out, adds something." IN THE APODYTERIUM, the dressing room, I think to myself, this is pure Schinkel, the ultimate design in form and function. Before me stands a Roman-inspired daybed, somehow naked without its leather cushion. At one end is a horizontal board, to hold oils for massage. Schinkel understood the true intention of this room, and he went to the extent of providing the most accurate of details, without compromise. He was fully aware that the crown prince and princess, as well as their various guests, would never use it. It was for their amusement only. THE CALDARIUM is the bath with a warm-water basin and a semi-circular niche extending at one end. Four caryatids carry an entablature to a skylight that adorns the ceiling. The floors are decorated with painted mosaics following more Pompeian motifs. Eight consoles cast in zinc rest against the walls. A nearby billiard room is fitted with a terra-cotta fireplace. While gentlemen were playing, ladies enjoyed themselves in an intimate garden that is partly enclosed, the Viridarium. The room is decorated with Doric columns and painted in a more delicate style, with a background of soft Mediterranean blue. Warm golds, rosy terra cotta, and rich earthy browns complete the painted drapery and the ceiling design of the apse. I FEEL ELATED by this visual celebration of art and fantasy that is Schinkel's realm. Upon saying good-bye, I ask Frau Zumpe, "What is it like to work in such beautiful surroundings for twenty-seven years?" She responds, "When I returned from my first trip to Italy, I was sitting in my office and thinking, my God, I have no reason to travel to Italy. I am in Italy."

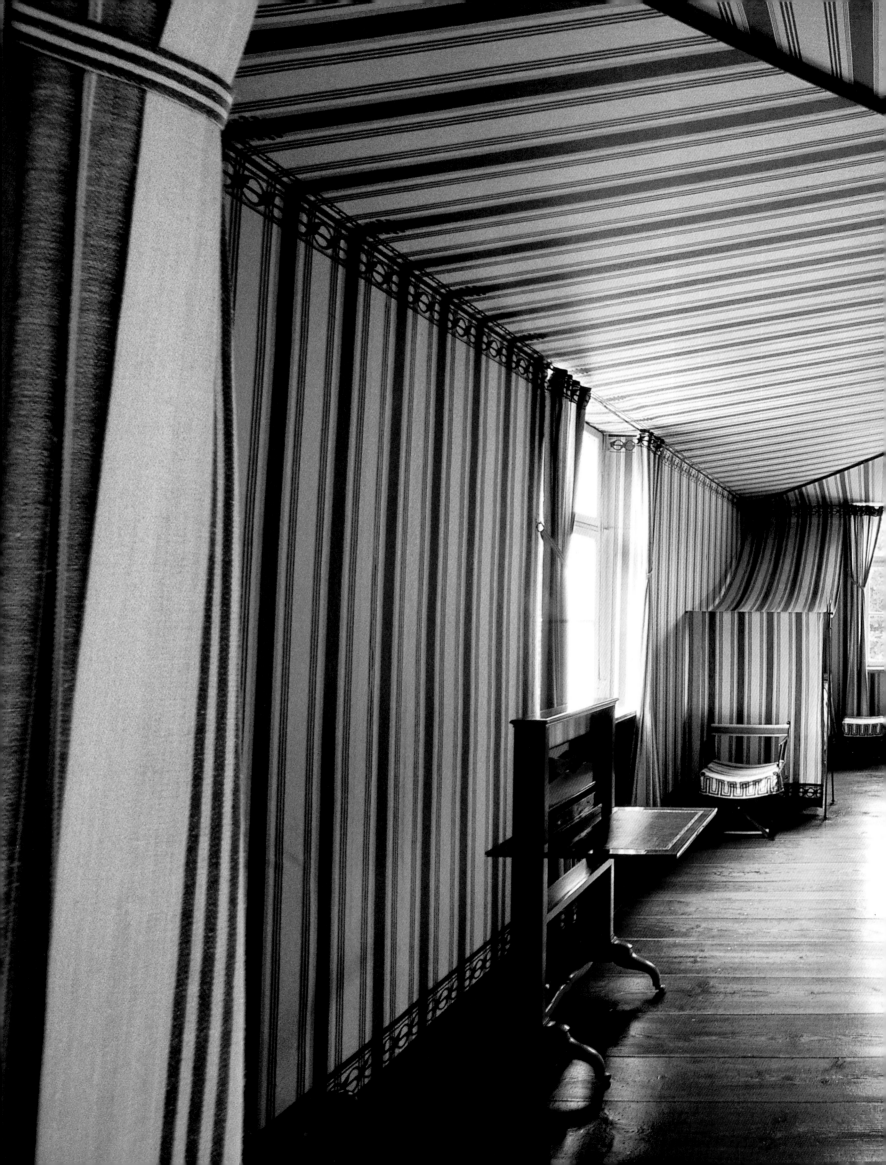

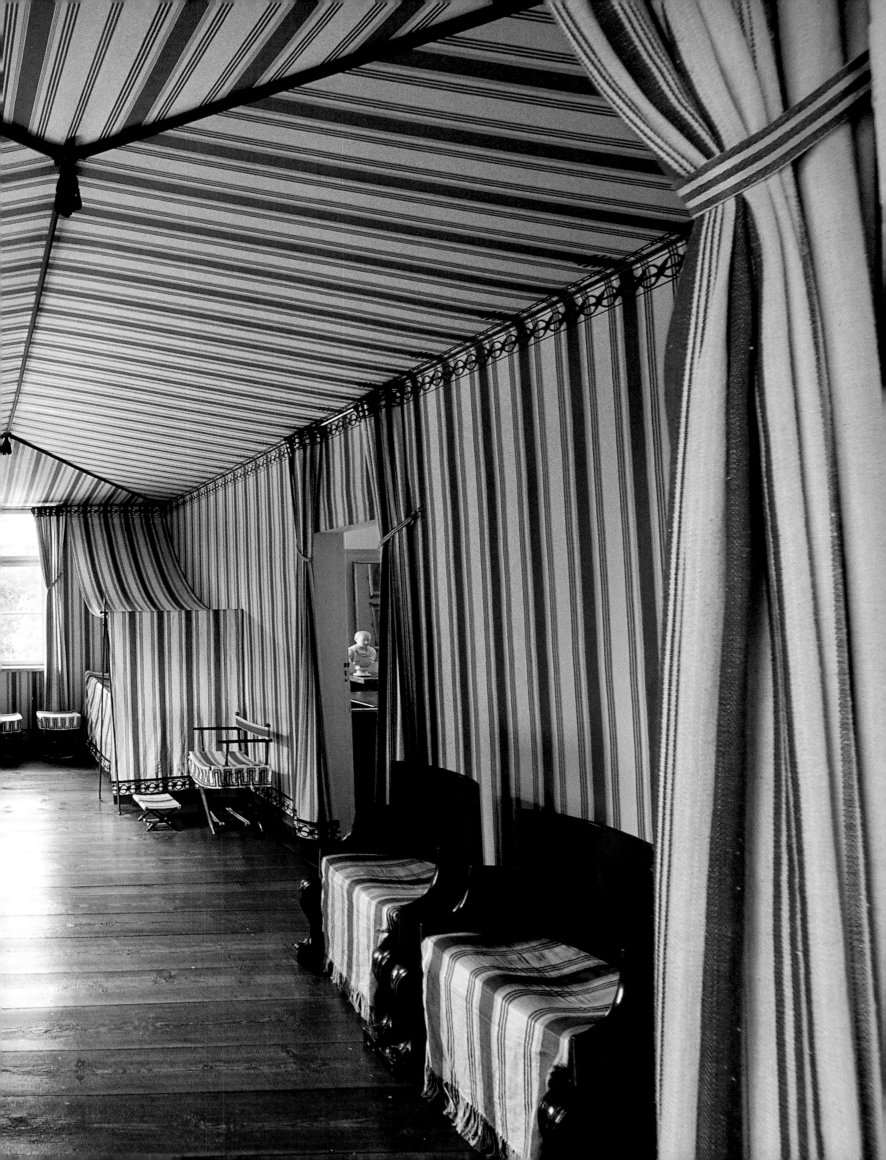

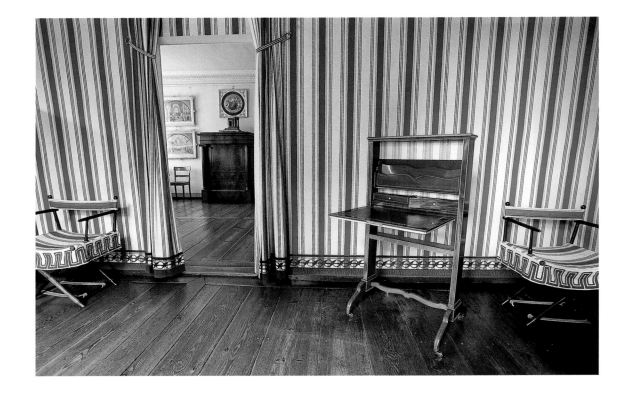

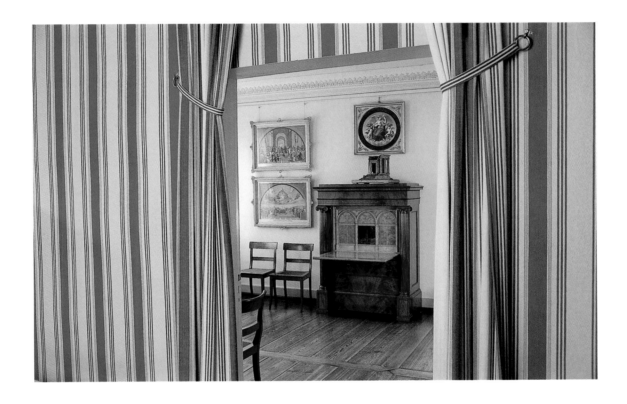

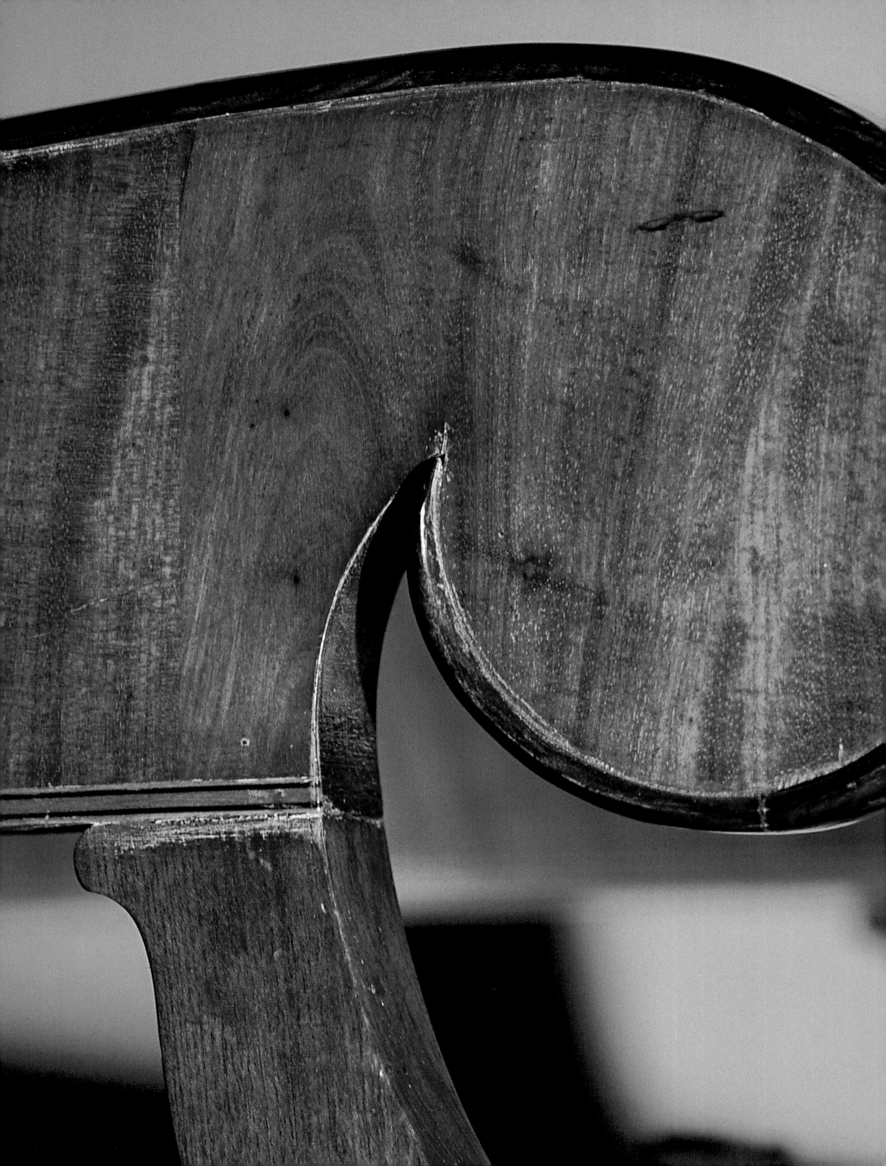

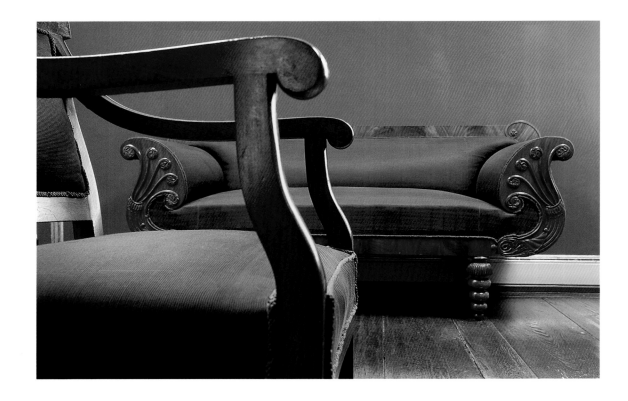

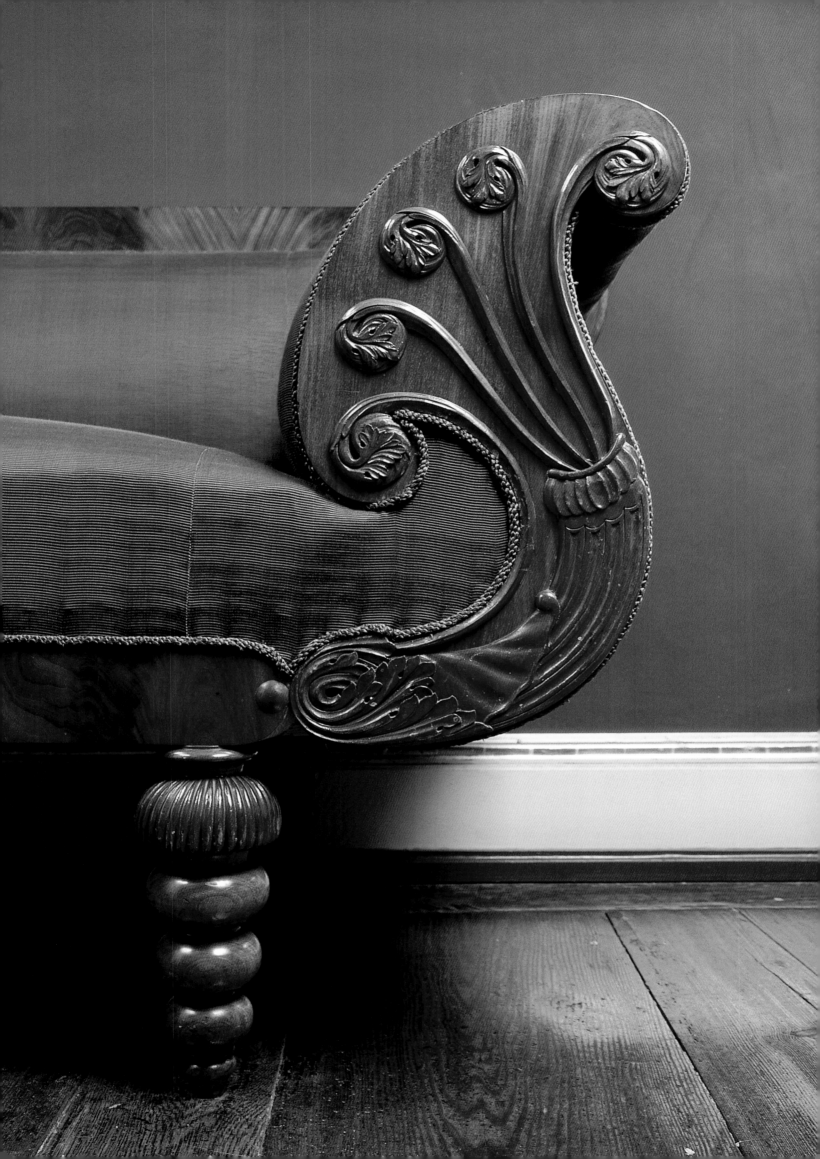

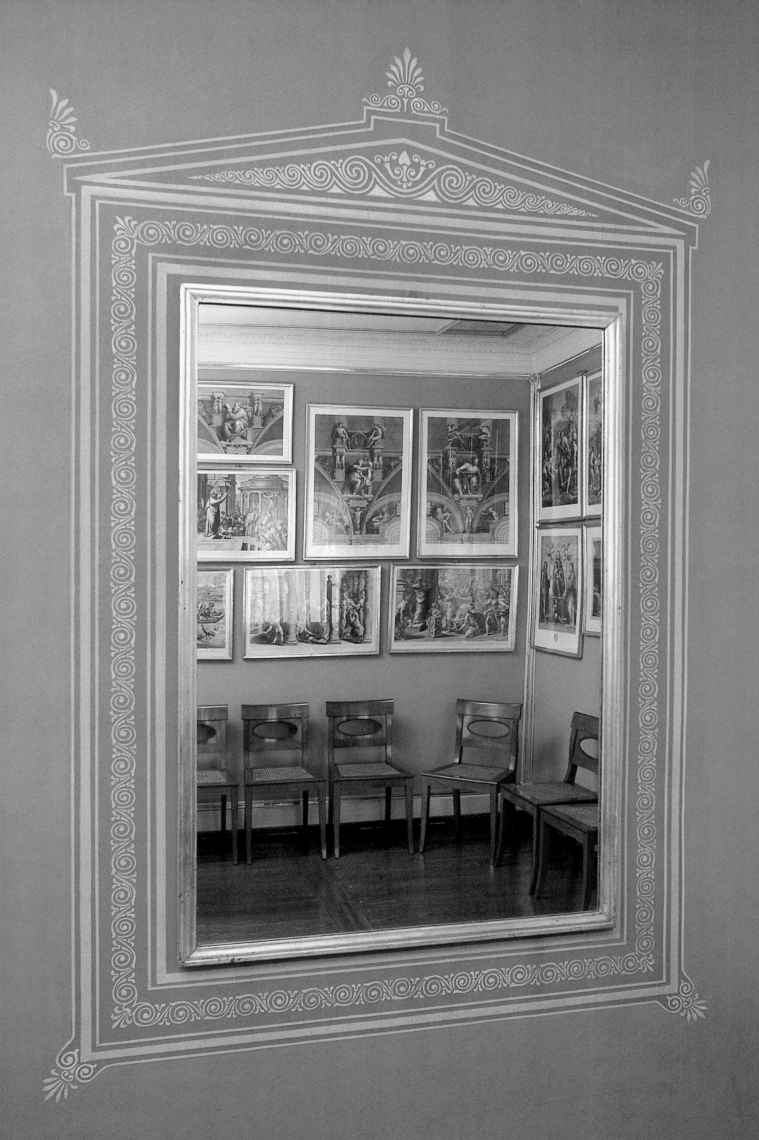

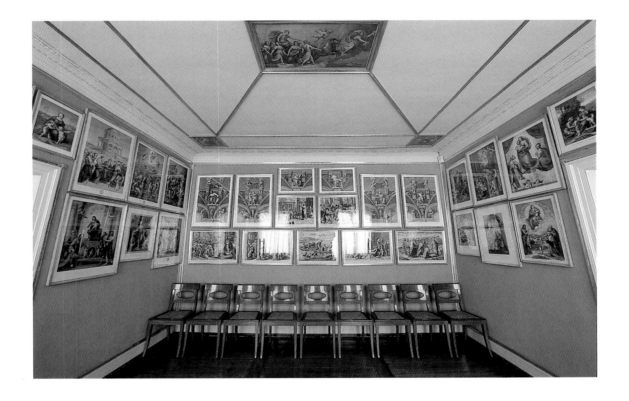

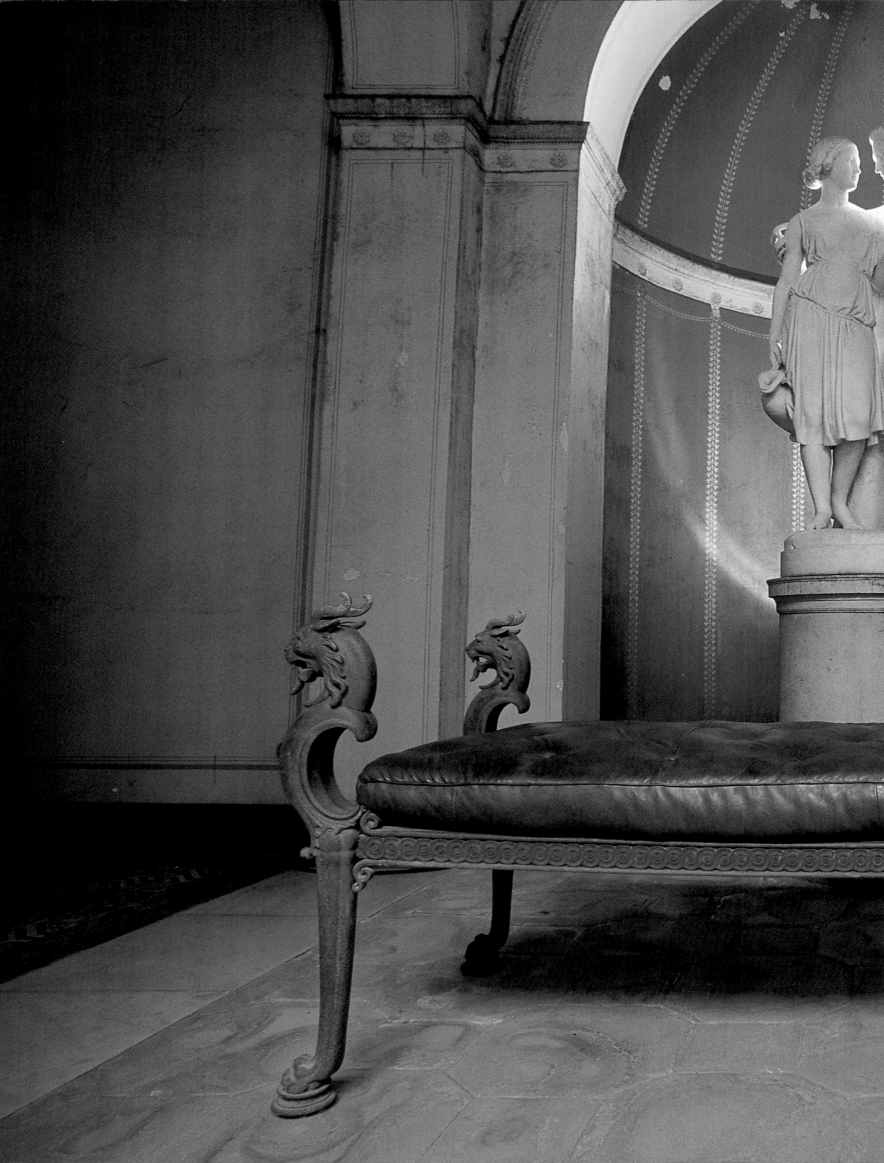

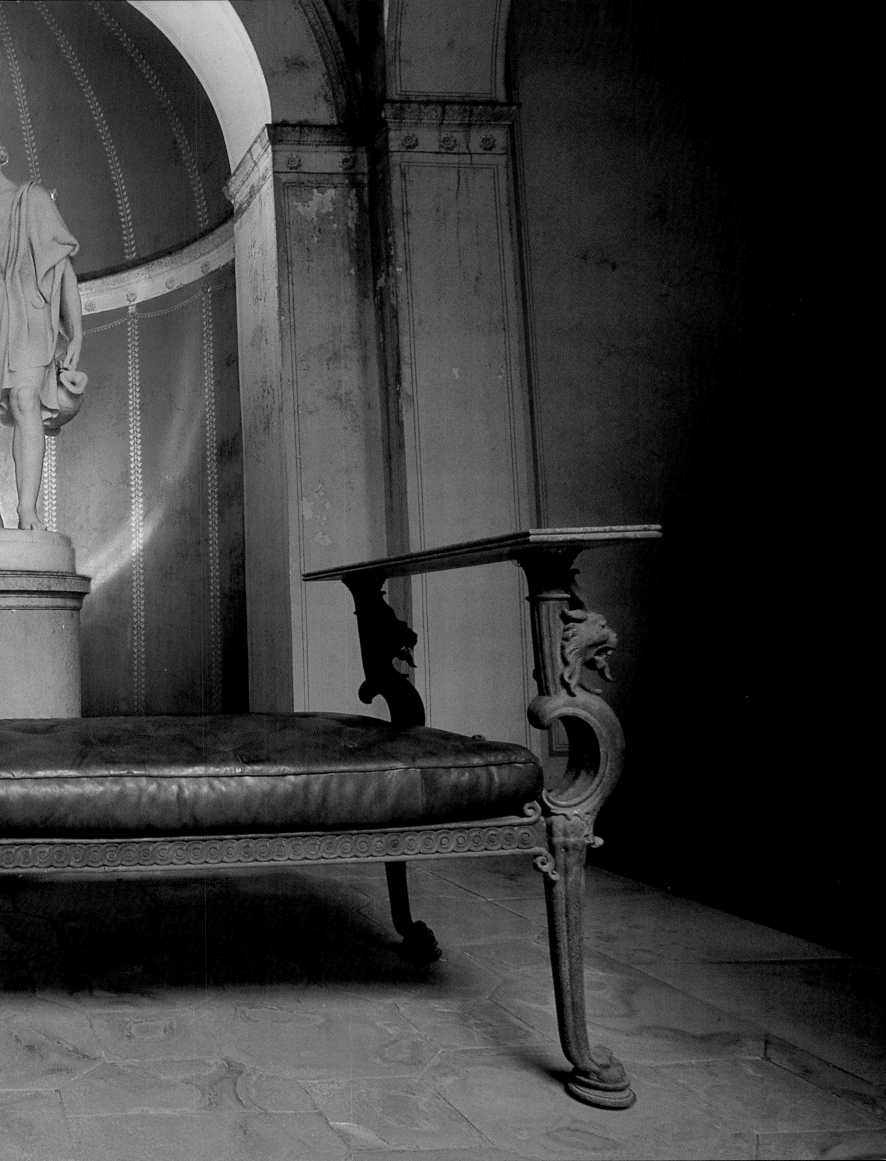

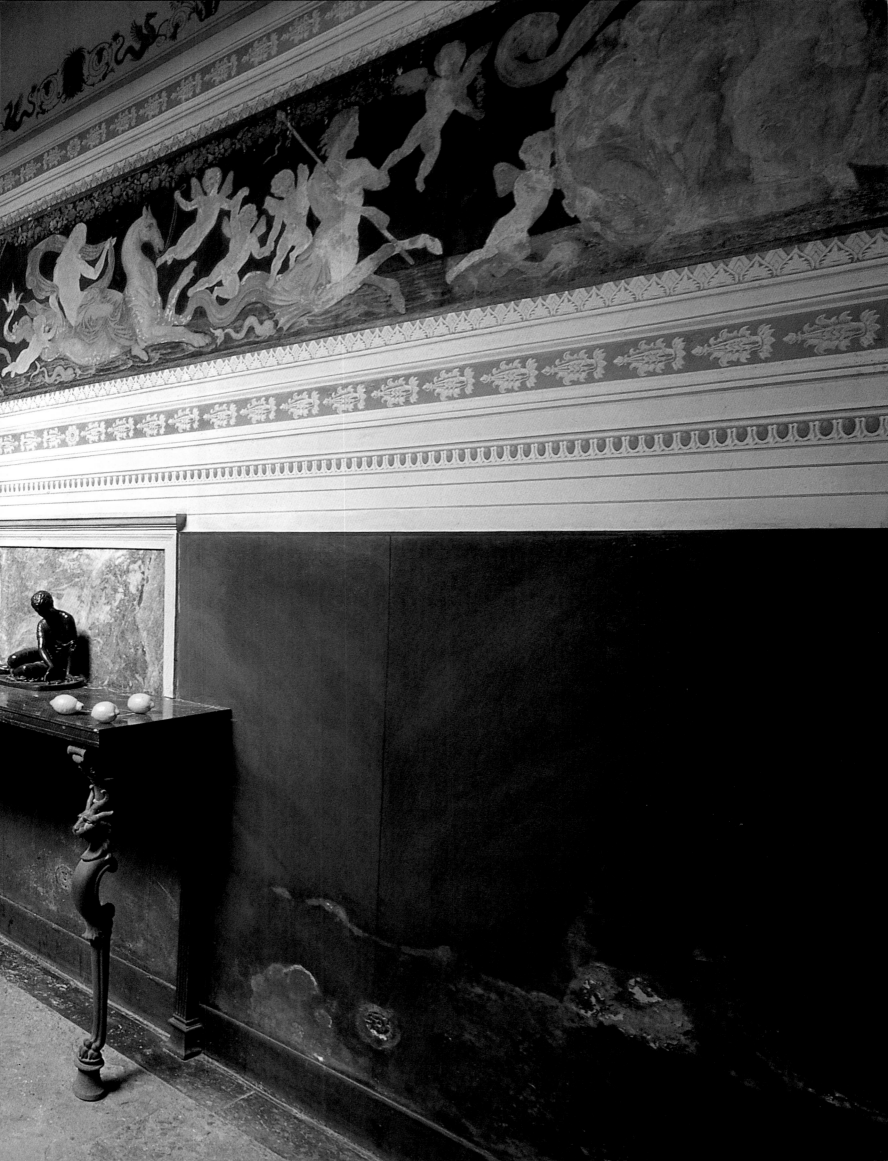

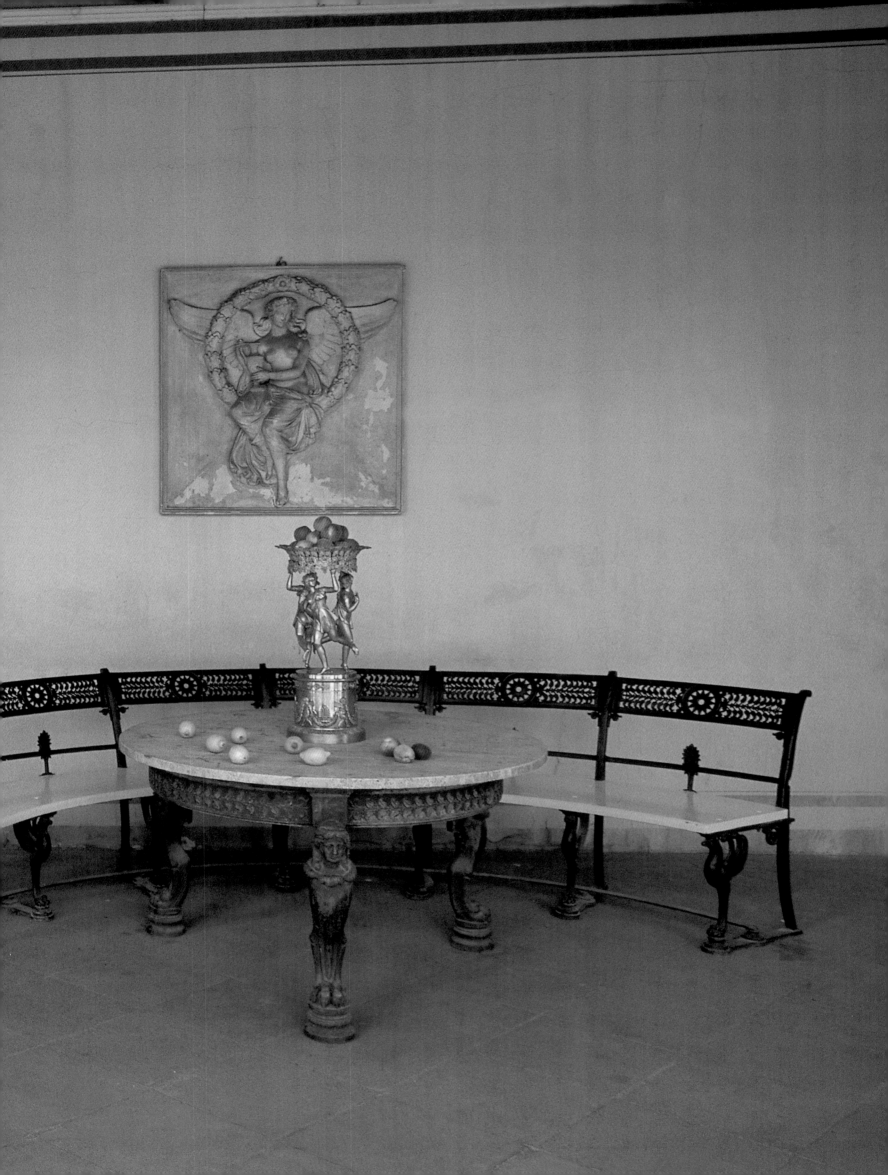

[266] RECEPTION ROOM DESIGNED BY KARL FRIEDRICH SCHINKEL, CASTLE CHARLOTTENHOF CIRCA 1825-1830. POTSDAM. [268] VIEW FROM THE RECEPTION ROOM TO THE CROWN PRINCE'S STUDY, ALL DESIGNS BY KARL FRIEDRICH SCHINKEL, CASTLE CHARLOTTENHOF CIRCA 1825-1830. POTSDAM. [269] VIEW FROM THE CROWN PRINCE'S STUDY TO THE BEDROOM, ALL DESIGNS BY KARL FRIEDRICH SCHINKEL, CASTLE CHARLOTTENHOF CIRCA 1840-1850. POTSDAM. [270] VIEW OF BEDROOM AND CROWN PRINCESS ELIZABETH'S STUDY, ALL DESIGNS BY KARL FRIEDRICH SCHINKEL, CASTLE CHARLOTTENHOF CIRCA 1825-1830. POTSDAM. [272] [273] THE CROWN PRINCESS ELIZABETH'S STUDY, PAINTINGS AND ALL DESIGNS BY KARL FRIEDRICH SCHINKEL, CASTLE CHARLOTTENHOF CIRCA 1827. POTSDAM. [274] DETAIL OF DINING HALL, ALL DESIGNS BY KARL FRIEDRICH SCHINKEL, CASTLE CHARLOTTENHOF CIRCA 1825-1830. POTSDAM. [276] VIEW OF THE DINING HALL, ALL DESIGNS BY KARL FRIEDRICH SCHINKEL, CASTLE CHARLOTTENHOF CIRCA 1825-1830. POTSDAM. [277] DETAIL OF DINING HALL, "GANYMEDE" BY AUGUST WREDOW, ALL DESIGNS BY KARL FRIEDRICH SCHINKEL, CASTLE CHARLOTTENHOF CIRCA 1825-1830. POTSDAM. [288] TENT ROOM, ALL DESIGNS BY KARL FRIEDRICH SCHINKEL, CASTLE CHARLOTTENHOF CIRCA 1825-1830. POTSDAM. [290] [291] VIEW FROM THE TENT ROOM INTO THE SITTING ROOM OF THE LADIES-IN-WAITING, MAHOGANY SECRETARY WITH FOLD DOWN FRONT. ALL DESIGNS BY KARL FRIEDRICH SCHINKEL, CASTLE CHARLOTTENHOF 1826. POTSDAM. [292] DETAIL OF MAHOGANY SWIVEL CHAIR BY KARL FRIEDRICH SCHINKEL, CASTLE CHARLOTTENHOF 1825-1830. POTSDAM. [294] RED ROOM: MAHOGANY SETTEE, CIRCA 1810-1820. MAHOGANY ARMCHAIR, CIRCA 1810-1820. ALL DESIGNS BY KARL FRIEDRICH SCHINKEL. CASTLE CHARLOTTEN-HOF, POTSDAM. [295] DETAIL OF [294]. [296] COPPERPLATE ROOM: MIRROR WITH STENCILED ORNAMENTAL FRAME BY SCHICKLER AND SPLITGERBER, BERLIN 1828. ALL DESIGNS BY KARL FRIEDRICH SCHINKEL, CASTLE CHARLOTTENHOF CIRCA 1825-1830. POTSDAM. [297] COPPERPLATE ROOM: GRAY-GREEN WALLS AND PLASTER CORNICE BORDERED BY GILT WOOD MOLDINGS. COPPERPLATE PRINTS FEATURING WORKS OF RAFFAEL AND MICHELANGELO. WALNUT CHAIRS WITH CANEWORK SEATS. ALL DESIGNS BY KARL FRIEDRICH SCHINKEL, CASTLE CHARLOTTENHOF CIRCA 1825-1830. POTSDAM. [298] DETAIL OF THE ATRIUM: ALL DESIGNS BY KARL FRIEDRICH SCHINKEL, THE ROMAN BATHS CIRCA 1829-1840. POTSDAM. [300] DETAIL OF THE APODYTERIUM: MARBLE STATUE "YOUNG MAN AND YOUNG WOMAN AT THE WELL" BY JOHANN WERNER HENSCHEL, 1826. CAST IRON DAYBED BY KARL FRIEDRICH SCHINKEL, 1840. THE ROMAN BATHS, POTSDAM. [302] DETAIL OF THE IMPLUVIUM: ALL DESIGNS BY KARL FRIEDRICH SCHINKEL, THE ROMAN BATHS CIRCA 1829-1840. POTSDAM. [304] DETAIL OF THE ARCADE HALL OR ORANGERY: CAST IRON SEMI-CIRCULAR BENCH AND CAST IRON TABLE WITH MARBLE TOP, BOTH DESIGNED BY KARL FRIEDRICH SCHINKEL, CIRCA 1840. GILDED BRONZE EPERGNE BY THOMIRE, FRANCE EARLY 19TH CENTURY. THE ROMAN BATHS, POTSDAM. [306] DETAIL OF THE GROSSE LAUBE: CAST IRON ARM-CHAIR BY KARL FRIEDRICH SCHINKEL, THE ROMAN BATHS CIRCA 1840. POTSDAM.

BIEDERMEIER TODAY

TEN THOUSAND DOLLARS WAS NOT ENOUGH.

I WAS VERY DISAPPOINTED AS I HUNG UP THE TELEPHONE.

THIS IS WHAT I EXPERIENCED THE FIRST TIME

I PURCHASED A BIEDERMEIER PIECE: I WAS EXPECTING MY SON

ALEXANDER, AND WHILE PERUSING A CATALOGUE FROM

CHRISTIE'S FOR AN UPCOMING AUCTION,

I CAME ACROSS THE MOST WONDERFUL CRADLE.

A CRADLE I DECIDED I HAD TO HAVE.

A RICH MAHOGANY "VESSEL," SUPPORTED BY TWO TAPERED POSTS

WITH SCROLLING BRONZE ORNAMENTS THAT HELD

FABRIC LIKE A SAIL—ALL SUSPENDED ABOVE AN ELLIPTICAL BASE.

I TELEPHONED CHRISTIE'S TO ASK FOR A CONDITION REPORT,

AND INQUIRED HOW MUCH INTEREST

THERE HAD BEEN IN THE PIECE. I WAS HAPPY TO LEARN

THAT THE CRADLE WAS IN PERFECT CONDITION,

BUT SORRY TO FIND OUT THAT THERE WERE A NUMBER

OF PARTIES INTERESTED IN IT.

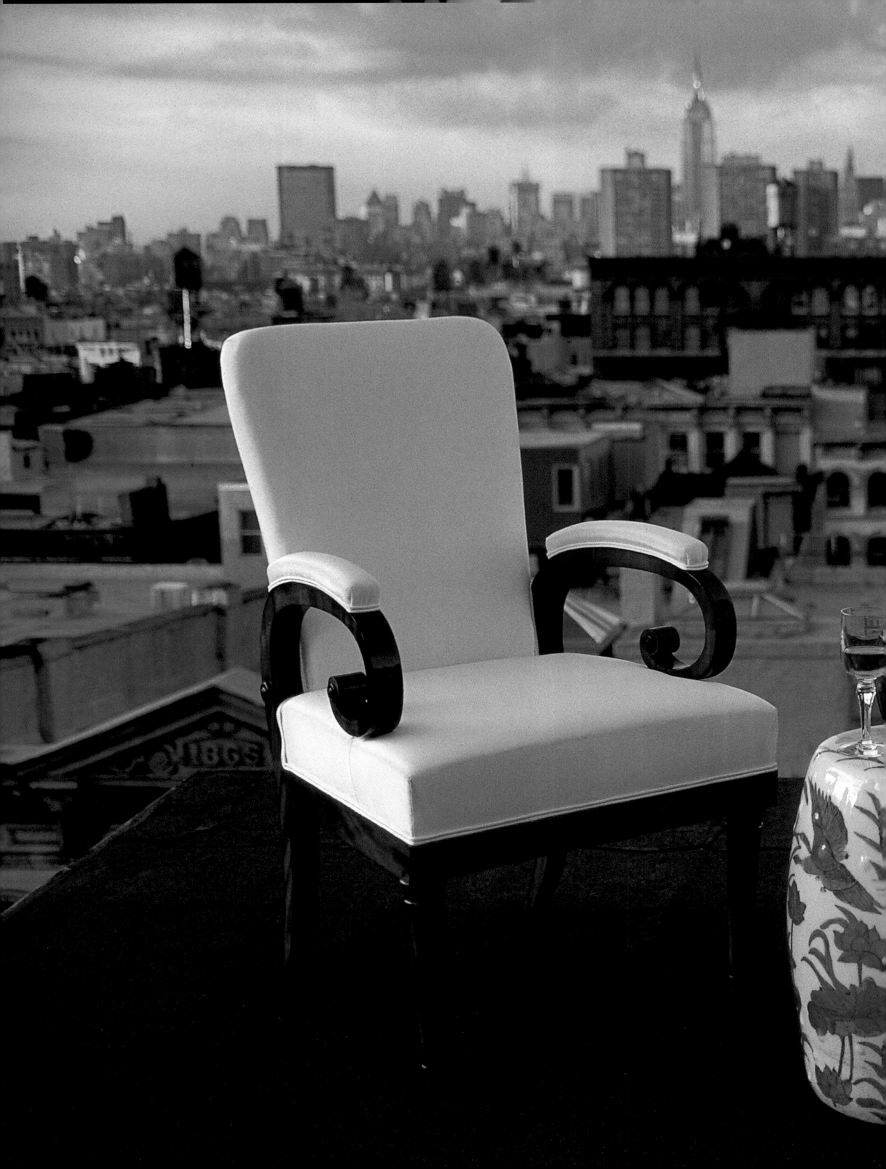

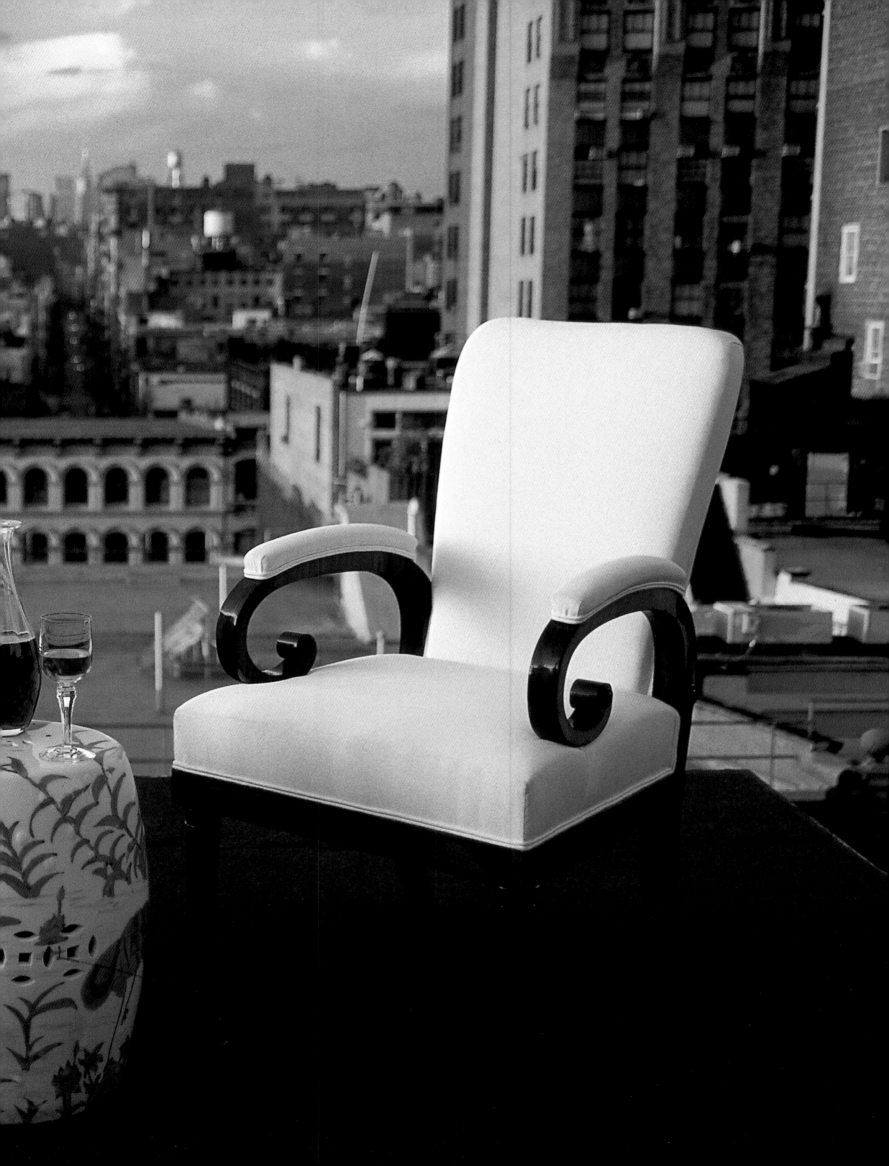

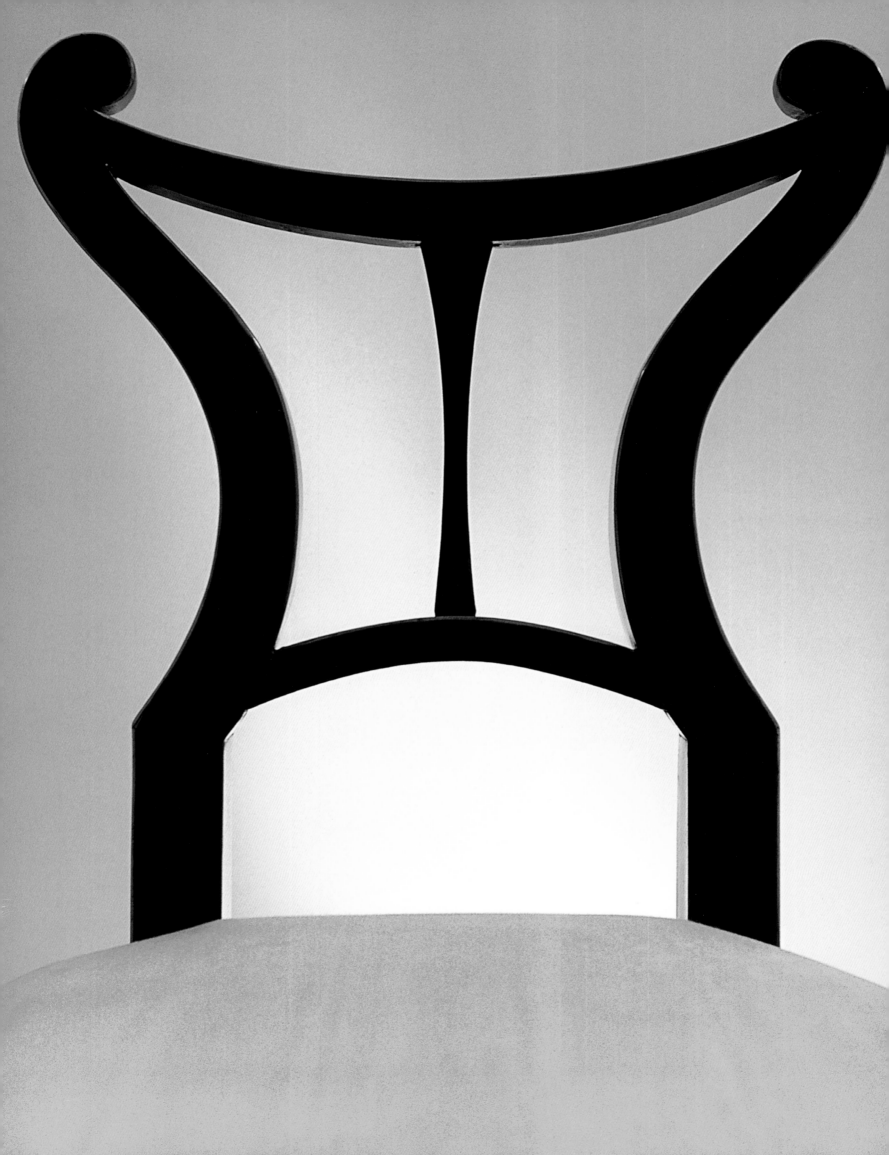

"I THINK OF FORM AS THE REALIZATION OF NATURE, MADE UP OF INSEPARABLE ELEMENTS. FORM HAS NO PRESENCE. ITS EXISTENCE IS IN THE MIND. IF ONE OF ITS ELEMENTS WERE REMOVED, ITS FORM WOULD HAVE TO CHANGE. THERE ARE THOSE WHO BELIEVE THE MACHINE WILL EVENTUALLY TAKE THE PLACE OF THE MIND. THERE WOULD HAVE TO BE AS MANY MACHINES AS THERE ARE INDIVIDUALS. FORM PRECEDES DESIGN. IT GUIDES ITS DIRECTION, FOR IT HOLDS THE RELATION OF ITS ELEMENTS. DESIGN GIVES THE ELEMENTS THEIR SHAPE, TAKING THEM FROM THEIR EXISTENCE IN THE MIND TO THEIR TANGIBLE PRESENCE." LOUIS I. KAHN

THE ASSOCIATE COMMENTED that she was not sure if the interest came from prospective buyers or from those who were merely curious. I registered to bid by telephone, and decided on the amount I was willing to spend. The auction date came, and I awaited the call to start bidding. I did not get the cradle. THE NEXT DAY, I contacted the auction house and requested that they approach the purchaser on my behalf. I was thrilled to hear that the purchasers had had a change of heart, and intended to put the piece up for sale again. After numerous calls, I became the proud owner of this Biedermeier cradle. SHORTLY THERE-AFTER I BEGAN integrating Biedermeier pieces into many of the private residences I design. While I initially selected these bold, classical pieces for their visual impact, I soon discovered their unique power to effect a transition from one place in a room to another. What struck me most was Biedermeier's definitive presence. I came to admire the craft and the distinct personality each piece exhibits. The center tables become pure sculpture in entrances and vestibules. The chairs offer something for everyone, whether they are simple and elegant or fanciful in design. Their perfect proportions and pared-down aesthetics are the essence of pure form. This furniture delights and enchants us with its fluid lines, lyrical shapes, and dominant forms. The quality of these pieces reflects a time in history when people dared to express themselves. THE IMPRESSION I AM LEFT WITH after this rich foray into the world of Biedermeier is its timeless modernity. I remember that the furniture belonging to the salon of Archduchess Sophie displayed characteristics that would later turn up in Art Deco. I think about how

[312] MAHOGANY ARMCHAIRS, AUSTRIA CIRCA 1820. PRIVATE COLLECTION, NEW YORK CITY. [314] MAHOGANY AND WALNUT BURL CENTER TABLE, VIENNA 1820. SIX MAHOGANY SIDECHAIRS BY JOSEPH ULRICH DANHAUSER, VIENNA CIRCA 1810-1820. PRIVATE COLLECTION, NEW YORK CITY. [316] CHERRYWOOD DINING TABLE, AUSTRIA 1835. CHERRYWOOD SIDECHAIRS, BY JOSEPH ULRICH DANHAUSER, VIENNA 1820. PRIVATE COLLECTION, NEW YORK CITY. [318] DETAIL OF AN EBONIZED FRUITWOOD SIDECHAIR, VIENNA 1820. PRIVATE COLLECTION, NEW YORK CITY.

much time passed before Biedermeier's modern qualities were recognized. Not until 1898 did a revival take place, after the exhibition on the Congress of Vienna held in the Hofburg Palace. The architects Adolf Loos and Joseph Hoffmann, among others, were inspired by designs from the period and began including elements of Biedermeier in their work. Their enthusiasm and the public's overwhelming response marked the rebirth of Biedermeier and forever established its place in art history. ON THE MANY OCCASIONS I'VE VISITED KARL KEMP'S GALLERY I have often wondered how he developed such an incredible eye, and where he finds so many exquisite pieces. One day Karl and I sat down, and he shared his story and his thoughts about Biedermeier: "I GREW UP IN COLOGNE, GERMANY. My mother had inherited a few pieces of Biedermeier furniture from her parents. She was a business woman who traveled extensively throughout Europe, and whenever she went away, she always came home with something special. Most of the time she would bring back a beautiful chair. Sometimes she bought larger pieces, and I especially remember a wonderful secretary and an entire dining suite. My mother put a very nice home together for us. Years later, when I came to America, I picked out eight pieces to bring with me. That was all I could manage to ship at the time. Today I still live with them. I have always loved this style of furniture, and began working with the Swiss antiques dealer Urs Christen in 1985, managing his gallery in New York for four years. I feel very fortunate to have learned the trade from such a great teacher. Christen loved to share his knowledge, and his passion for furniture. He taught me the American trade, which is very different from the one in Europe. At the end of the 1980s, I opened my own business. It took me a few years to get on my feet, but with the knowledge and expertise I had gained through Christen and a clientele I had developed, my business began to flourish. YOU MUST KEEP IN MIND that

Niall Smith was the first dealer to recognize Biedermeier's appeal and to bring it to America in the 1970s. He always joked that when he started, people came into his shop and thought these pieces were 'American Deco'! He traveled to Austria and Germany, importing beautiful furniture. Niall paved the way for many of us. IN THE YEARS that I have had my own business, I have come across some exceptional furniture. I will never forget a set of twelve fan-back chairs by Danhauser, made in 1822. The quality was absolutely superb. I was fortunate to find this complete set, which is very rare. It came from a castle in Germany, and it took years of negotiations for me to acquire. When I received the chairs, I emptied an entire room to display them. They remained for only a few days before being noticed by a firm from Chicago, which contacted its client. He flew in the same afternoon. The chairs were sold within hours. They are at home today in Chicago in a glass dining room, complete with a glass floor that was designed especially for them. The chairs appear to float within the space. I was never able to find so large a set of magnificent chairs again. IT IS ALWAYS INTERESTING to see which pieces designers respond to. Many look for center tables, which are one of a kind and tend to be very architectural. These were originally used as dining tables, but because of their size they are impractical for such use today. I'm always searching for pieces with integrity and character, and have several people scouting throughout Europe, locating unique furniture for me. I spend a few months training these scouts in my gallery in New York, teaching them how to identify original pieces that are unaltered and not bastardized in any way. They develop an extensive knowledge of quality, materials, and craftsmanship, and have a keen understanding of the look and style that my gallery represents. As a result, when I am not in Europe, and one of my scouts calls me with news of special pieces, I am often

able to purchase solely on the basis of the scout's description. EASTERN EUROPE has also been a source for me for many years, through contacts in Switzerland. In earlier times, before the fall of the Berlin Wall, we would pay exorbitant fees, as much as $30,000 or $40,000, and were then led to warehouses in the GDR where furniture was stored. You were allowed to select thirty or forty pieces, but you had to take the good with the bad. Sometimes it was very exciting; you could find wonderful pieces. At other times it was an utter disappointment. When the Wall came down, more items became accessible. Today, there is even more available. People are getting their properties back, which were taken from them forty or fifty years ago. After long court battles, many collections that had even found their way into museums have been returned to families. Subsequently, within the last two or three years, many pieces are making their way into the marketplace. WHILE EVERY ANTIQUES DEALER features his own specific look, my preference is for antiques that are starkly modern. These unfussy pieces somehow drive home the message that today's design is very much based on an early 19th-century classicist aesthetic. Biedermeier works very well with more restrained styles. I have chosen to offer Neo-classical, Art Deco, and Moderne examples with Biedermeier because they complement each other in a vital way. My approach with my gallery reflects what I have felt from the beginning. Whatever one's interests, there are people to share them with. In this sense, my gallery is a place where worlds come together. They converge, no matter the art, the style, the avocation. Whatever your fascinations, there will always be those who share your dreams." TO UNDERSTAND AN ARCHITECT'S PERSPECTIVE, I meet with Calvin Tsao, an architect known for his modernist designs that enhance the subtleties of surfaces, texture, and light, and for his expertise in creating large-scale, technologically advanced

corporate, commercial, and residential spaces. Here is what he tells me: "MY VIEWS ON THE RELEVANCE OF BIEDERMEIER depend largely on my personal approach to architecture. I want to understand what took place during this specific period and its impact on design today. What I believe is that everything has to have some kind of purpose. In contemporary life, we are bombarded with so much, that design can be—in fact is—a process and a journey to some revelation about ourselves. It facilitates a life that we want to live. It's not a commodity, it's not a device to elevate our social status—though I think many times design has become a dispensable indulgence or a whimsy of the privileged. For me, design is for everyone. It's a way of finding out, of discovering and defining our objectives in life and facilitating their realization. What interests me about Biedermeier is that it served that purpose. Biedermeier is the first democratic approach to furniture, which resulted from a new world order. All of a sudden, an entire class of people was able to afford something that was previously unavailable. IT IS INTERESTING that Classicism is the language from which Biedermeier took its inspiration. This goes right to the root of Western cultural aspirations. And, of course, Greek, Roman—any classical—architecture is filled with visual iconic meaning. If we consider what was going on with Empire and Biedermeier, both were looking to Classicism as well as other cultures for inspiration. And both employ the same language. Empire is very highbrow, very arch, and, to me, pretentious at the same time. This is not to say that Empire did not inspire beautiful pieces. The same vocabulary was employed in a much more populist way in the Biedermeier. It is striking to see how a set of assumptions was translated in one way or another through the manipulation of scale and of purpose. I THINK ONE CANNOT EXAMINE BIEDERMEIER, or any period style, without looking at the context within which it arose. It's obvious that there was a kind of upbeat

moment there. I always look at that and sense the spirit of the furniture. Biedermeier was the paring down of the complex aesthetics of Classicism to essential moods, which resulted in designs that are extremely refreshing, relevant, and timeless. The way pieces were fabricated and designed reflected an economy of means. We can even look at Mies van der Rohe's designs for chairs and see a connection in this respect to Biedermeier. Prior to mass production, furniture was for a long time a playground for the privileged—because they were all so craft-driven. That is not to say that it was not a wonderful thing. You had so many prominent families commissioning extraordinary furniture that was unique. What we need to remember is that there is a craft to industrial production, and to looking at how to produce things in multiples, while remaining very pure to the process of construction. Biedermeier was the time that marked the beginning of this industrial craft, and is relevant to this day, as we work in this same method. We streamline and pare down in good design to show how things are put together. Biedermeier was born of a very commercial venture, and in many ways it worked. There was a definite market for furniture, and this market was realized. It was exploited to the fullest. To me, this is a prime example of supply and demand working extremely well. Today people talk about post-consumerism and all that it involves, but I don't know where we are in terms of our cultural sensibilities. I am not against commercialism or market forces, but I think our culture needs to be much clearer about our desires. We have to be able to find the appropriate channels for expressing those desires, whether it be altruistically or commercially, because then truth will prevail. I think that in many ways we want clarity. We want a community, a society that has less ambiguity about its aspirations. Today, commercialism has become so baroque in its machinations that I believe we need to get to a purer place. It would not hurt if we had a bit more civic vision

to enable us to get out of our myopic condition and serve our community in a much more global way. TWO OF THE ARCHITECTS FROM THE BIEDERMEIER PERIOD were remarkable for translating design into a kind of collective aspiration and a new way of looking at how society could be vitalized and invigorated. David Gilly and Karl Friedrich Schinkel were certainly not gentleman architects, interested only in the game of aesthetics. They employed the complex visual language that is architecture—an architecture that developed a collective mythology, or a collective aspiration. While Gilly, one of my favorite architects, did not build very much, the fact remains that he inspired a great many architects. In this respect it is not so much his actualization of a building as his contribution to the perpetuation of the ways of our culture. IT IS UNFORTUNATE that many of the plans from Gilly and Schinkel were never realized; many buildings were designed but never built. This was a result of anxieties concerning immigration, as well as the different cultural and ethnic currents at the time. In the end, all of the aspirations that went into laying the infrastructure of the community, in terms of architecture, remained visionary. I do believe that this vision was eventually translated into popular culture. We, as architects, suffer the same frustrations today when it comes to our profession. We have to rely on so many different forces in order to have something realized. To me, the age of Biedermeier was one of those periods filled with so much uncertainty that architecture suffered. This explains why it can be misleading to look at any cultural phenomenon, whether it be furniture, architecture, literature, or music, without considering the context of what was happening at the time. For example, I never look at pieces of furniture as artifacts. I think that would be sad. I view these works as a map that can help us understand another time, another set of desires. They are useful as information; they inform us as we create our own world."

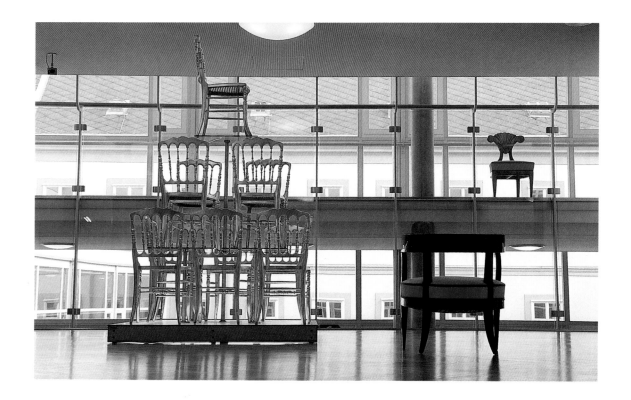

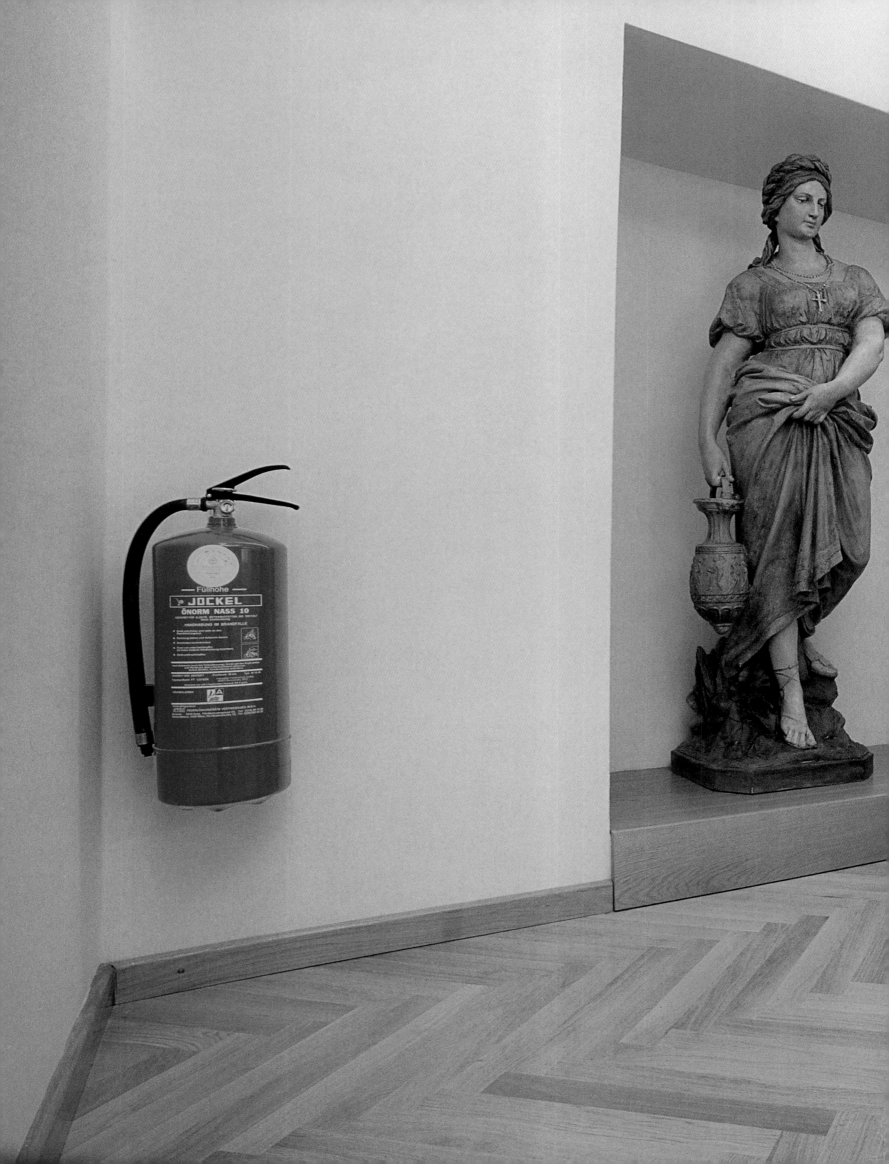

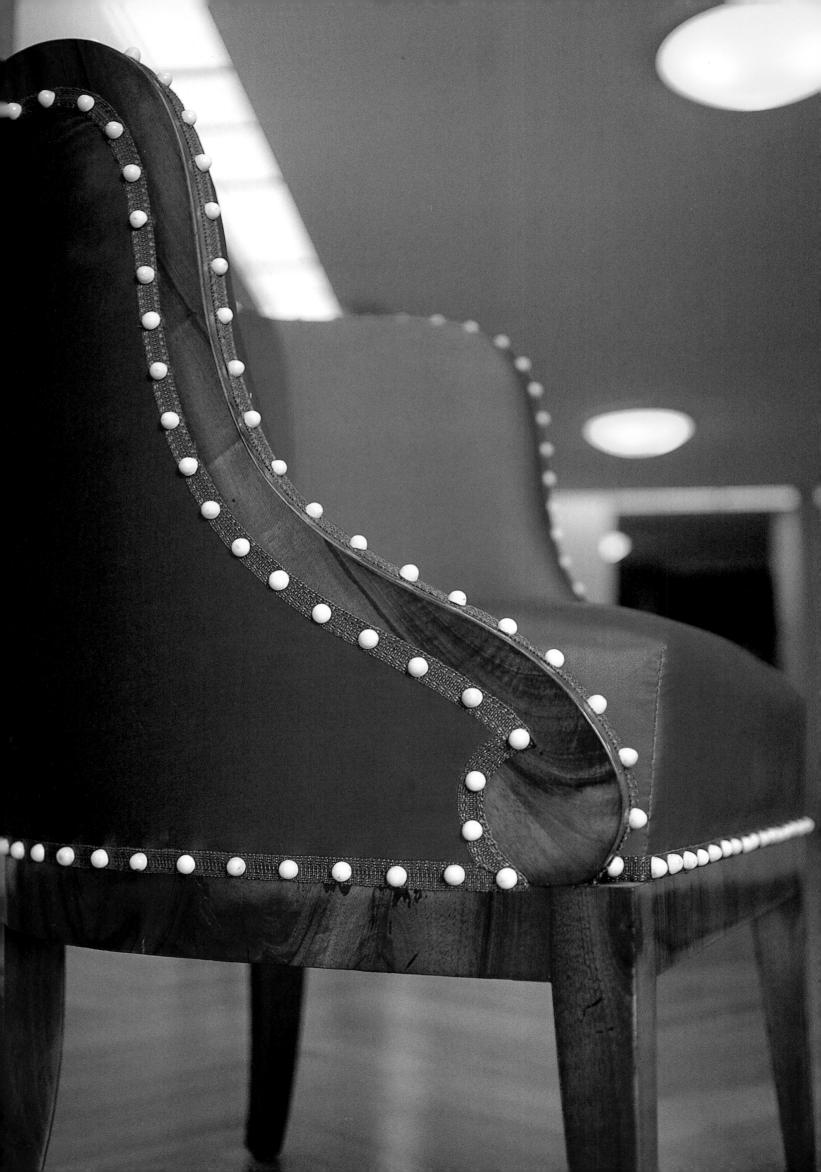

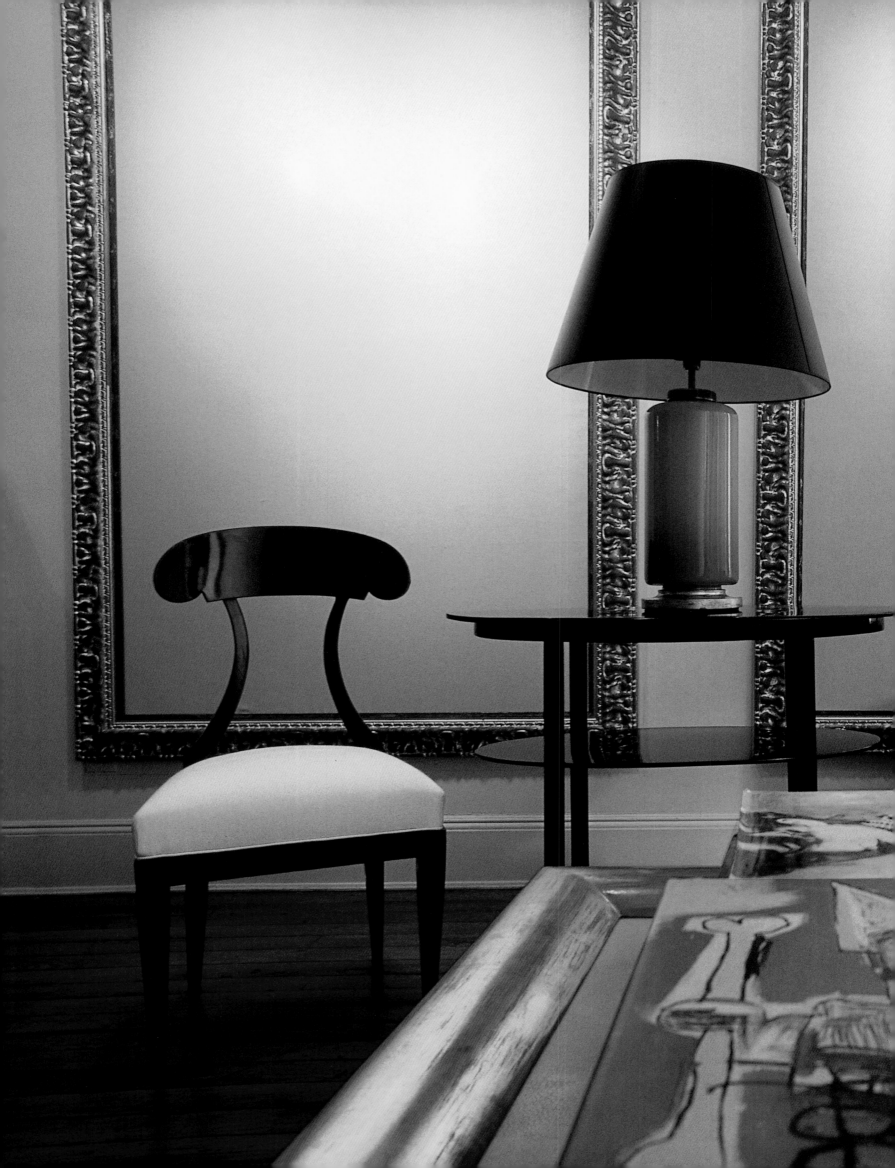

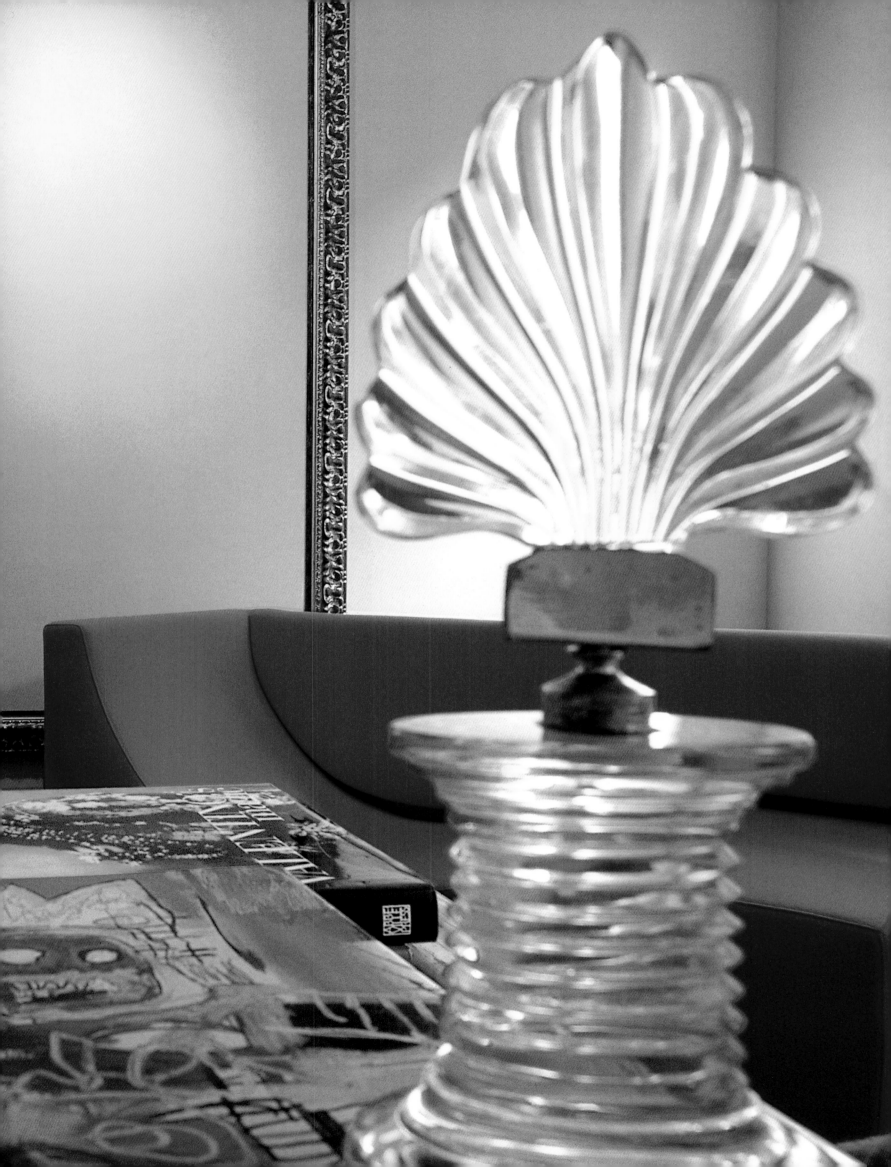

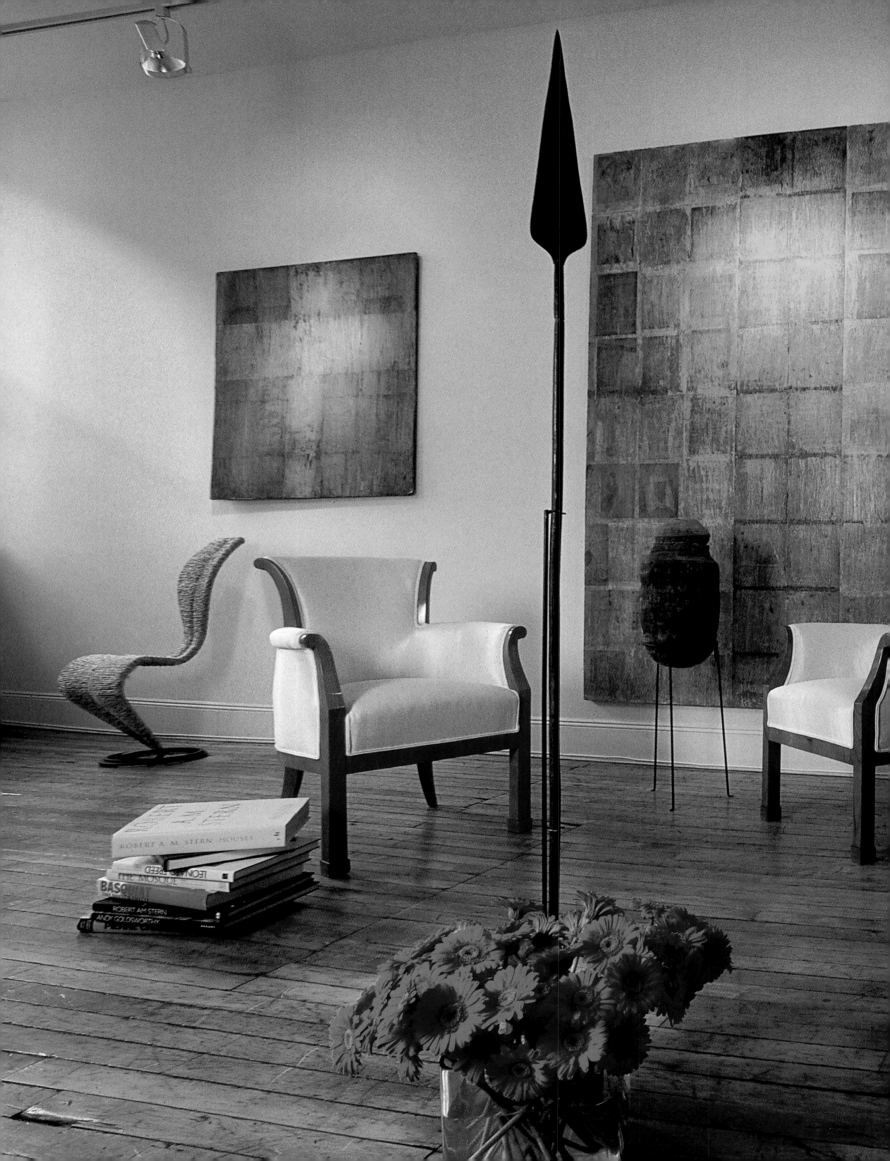

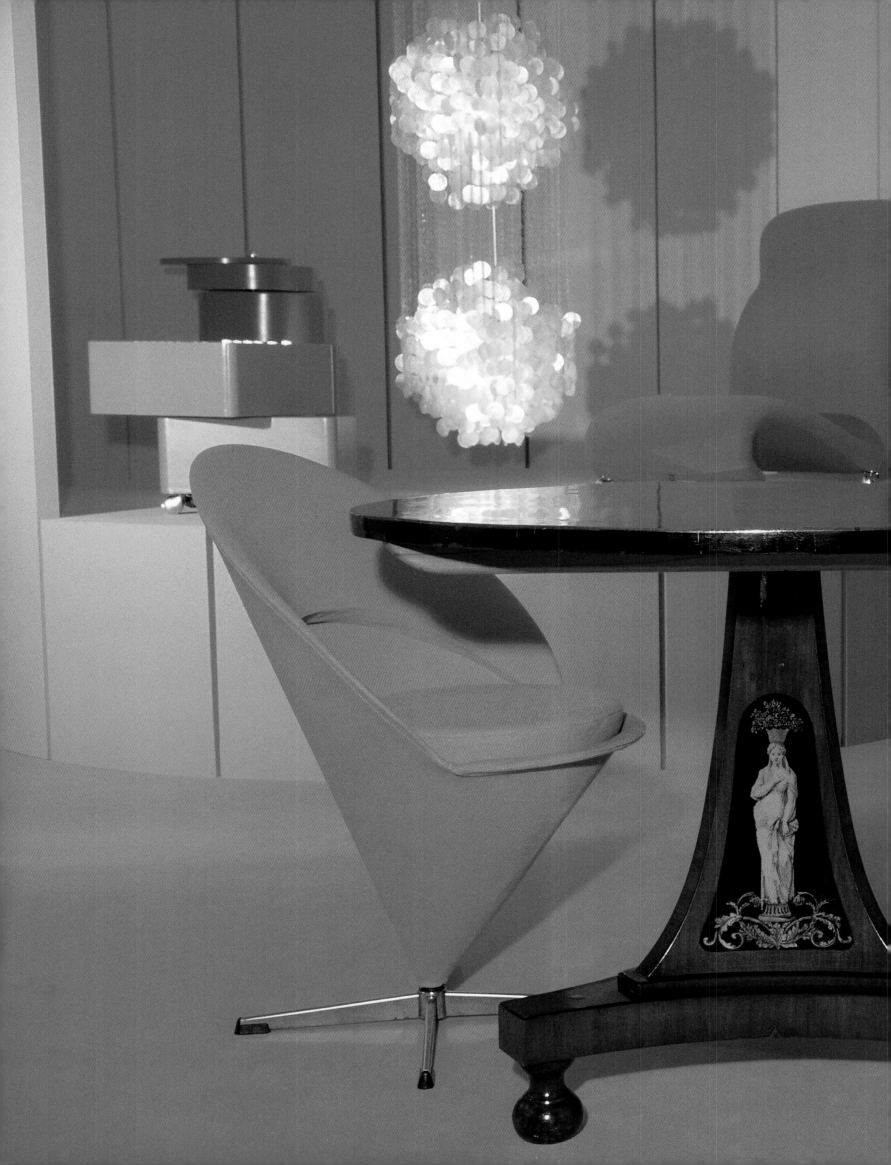

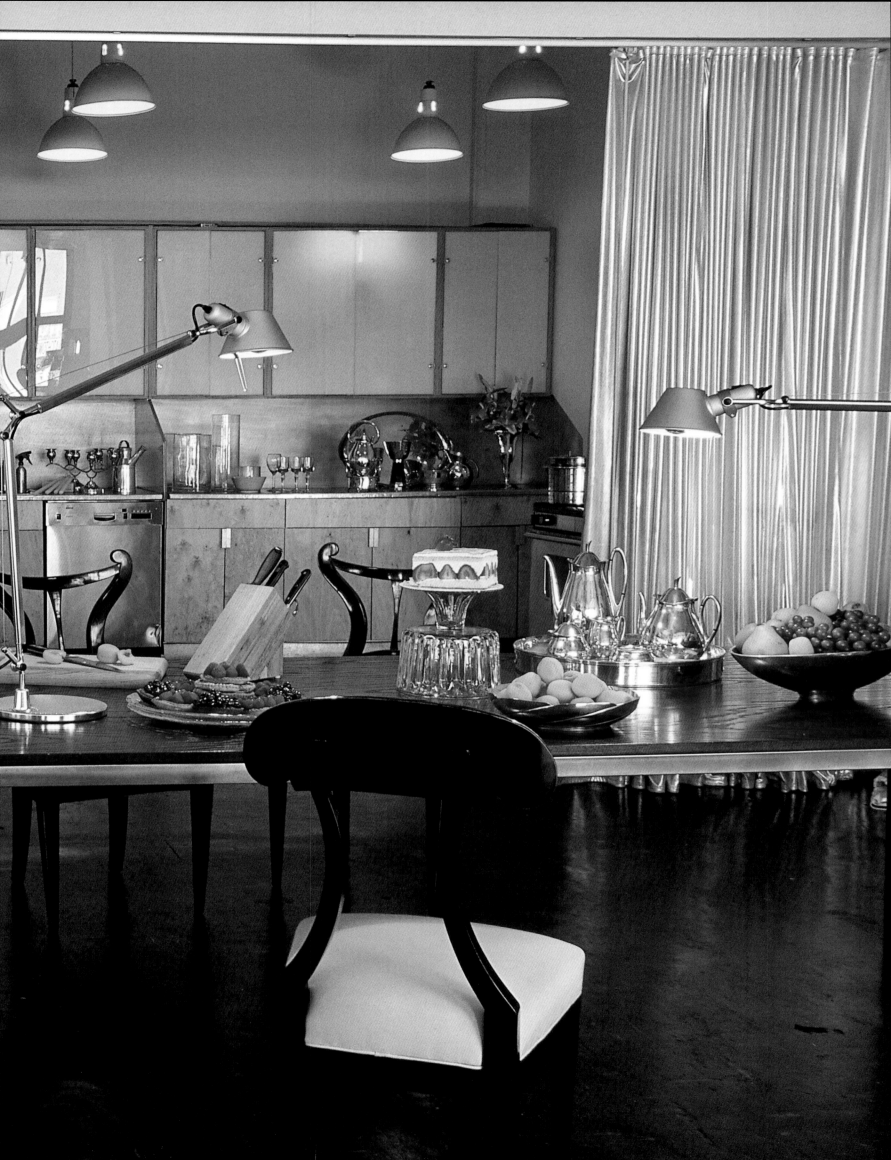

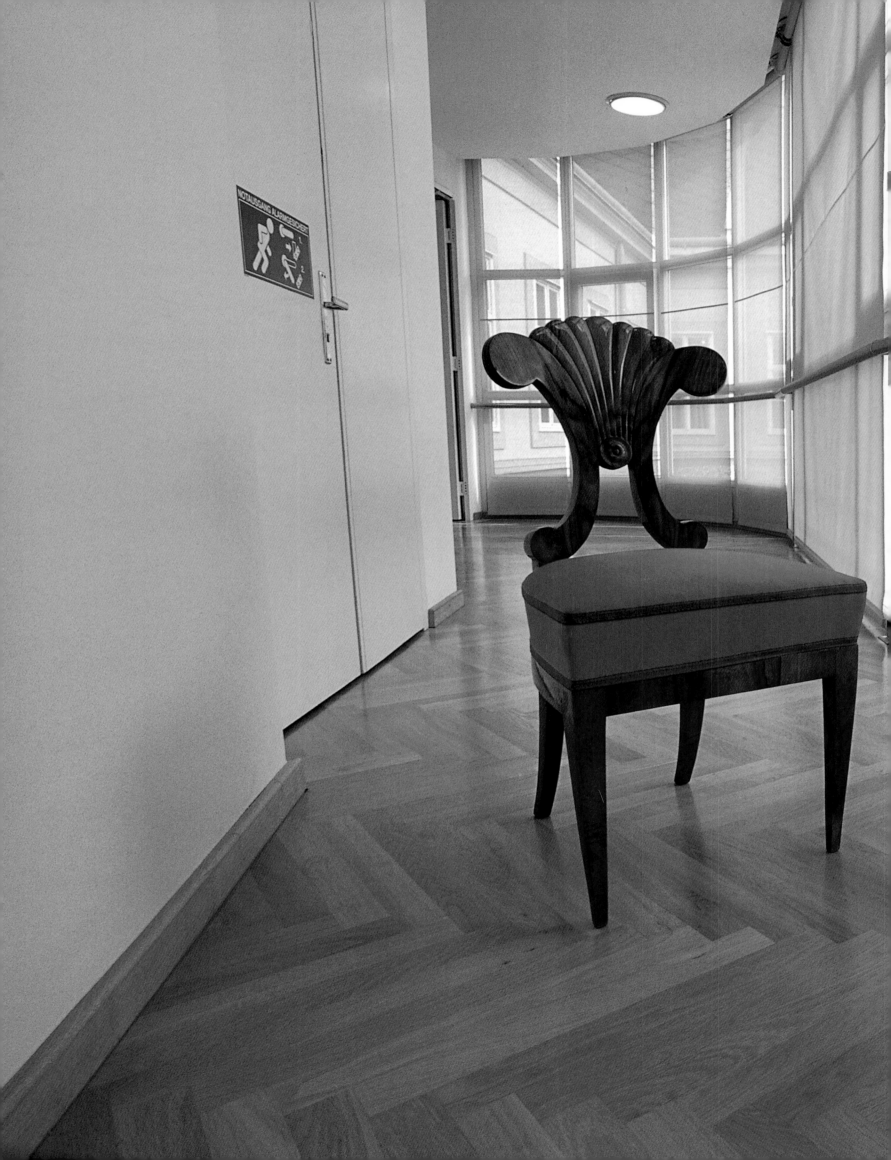

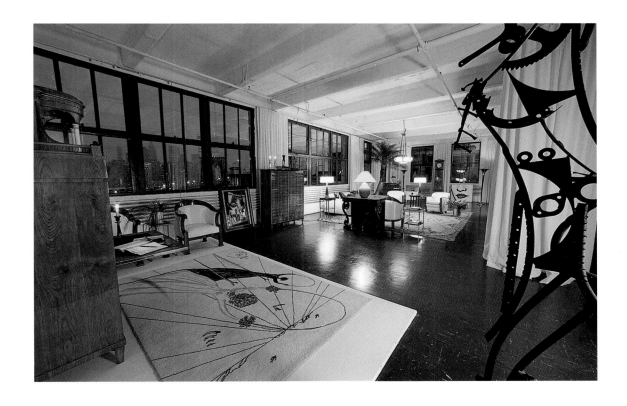

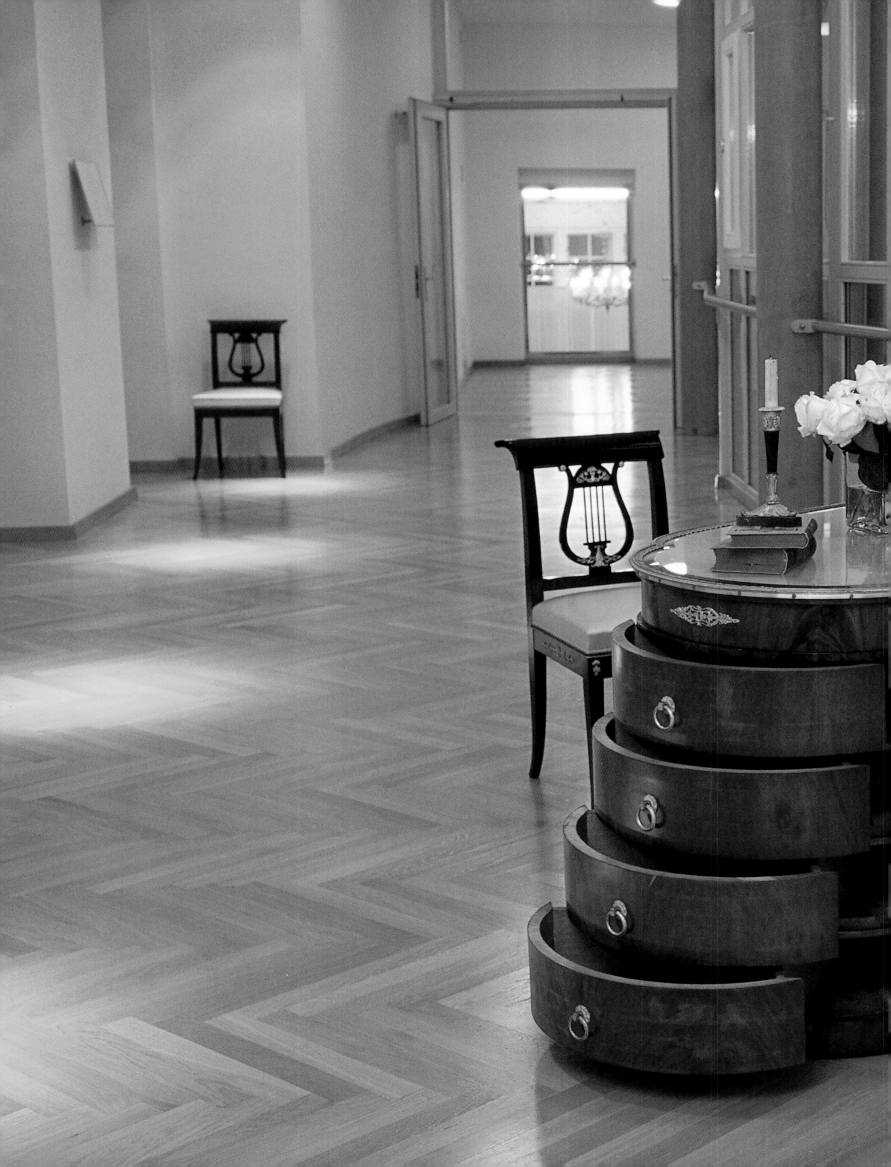

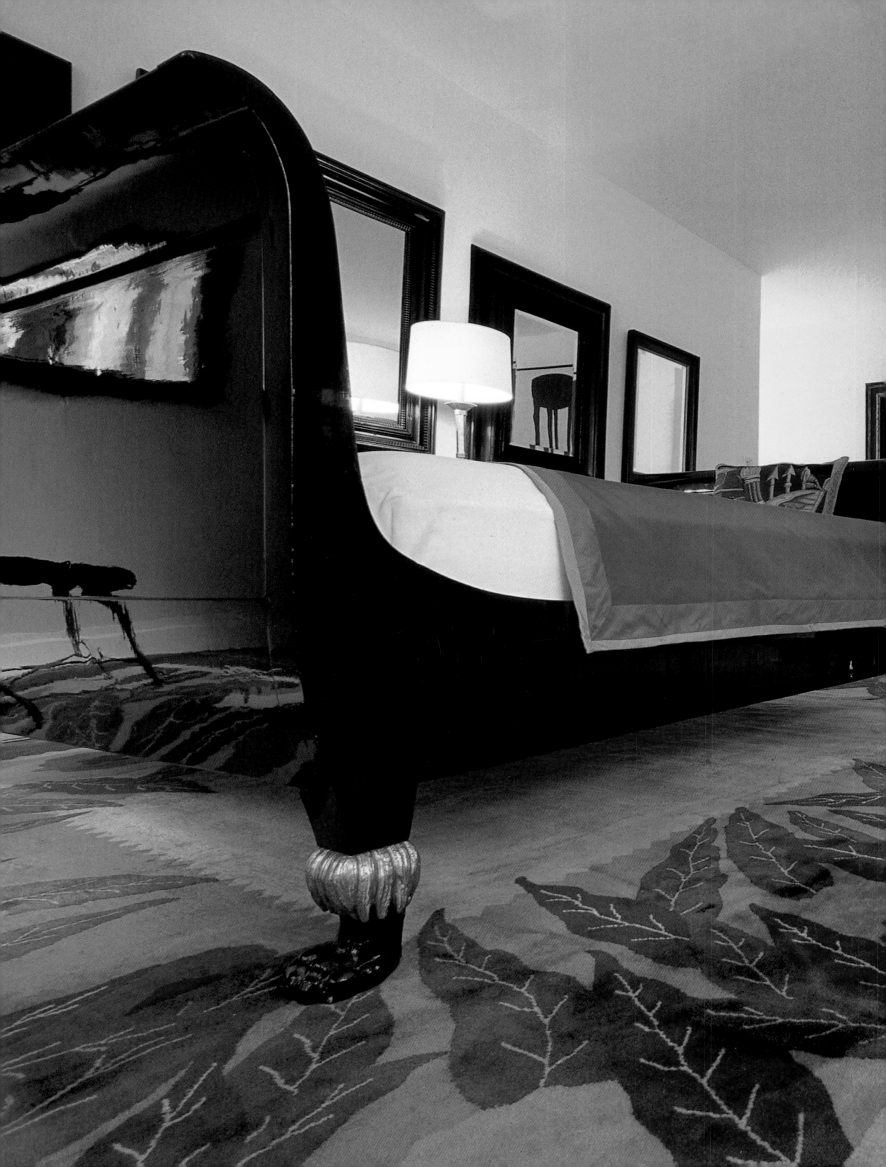

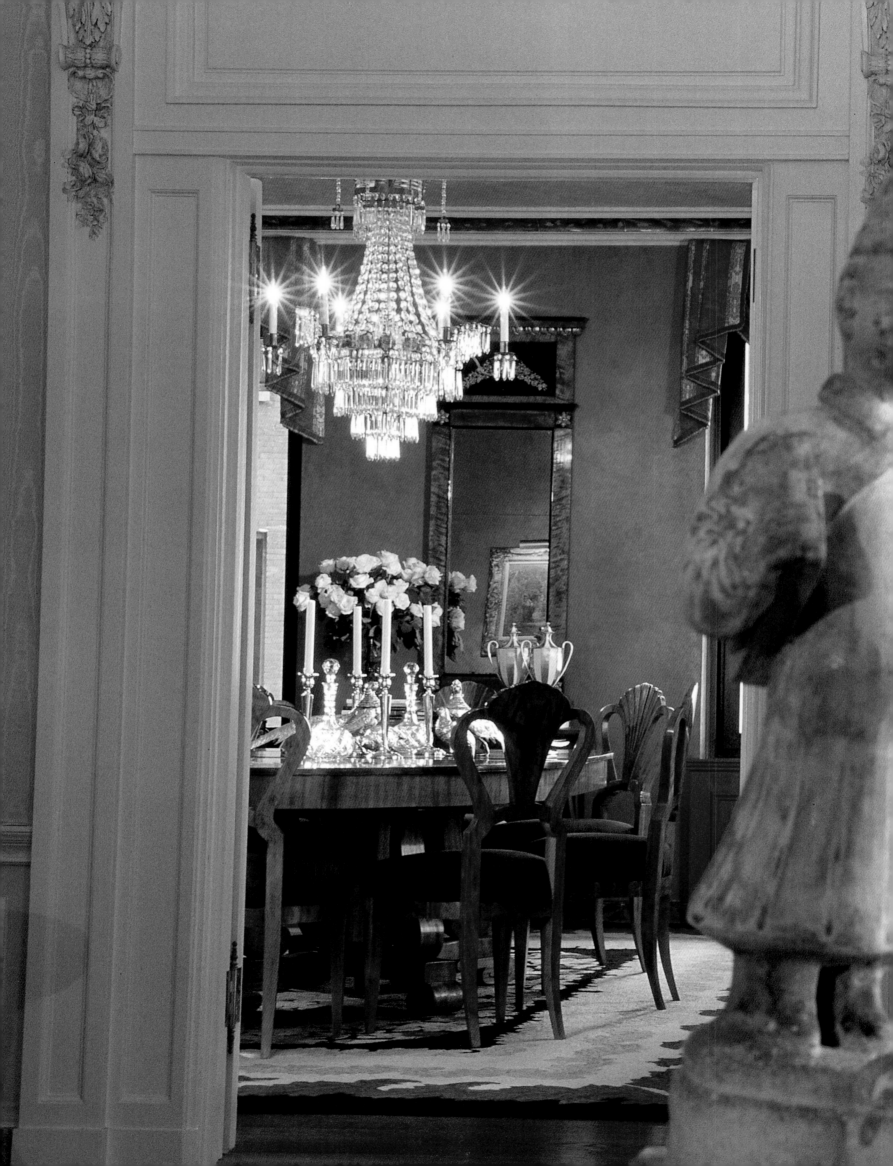

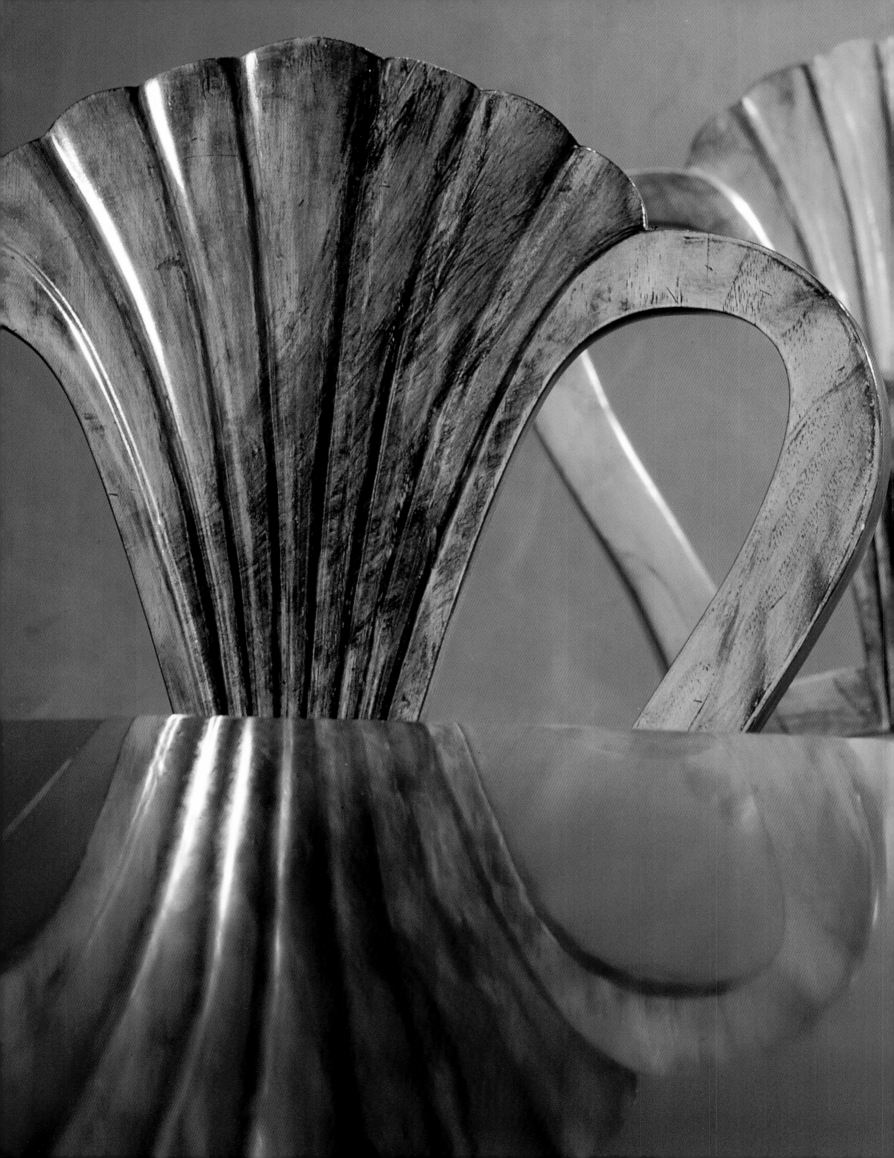

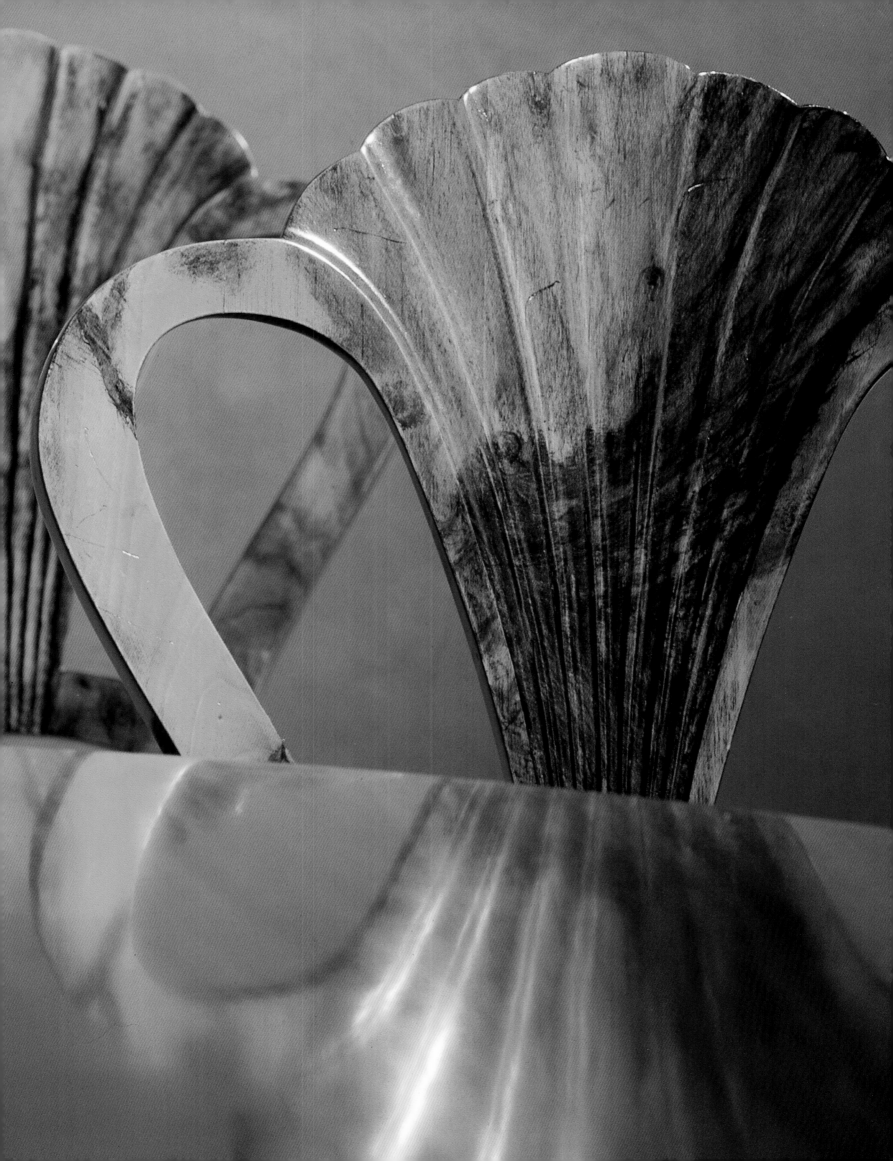

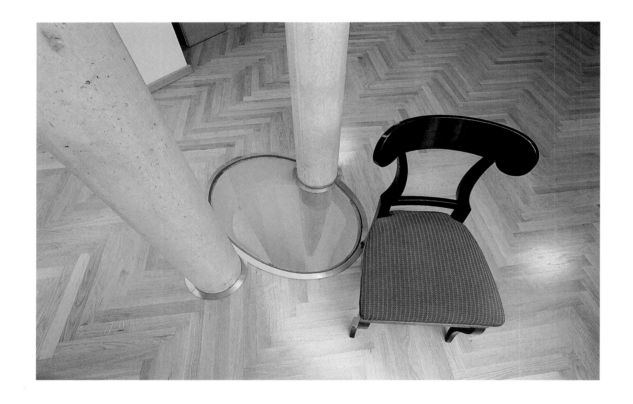

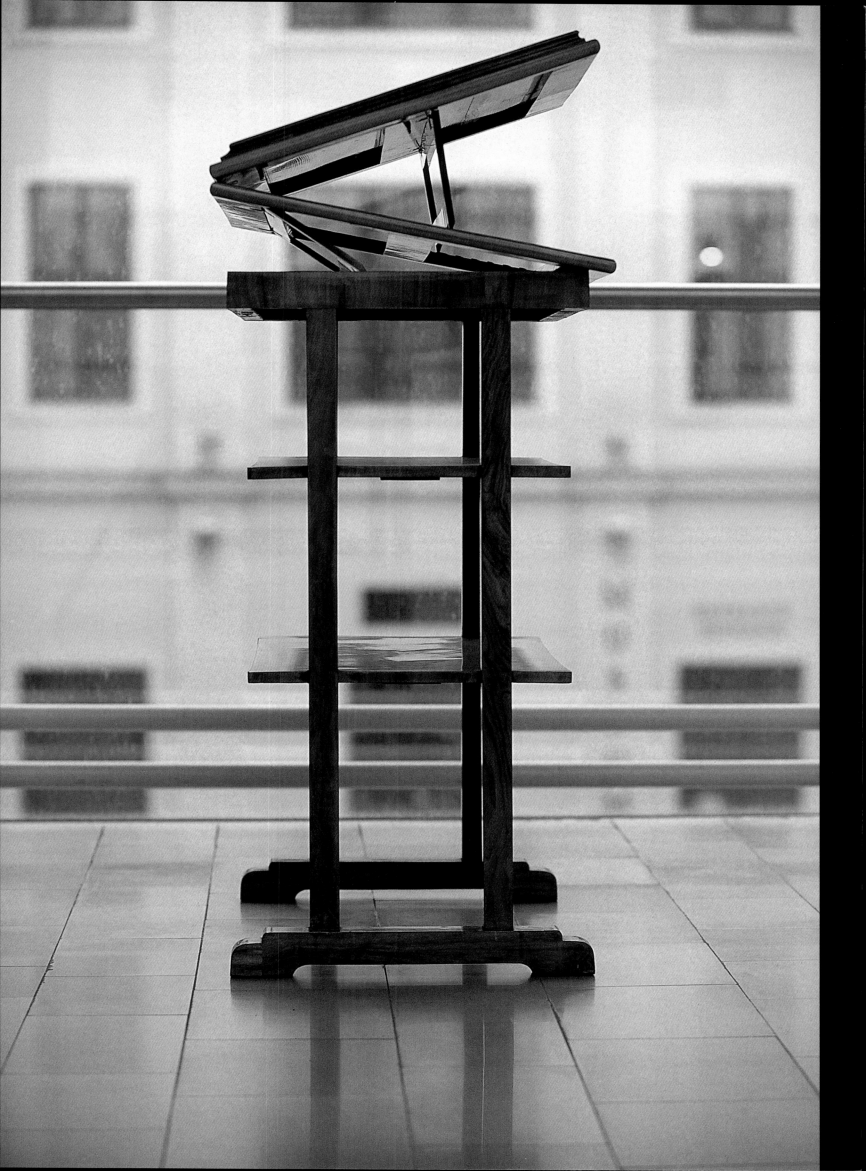

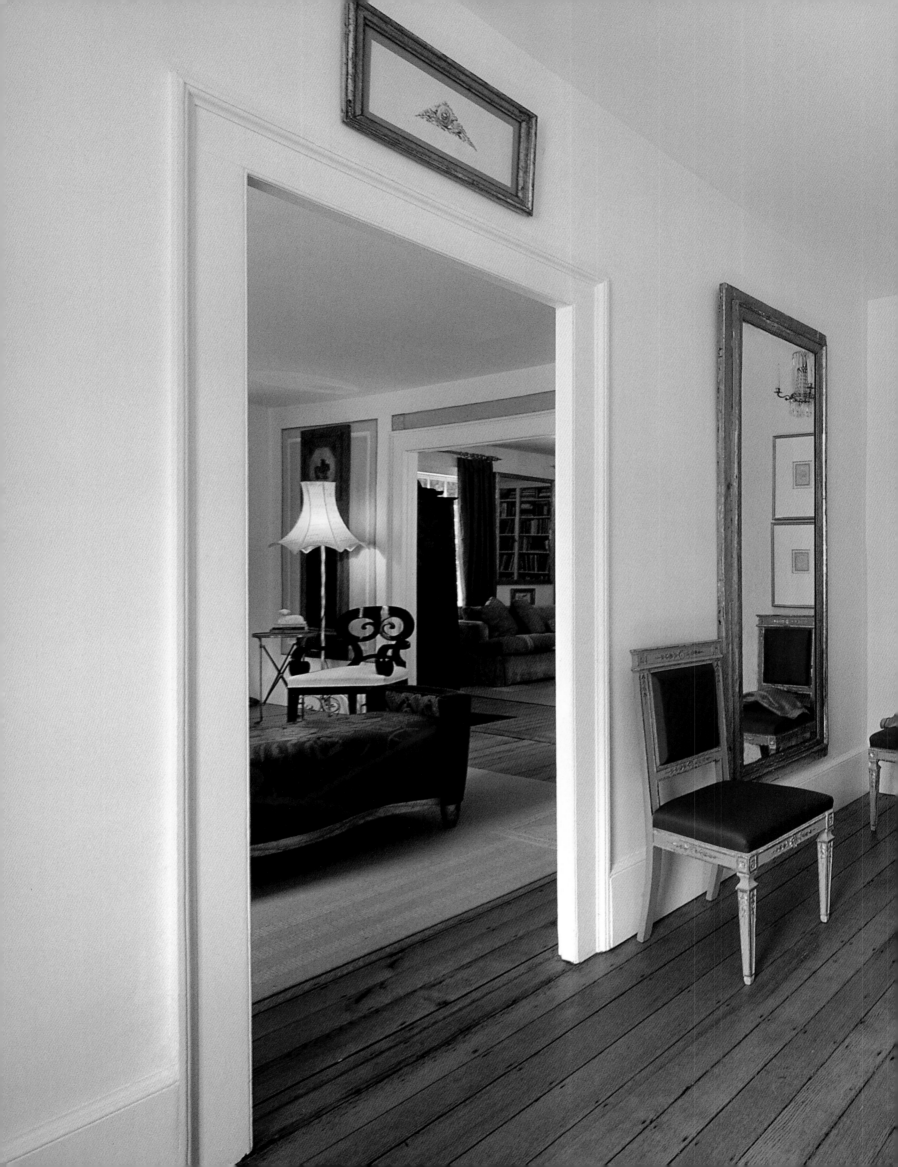

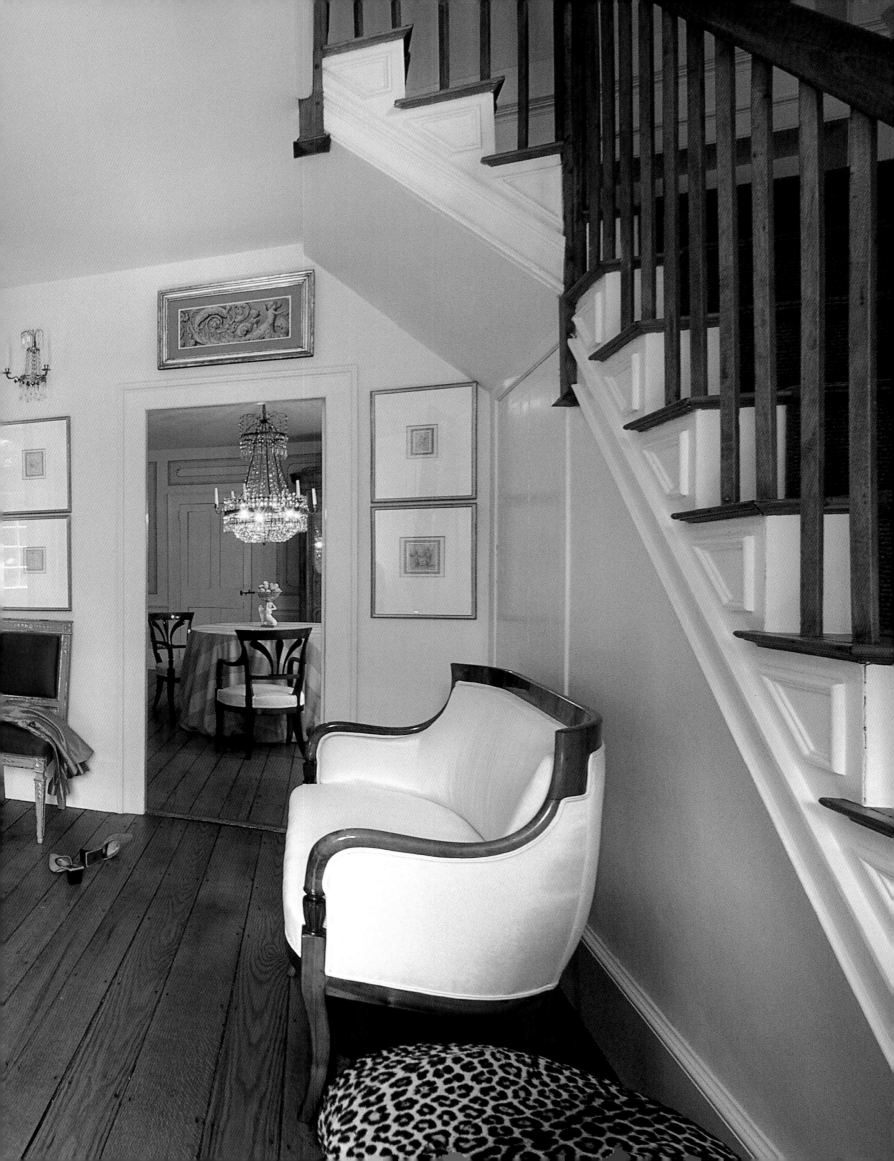

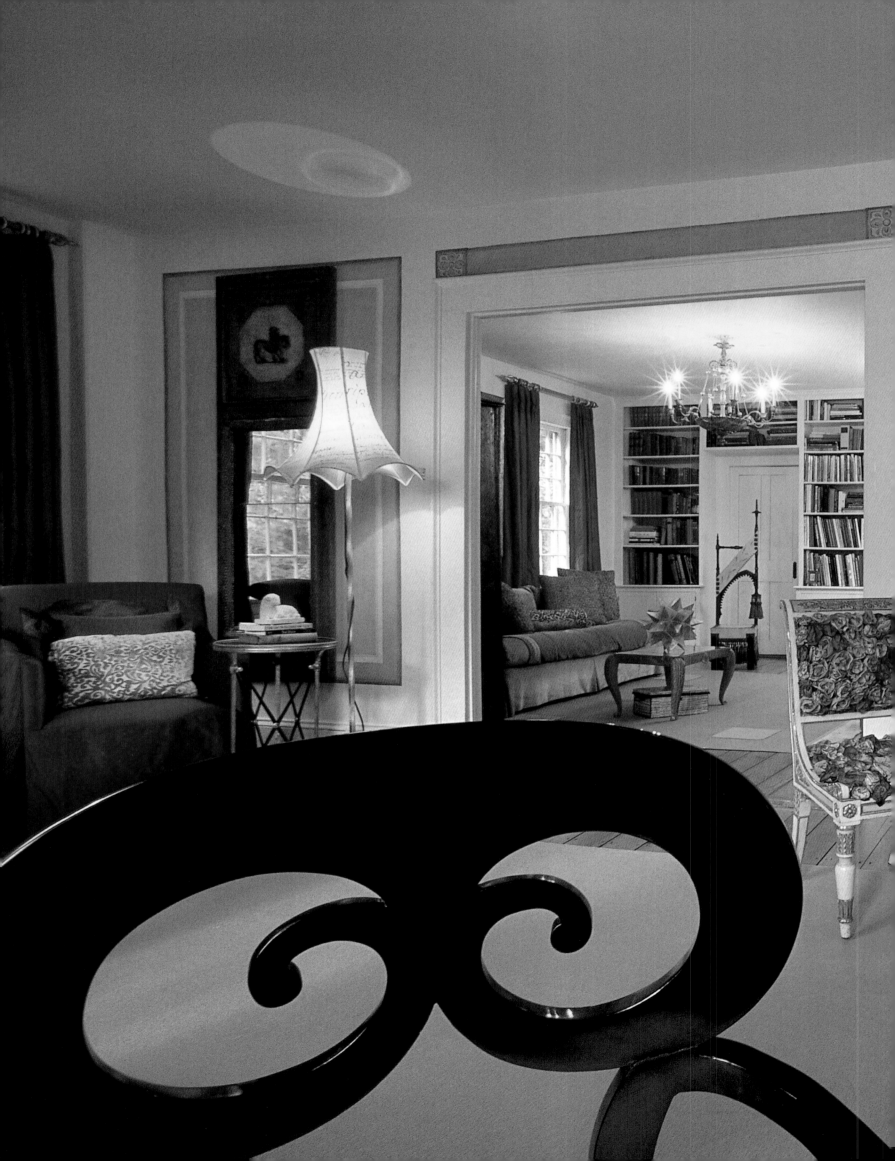

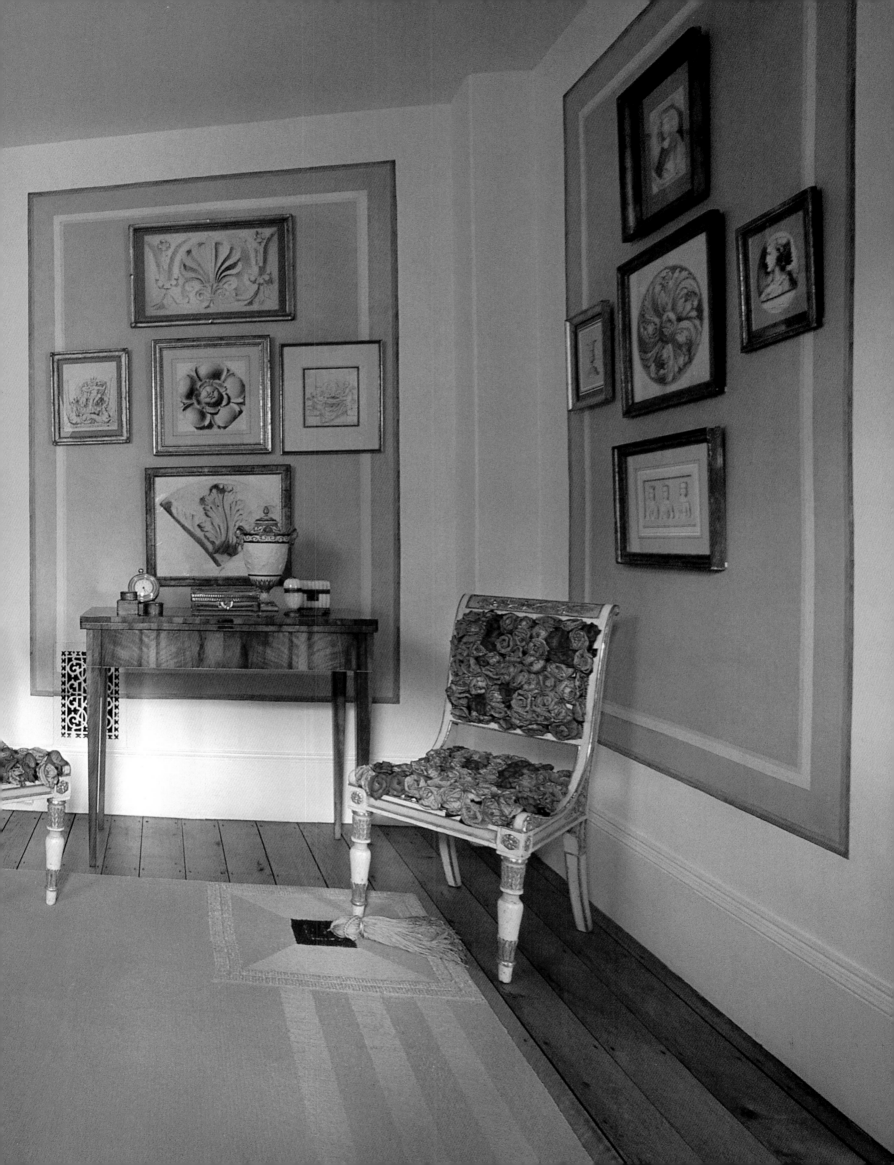

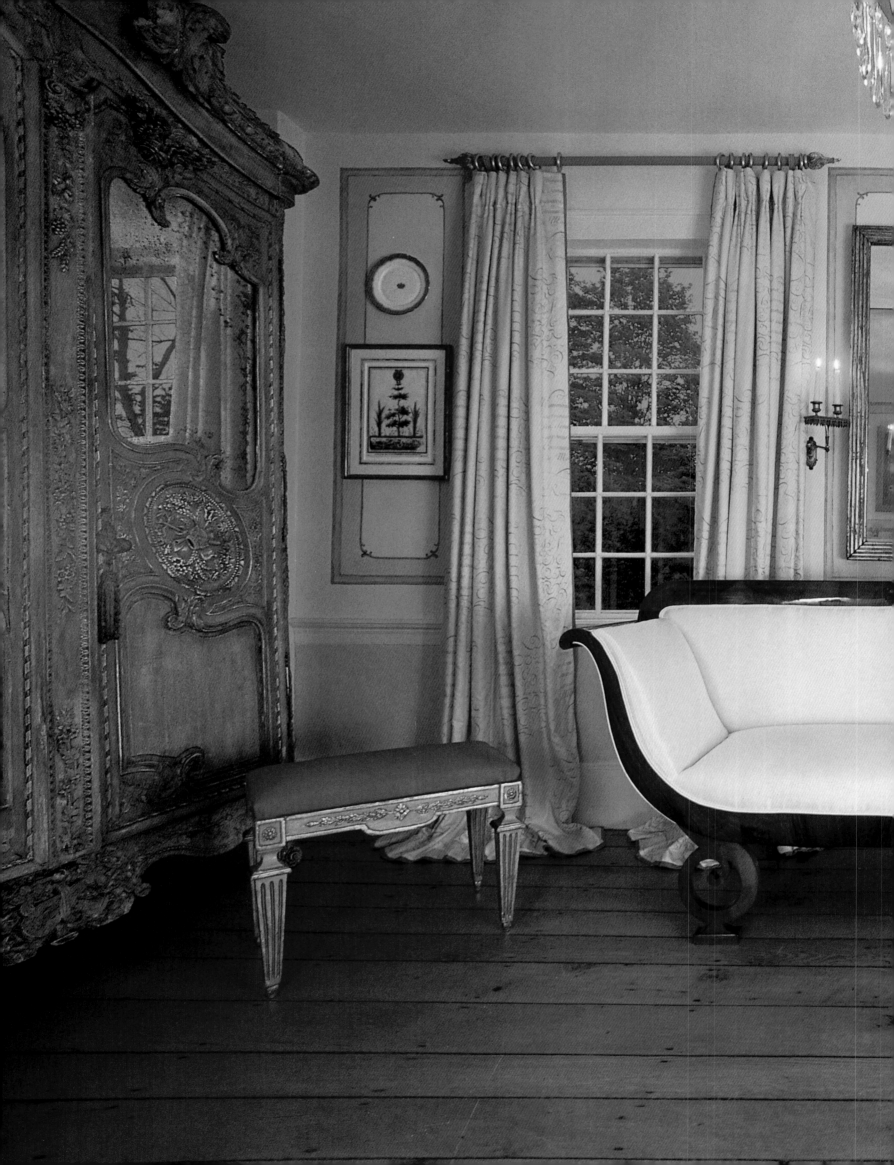

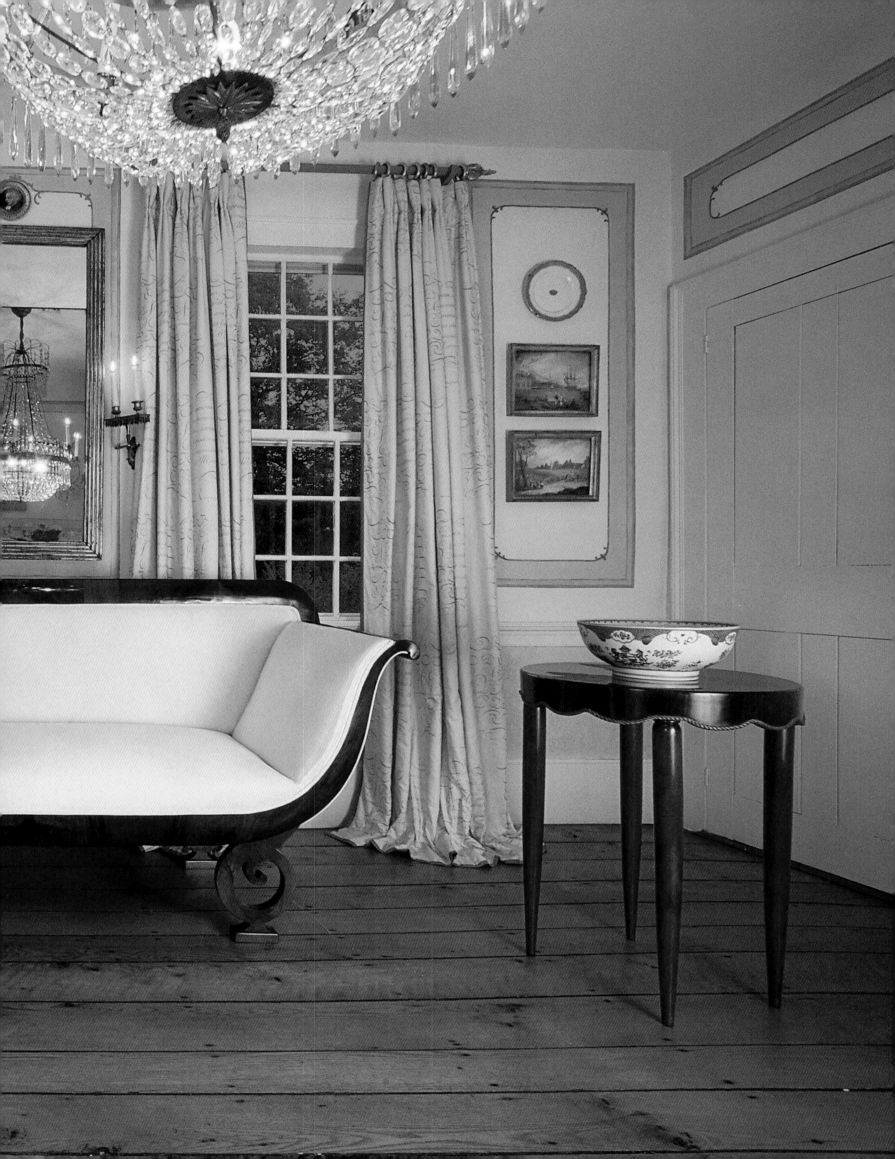

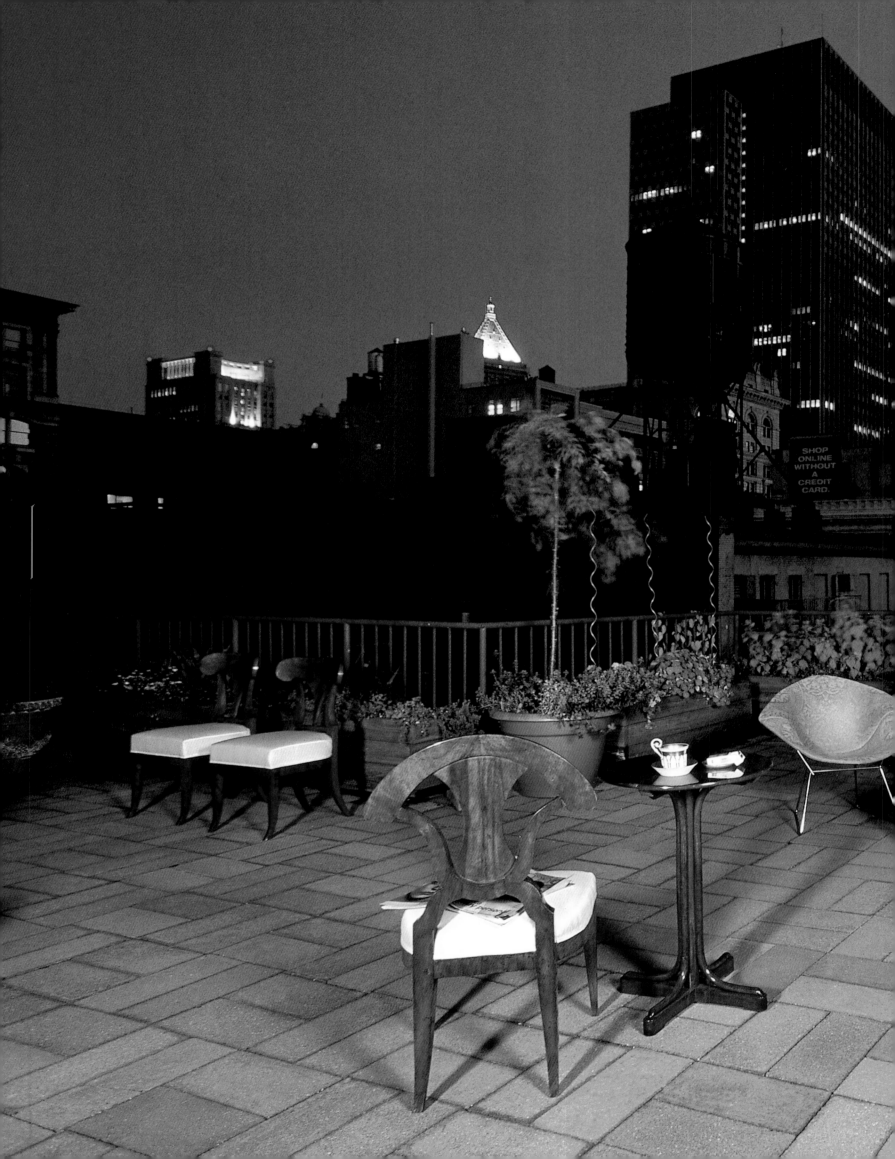

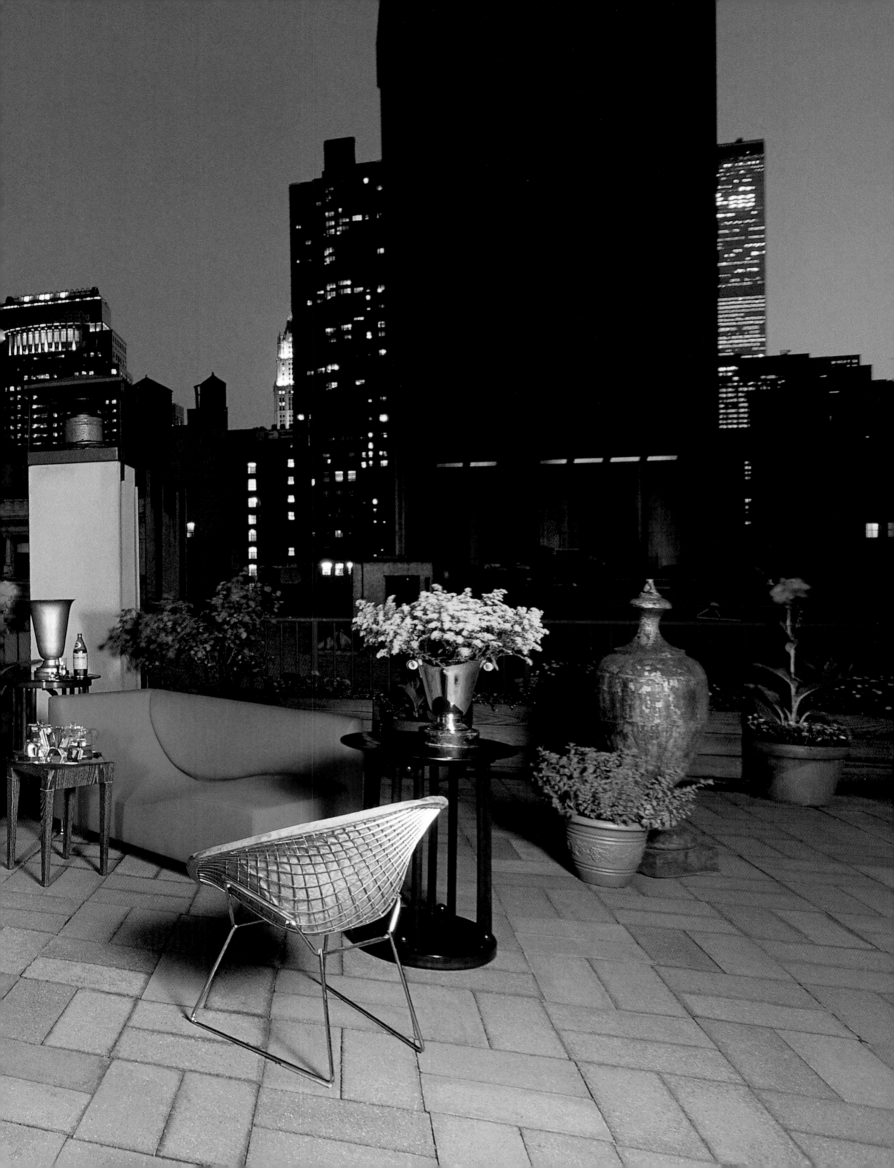

[327] PAIR OF MAHOGANY SIDECHAIRS, VIENNA CIRCA 1820. PRIVATE COLLECTION, NEW YORK CITY. [328] PAIR OF MAHOGANY TABOURETS, AUSTRIA CIRCA 1820-1830. PAIR OF MAHOGANY SIDECHAIRS BY DANHAUSER'S K.K. PRIV. FURNITURE FACTORY, VIENNA CIRCA 1825. PRIVATE COLLECTION, NEW YORK CITY. [330] WALNUT ARMCHAIR, VIENNA CIRCA 1825. WALNUT SIDECHAIR, VIENNA CIRCA 1830. [331] [332] PAIR OF MAHOGANY BERGERES, VIENNA CIRCA 1825. [334] MAHOGANY BERGERE WITH PORCELAIN COVERED NAIL HEADS, VIENNA CIRCA 1830. RESTORED STATUE FROM THE FACADE OF A BUILDING IN VIENNA, VIENNA CIRCA 1850. [336] DETAIL OF [334]. [337] WALNUT SIDECHAIR, VIENNA 1820. [338] EBONIZED PEARWOOD SIDECHAIR, AUSTRIA CIRCA 1825. PRIVATE COLLECTION, NEW YORK CITY. [340] WALNUT SIDECHAIR, AUSTRIA CIRCA 1820-1825. PRIVATE COLLECTION, NEW YORK CITY. [342] PAIR OF FRUITWOOD BERGERES, AUSTRIA CIRCA 1825-1830. PRIVATE COLLECTION, NEW YORK CITY. [344] MAHOGANY WRITING TABLE, VIENNA CIRCA 1825. REFLECTED IN VENETIAN MIRROR: DINING ROOM FURNITURE, VIENNA CIRCA 1820. PRIVATE COLLECTION, NEW YORK CITY. [346] MAHOGANY TABLE, VIENNA CIRCA 1830. EXHIBITION OF VERNER PANTON, 2001. HOFMOBILIENDEPOT MUSEUM. [348] KITCHEN FEATURING BIEDERMEIER FURNITURE. PRIVATE COLLECTION, NEW YORK CITY. [350] WALNUT SIDECHAIR, VIENNA CIRCA 1825. [352] PAIR OF WALNUT SETTEES, AUSTRIA CIRCA 1830. PRIVATE COLLECTION, HOUSTON, TEXAS. [353] LOFT APARTMENT FEATURING BIEDERMEIER FURNITURE. PRIVATE COLLECTION, NEW YORK CITY. [354] MAHOGANY DRESSING TABLE, VIENNA CIRCA 1810. PAIR OF MAHOGANY SIDECHAIRS, VIENNA CIRCA 1815. HOFMOBILIENDEPOT MUSEUM. [356] CHERRYWOOD WORK-TABLE, VIENNA CIRCA 1820. PRIVATE COLLECTION, NEW YORK CITY. [357] ASHWOOD TABOURET, VIENNA 1820. ASHWOOD BURL SIDECHAIR, SOUTHERN GERMANY CIRCA 1815. PRIVATE COLLECTION, NEW YORK CITY. [358] PEARWOOD BED, VIENNA EARLY 19TH CENTURY. PRIVATE COLLECTION, NEW YORK CITY. [360] WALNUT DINING TABLE, AUSTRIA CIRCA 1825. SUITE OF WALNUT SIDECHAIRS, AUSTRIA CIRCA 1825. PRIVATE COLLECTION, NEW YORK CITY. [362] DETAIL OF [360]. [364] PENTHOUSE APARTMENT FEATURING BIEDERMEIER FURNITURE. PRIVATE COLLECTION, NEW YORK CITY. [366] [368] [369] GARDEN ROOM, LIVING ROOM AND VESTIBULE FEATURING BIEDERMEIER FURNITURE. PRIVATE COLLECTION, HOUSTON, TEXAS. [370] EBONIZED FRUITWOOD SIDECHAIR, VIENNA CIRCA 1820. [371] WALNUT HIGH DESK, VIENNA CIRCA 1815. [372] WALNUT SETTEE, NORTHERN ITALY CIRCA 1820. SUITE OF WALNUT ARMCHAIRS, NORTHERN ITALY CIRCA 1820. EBONIZED PEARWOOD ARMCHAIR, AUSTRIA CIRCA 1815-1820. PRIVATE COLLECTION, CONNECTICUT. [374] WALNUT GAME TABLE, AUSTRIA CIRCA 1820. EBONIZED PEARWOOD ARMCHAIR, AUSTRIA CIRCA 1815-1820. PRIVATE COLLECTION, CONNECTICUT. [376] WALNUT BURL SETTEE BY JOSEPH ULRICH DANHAUSER, VIENNA CIRCA 1820. PRIVATE COLLECTION, CONNECTICUT. [378] WALNUT SIDECHAIR, AUSTRIA CIRCA 1820-1825. PAIR OF MAHOGANY SIDECHAIRS BY JOSEPH ULRICH DANHAUSER, VIENNA CIRCA 1815-1820. PRIVATE COLLECTION, NEW YORK CITY. [380] EBONIZED PEARWOOD SIDECHAIR, VIENNA CIRCA 1811.

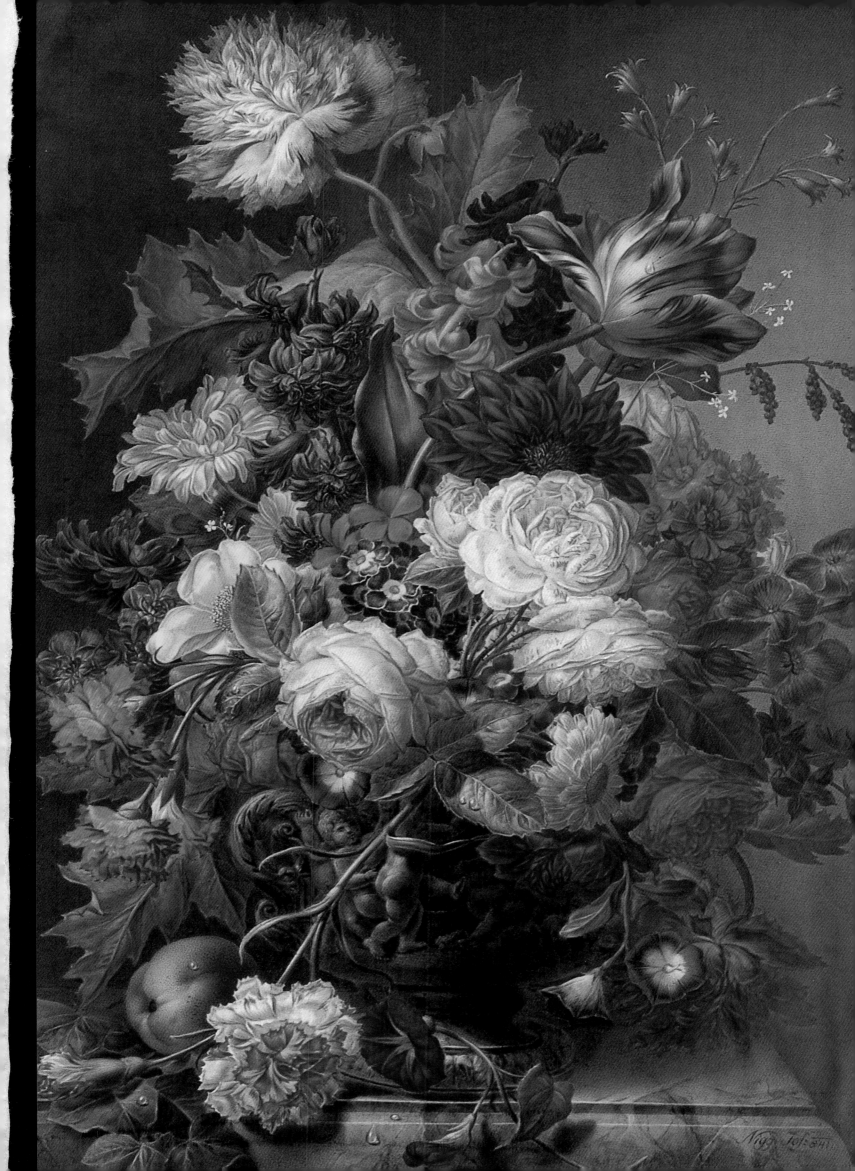

REFERENCE

THE FOLLOWING PAGES GIVE FULL DESCRIPTIONS
OF ALL BIEDERMEIER PIECES CONTAINED IN THIS WORK.
THIS INFORMATION HAS BEEN COMPILED IN COLLABORATION WITH
THE BIEDERMEIER EXPERTS DR. PETER PARENZAN, DIRECTOR
OF THE HOFMOBILIENDEPOT MUSEUM AND DIRECTOR OF
THE SILBERKAMMER IN VIENNA, DR. CHRISTIAN WITT-DÖRING,
CURATOR OF FURNITURE AND WOODWORK, MUSEUM
FÜR ANGEWANDTE KUNST (MAK) IN VIENNA, AND
DR. BURKHARDT GÖRES, DIRECTOR OF STIFTUNG PREUSSISCHE
SCHLÖSSER BERLIN-BRANDENBURG IN POTSDAM. THEIR JOINT
EFFORTS HAVE RESULTED IN A DOCUMENTATION OF DATA
THAT MEETS MUSEUM ARCHIVAL STANDARDS. IT IS ACCEPTED
THAT BIEDERMEIER AND EMPIRE COEXISTED.
REPRESENTATIONAL FURNITURE, USED IN OFFICIAL ROOMS, WAS
ALMOST ALWAYS EMPIRE IN DESIGN. ACCORDING TO DR. HANS
OTTOMEYER, AUTHOR OF THE BOOK BIEDERMEIER: INTERIEURS UND
MÖBEL, THESE ROOMS WERE ALMOST NEVER LIVED IN.

For the private lifestyle exhibiting *vornehme Bescheidenheit*, or 'distinguished modesty,' the preference was Biedermeier. These two worlds of furniture were only to be enjoyed by the members of the court, the princes of the church, high ranking state officials, the upper echelon of the military, educated patricians and the most affluent of the middle-class. Due to the political and socio-economic evolutions, Biedermeier became the desired furniture for the emerging middle-class bourgeoisie as well. Their demands fueled the creativity of cabinetmakers, which often led to the production of pieces that display characteristics of both styles. Even our most qualified experts have expressed that is difficult at times to draw a clear distinction between Biedermeier and Empire furniture. THE DESCRIPTION OF WOOD TYPES refers to the veneers applied over blindwood, unless otherwise noted. Very few pieces were carved from solid wood. BRONZE MOUNTS that decorated furniture were considered one of the greatest luxuries. Often, the price of the mounts exceeded that of the furniture, sometimes costing three times as much. Prior to approximately 1840, all bronze mounts were fire gilded. Due to technologies employed by Christofle in St. Denis, Paris other less expensive methods of gilding became available and were commonly used. Gilded carved wood and gilded paste were often substituted for fire-gilded bronze. Many mounts, which were originally fire gilded, have since been renewed using other materials and techniques. We have noted fire gilded mounts only when they have not been altered.

THE WORLD OF BIEDERMEIER:

[COVER] Detail of an ebonized fruitwood sidechair, renewed upholstery, Vienna circa 1820. Private collection, New York City.

[BACKCOVER] Detail of figural alabaster mantel clock, anonymous, probably by Caspar Kaufmann, Vienna 1824. Geymüller-Schlössl.

[2] Cast iron armchair designed by Karl Friedrich Schinkel, Berlin early 19th century. Schinkel Pavilion, Castle Charlottenburg.

[4] Banded baluster shaped porcelain chocolate cup with rosette scroll handle depicting playing cards against a gilt ground, manufactured by Königliche Preussische Porzellanmanufaktur (KPM), Berlin circa 1815. Private collection, New York City.

[6] Figural alabaster mantle clock, probably by Caspar Kaufmann, Vienna circa 1824. Geymüller-Schlössl.

[8] Walnut sidechair, Vienna circa 1820. Hofmobiliendepot Museum.

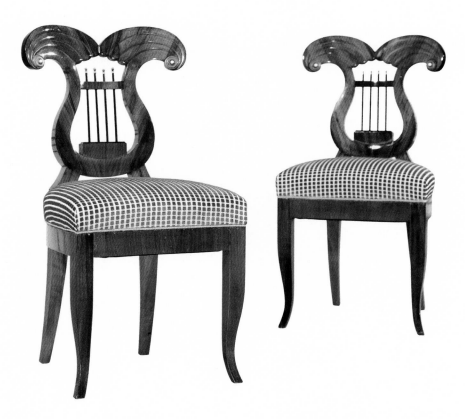

[10] Walnut cuspidor, Vienna circa 1825. Oil on canvas depicting "Hemera" (Goddess of the Day) by Hans Makart, Vienna 1825. Hofmobiliendepot Museum.

[12] Cut glass with k.k. double eagle by Joseph Rohrweck, Vienna circa 1828. Silberkammer.

[14] Set of silver soupspoons manufactured by Mayerhofer & Klinkosch (M&K) from the court of Emperor Ferdinand, Vienna 1845. Silberkammer.

[16] Porcelain with veduta (landscape view) of Vienna, gold relief border, manufactured by the Vienna Porcelain Factory, Vienna 1804. Silberkammer.

[18] Assembly of busts featuring daughters and sons

of the Habsburg Empire, top and center: poet and playwright Franz Grillparzer. Hofmobiliendepot attic, Vienna.

[20] View of a workroom. Hofmobiliendepot attic, Vienna.

[22] Detail of walnut burl sidechairs, Austria circa 1828. Private collection, Houston, Texas.

[24] Display of 18th, 19th, and 20th century chairs. Hofmobiliendepot Museum, Vienna.

[26] Picture clock with automatic figures and playing mechanism, Vienna circa 1840-1850. Geymüller-Schlössl.

[28] Blue Salon designed by Joseph Ulrich Danhauser: Panorama wallpaper

"Hindustan" by Zuber, Rixheim, France circa 1820. Suite of ebonized pearwood furniture with gilt wood decorations, comprised of a settee, two armchairs, eight sidechairs, and a pedestal table, renewed upholstery in original colors, Vienna circa 1810. Mahogany armchair with inset gilt wood carved decorations, renewed upholstery in original colors, Vienna circa 1810. Patinaed

and gilt bronze figural ten-arm candelabrum, Vienna circa 1810. Eight-arm crystal chandelier with filigree gilt bronze decorations, Vienna. Dining Room installation background, see [166]. Geymüller-Schlössl.

[30] Detail of chaise longue in Princess Elizabeth's Sitting Room designed by Karl Friedrich Schinkel, Castle Charlottenhof circa 1827. Potsdam.

[385] FLORAL STILL LIFE ON PORCELAIN BY JOSEPH NIGG, MANUFACTURED BY VIENNA PORCELAIN FACTORY, VIENNA CIRCA 1820. GEYMÜLLER-SCHLÖSSL. [386] WALNUT SIDECHAIR WITH RUSH SEAT, VIENNA CIRCA 1815. WORKSHOP OF THE HOFMOBILIENDEPOT. [388] PAIR OF CHERRYWOOD SIDECHAIRS WITH EBONIZED DECORATIONS, RENEWED UPHOLSTERY, VIENNA CIRCA 1820. PRIVATE COLLECTION, NEW YORK CITY. [389] PAIR OF WALNUT BURL SIDECHAIRS, RENEWED UPHOLSTERY, VIENNA CIRCA 1820. PRIVATE COLLECTION, CHICAGO, ILLINOIS.

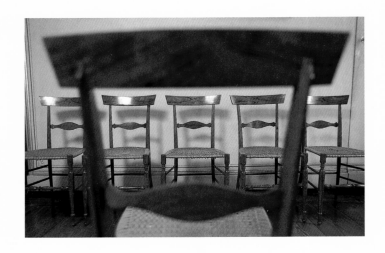

[32] Manufacturer's label of Joseph Ulrich Danhauser, Vienna circa 1825. Silberkammer.

[35] Biedermeier handicraft: Floral arrangement fabricated of butterfly wings, anonymous, Prague circa 1840. Geymüller-Schlössl, Vienna.

[36] Mahogany dressing mirror, fire gilded mounts, Vienna circa 1815. Mahogany sidechair by Johann Nepomuk Geyr, Innsbruck 1838. Portrait of Archduke Franz Karl, son of Emperor Franz II(I), by Joseph Stieler, Vienna circa 1807. Pair of gilded bronze candelabrum, Vienna circa 1810. Hofmobiliendepot Museum.

[38] Detail of a plaque adorning a bronze sculpture by Johann Georg Danninger, depicting "Apollo in the Sun Chariot," Vienna circa 1840. Hofmobiliendepot Museum.

[40] Mahogany cradle with baldaquin, brass mounts and scroll ornament, Austria circa 1820. Private collection, Connecticut.

[48] Funeral crowns, replicas of the originals, used by the Habsburg monarchs, first half of the 19th century. Hofmobiliendepot attic, Vienna.

[58] Statues atop the Museum of Natural History look toward Vienna's city center: The center cupola is part of the Hofburg Palace, to the left is the cupola of Peter's Church, to the right is the clock tower of Michaela Church.

[60] View of the Hofburg Palace, Michaela Church and Stephansdom, Vienna.

[62] View of the city center and the Hofburg Palace, Vienna.

[64] Bisque porcelain bust of Franz II(I), probably by Elias Hutter, manufactured by Vienna Porcelain Factory, Vienna circa 1810-1815. Silberkammer.

[68] Grisaille portrait of Emperor Franz II(I) and his family: Empress Maria Theresia of Naples, Maria Louisa (later married to Napoleon), Leopoldina (later became Empress of Brazil), Maria Clementina, Ferdinand and Franz Karl (father of Emperor Franz Joseph I), Castle Laxenburg, anonymous, Vienna circa 1807. Hofmobiliendepot Museum.

[70] Watercolor depicting the private gardens of Emperor Franz II(I), mounted within a walnut tabletop, which lifts to reveal individual compartments for specimen seeds, gift to the emperor from the court gardeners, anonymous, Vienna circa 1810-1815. Hofmobiliendepot Museum.

[74] Oil on canvas, portrait of Prince Clemens Lothar Wenzel von Metternich by Johann Ender, Vienna circa 1835. Workshop of the Hofmobiliendepot.

[76] Biedermeier chandelier

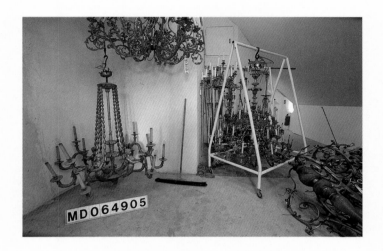

MD064905

awaiting restoration.
Workshop of the
Hofmobiliendepot, Vienna.
[77] Naïve example of a
Biedermeier sidechair,
Austria circa 1820.
Hofmobiliendepot attic,
Vienna.
[78] [79] Some of the thirty
thousand chairs arranged
by inventory numbers,
many of them Biedermeier.
Hofmobiliendepot attic,
Vienna.
[80] Assembly of
Biedermeier cuspidors,
Vienna circa 1815-1830.
Hofmobiliendepot Museum,
Vienna.
[82] [83] Reproduction of a
19th century machine used
by cabinetmakers to plane
veneers. This machine is
used by the museum

carpenters today to replace
and restore damaged veneers.
Workshop of the
Hofmobiliendepot, Vienna.
[84] [85] Original inventory
book #66 listing the
contents of the apartment
of Count Bombelles, the
instructor of Emperor
Franz Joseph I, when he
was a child, at the Hofburg
Palace, Vienna 1826.
Hofmobiliendepot.
[89] Miniature model of the
Study of Emperor Franz II(I),
Vienna 1896.
Hofmobiliendepot Museum.
[90] Detail of [89].
[91] Installation of the Study
of Emperor Franz II(I) in
the Hofburg Palace: Marble
bust of Emperor Franz II(I)
by Josephus Cerrachi, circa
1784. Walnut high desk and

writing table with gilt bronze
mounts, Vienna circa 1815.
Walnut sidechairs with
cane-work, Vienna 1815.
Oak riding chair with leather
upholstery, Vienna 1815.
Brass birdcage with walnut
stand, Vienna circa 1820.
Hofmobiliendepot Museum.
[92] Bibi and Büberl, the
favorite birds of Emperor
Franz II(I), preserved.
Original brass cage and
bronze pedestal against
document wallpaper,
Vienna circa 1840.
Hofmobiliendepot Museum.
[94] Oil on canvas depicting
Emperor Franz II(I) in his
Study, anonymous, Vienna

first half of the 19th century.
Hofmobiliendepot Museum.
[96] Oil on canvas, portrait
of Empress Maria Ludovica
d'Este, anonymous, Vienna
circa 1810. Painting in
background: Oil on canvas,
portrait of Emperor Joseph
II as a child by Meytens,
Vienna circa 1750.
Hofmobiliendepot Museum.
[98] Gilded fruitwood furni-
ture from Empress Carolina
Augusta's Reception Room
in the Hofburg Palace,
Vienna circa 1816.
Hofmobiliendepot Museum.
[99] Oil on canvas, portrait
of Sophie of Bavaria by
Joseph Stieler, Vienna circa

[390] ALDERWOOD SIDECHAIRS WITH FAUX PAL-
ISANDER GRAINING AND RUSH SEATS, ITALY CIRCA
1825. CASTLE CHARLOTTENHOF, POTSDAM. [391] VIEW
OF WORKROOM. HOFMOBILIENDEPOT ATTIC, VIENNA.

1825. Hofmobiliendepot Museum.

[100] Furniture from the bedroom of Emperor Franz II(I) and Empress Carolina Augusta in the Swiss Wing of the Hofburg Palace: Mahogany bed with gold plated brass mounts, Vienna circa 1816. Mahogany lounge chair, renewed upholstery in original colors, adjustable headpiece, Vienna circa 1825. Stenciled painted floor in the design of the original moquette carpet, manufactured by the Royal Imperial Linz Woolen Fabrics and Carpet Factory, Linz early 19th century. Hofmobiliendepot Museum.

[101] Furniture from the bedroom of Emperor Franz II(I) and Empress Maria Ludovica d'Este at Castle Laxenburg: Ebonized pearwood sidechair and settee with gilt wood decorations, front legs prepared in carved soft-wood, renewed upholstery in original colors, Vienna circa 1808. Hofmobiliendepot Museum.

[104] Detail of a chair back and a settee from the bed-room of Emperor Franz II(I)

and Maria Ludovica d'Este at Castle Laxenburg, ebonized pearwood with gilt wood decorations, renewed upholstery in original colors, Vienna circa 1808. Hofmobiliendepot Museum.

[106] Detail of a chair back from the bedroom of Emperor Franz II(I) and Empress Carolina Augusta, mahogany, renewed upholstery in the original colors, fabricated by the cabinetmaker Gregor Nutzinger and upholsterer Leopold Auernhamer, Vienna circa 1816. Hofmobiliendepot Museum.

[108] Document reproduction silk moiré from the Biedermeier period, original manufacturer unknown. Hofmobiliendepot Museum, Vienna.

[110] Furniture from the bedroom of Emperor Ferdinand at the Imperial Residence in the Hofburg Palace at Innsbruck: Two mahogany beds with colored inlays, Innsbruck 1838. Pair of mahogany bed stands, Innsbruck 1838. Mahogany chaise longue with

mahogany hassock, newly upholstered in original colors, Innsbruck 1838. Mahogany secretary, Innsbruck 1838. Mahogany washstand with gilt decorations and bronze mounts, Innsbruck 1838. Mahogany table and suite of mahogany sidechairs, renewed upholstery in original colors, Innsbruck 1838. Mahogany cuspidor, Innsbruck 1838. Gilded carved softwood eight-arm chandelier, Vienna 1838. All designs by Johann Nepomuk Geyr. Three carpets manufactured by The Royal Imperial Linz Woolen Fabrics and Carpet Factory, Linz circa 1835. Hofmobiliendepot Museum, Vienna.

[111] Detail of a figured maple table with silvered decorations, Vienna circa 1811. Document reproduction wallpaper from the Biedermeier period, originally manufactured by Zuber, Rixheim, France. Hofmobiliendepot Museum.

[112] Detail of an ebonized pearwood sewing table, fire gilded bronze mounts, inset porcelain top, Vienna circa 1810. Document reproduc-tion wallpaper from the Biedermeier period, original

manufacturer unknown. Hofmobiliendepot Museum.

[113] Detail of a mahogany and walnut tilt-top table with mother-of-pearl inlay by Friedrich Reimann, Vienna circa 1827. Document reproduction wallpaper from the Biedermeier period, original manufacturer unknown. Hofmobiliendepot Museum.

[114] Bronze sculpture "Apollo" by Johann Georg Danninger, Vienna circa 1840. Document reproduc-tion wallpaper from the Biedermeier period, originally manufactured by Zuber, Rixheim, France. Hofmobiliendepot Museum.

[116] Furniture from the apartment of Emperor Franz II(I) in the Hofburg Palace: Detail of a Music Room installation with panorama wallpaper "Brazil." Mahogany chairs with gilt bronze mounts, renewed upholstery in original colors, Vienna circa 1815. Mahogany and ebonized pearwood table with gilt decorations, Vienna circa 1810. Dining Room installation in background: Oil on canvas, family portrait, anonymous, Vienna circa 1830. Hofmobiliendepot Museum. Dining room furniture, see [120].

[393] POPLAR BURL CASE CLOCK, EBONIZED FRUITWOOD DECORATIONS AND BASE, PYRAMID SHAPE, BERLIN CIRCA 1810. PRIVATE COLLECTION, CHICAGO, ILLINOIS.

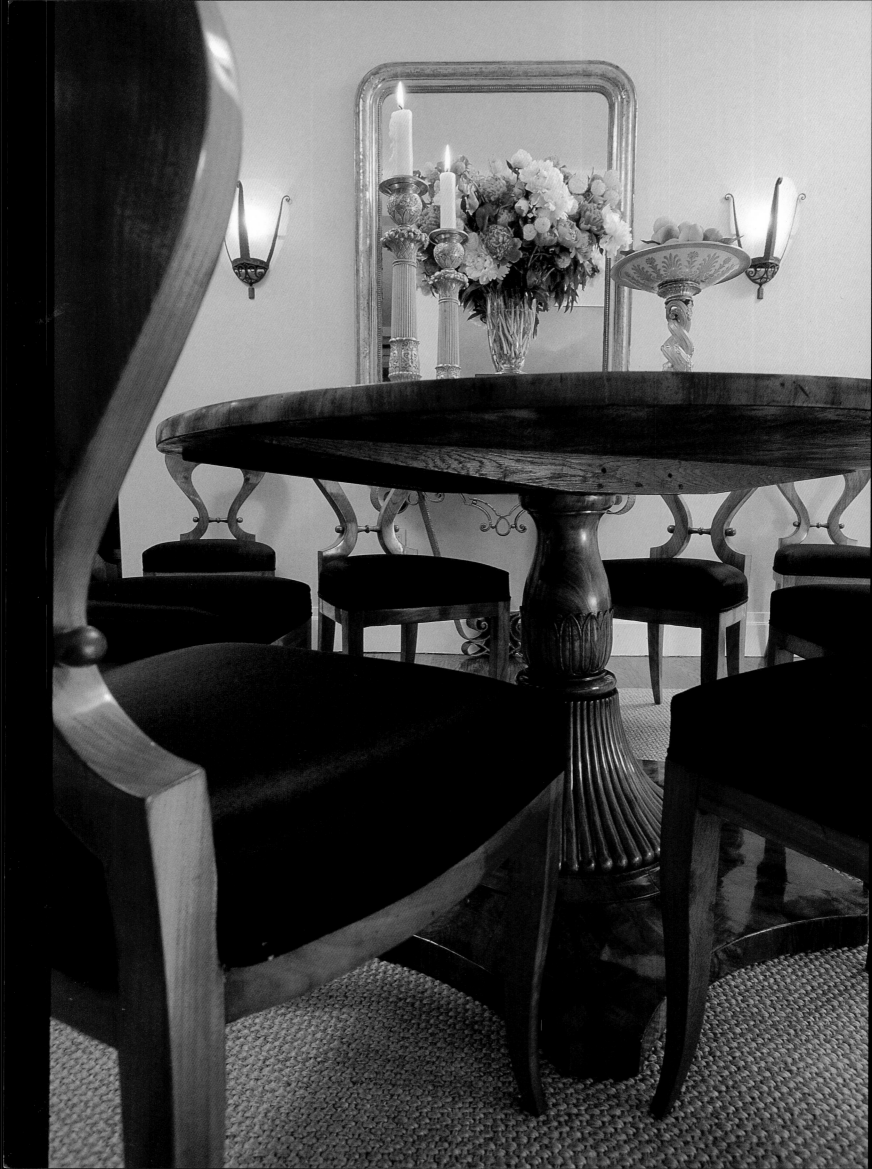

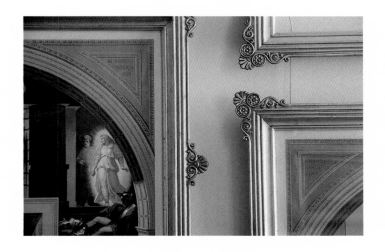

[118] Furniture from the apartment of Emperor Franz II(I) in the Hofburg Palace: Installation of a Music Room with panorama wallpaper "Brazil." Mahogany and maple giraffe piano-forte with ink decoration by Martin Seuffert, renewed upholstery, Vienna circa 1815. Mahogany sidechairs with gilt bronze mounts, renewed upholstery, Vienna circa 1815. Mahogany and ebonized pearwood table with gilt decorations, Vienna circa 1810. Mahogany table with gilt bronze mounts, Vienna circa 1815. Softwood chandelier with gilt woodcarvings and bronze mounts, Vienna circa 1810. Hofmobiliendepot Museum.

[120] Furniture from the apartment of Emperor Franz II(I) in the Hofburg Palace: Installation of a Dining Room: Mahogany table with gilt bronze mounts, Vienna circa 1815. Mahogany side chairs with gilt bronze mounts, renewed upholstery, Vienna circa 1815. Mahogany and glass vitrine with gilt bronze mounts, Vienna circa 1815. Rosewood long-case clock with gilt bronze mounts, Vienna circa 1780. Mahogany and boxwood cabinet with decorations in ink, gilt bronze mounts, Vienna circa 1810. Mahogany serving table with gilt bronze mounts, Vienna circa 1820. Pair of candelabrum, fire gilded bronze, Vienna circa 1810. Softwood chandelier with gilt woodcarvings and bronze mounts, Vienna circa 1810. Hofmobiliendepot Museum.

[122] Detail of mahogany table with one hundred fifty removable numbered stone specimens, Vienna circa 1815. Hofmobiliendepot Museum.

[124] Mahogany table with one hundred fifty removable numbered stone specimens for the instruction of the thirteen children of Emperor Franz II(I), Vienna circa 1815.

Hofmobiliendepot Museum.

[127] Patinaed bronze vase clock with fire gilded bronze appliques, a grape eating Bacchus adorns the top, eight day movement, to be lighted at night, anonymous, Vienna early 19th century. Geymüller-Schlössl.

[130] Mosque inspired Balcony Room: Specimen marble floor and painted wall decorations. Marble top table with alabaster base, Florence circa 1850. Alabaster vases decorated with fruit and grape leaves, Vienna. Fire gilded bronze mantel clock by

[394] WALNUT BURL CENTER TABLE WITH PEDESTAL BASE, CARVED DECORATIONS, VIENNA CIRCA 1815-1820. SUITE OF EIGHT CHERRYWOOD SIDECHAIRS, RENEWED UPHOLSTERY, SOUTHERN GERMANY CIRCA 1820. PRIVATE COLLECTION, NEW YORK CITY. [395] GILDED SOFTWOOD FRAMES, CASTLE CHARLOTTENHOF CIRCA 1820-1830. POTSDAM.

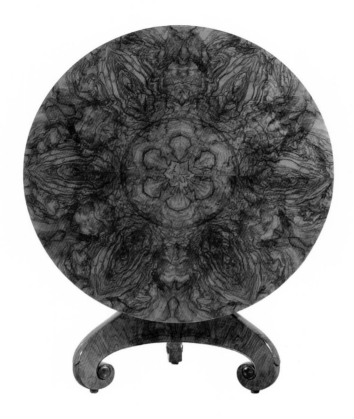

Mathias Wibral, Vienna circa 1815. Maple sidechairs with ink decoration, Vienna circa 1820-1825. Geymüller-Schlössl.

[134] Vestibule with ebonized pearwood long-case clock in foreground. Two picture clocks with play mechanisms for music, Vienna circa 1830-1831. Pair of walnut jardinieres, probably by Joseph Ulrich Danhauser, Vienna first half of the 19th century. Walnut writing table, probably by Joseph Ulrich Danhauser, Vienna circa 1830. Cherrywood sidechair with cane seat, Vienna circa 1820. Geymüller-Schlössl.

[136] Reception Hall with pieces belonging to Empress Maria Ludovica d'Este: Suite

of mahogany furniture with bronze appliques, Vienna circa 1811. Geymüller-Schlössl.

[137] Floral still life on porcelain by Joseph Nigg, manufactured by Vienna Porcelain Factory, Vienna circa 1820. Geymüller-Schlössl.

[138] View from the existing Dining Room to the Reception Room: Restored original stencil painted wall designs. Oil on canvas, portrait of an unknown gentleman by Franz Kriehuber, Vienna circa 1840. Mahogany table with maple inlay, Vienna circa 1810-1820. Mahogany long-case clock, anonymous, circa 1810. Ebonized pearwood base supporting

free-swinging clock, circa 1820. Background: cedar long-case clock, Klagenfurt circa 1800. Pair of mahogany sidechairs, Vienna circa 1825. Geymüller-Schlössl.

[140] Detail of walnut desk with oval top supported by two fluted columns, probably by Joseph Ulrich Danhauser, Vienna circa 1820. Figural mantel clock by Christian Federl, Vienna circa 1820. Geymüller-Schlössl.

[141] View of the Cupola Room: Walnut desk with oval top supported by two fluted columns, probably by Joseph Ulrich Danhauser, Vienna circa 1820. Three mahogany sidechairs with curved backs, Vienna 1835. Patinaed bronze vase clock

with fire gilded bronze appliques, a grape-eating Bacchus adorns the top, eight-day movement, to be lighted at night, anonymous, Vienna early 19th century. Mahogany drum cabinet, Vienna circa 1830. Pair of alabaster urn shaped sconces with fire gilded decorations, Vienna circa 1820. Mahogany trumeau with console, maple inlays, Vienna circa 1830. Pair of nutwood armchairs, renewed upholstery, Vienna circa 1840. Top of mantelpiece: Bronze mantel clock with fire gilded decorations on marble base, fourteen-day movement by Brändl, Vienna 1800. Oil on canvas, portrait of an unknown lady, anonymous. Nutwood wall clock with

brass case, eight-day movement by Jakob Streicher. Bust of Emperor Franz II (I) by Anton Zuksch; circa 1820-1830. Figural mantel clock by Christian Federl, Vienna circa 1820. Burl wood worktable, Vienna 1810. Fruitwood center table with faux verde antico painting and gilded composition decorations, by Danhauser's k.k. priv. Furniture Factory, Vienna circa 1815. Sixteen-candle crystal chandelier with concave filigree bronze band supporting a suspended crystal dish decorated with blossoms and rosettes, Vienna circa 1808. Background: Mahogany table with bronze appliques, Vienna circa 1811. Mahogany chair, Vienna circa 1811. Fire gilded bronze mantel clock by Mathias Wibral, Vienna 1815. Cedar long-case clock, Klagenfurt circa 1800. Geymüller-Schlössl.

[142] Figural alabaster mantel clock, anonymous, probably by Caspar Kaufmann, Vienna 1824. Geymüller-Schlössl.

[143] Detail of [142].

[144] Gilt wood mirror with brass candleholders supporting a bisque porcelain plaque depicting East Berlin motifs, circa 1820-1830.

Mahogany bracket clock, Vienna early 19th century. Geymüller-Schlössl.

[145] Detail of [144].

[146] Mahogany settee with gilt wood decorations and pressed metal decorations, renewed upholstery, built-in flute works with forty-four open Viennese flutes, by the organ and clock maker Christian Heinrich, Vienna circa 1830. Ebonized mahogany sidechair, renewed upholstery, by Joseph Ulrich Danhauser, Vienna circa 1830. Cherrywood bedside table by Joseph Ulrich Danhauser, Vienna first half of the 19th century. Geymüller-Schlössl.

[148] Back view of [146].

[149] Detail of storage cabinet with music cylinders for settee [146]. Vienna circa 1830. Geymüller-Schlössl.

[150] Detail of two music cylinders: Ouvertür "Figaro" by Mozart 1786, "Aline Walzer" by Müller 1822. Geymüller-Schlössl, Vienna.

[152] Ebonized pearwood mantel clock with alabaster columns, playing mechanism with two tunes, anonymous, Vienna circa 1840. Geymüller-Schlössl.

[154] Picture clock, depicting members of the Habsburg family participating in a

procession in Mariazell by Duschek, Vienna circa 1850. Geymüller-Schlössl.

[158] Example of a machine made carpet, which was available by the meter and could be used as an area rug or fitted carpet, manufactured by the Royal Imperial Linz Woolen Fabrics and Carpet Factory, Linz first half of the 19th century. Hofmobiliendepot Museum, Vienna.

[162] Blue Salon designed by Joseph Ulrich Danhauser: Panorama wallpaper "Hindustan" by Zuber, Rixheim, France circa 1820. Suite of ebonized pearwood furniture with gilt wood decorations, comprised of a settee, two armchairs, eight sidechairs, and a pedestal table, renewed upholstery in original colors, Vienna circa 1810. Pair of mahogany armchairs with inset gilt wood carved decorations, renewed upholstery in original colors, Vienna circa 1810. Mahogany writing table with ebonized pearwood and gilt decorations, gilded bronze mounts, Vienna circa 1810. Gilt brass mantel clock, by Anton List, Vienna circa

1820. Cherrywood long-case clock, anonymous, 1800. Pair of patinaed gilt bronze figural ten-arm candelabrum, Vienna circa 1810. Eight-arm crystal chandelier with filigree gilt bronze decorations, Vienna. Geymüller-Schlössl.

[164] Detail of [162].

[165] Detail of existing Dining Room and Blue Salon: Walnut fauteuil upholstered in embroidered fabric, Vienna first half of the 19th century. Marble pedestal with figure of "Hermes" holding an enamel pocket watch with fire gilded case, anonymous, circa 1820. Mahogany sewing table with maple inlays, Vienna first half of the 19th century. Geymüller-Schlössl.

[166] Reflected view of the existing Dining Room and the Blue Salon: Restored original stencil painted wall designs. Mirror with mahogany frame and maple inlay, Vienna circa 1830. Decorated pair of plaster urns, anonymous. Mahogany extension dining table with column-shaped legs resting on circular base, Vienna 1825. Suite of mahogany sidechairs, Vienna 1825. Gilded soft-

[396] WALNUT BURL TILT-TOP TABLE, AUSTRIA CIRCA 1820-1825. PRIVATE COLLECTION, CHICAGO, ILLINOIS.

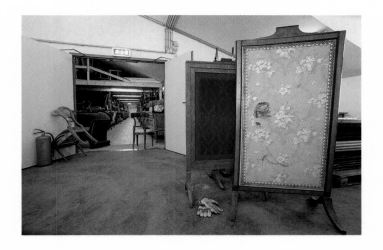

wood chandelier, Vienna 1830. Geymüller-Schlössel. Blue Salon see [165].

[168] Detail of existing Dining Room: Mahogany Hamburger Sekretär or secretary in the Hamburg style by Vinzenz Hefele: The lower cabinet contains three drawers, the roll top above reveals three additional drawers located on either side, two mail slots, two supplementary drawers with hidden compartments behind letter slots, and to the left thirty-two small hidden compartments; in the center of the cabinet is a tabernacle type compartment in palisander with inlay and filigree work, one side mirrored with a maple frame, and another representing a Byzantine temple with movable mirror concealing five additional drawers, Vienna 1840. Geymüller-Schlössl.

[169] Detail of existing Living Room: Pyramid mahogany secretary with bowed front, ink decoration on boxwood, fire gilded brass mounts; pocket doors slide into openings behind Corinthian columns located at either side, revealing a tabernacle in the Greek style with additional columns supporting two upper drawers, by Anton Haerle, Vienna 1813. Three mahogany sidechairs, renewed upholstery, manufactured by Danhauser's k.k. priv. Furniture Factory, Vienna circa 1820. Geymüller-Schlössl.

[170] Existing Living Room: Mahogany writing table with oak interior and fire gilded bronze mounts, manufactured by Danhauser's k.k. priv. Furniture Factory, Vienna 1820. Mahogany corner cabinet with glass doors, Vienna circa 1825-1830. Mantel clock, anonymous, Vienna early 19th century. Mahogany chairs, Vienna circa 1825-1830. Walnut wastepaper basket in book design with straw liners, Vienna first half of the 19th century. Geymüller-Schlössl.

[172] Detail of [173].

[173] Existing Living Room: Mahogany suite of furniture, renewed upholstery in violet and gold, manufactured by Danhauser's k.k. priv. Furniture Factory, Vienna circa 1820. Oil on canvas, portrait of an unknown lady in gilded ox-eye frame by Schrotzberg, Vienna circa 1838. Needlepoint carpet with floral design, Vienna first half of the 19th century. Geymüller-Schlössl.

[174] Burl wood craft table with polished steel fittings

[398] EXAMPLE OF A MACHINE-MADE CARPET, WHICH WAS AVAILABLE BY THE METER AND COULD BE USED AS AN AREA RUG OR FITTED CARPET, MANUFACTURED BY THE ROYAL LINZ WOOLEN FABRICS AND CARPET FACTORY, LINZ FIRST HALF OF THE 19TH CENTURY. HOFMOBILIENDEPOT MUSEUM, VIENNA. [399] FIRE SCREENS, CHAIRS AND SETTEES, MANY OF THEM BIEDERMEIER. HOFMOBILIENDEPOT ATTIC, VIENNA.

N° 65.

Inventarium,

Der in dem Appartement
Sr. K. H. des Herrn Erzherzogs
Kronprinz Ferdinand befind-
lichen Hofmobilien.

1826.

featuring numerous compartments to hold items for cosmetics, perfume, manicure accessories, needlework, crocheting, lacework, painting, and writing; hinged top opens to reveal four mounted watercolors depicting vedutas (landscape views) by Balthasar Wigand, Vienna circa 1810-1815. Geymüller-Schlössl.

[176] Bedroom: Walnut bed manufactured by Danhauser's k.k. priv. Furniture Factory, Vienna 1825. Mahogany hamper with gold silk,

Vienna circa 1825. Mahogany etegere with ink decorations on maple by Benedict, Vienna 1807. Mahogany console table, Vienna circa 1835-1840. Document reproduction carpet originally manufactured by The Royal Imperial Linz Woolen Fabrics and Carpet Factory, Linz 1820. In the background: view of the Cupola Room. Geymüller-Schlössl.

[178] Detail of Cupola Room ceiling with restored original stencil painted design. A sixteen-candle crystal

chandelier with concave fili-gree bronze band supporting a suspended crystal dish decorated with blossoms and rosettes. Vienna circa 1808. Geymüller-Schlössl.

[184] View of the cupola in the Hofburg Palace where one of the entrances to the Silberkammer is located, Vienna.

[186] View through the last remaining 18th century window in the Hofburg Palace: Table setting commissioned for the coronation of Emperor Ferdinand I, designed and fabricated by Luigi Manfredini, Milan 1838. Silberkammer, Vienna.

[188] Porcelain bottle coolers: Gothic inspired design, part of a dessert service

depicting the predecessors of the Habsburg family, commissioned for the marriage of Archduke Franz Karl and Sophie of Bavaria, manufactured by Vienna Porcelain Factory, Vienna 1826. Silberkammer.

[190] Imperial napkin with kaisersemmel, the typical roll served during the Biedermeier period. Porcelain dessert plate manufactured by Vienna Porcelain Factory, Vienna 1807. Silberkammer.

[201] Porcelain soup plates: each plate displaying three vedutas (landscape views), gold relief borders, second plate from bottom features a panorama of Vienna, manu-factured by Vienna Porcelain Factory, Vienna circa 1804-1806. Silberkammer.

[400] ORIGINAL INVENTORY BOOK #65, LISTING THE CONTENTS OF THE APARTMENT OF CROWN PRINCE FERDINAND, VIENNA 1826. HOFMOBILIENDEPOT MUSEUM, VIENNA. [402] ASSEMBLY OF MIRRORS, SOME OF THEM BIEDERMEIER. HOFMOBILIENDEPOT MUSEUM, VIENNA. [403] DETAIL OF A CHERRYWOOD SETTEE WITH INK DECORATIONS, VIENNA 1825-1830. GEYMÜLLER SCHLÖSSL.

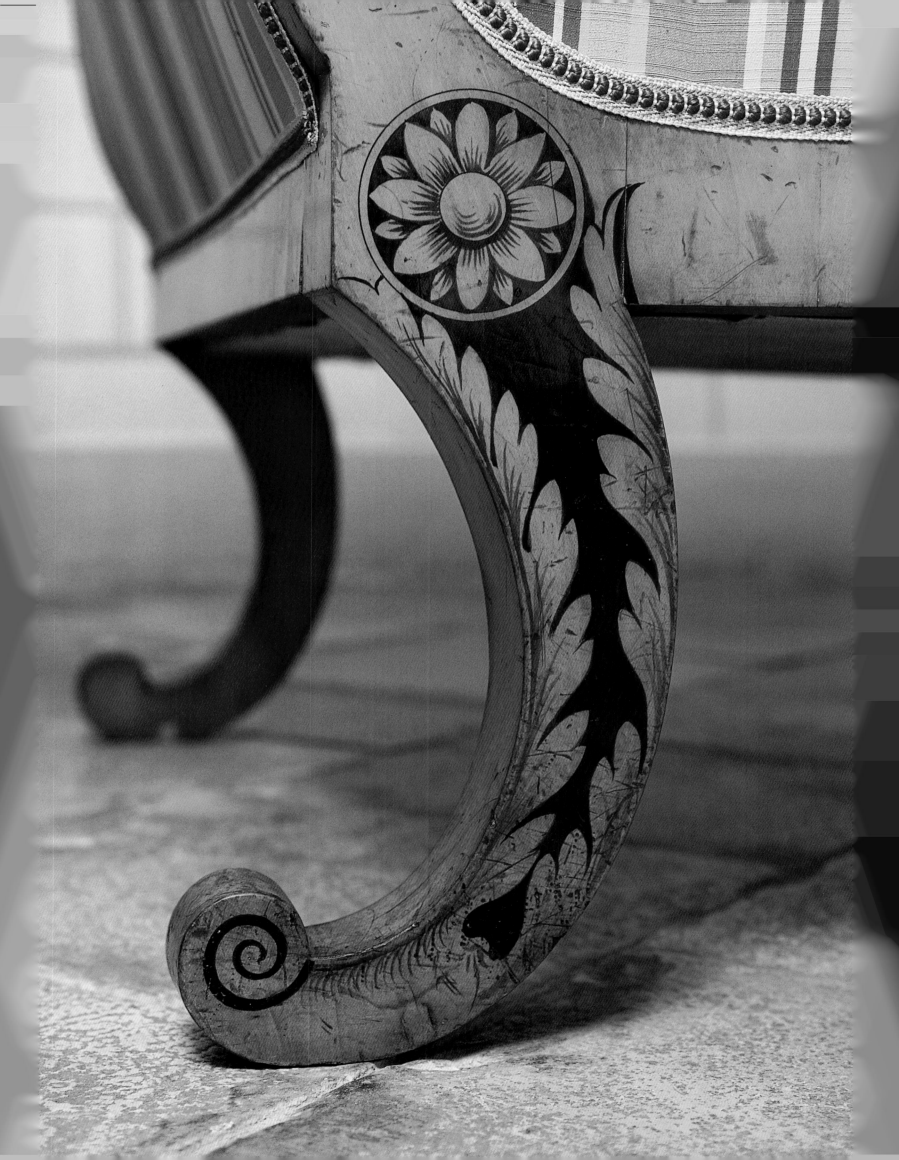

[202] Detail of porcelain dessert plate: "Venus Introducing Helena to Paris" after a painting by Angelika Kaufmann, manufactured by Vienna Porcelain Factory, Vienna 1807. Silberkammer.

[204] Detail of a porcelain dessert plate: "Amorette and Lion", painted by Siegmund Ferdinand Perger, manufactured by Vienna Porcelain Factory, Vienna 1807. Silberkammer.

[206] Detail of a porcelain dessert plate: "Orpheus Before The God of the Underworld", painted by Siegmund Ferdinand Perger, after a painting by Heinrich Füger, manufactured by Vienna Porcelain Factory, Vienna 1806. Silberkammer.

[208] Porcelain chocolate cup: "Suicide of Dido After Being Abandoned by Aeneas", painted by Herr, after a painting by Heinrich Füger, manufactured by Vienna Porcelain Factory, Vienna 1807. Silberkammer.

[210] Solid gold table settings: Service of Empress Maria Theresia, deep blue velvet lined case, Vienna circa 1750. Service of Emperor Franz II(I), burgundy velvet lined

case, Vienna circa 1780. Silberkammer. (Author's note: Until approximately 1805-1810, each member of the Habsburg royal family had individually designed table settings and cutlery. At this time, Emperor Franz II(I) decided that each member of the Habsburg family would eat from a common set in order to simplify life, resulting in the design and manufacture of enormous sets, which were shared by all. This was a marked change in protocol at the court that occurred during the Biedermeier period. The individual sets, which were previously used, were moved to the Silberkammer, where they remain today).

[212] Ivory and stainless steel hunting cutlery: Engravings depicting Emperor Franz Joseph I, displaying the years 1848 and 1898, gift to commemorate the year he ascended to the throne, and the fiftieth anniversary of his reign, manufactured by Weittmann, Vienna 1898. Silberkammer. (Author's note: The fifty-year reign of Franz Joseph I is considered by historians to be the "dead" years of Biedermeier. 1848

marked the end of Biedermeier. In 1898 the exhibition "The Congress of Vienna" featuring furniture from 1800-1848, marked its revival. The public's response was tremendous. Architects Adolf Loos and Josef Hoffman responded enthusiastically. This event gave way to the rebirth of Biedermeier and contributed to its place in history).

[213] Silver cutlery: Neo-Gothic style, with tooled leather traveling case in red with gold decoration, by Franz Würth, commissioned by Emperor Franz II(I), Castle Laxenburg 1801. Silberkammer, Vienna.

[214] Cut crystal: Diamond pattern, manufactured by Harrachsche Hütte, Bohemia, commissioned by Franz II(I) for the Habsburg Palace, Vienna circa 1825-1830. Silberkammer.

[216] Crystal: Prism cut, k.k. double eagle, manufactured by Joseph Rohrweck, Bohemia, commissioned by the Habsburg Palace, Vienna circa 1828. Silberkammer.

[222] Panorama of the Schlossbrücke: Built by Karl Friedrich Schinkel, construction began 29 May 1822. The bridge was inaugurated 28 November 1823, on the

occasion of the ceremonial entry into Berlin of the Crown Princess.

[224] Detail of the Schlossbrücke: Statue depicting "The Goddess of Victory" designed by Karl Friedrich Schinkel, executed by sculptors of The Rauch School, erected 1853-1857. Berlin.

[226] Detail of the Schlossbrücke: View of a victory statue and the Berliner Dom.

[228] Statue of Karl Friedrich Schinkel (1781-1841) in Schloss Square. Berlin.

[234] Garden Room: Light gray and green panels surrounded by white borders. Floor in paneled oak. Semi-circular banquette in an alcove, decorated with blue silk drapery. Gilt wood chairs from the palais of Prince Karl of Prussia (the third eldest son of Friedrich Wilhelm III) upholstered in blue with intricate embroidery and passementerie, designed by Karl Friedrich Schinkel. Marble busts depicting members of the Royal Family by Christian Daniel Rauch, Berlin circa 1824. Schinkel Pavilion.

[240] Detail of a gilt wood chair upholstered in blue with gold embroidery and silk passementerie by Karl

[405] CHERRYWOOD WASHSTAND SUPPORTING ORIGINAL PORCELAIN BASIN BY JOSEPH ULRICH DANHAUSER, VIENNA CIRCA 1820-1825. HOFMOBILIENDEPOT MUSEUM.

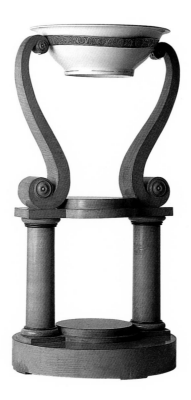

Friedrich Schinkel, Berlin circa 1825. Schinkel Pavilion.

[242] Detail of semi-circular white lacquer banquette based on a design from Pompeii by Karl Friedrich Schinkel, Berlin circa 1826. Schinkel Pavilion.

[243] Garden Room: Exedra style niche with semi-circular white lacquer banquette, upholstered in blue gros d'isphahan silk, below blue drapery decorated with gold stars and a stylized border. Niche situated between two carrara marble fireplaces with painted bordered panels. Gilded softwood table with fire gilded bronze gallery holds an intricately painted porcelain tabletop by Ernst Sager, Berlin 1830. Pair of fire gilded bronze candelabrum,

Berlin 1835. Marble statue of a female figure holding a flower bowl by Christian Daniel Rauch. All designs by Karl Fredrich Schinkel, Berlin circa 1826. Schinkel Pavilion.

[244] Red Room: Document reproduction of a red velvet wallcovering with Pompeian motifs and figural medallions. Carrara marble fireplace with gilded over mantel mirror. Gilded bronze six-arm chandelier. Marble bust on mantel depicts Auguste Fürstin von Liegnitz by Eduard Stützel, 1838. Sculptures in background by Johann Gottfried Schadow and his pupils, executed 1835-1852. All designs by Karl Friedrich Schinkel, Berlin 1826. Schinkel Pavilion.

[246] Recital Room: Document reproduction wallpaper. Oak paneled floor, bordered with mahogany. Catel marble fireplace with plaster inlay decoration. Mahogany and maple table, partially gilded, with a decorative painted top, Berlin circa 1830. Birchwood sidechairs with canework seats originally designed for the Garden Room, Berlin circa 1825. Paintings by Carl Blechen, circa 1824-1839. All designs by Karl Friedrich Schinkel, Berlin 1826. Schinkel Pavilion.

[248] Detail of a cherrywood sidechair with cast iron inlays by The Royal Iron Foundry, possibly designed by Karl Friedrich Schinkel, Berlin circa 1810. Schinkel Pavilion.

[250] Previous Servants Room: Mahogany furniture, settee with maple inlays. All designs by Karl Friedrich Schinkel, fabricated by Karl Wanschaff, Berlin circa 1824-1826. This furniture was previously owned by the Schinkel biographer, Professor Johannes Sievers. Marble sculpture of a young girl by Karl Reinhardt, Berlin 1837. Schinkel Pavilion.

[252] [253] [254] Bedroom of Queen Luise: Original wall covering, white voile over pink wallpaper. Marble fireplace surround with gilded bronze mounts. Pearwood bed and flower tables, Berlin 1810. Pearwood long-case pyramid shaped clock, Berlin circa 1800. Pearwood tabouret, Berlin

circa 1825. Boulliot lamp on mantelpiece, Paris circa 1810. Porcelain urns, Berlin circa 1803-1813. Marble bust of Queen Luise by Johann Gottfried Schadow, Berlin 1810. All designs by Karl Friedrich Schinkel, Berlin 1810. Charlottenburg Palace.

[256] Vestibule: Oak staircase with polished brass rails and mahogany handrail. Renewed wall decorations with Pompeian grotesque designs on paper, originals by Julius Schoppe, Berlin 1826. All designs by Karl Friedrich Schinkel, Berlin 1810. Schinkel Pavilion.

[258] Vestibule: Bronze pedestal fountain with fantasy figures, palmettes and stylized dolphins, designed by Karl Friedrich Schinkel, Castle Charlottenhof 1827, installed 1843. Potsdam.

[261] Details of doors: Upper, red felt upholstery with brass nailheads decorates Dining Room doors. Middle, silvered relief doors with arabesque designs in Crown Princess Elizabeth's Study. Lower, ebonized softwood doors with gilt wood decorations leading to the Tent

Room. All designs by Karl Friedrich Schinkel, doors fabricated by master cabinetmaker Freudemann, Castle Charlottenhof 1825-1830. Potsdam.

[266] Reception Room: Stencil painted walls bordered with gilded profile moldings rest beneath an intricate crown molding with classical frieze. Alderwood chairs with faux palisander graining and rush seats, Italy circa 1825. Italian landscape drawings by Johann Gottlieb Samuel Rosel, the Crown Princes' drawing instructor, circa 1823-1824. All designs by Karl Friedrich Schinkel. Castle Charlottenhof circa 1825-1830. Potsdam.

[268] View from the Reception Room to the Crown Prince's Study: Walls painted in Schweinfurt green, produced by Sattler. Mahogany writing table with gallery, mahogany swivel chair. All designs by Karl Friedrich Schinkel, Castle Charlottenhof circa 1825-1830. Potsdam.

[269] View from the Crown Prince's Study to the Bedroom: Lithographs by Claude Lorrain and Salomon

Gessner selected from the Crown Prince's collection. Copperplate prints by Raffael, Domenichino, and Reni. Mahogany armchair with reading lectern, leather upholstery, anonymous. All designs by Karl Friedrich Schinkel, Castle Charlottenhof circa 1840-1850. Potsdam.

[270] View of Bedroom and Crown Princess Elizabeth's Study: Green silk drapery suspended from brass rods, supported by gilded candelabrum, probably crafted in Munich. Double bed designed 1829 and renewed 1978. Drawing depicting "The Transfiguration of Christ" by Heusinger after Raffael. Silvered relief doors connect to the Study. All designs by Karl Friedrich Schinkel, Castle Charlottenhof circa 1825-1830. Potsdam.

[272] [273] The Crown Princess Elizabeth's Study: Stenciled pink walls, silver-leafed profile moldings with zinc decorations including astragals, palmettes, and strings of pearls. Frieze displaying paintings of twenty Pompeian dancers and one winged genie. Silver leafed corner banquette and chaise longue with green silk

upholstery. Paintings and all designs by Karl Friedrich Schinkel, Castle Charlottenhof circa 1827. Potsdam.

[274] Detail of Dining Hall: gilt wood table with rosso carolino marble table top, red felt upholstered doors with brass nailheads. All designs by Karl Friedrich Schinkel, Castle Charlottenhof circa 1825-1830. Potsdam.

[276] Dining Hall: White walls framed by gilt wood moldings. Two corner niches hold marble statues of "David with the Head of Goliath" by Heinrich Maximilian Imhof and "Ganymede" by August Wredow. Colored copperplate prints depicting fifty-three views, according to Raffael's frescoes in the loggia of the Vatican. Suspended gilt bronze oil lamp could also be used to hold flowers. All designs by Karl Friedrich Schinkel, Castle Charlottenhof circa 1825-1830. Potsdam.

[277] Detail of Dining Hall niche: "Ganymede" by August Wredow looks up into the starry sky of his corner niche. The niche is decorated with red draped felt and star appliques against a painted blue sky. All designs by Karl

[407] DETAIL OF A PLAQUE ADORNING A BRONZE SCULPTURE BY JOHANN GEORG DANNINGER DEPICTING "DANAE FLEE-ING APOLLO," VIENNA 1840. HOFMOBILIENDEPOT MUSEUM.

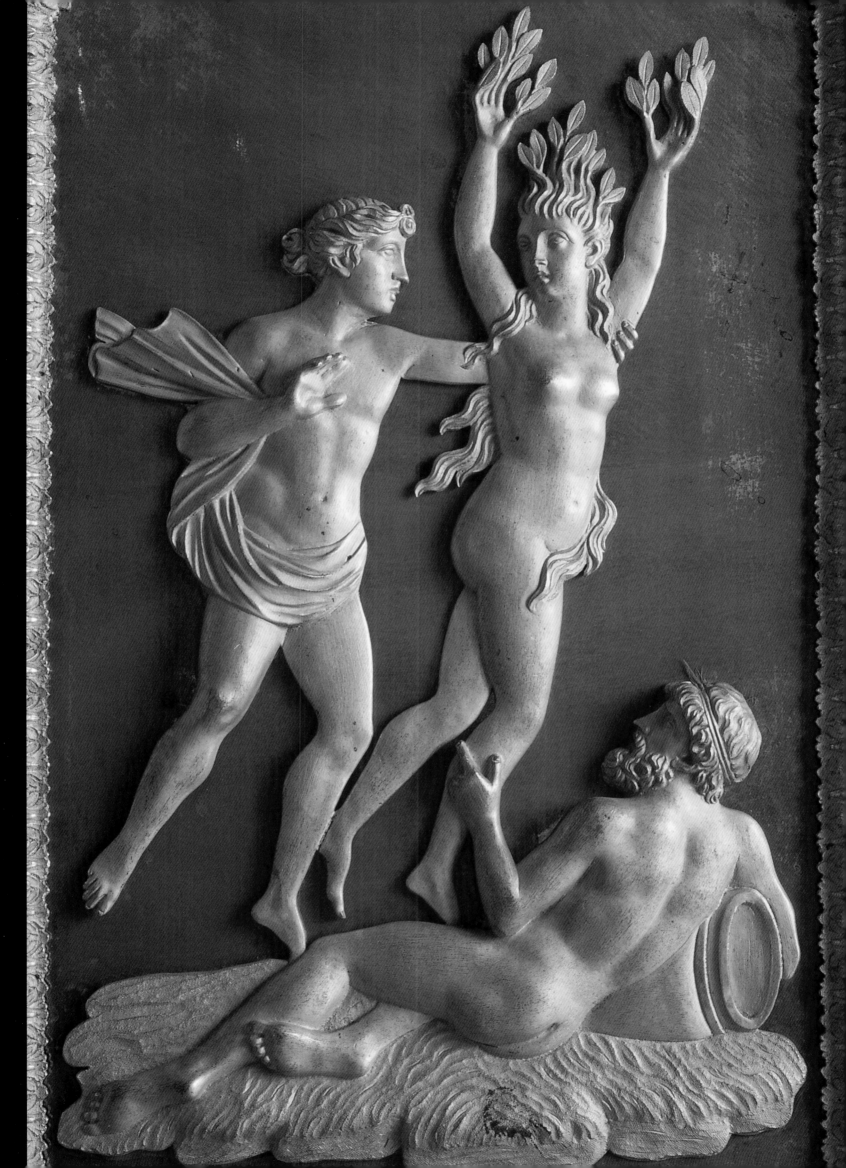

Friedrich Schinkel, Castle Charlottenhof circa 1825-1830. Potsdam.

[280] [281] Dining Room: Detail of gilded softwood ornaments, designed by Karl Friedrich Schinkel, Castle Charlottenhof circa 1825-1830. Potsdam.

[282] Vestibule: Detail of skylight window with blue glass and yellow stars, designed by Karl Friedrich Schinkel, Castle Charlottenhof circa 1825-1830. Potsdam.

[284] [285] Details of stained spruce floor in the Tent Room and the Sitting Room of the Princess's Ladies-in-Waiting, Castle Charlottenhof circa 1825-1830. Potsdam.

[288] Tent Room: Ceiling and walls covered in blue and white striped wallpaper, curtains in linen. Folding field beds, folding chairs and folding stools in cast iron. Black painted alderwood bath chairs with striped linen covers, 1810. Mahogany travel secretary with maple inlays, 1845. All designs by Karl Friedrich Schinkel, Castle Charlottenhof circa 1825-1830. Potsdam.

[409] MAHOGANY CRADLE SUSPENDED ABOVE OVAL BASE, BALDAQUIN, BRASS MOUNTS AND SCROLL ORNAMENTS, AUSTRIA CIRCA 1820. PRIVATE COLLECTION, CONNECTICUT.

[290] [291] View from the Tent Room into the Sitting Room of the Princess's Ladies- in Waiting: Mahogany secretary with fold down front reveals writing surface with freestanding Ionic columns supporting an entablature containing hidden drawers; inside are detailed Gothic arches with contrasting maple and poplar. All designs by Karl Friedrich Schinkel, Castle Charlottenhof 1826. Potsdam.

[292] Detail of a mahogany swivel chair by Karl Friedrich Schinkel, Castle Charlottenhof 1825-1830. Potsdam.

[294] Red Room: Walls painted with multiple reds, resulting in bold carmine. Mahogany settee, circa 1810-1820. Mahogany armchair, circa 1810-1820. Settee and armchair in original fabric. All designs by Karl Friedrich Schinkel, Castle Charlottenhof. Potsdam.

[295] Detail of [294].

[296] Copperplate Room: Mirror with stenciled ornamental frame manufactured by Schickler and Splitgerber, Berlin 1828. Reflected view of copperplate prints

features works of Raffael and Michelangelo; walnut chairs with rectangular backs displaying oval designs and canework seats. All designs by Karl Friedrich Schinkel, Castle Charlottenhof circa 1825-1830. Potsdam.

[297] Copperplate Room: Gray-green walls and plaster cornice bordered by gilt wood moldings. Walls and ceiling display copperplate prints featuring works of Raffael and Michelangelo. Walnut chairs with rectangular backs displaying oval designs and canework seats. All designs by Karl Friedrich Schinkel, Castle Charlottenhof circa 1825-1830. Potsdam.

[298] Detail of the Atrium: Picturesque wall paintings after Pompeian examples. Fantasy painting "Romantic Landscape near Capri" by Lompeck, 1852. Door leads to the Veridarium. All designs by Karl Friedrich Schinkel, The Roman Baths circa 1829-1840. Potsdam.

[300] Detail of the Apodyterium: Marble statue "Young Man and Young Woman at the Well" by Johann Werner Henschel, 1826. Cast iron daybed with mattress, original leather, by Karl Friedrich Schinkel,

1840. The Roman Baths. Potsdam.

[302] Detail of the Impluvium: Wall painting with frieze depicting gods and goddesses of the sea as well as marine animals by Rosendahl, 1839. Against the wall: cast iron console with marble top, circa 1840. Bronze sculpture "Boy with a Thorn", miniature copy of an antique marble statue in The Capitolian Museum in Rome. All designs by Karl Friedrich Schinkel, The Roman Baths circa 1829-1840. Potsdam.

[304] Detail of the Arcade Hall or Orangery: Cast iron semi-circular bench and cast iron table with marble top, both designed by Karl Friedrich Schinkel, circa 1840. Gilded bronze epergne with figural supports by Thomire, France early 19th century. The Roman Baths, Potsdam.

[306] Detail of the Grosse Laube: Cast iron armchair by Karl Friedrich Schinkel, The Roman Baths circa 1840. Potsdam.

[312] Pair of mahogany arm-chairs, renewed upholstery, Austria circa 1820. Private collection, New York City.

[314] Mahogany and walnut burl center table, Vienna

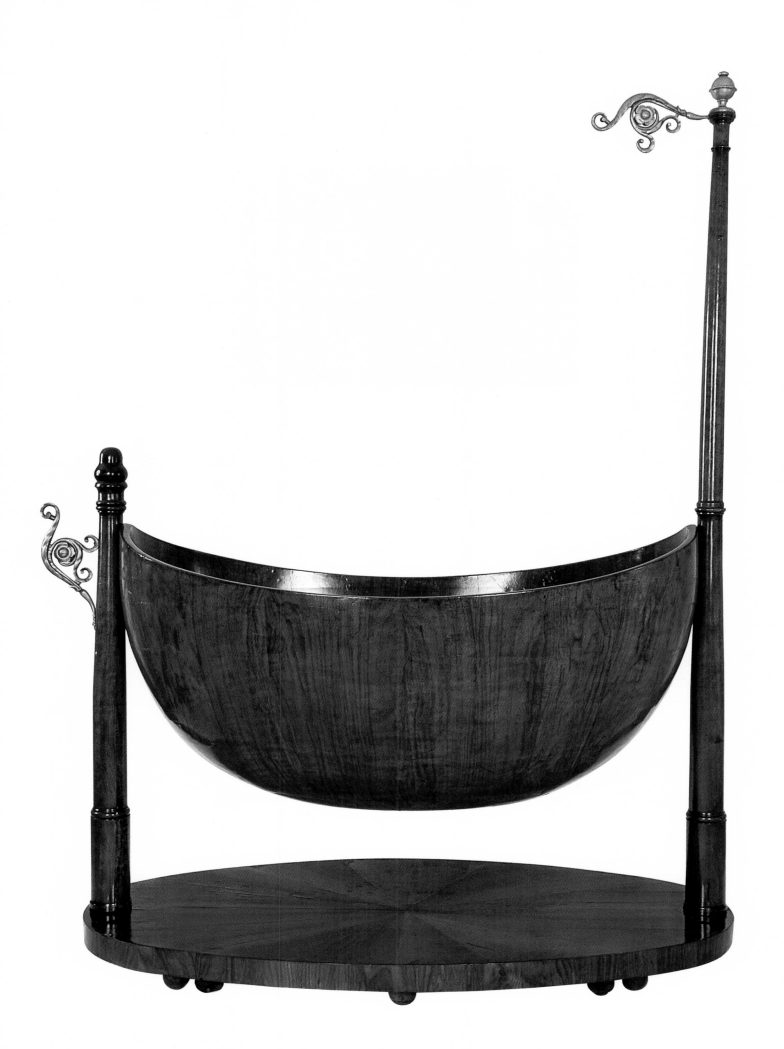

circa 1820. Set of six mahogany sidechairs, renewed upholstery, by Joseph Ulrich Danhauser, Vienna circa 1810-1820. Private collection, New York City.

[316] Cherrywood extension dining table with ebonized fruitwood accents, Austria circa 1835. Cherrywood sidechairs, renewed upholstery, by Joseph Ulrich Danhauser, Vienna circa 1820. Private collection, New York City.

[318] Detail of an ebonized fruitwood sidechair, renewed upholstery, Vienna circa 1820. Private collection, New York City.

[327] Pair of mahogany sidechairs, renewed upholstery, Vienna circa

1820. Private collection, New York City.

[328] Pair of mahogany tabourets, Austria circa 1820-1830. Pair of mahogany sidechairs, with fruitwood inlays, by Danhauser's k.k. Priv. Furniture Factory, Austria circa 1830-1835. Private collection, New York City.

[330] Walnut armchair, renewed upholstery, Vienna circa 1825. Walnut sidechair, renewed upholstery, Vienna circa 1830.

[331] [332] Pair of bergeres from the bedroom of Archduke Franz Karl and Sophie of Bavaria in the Blue Wing of Castle Laxenburg, mahogany, renewed upholstery in original colors, Vienna circa 1825.

[334] Mahogany bergere with porcelain covered nail heads, Vienna circa 1830. Restored statue from the facade of a building in Vienna, Vienna circa 1850.

[336] Detail of [334].

[337] Walnut sidechair, Vienna 1820.

[338] Ebonized pearwood sidechair, renewed upholstery, Austria circa 1825. Private collection, New York City.

[340] Walnut sidechair with fruitwood inlay, Austria circa 1820-1825. Private collection, New York City.

[342] Pair of fruitwood bergeres, renewed upholstery, Austria circa 1825-1830. Private collection, New York City.

[344] Mahogany writing table, Vienna circa 1825. Reflected in Venetian mirror: Suite of walnut burl sidechairs, renewed upholstery, by Danhauser's k.k. priv. Furniture Factory, Vienna circa 1820. Mahogany center table with pedestal base, Vienna circa 1815-1820. Private collection, New York City.

[346] Mahogany table with ink decorations and cherrywood figural inlay, Vienna circa 1830. Exhibition of Verner Panton, Hofmobiliendepot Museum.

[348] Ebonized pearwood sidechair, renewed upholstery, Austria circa 1825. Pair of ebonized fruitwood sidechairs, renewed upholstery, Vienna circa

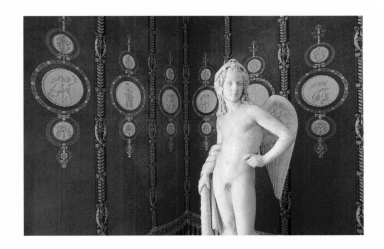

1820. Walnut mirror, Austria circa 1820-1825. Walnut cabinet, southern Germany, early 19th century. Private collection, New York City.

[350] Walnut sidechair, renewed upholstery, Vienna circa 1825.

[352] Pair of walnut settees, renewed upholstery, Austria circa 1830. Private collection, Houston, Texas.

[353] Cherrywood collector's cabinet with ebonized fruitwood details and bronze mounts, southern Germany circa 1815. Ashwood secretary with ebony inlays, ink decorations, ivory details and alabaster columns, Baltic circa 1810-1815. Cherrywood tall-case clock, Vienna circa 1820. Pair of cherrywood bergeres, renewed upholstery, Austria circa 1820-1830. Pair of walnut burl bergeres with pearwood inlays, renewed upholstery, Vienna circa 1820-1830. Walnut console with fruitwood inlays, Vienna circa 1820. Private collection, New York City.

[354] Mahogany dressing table with fire gilded bronze mounts, belonging to Emperor Franz II(I), Vienna circa 1810. Pair of mahogany sidechairs with gilt bronze mounts, renewed upholstery in original colors, Vienna circa 1815. Hofmobiliendepot Museum.

[356] Cherrywood worktable, Vienna circa 1820. Private collection, New York City.

[357] Ashwood tabouret with ebononized fruitwood inlays, renewed upholstery, Vienna 1820. Ashwood burl sidechair with ebonized fruitwood details, renewed upholstery, southern Germany circa 1815. Private collection, New York City.

[358] Black lacquered pearwood bed with carved gilt wood details, Vienna early 19th century. Private collection, New York City.

[360] Walnut dining table with pedestal bases, Austria circa 1825. Suite of walnut sidechairs, renewed upholstery, Austria circa 1825. Private collection, New York City.

[362] Detail of [360].

[364] Mahogany secretary with birchwood details, renewed upholstery, Prussia circa 1810-1815. Pair of solid mahogany "Retour d'Egypte" armchairs, renewed upholstery, attributed to Jacob, France circa 1805-1808. Cherrywood sidechair, renewed upholstery, by Joseph Ulrich Danhauser, Vienna circa 1820. Mahogany cabinet, southern Germany circa

[410] [411] DETAILS OF RED ROOM: DOCUMENT REPRO-DUCTION OF A RED VELVET WALLCOVERING WITH POMPEIAN MOTIFS AND FIGURAL MEDALLIONS. SCULPTURES BY JOHANN GOTTFRIED SCHADOW AND HIS PUPILS, BERLIN 1835-1852. ALL DESIGNS BY KARL FRIEDRICH SCHINKEL, BERLIN 1826. SCHINKEL PAVILION.

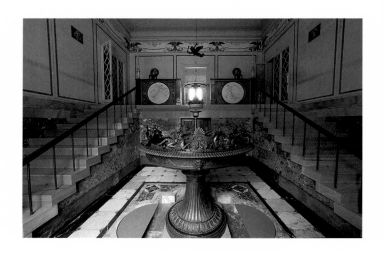

1810-1815. Private collection, New York City.

[366] Pair of walnut bergeres, renewed upholstery, Austria circa 1820-1825. Walnut console, Austria circa 1820-1825. Walnut drop-front writing table, Austria circa 1820-1825. Walnut sidechair, renewed upholstery, with ebonized fruitwood details, Austria circa 1820-1825. Private collection, Houston, Texas.

[368] Pair of walnut bergeres, renewed upholstery, Austria circa 1820-1825.

Walnut center table with pedestal base, Austria circa 1820-1825. Walnut secretary with pearwood inlay, bronze mounts, Austria circa 1820-1825. Background: Walnut center table, Austria circa 1820-1825. Private collection, Houston, Texas.

[369] Walnut architect's table with lift-top, gallery and bronze mounts, Austria

1820. Private collection, Houston, Texas.

[370] Ebonized fruitwood sidechair, renewed upholstery, Vienna circa 1820.

[371] Walnut high desk with fold-up top, Vienna circa 1815.

[372] Walnut settee, renewed upholstery, northern Italy circa 1820. Suite of walnut armchairs with ebonized fruitwood details, renewed upholstery, northern Italy circa 1820. Ebonized pearwood armchair, renewed upholstery, Austria circa 1815-1820. Private collection, Connecticut.

[374] Walnut game table with pearwood inlays, Austria circa 1820. Ebonized pearwood armchair, renewed

upholstery, Austria circa 1815-1820. Private collection, Connecticut.

[376] Walnut burl settee by Joseph Ulrich Danhauser, renewed upholstery, Vienna circa 1820. Private collection, Connecticut.

[378] Walnut sidechair with fruitwood inlay, renewed upholstery, Austria circa 1820-1825. Pair of mahogany sidechairs, renewed upholstery, by Joseph Ulrich Danhauser, Vienna circa 1815-1820. Private collection, New York City.

[380] Ebonized pearwood sidechair with diagonal mahogany splays, gilt bronze details, renewed upholstery in original colors, Vienna circa 1811.

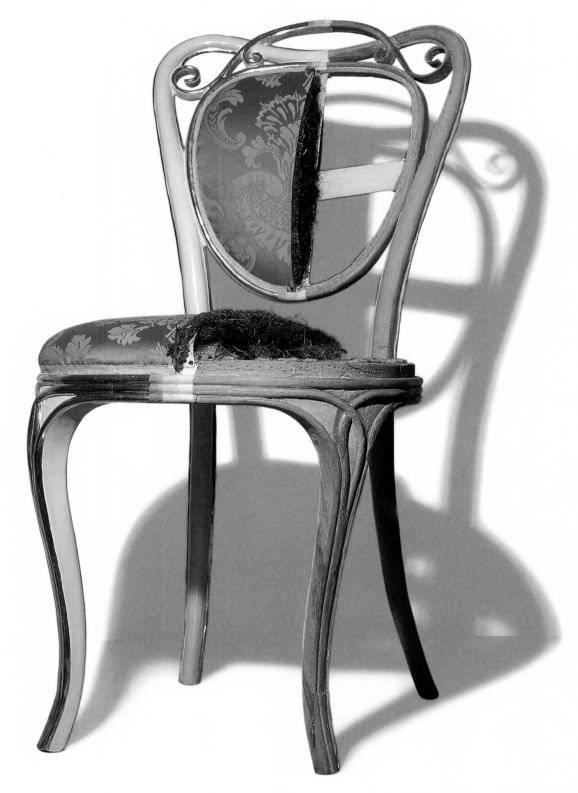

[413] MUSEUM DISPLAY OF A BIRCH SIDECHAIR, ORIGINAL PADDING, BENTWOOD, ILLUSTRATING THE METHOD OF CONSTRUCTION, FINISHING AND UPHOLSTERING METHODS, BY MICHEAL THONET, VIENNA 1848. HOFMOBILIENDEPOT MUSEUM. (AUTHORS NOTE: IN APPROXIMATELY 1830, BIEDERMEIER CABINETMAKER MICHAEL THONET DEVISED AN ALTERNATIVE METHOD TO CUTTING AND CARVING WOOD SECTIONS FOR FURNITURE. BY LAYERING THINLY CUT VENEERS AND BOILING THEM IN GLUE HE COULD PRODUCE STRONGER, LIGHTWEIGHT FURNITURE MORE ECONOMICALLY. THONET SPENT MUCH OF THE 1830S AND 1840S PERFECTING HIS INVENTION WITH THE HELP OF NEW TECHNICAL METHODS AND MACHINERY. BY THE 1850S BENTWOOD FURNITURE WAS BEING MASS-PRODUCED). [414] MONITORS IN THE SECURITY ROOM. HOFMOBILIENDEPOT MUSEUM, VIENNA.

ACKNOWLEDGEMENTS THIS BOOK IS DEDICATED TO THOSE WHO PROMOTE, CREATE AND APPRECIATE EXCELLENCE IN DESIGN. THIS WORK WOULD NOT HAVE BEEN POSSIBLE WITHOUT THE KIND ASSISTANCE AND EXPERTISE OF THE FOLLOWING INDIVIDUALS AND MUSEUMS. WE SINCERELY THANK YOU. LINDA CHASE, KARL KEMP AND LOIS LAMMERHUBER. ▪ NIALL SMITH AND ANGUS WILKIE FOR THEIR CONTRIBUTIONS TO BIEDERMEIER IN AMERICA. ▪ GILBERTO "BETO" OLIVEROS FOR HIS EXPERTISE, ORGANIZATION AND PATIENCE. ▪ ALEXANDER SMOLTCZYK, BERLIN. ▪ HOFMOBILIEN-DEPOT MUSEUM, VIENNA: DR. PETER PARENZAN [DIRECTOR], DR. ILSEBILL BARTA, DR. EVA B. OTTILLINGER, DR. LISELOTTE HANZEL-WACHTER, MAG. DANIELA KABELE, MAG. WOLFGANG SMEJKAL, GÜNTHER JUNGMANN. ▪ SILBERKAMMER, VIENNA: DR. PETER PARENZAN [DIRECTOR], INGRID SALZER, HERBERT HORNACEK. ▪ GEYMÜLLER-SCHLÖSSL, VIENNA: DR. CHRISTIAN WITT-DÖRING [CURATOR OF FURNITURE AND WOODWORK, MUSEUM FÜR ANGEWANDTE KUNST (MAK)], WALTER FRÜWIRTH. ▪ STIFTUNG PREUSSISCHE SCHLÖSSER UND GÄRTEN, BERLIN-BRANDENBURG: DR. BURKHARDT GÖRES [DIRECTOR OF CASTLES], ULRIKE ZUMPE. ▪ DEUTSCHES HISTORISCHES MUSEUM, BERLIN: DR. HANS OTTOMEYER [DIRECTOR]. ▪ COORDINATION: HILDE DAMIATA, MIDDLETOWN, CT. ▪ BOOK DESIGN: A/3 DESIGN, ADRIAN PULFER, RYAN MANSFIELD, CHRISTIAN ROBERTSON, SALT LAKE CITY, UTAH; LINDA CHASE, LOIS LAMMERHUBER. ▪ PHOTO EDITING: LINDA CHASE, LOIS LAMMERHUBER. ▪ COLOR SEPARATION AND PRINTING: KRAMMER-REPRO FLEXO PRINT GMBH, LINZ, AUSTRIA: REGINA ANGERER, ERWIN BRANDSTÖTTER, HELMUT EISNER, KARL GÖTSCHHOFER, HELMUT GROSS, WILHELM HAMMERL, EWALD HIMMELSBACH, HELMUT HOFER, HELMUT HOLLY, WILHELM LORENZ, ROMAN MAYRHOFER, PAUL NEUGEBOREN, CHRISTIAN ROLL, BRIGITTE PENEDER, ROLAND PENTZ, DIETER PRESLMAYER, JOHANN SCHINNERL, EWALD TRUHLAR, KURT WIMMER, VERONIKA YEPREM. ▪ BINDING: FRAUENBERGER, NEUDÖRFL, AUSTRIA. ▪ PRINTED ON: CRISTALLA, 110 GRAM; PHOENO-RECYCLED, HALF MATT 170 GRAM; EUROART 115 GRAM; EUROART GLOSSY 150 GRAM. ▪ TYPEFACE: REQUIEM TEXT, THE HOEFLER TYPE FOUNDRY, NEW YORK CITY. ▪ COPY EDITING AND TRANSLATION: KRISHNA WINSTON [PROFESSOR OF GERMAN STUDIES], WESLEYAN UNIVERSITY, MIDDLETOWN, CT. ▪ EDITING AND COMPUTER INPUT: REGINA WALSH, COBALT, CT. ▪ PRIVATE LOCATIONS: LUCIA PRIETO AND RODNEY STEINBURG, HOUSTON, TX. BARBARA TAYLOR BRADFORD AND ROBERT BRADFORD, NEW YORK CITY. JULIAN SMERKOVITZ, NEW YORK CITY. WILLIAM DEMAS, CHICAGO, IL ▪ DESIGNERS AND ARCHITECTS: JOHN BARMAN, JEFFREY BILLHUBER, ALBERT HADLEY, JOHN IKE, NOEL JEFFREY, DAVID KLEINBERG, BENJAMIN NORIEGA-ORTIZ, PRESTON PHILLIPS, SCOTT SALVATORE, MATTHEW SMYTH, CALVIN TSAO, ALL LOCATED IN NEW YORK CITY ▪ SPECIAL ASSISTANCE TO LINDA CHASE AND KARL KEMP: STACY McLAUGHLIN, NEW YORK CITY; SIBYLLE KALDEWEY, BERLIN, GERMANY. ▪ PHOTOGRAPH CREDITS: ©2001 BY LOIS LAMMERHUBER WITH THE FOLLOWING EXCEPTIONS: ©2001 LAM-MERHUBER FOR VERANDA, ATLANTA, GA. P. 358, 394; ©1999, WILLIAM WALDRON, P. 328; ©1999, DAVID TAYLOR, P. 388, 389, 393, 396. ASSISTANTS TO LOIS LAMMERHUBER: KLAUS POLLANS, ALEXANDER CARLSON. ▪ PERMISSION TO PHOTOGRAPH FOR PAGE 346, EXHIBITION VERNER PANTON, HOF-MOBILIENDEPOT MUSEUM, VIENNA, 2001: ALEXANDER VON VEGESACK [DIRECTOR], VITRA DESIGN MUSEUM, WEIL AM RHEIN, GERMANY. BIBLIOGRAPHY VIENNA IN THE BIEDERMEIER ERA 1815-1848, EDITED BY ROBERT WAISSENBERGER, MAILLARD PRESS, AN IMPRINT OF BDD PROMOTIONAL BOOK COMPANY, INC., GERMAN LANGUAGE EDITION: WIEN 1815-1848: ZEIT DES BIEDERMEIER, © 1986 BY OFFICE DU LIVRE S.A., FRIBOURG, SWITZERLAND; ENGLISH TRANSLATION: ©1986 BY OFFICE DU LIVRE S.A., FRIBOURG, SWITZERLAND; WORLD ENGLISH LANGUAGE RIGHTS RESERVED BY W.S. KONECKY ASSOCIATES, INC., NEW YORK; ©1986 BY RIZZOLI INTERNATIONAL PUBLICATIONS, INC.; HANS URBANSKI, THE CONGRESS OF VIENNA, P. 17; GÜNTHER DÜRIEGL, FROM REVOLUTION TO REVOLUTION, P. 42, 44, 45, 48; ROBERT WAISSENBERGER, THE BIEDERMEIER MENTALITY, P. 86; PETER PARENZAN, THE DEVELOPMENT OF TASTE IN HOME DECORATIONS, P. 109, 110, 117, 118; WALTER OBERMAIER, LITERATURE IN THE BIEDERMEIER PERIOD, P. 229, 230; HEINRICH LAUBE, P. 118, 120; SPERL IN FLORIBUS, REISE DURCH DAS BIEDERMEIER, P. 247 FF, HAMBURG, 1965; J.A. LUX, P. 112; BIEDERMEIER ALS ERZIEHER, MODERNE VERGANGENHEIT 1800-1900, P. 90 FF, VIENNA, 1981; CLEMENS LOTHAR WENZEL VON METTERNICH, P. 230. ▪ HANS OTTOMEYER, AXEL SCHLAPKA, BIEDERMEIER INTERIEURS UND MÖBEL, P. 56, 57, 58, 59, 60; ©1991 BY WILHELM HEYNE VERLAG GMBH&CO. KG, MÜNCHEN: JOHANN WOLFGANG VON GOETHE, ZUR FARBENLEHRE, SCHORNSCHES KUNSTBLATT, NO. 76, 1820, P. 57; ADALBERT STIFTER, NACHSOMMER, 1835, ed.1857, P. 58, 59. ▪ MUSICAL LIFE IN BIEDERMEIER VIENNA, ©1985 CAMBRIDGE UNIVERSITY PRESS. ▪ WIEN!, ALFRED KOMAREK, LOIS LAMMERHUBER, ©1995 BY J&V, EDITION WIEN, DACHS-VERLAG GES.MBH., WIEN. ▪ DER STANDARD SPEZIAL, GESCHICHTENERZÄHLER, IN ZUSAMMENARBEIT MIT SCHLOSS SCHÖNBRUNN KULTUR- UND BETRIEBSGES.MB.H., REDAKTION: BETTINA LOIDL, MARGIT WIENER, 1997. ▪ GEO SPECIAL ÖSTERREICH, STEFAN SCHOMANN, BEI HABSBURGS UNTERM SOFA, 1989. ▪ GEO AUSTRIA, ALFRED KOMAREK, LOIS LAMMERHUBER, DAS GEYMÜLLERSCHLÖSSEL, 2001. ▪ SCHLOSS CHARLOTENHOF UND DIE RÖMISCHEN BÄDER, ©1998 BY AMTLICHER FÜHRER, HERAUSGEGEBEN VON DER STIFTUNG PREUSSISCHE SCHLÖSSER UND GÄRTEN, BERLIN-BRANDENBURG, TEXT: ULRIKE ZUMPE, SILKE HERZ, POTSDAM. ▪ SCHLOSS CHARLOTTENBURG, ©1999 BY AMTLICHER FÜHRER, HERAUSGEGEBEN VON DER STIFTUNG PREUSSISCHE SCHLÖSSER UND GÄRTEN, BERLIN-BRANDENBURG, TEXT: RUDOLF G. SCHARMANN, POTSDAM. ▪ KARL FRIEDRICH SCHINKEL, PAUL ORTWIN RAVE, P. 25, ©1981 BY DEUTSCHER KUNSTVERLAG, MÜNCHEN. ▪ POTSDAM, GERT STREIDT, KLAUS FRAHM, ©1996 BY KÖNEMANN VERLAGSGESELLSCHAFT MBH, KÖLN. ▪ THE AGE OF NAPOLEON, J. CHRISTOPHER HEROLD, ©1963 BY AMERICAN HERITAGE, A DIVISION OF FORBES INC. ▪ LOUIS I. KAHN: WRITINGS, LECTURES, INTERVIEWS, EDITED BY ALESSANDRA LATOUR, P. 225, ©1991 BY RIZZOLI INTERNATIONAL PUBLICATIONS, INC. ▪ 50 MAL AMERIKA, RAYMOND CARTIER, ©1954, 1985 R. PIPER GMBH&CO.KG, MÜNCHEN. ▪ PERMISSION FOR COPYRIGHTED MATERIAL CITED IN THIS BOOK HAS BEEN OBTAINED WHEREVER POSSIBLE. SUBSEQUENT CLAIMS WILL BE HONORED BY THE AUTHORS AT THE CONVENTIONAL RATE UPON THE COPYRIGHT HOLDER'S PRESENTING APPROPRIATE LEGITIMATION. ▪ THANK YOU

First published in hardcover in the United States of America in 2001 by Thames & Hudson Inc.,
500 Fifth Avenue, New York, New York 10110

First published in the United Kingdom in 2001 by Thames & Hudson Ltd,
181A High Holborn, London WC1V 7QX

Library of Congress Catalog Card Number 2001087788

British Library Cataloguing-in-Publication data
A catalogue record for this book is available from the British Library

ISBN 0-500-51055-5

Printed and bound in Austria by Krammer-Repro Flexo Print (GmbH)